ON CLASSIC GROUND

Sponsored by

REED INTERNATIONAL

ELIZABETH COWLING

JENNIFER MUNDY

ON CLASSIC GROUND

Picasso, Léger, de Chirico

and the New Classicism 1910-1930

Tate Gallery

front cover/jacket
'Two Women Running on the Beach (The Race)' 1922, Pablo Picasso
(cat.142) © DACS 1990

ISBN 1 85437 043 X paper
ISBN 1 85437 044 8 cloth

Published by order of the Trustees 1990
on the occasion of the exhibition at the
Tate Gallery: 6 June – 2 September 1990

Designer: Caroline Johnston
Editor: Angela Dyer
Published by Tate Gallery Publications, Millbank, London SWIP 4RG
Copyright © 1990 The Tate Gallery All Rights Reserved

Printed on Parilux matt 150gsm and typeset in Ehrhardt
Printed by Balding + Mansell Limited, Wisbech, Cambs

CONTENTS

7 Foreword

9 Acknowledgments

11 Introduction

31 Catalogue

260 Lenders

261 Index of Artists and their Works

FOREWORD

A major revival of the classical tradition in art gathered momentum during and after the First World War, affecting many of the most radical artists of the time and causing them to modify the revolutionary styles they themselves had invented. *On Classic Ground* explores the various manifestations of this 'call to order' in France, Italy and Spain where the classical tradition was claimed as the natural and exclusive heritage of the Mediterranean peoples. The exhibition highlights the real local differences, but also the many shared preoccupations. It places the movement in its context by including a small group of works from the first decade of the century, by which time the idea of an innovative form of classicism as the correct means to purge art of the 'curse' of anecdote had already taken firm root. It demonstrates the sheer resilience of the classical ideal in early twentieth-century painting and sculpture, not least in the work of some of the greatest artists. In its particular emphasis and approach, the exhibition is the first of its kind and will, we hope, stimulate further study of a period that is still well within living memory, but which remains so little known and its rich variety so little appreciated.

The exhibition has been devised and selected by Elizabeth Cowling, Lecturer in History of Art at Edinburgh University, with Jennifer Mundy of the Tate Gallery's Modern Collection, and they have written this catalogue. We are most grateful to them for the enthusiasm and dedication that they have devoted to the successful realisation of the project.

Above all we should like to offer our sincere thanks to all lenders, whether private collectors or public collections. It is their generosity that has made possible the installation of such an important survey of the period and we are deeply grateful.

We are particularly indebted to the following who have lent extensively from their collections: to Jean-Hubert Martin, Director of the Musée National d'Art Moderne, Paris, to Gérard Régnier, Director of the Musée Picasso in Paris, to Tomás Llorens, Director of the Centro de Arte Reina Sofia in Madrid, to Cristina Mendoza, Director of the Museu d'Art Modern in Barcelona, and to Kirk Varnedoe, Director of the Museum of Modern Art in New York. We are equally grateful to the Italian Ministry of Culture and National Heritage for so generously approving so many loans from Italian collections and to its Director General, Professor Francesco Sisinni, as well as to the Italian Ambassador in London, His Excellency Mr Boris Biancheri who, with the Cultural Attaché, Professor Alessandro Vaciago, have given so much invaluable help and advice. We are most grateful to them all for their exceptional cooperation and support.

Included in the cloth-bound version of the catalogue are essays by a number of international scholars which illuminate and enlarge upon related areas that could not be dealt with in the actual exhibition. We should like to thank all the authors.

The final realisation of such an ambitious project has also depended on the

generous sponsorship which we have received from Reed International, a company which has quickly established itself as one of the more imaginative supporters of the arts of this country. We are sincerely grateful to them for their support.

Nicholas Serota
Director

SPONSOR'S PREFACE

We are delighted to support the Tate Gallery in presenting *On Classic Ground: Picasso, Léger, de Chirico and the New Classicism, 1910–1930*.

This remarkable exhibition explores the revival of the classical tradition during and after the First World War. By bringing together the finest painters of the period in this way, the survey breaks new ground and expands greatly our understanding of the driving forces behind the artists' work.

As Britain's largest publisher, Reed International has an especially close affinity with the visual arts. Through our interests in consumer and business magazines, newspapers and books we rely heavily upon the elements of composition, light and colour to report and comment on the events and thinking of the day.

We believe *On Classic Ground* to be a very exciting exhibition and it gives us much pleasure to be part of it.

Peter Davis
Chairman & Chief Executive

ACKNOWLEDGMENTS

The ever-increasing demands placed on museum directors and private collectors have made 'theme' exhibitions notoriously difficult to mount in recent years. Although we have encountered some setbacks over loans, the generosity of lenders, both public and private, has been outstanding. The great kindness we were shown, and the enthusiastic response with which the project was greeted, made our various trips to France, Italy and Spain a great pleasure, and our task easier than we had dared to anticipate. Many collectors, who prefer to remain anonymous, allowed us into their homes and discussed the artists' works with us at length, and our warmest thanks are extended to all of them.

We benefited from the unstinting cooperation of many museum directors and curators, and in particular Marie-Amélie Anquetil, Gabriella Belli, Paolo Biscottini, Marie-Odile Briot, Rhodia Dufet-Bourdelle, Thérèse Burollet, Christian Derouet, Michel Hoog, Eugenio Manzato, Isabelle Monod-Fontaine, Jacqueline Munck, Alvaro Novillo, M.-Teresa Ocaña, Marilena Pasquali, Joëlle Pijaudier, Jean-Louis Prat, Cora Roscvear, Laura Safred, Didier Schulmann, Rosanna Maggio Serra, Björn Springfeldt and Evelyne Tréhin. But we especially wish to thank Marie-Laure Bernadac, Cristina Mendoza, Augusta Monferini and Pia Vivarelli, who not only helped us over the works in their care, but gave us invaluable advice and information. We also owe a particular debt to Massimo di Carlo, Professor Massimo Carrà, Philippe Daverio, Professor Maurizio Fagiolo dell'Arco, Claudia Gian Ferrari, Professor Rafaele de Grada, Maurice Jardot, Quentin Laurens, Joan A. Maragall, Marta Maragall, Marilyn McCully, Mario Quesada, Massimo Simonetti, Josep Subiros, Jaume Sunyer, Professor Toni Toniato, Lucia Stefanelli Torossi and Dina Vierny: they were always ready to share their knowledge with us, and repeatedly helped us in our efforts to secure loans. We are also most grateful to Professor Alessandro Vaciago for his support.

Many others have helped us in a variety of ways connected with the content of the exhibition and the cataloguing of the works. We gratefully acknowledge the cooperation of Maria Accorinti, Anna Achille Jarvis, Stanley John Allen, Thomas Ammann, Carmen Arnau, Luisa Arrigoni, Patrice Bachelard, Robin Barber, Antonella Bensi, Juan Manuel Bonet, Emily Braun, Miren de Bustinza, Teresa Camps, Rosa-Maria Carrasco, Antonia Casanovas, Peter Chisnall, Antonio Columba, Nicoletta Columba, Victoria Combalia, Alan Cowling, Faried Dangor, Christopher Duggan, Patrick Elliott, Eric Estorick, Michael Estorick, Lia Fossati, the late Contessa Gaetani-Sarfatti, Matthew Gale, Isabel García Lorca, Pierrette Gargallo-Anguera, Elvira González, Christopher Green, Ann Jones, Pare Laplana, Jane Lee, Michel Leiris, Rosa-Maria Letts, Roger Ling, Robert Lubar, Marie-José Lundström, Eli Palmer, Salvador Riera, Margit Rowell, Angelica Savinio, Gina Severini Franchina, Carmine Sinascalco, Mario Socrate, Robert Stoppenbach, Denys Sutton,

Geneviève Taillade, Netta Vespigniani, Barry and Saria Viney, and Lamberto Vitali.

Finally, we should like to thank Iain Bain, Caroline Johnston, Jo Ennos and Mollie Luther of the Tate Gallery Publications Department for their part in producing a very complex catalogue, Pamela Waley for her translations, Angela Dyer for her editorial work, the staff of the Tate Gallery Library and the Photographic Department for their forbearance and constant readiness to help, and Bruce McAllister of the Technical Services Department. We are especially grateful to Ruth Rattenbury, Sarah Tinsley, Helen Sainsbury and Clarissa Little of the Exhibitions Department: without their commitment and support the exhibition could never have been mounted.

Elizabeth Cowling

Jennifer Mundy

INTRODUCTION

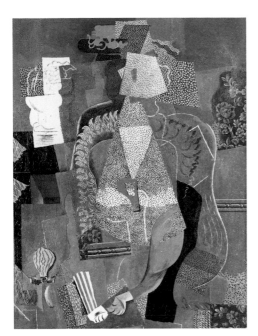

fig.1 Picasso, 'Portrait of a Young Girl', 1914, *Musée National d'Art Moderne, Centre Georges Pompidou, Paris*

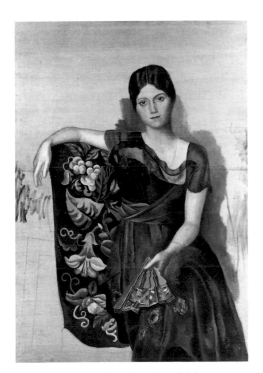

fig.2 Picasso, 'Olga Picasso in an Armchair', 1917, *Musée Picasso, Paris*

When war was declared on 2 August 1914 Pablo Picasso was staying in Avignon in the south of France. While he was there he painted two pictures – one Cubist (fig.1), the other naturalistic (cat.130) – which look so different that it is hard to believe they were painted by the same man, let alone at the same time. Perhaps only Picasso could have changed the direction of twentieth-century art with such casual ease. Three years later, pretending to be Ingres, he depicted his fiancée in a beautiful gown (fig.2), and his return to 'classicism' was confirmed.[1] At about the same time Gino Severini, associated in the public mind with the provocative Futurists and pictures such as 'Suburban Train Arriving in Paris' (fig.3), suddenly produced 'Maternity' (fig.4), which looks like a Mantegna or a Ghirlandaio.[2] Their 'defection' from an avant-garde position aroused excited debate, and anticipated a general shift within the art world after the war. It is this shift that is the main theme of the present exhibition.

'The classical revival', 'the call to order', 'the return to order' – the names by which this movement is most often known – gathered momentum during the First World War in France and Italy, and spread rapidly after peace was declared. The work of many painters and sculptors was visibly affected, and this exhibition could – some will say should – have represented many more of them than it does. In other countries directly involved in the fighting – for instance, Germany and Britain – there were parallel movements. However, the decision was taken to explore the specific reinterpretation of *classicism*, rather than a more general return to the figurative tradition, and thus to concentrate upon the Latin countries, where it was claimed, with a certain justification, that the classical tradition was the native tradition – the heritage and source by natural right.[3]

This impulse to return to the constants of the Great Tradition has been seen as conservative and reactionary, because avant-garde, individualistic styles of one kind or another were rejected or modified in the interests of greater clarity, order and universality, and because the changes usually met with the approval of the Establishment – bourgeois patrons and their favourite dealers, critics who had been hostile to avant-garde styles, and political leaders on the right who, alleging a Boche conspiracy, vaunted 'racial purity' in the arts. The fact that the Fascists embraced classicism for propagandist purposes, and that whenever artists were required to celebrate the aspirations or the power of their country they turned to classical models as if there were no possible alternative, has led to mistrust of the language of classicism itself. There is the suspicion that it is at worst authoritarian and oppressive, at best rhetorical and sham. Indeed because of its presumed *arrière-garde* nature, the post-war classical revival has received scant attention until quite recently,[4] and the work produced has often been treated with contempt.[5] Yet that work is often of the highest quality, and the accusation of conservatism (in the pejorative sense of reaction against innovation and invention) does not stand up.

The First World War has, rightly, been seen as a catalyst in the post-war

'return to order', inducing a craving for the stability and proven value of tradition following disruption, carnage and vandalism on a scale unparalleled in living memory. There is no question that that craving existed, and that it was articulated passionately by many of the most lastingly important figures of the time, as well as by the soap-box orators.[6] It had a wider context than the war itself, however, for it was the response of nations that had witnessed rapid, often devastating waves of industrialisation – given dramatic and horrific impetus by the war – and that had been engulfed by the materialist values of the nineteenth century which placed supreme emphasis on 'progress' and 'development'. In contrast, the classical tradition offered a haven of relative tranquillity.

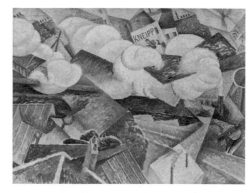

fig.3 Severini, 'Suburban Train Arriving in Paris', 1915, *Tate Gallery*

Classicism in art is most simply defined as 'an approach to the medium founded on the imitation of Antiquity, and on the assumption of a set of values attributed to the ancients'.[7] Although it is convenient to consider separately the situation in France, Italy and Spain, for there were real local differences, it is in the very nature of classicism that there should have been shared concerns and shared solutions, for classicism claims to be both universal and timeless. The reputation of Paris as the mecca of the art world meant that in practice most Italian and Spanish artists spent time there – some even making it their permanent home – so that a network of contacts developed, encouraging a rapid exchange of ideas, as well as, paradoxically, a sense of national identity.

At the simplest level there was uniformity in subject matter, for painters of all three nationalities addressed the 'classic' themes and worked within the established genres of figure composition, the nude, landscape and still life. The Maternity was, for instance, a favourite subject. It might be treated relatively naturalistically, as in Sunyer's painting of his wife and baby son (cat.171), or in an explicitly Renaissance style, with overtones of the Madonna and infant Christ, as in Severini's picture (fig.3), or in a neoclassical manner by Picasso (cat.140). Underpinning the shared subjects was their common cultural heritage. Greco-Roman sculpture was a source for numerous paintings and sculptures; the Italian Renaissance inspired not only the Italians but also the French and the Catalans, many of whom travelled to Italy in quest of the Great Tradition as generations of artists before them had done; Poussin, Ingres, Corot and Cézanne were important to painters as diverse as, say, Léger, Derain and Dalí. Above all, we notice certain 'constants' in the approach to classicism, certain recurrent and dominant myths.

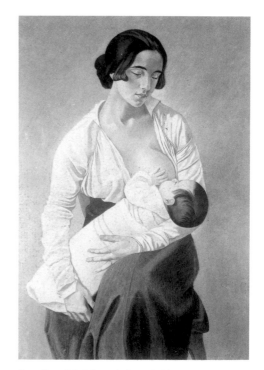

fig.4 Severini, 'Maternity', 1916, *Museo dell' Accademia Etrusca, Cortona*

Perhaps the most potent myth of all is that of the Mediterranean world as Arcadia – an earthly paradise protected from the sordid materialism of the modern industrialised world, free from strife and tension, pagan not Christian, innocent not fallen, a place where a dreamed-of harmony is still attainable. The myth, nourished by the pastoral poetry of Theocritus and Virgil, and by innumerable pastoral paintings of earlier periods, generated sensual images of sweeping fertile landscapes bathed in sunlight, calm blue seas, confident and handsome nudes, and peasants going about their daily lives as if nothing had changed for centuries. At its heart there lurked the potential for profound melancholy – the sense of loss and the knowledge that the ideal can never be attained. And just as melancholy pervades the pastoral paintings of Claude and Poussin and Corot, so it pervades the work of some of the new classicists –

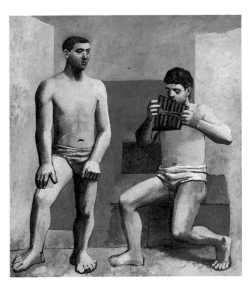

fig.5 Picasso, 'The Pipes of Pan', 1923, *Musée Picasso, Paris*

Derain, Picasso and de Chirico especially. Occasionally the myth assumed the old Ovidian guise.[8] But even when the setting was apparently contemporary there was always an intentional ambiguity, so that the present was seen through the perspective of the past, and thus idealised and made more resonant.

The painters and sculptors who lived part at least of their lives on the Mediterranean coast were especially susceptible to this myth. It permeates the late paintings of Renoir and his forays into sculpture (cats.147,148), the paintings of Matisse in his Nice period (cats.118,119), and the idylls of Bonnard (cats.6,7). All three used the richly coloured, painterly style derived from the Venetians which was traditionally associated with sensuality. De Chirico employed the same style in theatrically disposed scenes of Renaissance buildings set in hilly landscapes, animated by classical statues and figures in modern dress (cat.33), and in order to evoke the almost oppressive voluptuousness of the fruits of the south (cat.40). For Picasso the summers spent at Biarritz, Saint-Raphaël, Juan-les-Pins, Antibes and Cannes generated great paintings like 'The Pipes of Pan' (fig.5) in which the Mediterranean acts, nostalgically, as the site of the ideal. The myth permeates the bucolic imagery of the Catalans – Sunyer, Casanovas, Manolo, Miró, Gargallo, González and Togores; it ennobles the Poussinesque landscapes of Derain (cat.45); it receives a monumental statement in Martini's 'Woman in the Sun' (cat.112) and Maillol's 'Three Nymphs' (cat.95); it invests the sculpture of Laurens with a lyrical dimension; it motivates Gris's series of still lifes before windows that open out on to the sea (cat.67). It is a myth which rings out in much of the more airy critical writing of the 1920s. Here the author is describing Banyuls, the fishing village near Perpignan, where Maillol was born:

> A landscape of rounded hills creates a sort of amphitheatre where grey olive trees spread their luminous masses, and where the laden vines, supported on dry stone walls, surround some Spanish house or ancient ruined tower; at the foot of and around the village spread gardens full of oranges and fruit trees, with here and there a sharp-pointed cypress or the open fan of a splendid palm. It is there that Maillol was born, and there that for the first time his blue eyes contemplated the land and the sea. It was the scent of this landscape and its springtime orchards which he breathed in with each new day; it was on the slopes of those hills, enlivened by goats, and in the depths of those secret valleys that there awoke in him, during his wanderings, that profound sense of life, of beauty and of love. There is no place capable of giving a more complete idea of the Greece we learn about at school.[9]

It is a dream which also lies behind the contemporary architecture of Le Corbusier, with its flat roofs, white walls, expanses of window, balconies, cool tiled floors and open-plan interiors.

The theme of the continuity of peasant life, inseparable from the wider Arcadian theme, generated certain recurrent images. There are, for example, many Italian Novecento paintings in which a generalised peasant costume is used to confer an air of universality on a scene which might otherwise be interpreted either as contemporary, or as located in a specific period in the past, or as having a particular meaning. Thus Guidi rendered ambiguous the

meeting between an old and a young woman in the trance-like 'The Visit' (cat.69), and Funi suggested an indefinite span of time in his 'allegory' of fruitfulness ('Earth', cat.55). Donghi (cat.52), Dalí (cat.44) and Togores (cat.173) used an unspecific rustic costume to give their models the dignity of types. And by the mere addition of a peasant hat, Martini was able to give two generalised figure studies an earthy innocence (cats.108,112). Folk costume was used, particularly in France, for poetic and nostalgic effect, and to evoke reminiscences of the old masters: thus, Derain (cat.48), Matisse (cat.117) and Braque (cat.12) allude not simply to folk traditions, but to the Italian costume-pieces of Corot. And salvaged from the classical world was the ubiquitous white drapery which, cast over the models of Sironi or Picasso, lent them a vaguely antique air, without, however, necessarily detaching them from the present of the artist's studio. In all these cases costume alone lends that added dimension: anecdote is not involved.

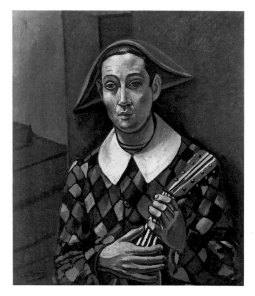

fig.6 Derain, 'Harlequin', 1919, *National Gallery of Art, Washington, Chester Dale Collection*

The *commedia dell'arte* provided another set of standardised types. Derain (fig.6), Picasso (cat.132), Andreu (cat.3), Gris (cat.68 and Severini (cat.155) were among those who plundered this resource. In part they were motivated by traditional images of the *commedia*, whether those by painters like Watteau and Cézanne or by eighteenth- and nineteenth-century print-makers and illustrators, for there was much interest in the 'call to order' period in the old, endangered traditions of popular theatre. In part the stimulus came from Diaghilev, and his commissions to leading avant-garde artists for sets and costumes for ballets with folk themes. (*Parade* in 1917, designed by Picasso, was an important event because the drop-curtain, fig.7, suggested, in the context of a public spectacle, the rich potential of this kind of poetic imagery.) But most important of all perhaps was the fact that the old Italian Comedy, with its stock characters, costumes and situations, suggested a viable alternative – still Latin in its roots – to classical mythology.

fig.7 Picasso, Drop-curtain for *Parade*, 1917, *Musée National d'Art Moderne, Centre Georges Pompidou, Paris*

In France after the war the 'call to order' – the resonant phrase was used by the writer Jean Cocteau, an influential voice at the time[10] – took a number of characteristic forms, and the idea of the French tradition as the ideal model for the new generation was an article of faith with many critics, ranging from the advanced to the conservative.[11] Picasso and Braque were among those to adapt neoclassical imagery, while Picasso also worked in a great variety of traditional 'naturalistic' styles. Gris returned to figure subjects in the middle of the war and made free transcriptions of old master paintings, and in the early 1920s his flat, synthetic Cubist style gave way to an increasingly volumetric and descriptive manner. Matisse's work after he settled in Nice in 1917 became more naturalistic than it had been for many years, and all obvious indications of his previous interest in Cubism disappeared. Laurens's sculpture became gradually less geometric, and in the late 1920s approached that of Maillol. Maillol himself was at the height of his reputation by the mid-1920s and produced a great sequence of life-sized classical statues, while Bourdelle and Despiau were admired for their ability to adapt Greco-Roman and Renaissance prototypes to their own expressive ends. Derain, who maintained a constant dialogue with the art of the past, was widely seen as one of the greatest artists of the period. Léger ceased to fragment his figures, made allusions to great paintings from the past, addressed himself to traditional subjects, and often

worked on a grand Salon scale. The Purist painters, although they practised a radical, abstracted style, set about codifying and ordering pre-war Cubism according to aesthetic and philosophic principles derived from antiquity and the Renaissance. And it was typical of the period that drawing should be regarded as an important discipline, and given special status in monographs and exhibitions.

In Italy the war, and the short history of national unity, engendered fiercely patriotic sentiments.[12] The contacts with France were close, for an important group of Italian painters, which included Severini, de Chirico and Savinio, was resident in Paris. But the overriding concern was with the Italian tradition. The ideology of the 'call to order' was promoted after the war by, among others, the painter and theorist Ardengo Soffici, and the critics and artists associated with Mario Broglio's art journal *Valori Plastici*, published in Rome between 1918 and 1922. Here the metaphysical paintings of de Chirico, Carrà and Morandi were illustrated, and the distinctive qualities of the Italian and the French tradition debated and analysed. The reaction against Cubism in France was paralleled by a reaction against the modern, narrative subject matter and the fragmented, abstracted style of Futurism. The writings as well as the paintings of de Chirico and Carrà during these years reflect their close study of Italian Renaissance traditions. De Chirico, who had received an intensive academic training, now demanded the most rigorous classical standards, made a number of close copies of old master paintings (cat.32), and like several of his compatriots, including Severini and Martini, became fascinated by largely disused historic techniques. For Carrà, once he had turned his back on Futurism, the Trecento and the Quattrocento represented the ideal source – pure in form and mysterious and spiritual in content. For Martini the Italian Primitives were initially just as important, as a work like 'Head of a Boy' (cat.107) demonstrates. But he was soon drawn to the recently excavated sculpture of the Etruscans, which he saw as the purest Italian expression of classicism. For Sironi, Funi, Guidi, Casorati, Oppi and other painters associated with the Novecento movement, which was promoted from 1922 onwards in a series of exhibitions and essays by the critic Margherita Sarfatti, the ideal was a marriage between the artistic tradition of the Italian Renaissance and the 'pure' plastic concerns of contemporary art. Their pictures reflect their sense of the continuity between past and present in frank allusions to favourite artists including Raphael, Bellini, Piero della Francesca, Masaccio and Mantegna.

Some of the artists associated with the Novecento, in particular Sironi and Funi, were from an early date supporters of the Fascist Party, to which Sarfatti herself was fully committed, and which deployed the imagery of classicism to foster nationalist sentiment and the dreamed-of revival of the glorious triumphs of the Roman Empire in Mussolini's modern state. But Mussolini himself, despite his personal relationship with Sarfatti, never officially endorsed any particular style or group, and association with the Novecento group did not automatically imply any specific political allegiance on the part of the artist concerned. Indeed an overtly propagandist stance was a significant feature only in the 1930s, when opportunities arose for large-scale public murals and sculptures celebrating Fascist ideals. For the longing to see modern

art enjoy the genuinely social role and influence that it had had in the past – an aspiration shared by artists on the political left, such as Léger – was a powerful motive behind the political activities of Sironi, who instigated the 'Manifesto della pittura murale' in 1933, and of Carrà, Funi and Campigli, who were among those to sign it. (See Carrà's and Sironi's cartoon-scale drawings, cats.20,167.)

In Catalonia the situation was somewhat different, not least because Spain was not involved in the First World War. The Noucentista movement, masterminded initially by the critic Eugeni d'Ors, was established as the leading movement in Barcelona between 1906, when d'Ors first began publishing his 'Glosari' in *La Veu de Catalunya*, and 1911, when the *Almanach des Noucentistes* came out. The movement was dedicated to the promotion of a modern form of classicism, which in painting was largely dependent on the example of Cézanne (and to a lesser extent on Renoir and Puvis de Chavannes), and in sculpture took Maillol as the ideal model. Noucentisme was thus intimately involved with developments in France, and much was made of the shared cultural history of southern France and Spanish Catalonia, as well as of the broader links with Latin culture in general.[13]

This said, Noucentisme had a strong local identity, and as a movement closely connected with Catalan nationalism was committed to the revival of Catalan folk customs and the great native traditions of the past, such as the Romanesque. It was also committed to the overthrow of Modernisme, which had prevailed in Barcelona in the late nineteenth century and in the 1900s. Modernisme, the equivalent of Art Nouveau, was seen as 'decadent' because of the strong influence from northern countries, particularly Germany, Austria and Britain – influences which had diverted the 'pure' Mediterranean course of Catalan art – and because of its emphasis on the experience of contemporary urban life. For Noucentisme saw itself as a movement of reclamation and restoration, and the recent successful excavations at the Greco-Roman site of Ampurias generated a sense of continuity between antiquity and modern times.[14]

A neoclassical strain in Noucentisme was evident from the first in the paintings of Joaquín Torres-García, a close associate of d'Ors and an influential theorist in his own right. His murals for public buildings in Barcelona were directly inspired by the work of Puvis de Chavannes, and were intended both as an alternative to anecdotal painting, whether naturalist or symbolist in style, and as proof of the continuing viability, and indeed necessity, of modern art on a public scale. The neoclassical Noucentista style was given more convincing expression in sculpture than in painting, however, particularly in the work of the hugely successful Clará, and of Casanovas, in whose stone carvings it took a distinctive primitivist orientation.

In painting, Puvisesque neoclassicism found few adherents of consequence besides Torres-García. But the lessons of Gauguin, and especially of Cézanne, had long-lasting impact through the new work of Sunyer. 'Pastoral' (cat.169) was hailed as a masterpiece of modern classicism and above all as the sign of a Catalan renaissance in painting. Sunyer's influence was considerable, and among those affected was Picasso, who spent several months in Barcelona in 1917 and was encouraged by the example of old Catalan friends to pursue his

own 'return to order'. (See cat.132.) The identification with Catalan folk-traditions and rural life remained an important motive behind Miró's work long after he had ceased to be influenced by Sunyer or d'Ors's form of Noucentisme, and was central to most of the work of Manolo. Indeed for all those touched by the movement, the sense of their Catalan heritage was of prime importance, expressed not only in loving depictions of the landscape, but in the symbolic image of the statuesque country women of Catalonia, taken as the emblem of the survival of the true Mediterranean spirit into the present – the very incarnation of living classicism.[15]

Even so schematic an account of Noucentisme draws attention to the fact that the 'call to order' movement significantly predates the outbreak of the First World War. Maurice Denis, formerly a member of the Nabi group, and a mural painter who worked in a manner developed from that of Puvis de Chavannes, was a vocal champion of classicism in his critical writings in the decade preceding the outbreak of the war. These were gathered in 1912 in *Théories (1890–1910): Du symbolisme et de Gauguin vers un nouvel ordre classique* – a book whose very title is a manifesto in miniature.[16] Denis locates the roots of the new classicism of the 1900s in the work of the post-Impressionists, and it is there that we must look for the origins of the 'call to order' of the wartime and post-war period. In France, Italy and Spain there was almost universal agreement on the immense importance of Cézanne's achievement. He is seen as the great hero by Denis himself, by Soffici, and by d'Ors.[17] Renoir's status was never quite as high, but he too was widely admired in all three countries. Impressionism, on the other hand, was condemned by writer after writer, with a degree of consistency which indicates just how dangerous a threat it was felt to be once it had become an officially accepted style. It was, went the general argument, too naturalistic, too preoccupied with merely ephemeral effects, too anarchic, too individualistic – incapable, in short, of universality of meaning, or of beauty of a grand dimension. The following passage from a piece by Guillaume Apollinaire is fairly typical: 'Ignorance and frenzy – these are the characteristics of impressionism. When I say ignorance, I mean a total lack of culture in most cases; as for science, there was plenty of it, applied without much rhyme or reason; they claimed to be scientific. Epicurus himself was at the basis of the system, and the theories of the physicists of the time justified the most wretched improvisations.'[18] The Purists agreed. The first issue of their magazine, *L'Esprit Nouveau*, published in 1920, carried six photographs of works designated as 'good' and 'bad'. On the good side were an archaic Greek statue, an African mask, Seurat's 'Chahut', and a still life by Gris, and on the bad, a sculpture by Rodin and a water-lily painting by Monet (fig.8).

This hostile judgement recapitulates quite closely that of the early critics of Impressionism, who, even if they were prepared to admit that it had charm and that it was remarkably truthful in its rendering of fleeting visual sensations, were shocked by its sketchiness and by, in their view, the absence of structure or seriousness. Emile Zola, an unremitting opponent of the empty pretensions of academic Salon painting, had been an early supporter of first Manet, and then Monet, Pissarro and the other members of the Impressionist group because he approved of their realistic subject matter. But by 1880 he had come regretfully to the conclusion that the emphasis on ephemeral effects and a

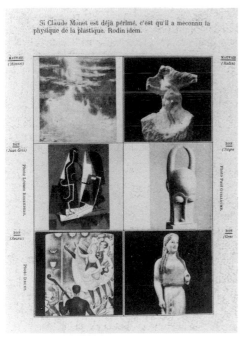

fig.8 *L'Esprit Nouveau*, no.1, 1920

correspondingly rapid technique precluded the creation of great art: 'Nowhere, not in the work of any one of them, is the formula applied with true mastery.... There are too many holes in their work; they neglect their facture too often; they are too easily satisfied; they are incomplete, illogical, extreme, impotent.'[19]

The leading Impressionist painters privately expressed similar anxiety, and by the early 1880s a 'crisis' had developed, with widespread defection from the group shows, and individual efforts to strike out in new directions.[20] For Cézanne and Renoir this took the immediate form of a classicist orientation. Renoir went to Italy to study Raphael and the old masters, and for a time practised a tight, draughtsmanlike style combined with Impressionist prismatic colour; this experiment was short-lived, but his subjects and compositions were altered ever afterwards as he embarked on a process of idealising and mythologising the women and landscapes that remained his favourite motifs (cat.147). Cézanne retreated to Provence to forge a style bridging the visual truth and colourism of Impressionist *plein-air* painting and the grand compositional structures of Poussin and Chardin (cat.28). Even Monet began to rely increasingly on synthesising his 'impressions' in the studio away from the motif, and, omitting all specifically contemporary references, used a serial method to dignify and universalise his chosen subjects. Pissarro, temporarily converted to the rigorous pointillist technique of Seurat, focused increasingly on generalised rural themes in which the figure played a much more important role than hitherto. Meanwhile the new paintings of Seurat and Gauguin were conceived in direct opposition to fundamental aspects of the Impressionist technique. Seurat's huge figure paintings were created from drawings and oil sketches in a painstaking process based on the academic method of composition, and drew on sources from the classical tradition. Gauguin addressed himself to the creation of a mythic, primitive Arcadia, depending on a wide range of artistic references to give his figure paintings an iconic depth and power. Both were directly influenced by the neoclassical murals of Puvis de Chavannes. In the sphere of literature the equivalent movement was the Ecole Romane, founded in 1891 by the Greek-born poet and theorist Jean Moréas, which was dedicated to the revival of the Latin roots of French literature.

The 'avant-garde classicism' of the post-Impressionists reached a climax of visibility around 1904–7. A series of exhibitions was mounted in the Salons des Indépendants and d'Automne: Cézanne, Puvis and Renoir retrospectives were held in the autumn Salon of 1904, a Seurat retrospective at the Indépendants in 1905, an enormous Gauguin exhibition in the autumn of 1906, and a memorial Cézanne show in the Automne in 1907. A barrage of critical analysis accompanied these events.

The term 'avant-garde classicism' has been used to draw attention to the vital distinction between the kind of classicism practised by the post-Impressionists and the classicism of the academic *arrière-garde*. Politics aside, if classicism is now generally assumed to be conservative and reactionary, so that we are almost reluctant to admit its centrality to the work of the 'progressive' nineteenth- and twentieth-century artists we admire, it is because of our lurking fear that academicism is a little too close for comfort. For, whether or not we identify the beginning of the modern movement with the

Romantics, with Courbet, with Manet, or with the Impressionists, we invariably identify it with a rejection of academicism. These artists are our heroes precisely because they refused to conform to the rigid and stifling standards set in the art academies. Our notion of an avant-garde battling against the dead weight of the academic classicism of meretricious, super-successful *pompiers* like Gérôme, Cabanel and Bouguereau (fig.9), has made us deeply suspicious of later classical revivals: might they not also be rearguard academic revivals? Because by the middle of the nineteenth century the classical tradition no longer had the weight of absolute authority it once enjoyed, we tend to assume that innovative artists were bound to reject its principles, abandoning it in favour of alternative traditions that were fresh and new (such as, say, Far Eastern art). But this assumption does not stand up under scrutiny. For all the evidence suggests that the avant-garde in the nineteenth century made an absolute distinction between 'true' and 'fake' classicism, and actually used experience of alternative traditions as a means of looking anew at the classical tradition, thus providing the model for the twentieth-century avant-garde.[21]

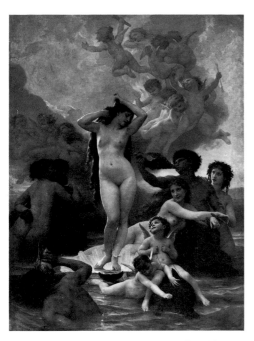

fig.9 Bouguereau, 'The Birth of Venus', 1879, *Musée d'Orsay, Paris*

The training of all European painters and sculptors around 1900 was still a training in classicism. The curriculum was more or less standardised, and whether or not the student intended to be a painter or a sculptor, he or she had to 'imitate' the antique by making accurate drawings from plaster casts of celebrated Greco-Roman sculptures, and by drawing repeatedly from the live model posed in the manner of a statue. Familiarity with the antique was complemented by the study of Renaissance and neoclassical art, since these traditions were assumed to reinforce the same values, and copying from the great masters was routine.[22] Of course, different teachers applied these standards more or less rigidly. But even in the free academies, drawing from plaster casts and from the nude model, and the study of museum art, were regarded as fundamental disciplines: when Matisse opened a school in 1908, he required his students to draw from the antique.[23] Meanwhile in the secondary schools a basic knowledge of classical literature and history was regarded as synonymous with education. This is the fundamental difference between the situation in the second half of the twentieth century and that in the first: today one cannot assume a general knowledge of the achievements of antiquity, then one could.

Where the academics and the avant-garde parted company was over the complex issue of 'imitation'. The academics, believing that the apex of civilisation had been reached in Periclean Athens and Augustan Rome (and attained once again in Italy at the time of Raphael), required a high degree of conformity to the outward forms of the past, and were consequently suspicious of innovation. The avant-garde, believing that it was the essential principles of classicism that were lastingly valuable, took a much more liberal view of formal invention. The academic attitude to classicism owed a great deal to the eighteenth-century writer and archaeologist Johann Winckelmann, whose purpose was to combat the 'decadence' of the prevailing Rococo style. From his study of Greek art Winckelmann had come to the conclusion that 'its last and most eminent characteristic is a noble simplicity and sedate grandeur in Gesture and Expression.' And he went on, 'As the bottom of the sea lies

peaceful beneath a foaming surface, a great soul lies sedate beneath the strife of passions in Greek figures.' Because of the absolute supremacy of Greek art, Winckelmann was convinced that 'There is but one way for the moderns to become great, and perhaps unequalled: I mean by imitating the ancients.'[24] Although for him 'imitation' was not the same as 'copying', that subtle distinction was all too easily eroded, and by the beginning of the twentieth century Winckelmann was being seen by the avant-garde as the apostle of 'fake', not 'true' classicism – the classicism of the *pompiers* who dominated the official Salons and appealed to a pretentious but ignorant public. This was the view of Apollinaire:

> It was the German aestheticians and painters who invented academicism, that fake classicism which true art has been struggling against ever since Winckelmann, whose pernicious influence can never be exaggerated. It is to the credit of the French school that it has always reacted against his influence; the daring innovations of French painters throughout the nineteenth century were above all efforts to rediscover the authentic tradition of art.[25]

The acute moral pressure applied by the academic tradition was felt perhaps most painfully by young artists in Italy, for nowhere else is the classical tradition so much a part of the consciousness of the present. Not isolated within abandoned historic sites or immured within a scattering of museums, it lives on in every town or city of consequence in the thousands of still functioning buildings that bear the visible imprint of classicism.[26] The sense of desperate frustration induced by this obsession with the past found one kind of outlet in iconoclasm – the iconoclasm of Marinetti's 'Futurist Manifesto' of 1909:

> Do you, then, wish to waste all your best powers in this eternal and futile worship of the past, from which you emerge fatally exhausted, shrunken, beaten down? . . . When the future is barred to them, the admirable past may be a solace for the ills of the moribund, the sickly, the prisoner. . . . But we want no part of it, the past, we the young and strong *Futurists*! So let them come, the joyful incendiaries with charred fingers! Here they are! Here they are! . . . Come on! set fire to the library shelves! Turn aside the canals to flood the museums! . . . Oh, the joy of seeing the glorious old canvases bobbing adrift on those waters, discoloured and shredded! . . . Take up your pickaxes, your axes and hammers and wreck, wreck the venerable cities, pitilessly![27]

The name for the new movement, Futurism, was, of course, pointed – intended to rally all those Italians who felt fettered by the past. The same reaction marked much Dada activity during and after the war. Their programme of stage-managed events, conducted in Paris with the maximum publicity, was intended to rally the endangered forces of anarchy and protest within the avant-garde. Especially in the pages of Picabia's *391*, the 'call to order' movement was repeatedly and brilliantly satirised. Picabia's contempt was expressed in typically terse style in his 'Homage to Rembrandt, Renoir and Cézanne' of 1920, where the three 'great masters' – the allusion to Renoir and

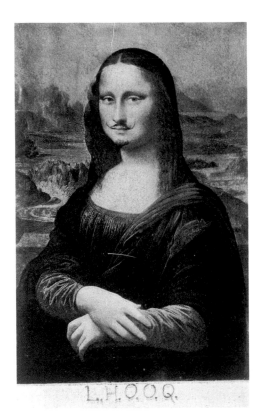

fig.10 Duchamp, 'L.H.O.O.Q.', 1919, *Private Collection, Paris*

Cézanne was especially topical – were lampooned as '*natures mortes*' and represented collectively by a stuffed and moth-eaten monkey. Duchamp took his ironic revenge not only in the elevation of a ready-made bottlerack or urinal to the status of masterpieces, but also in schoolboy graffiti on a cheap reproduction of Leonardo's 'Mona Lisa' (fig.10).[28]

But iconoclasm could not offer a long-term solution, however useful it might be in the short term as a means of achieving a *tabula rasa*. The long-term solution involved detaching the Great Tradition from all association with the academic concept of 'imitation', and in insisting on its potential as a source for innovation and invention. This is precisely what Apollinaire had done, in the passage quoted above, when he differentiated between 'fake classicism' and 'the authentic tradition of art'. Here Apollinaire was appealing to the concept of the abstract essence rather than the outward forms of classicism. When this crucial distinction was made, then the classical tradition could be claimed as the source for radical modernism. After his attack on Winckelmann, Apollinaire had immediately invoked 'the daring innovations of French painters throughout the nineteenth century'. He was thinking, among others, of the post-Impressionists who had invented new styles, but from the basis of a search for 'the authentic tradition of art'; and he went on to argue that Derain was the ideal example of a modern artist who 'studied the great masters passionately', whose new work was 'now imbued with that expressive grandeur that stamps the art of antiquity', but who had known how to avoid all 'factitious archaism'. Derain's work, he continues,

> is like the classical art of a Racine, who owed so much to the Ancients yet whose work bears not a trace of archaism. In the works that André Derain is exhibiting today, the viewer will thus recognize a temperament both audacious and disciplined. . . . He has blazed the way for a great number of painters, which does not mean that some of them will not lose their way. Nevertheless, they must follow his example all the way *and never stop daring* – for daring constitutes the true measure of discipline.[29]

In the history of the new and 'daring' classicism of the twentieth century the Salon d'Automne of 1905 was a climactic moment. It was, of course, the Salon in which the 'cage of the wild beasts' was the *succès de scandale*. But it was also the Salon in which Maillol exhibited 'The Mediterranean' (cat.88), and emerged as a major new sculptor who offered a radical alternative to the romantic expressionism of the then all-powerful Rodin. The importance of this piece was that although it was classical, it was not so in the *pompier* sense. For it was abstracted in form, and totally devoid of anecdote. Exhibited under the neutral title 'Femme' (Woman), it made not even a glancing reference to mythology, and offered instead a generalised type. For André Gide it was both beautiful and without meaning. 'One would', he wrote, 'have to go a long way back to find so complete a negligence of any preoccupation foreign to the simple manifestation of beauty.'[30]

The autumn Salon of 1905 was also the Salon of a great Ingres retrospective. We have been accustomed to see the contribution of the Fauves as the major event, but the Ingres retrospective was, arguably, more important in the sense that it had a wider influence. It is worth pausing to consider why. Partly

because of his famous rivalry with Delacroix, partly because in later life he had become a leading academic master with a following of undistinguished imitators, Ingres had come to be regarded after his death as a reactionary force in French art. Yet, after a brilliant beginning – he won the Prix de Rome in 1801 – Ingres's career had been far from straightforwardly successful. His submissions to the Salon were often greeted with hostility, and he did not win the great public commissions he craved. Much of the contemporary criticism turned on Ingres's subversive interpretation of classicism – the eccentric distortions of the anatomy of his figures, the attention to surface detail rather than illusionistic depth, the 'Chinese' play of line, the references to 'primitive' art.[31] But when Ingres was rediscovered by the 1905 generation it was these subversive aspects that were found exciting. According to Denis:

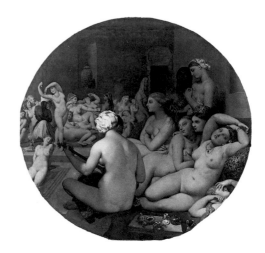

fig.11 Ingres, 'The Turkish Bath', 1862–3, *Musée du Louvre, Paris*

> No one now considers Monsieur Ingres a dangerous reactionary. . . . He is our newest master; but it is only recently that we have discovered him. . . . There has been talk of the senility of *The Turkish Bath* [fig.11], as much, I presume, because of its extremely voluptuous subject as because of the awkwardness of the figures. . . . He always retained that 'happy naïveté' which he recommended to his pupils. I noticed in the foreground a little still life, a few cups that might have been painted by a child: if Monsieur Ingres had lived longer, he would have painted like Rousseau.[32]

The great value of Ingres to the post-1900 generation was that he showed that the classical tradition could still have meaning and life if it was regarded as a stimulus to innovation, not as a pattern book. But his paintings might have made less impact had they been experienced in isolation. As it was they were not. They were seen in the context of the work of Cézanne, Renoir, Seurat, Gauguin and Rousseau, and the connections between his innovations and theirs were thrown into relief. For Apollinaire, writing a few years later, the stylisations of Ingres were a source for Cubism.[33] His very eccentricities focused attention on the whole question of the fundamental nature of classicism. And here there was a wide measure of agreement within and without the avant-garde. Concerned primarily with the ideal in content as well as in form, classical art, it was agreed, was conceptual rather than perceptual, contemplative rather than anecdotal. Governed by rationally determined rules, which were dependent on systems of harmonious proportions and precise measurement, its ultimate goal was 'universal' and 'timeless' beauty, achieved through a lucid, economical and impersonal style. It was serene and calm, and its effect was supposed to be ennobling, since the aim was to transport the spectator beyond the vagaries and trivialities of the here and now to the contemplation of a higher, purer and more perfect reality. In the words of Maurice Denis:

> In the notion of classical art the concept of synthesis is all-important. He who is not economical in his means, who does not subordinate the charm of individual details to the beauty of the whole, who does not attain grandeur through conciseness, is not classical. Classical art implies belief in the necessity of structural relationships, mathematical proportions and a form of beauty. . . . It involves a just balance between nature and style, between

expression and harmony. The classical artist synthesises, stylises or, if you prefer, invents beauty, not only when he sculpts or paints, but also when he uses his eyes, and contemplates the natural world.[34]

Classicism in avant-garde art in France was consolidated in the years that followed the 1905 Salon d'Automne. After his success with 'The Mediterranean', Maillol went on to create a steady flow of monumental works before the war.[35] Bourdelle's break with the expressionist style of Rodin belongs to the same time.[35] In 1904–5 Picasso, anticipating d'Ors's rejection of Modernisme, abandoned the symbolist manner of the Blue period, and within a year was working in an archaising classical style which culminated in the great series of paintings and drawings executed in the autumn of 1906 following his return from a trip to Catalonia (cat.128). By 1907–8 Matisse and Derain were already moving away from the spontaneous, individualistic, 'wild' manner typical of Fauvism, in favour of a more synthetic, restrained and volumetric approach indebted to Cézanne and the old masters. That Matisse thought of works such as 'Bathers with a Turtle' (cat.116) as classical in essence is evident from his 'Notes d'un peintre', published in December 1908. For this much quoted passage from the essay uses the familiar terminology of the classical aesthetic: 'What I dream of is an art of balance, of purity and serenity, devoid of troubling or depressing subject matter, an art which could be . . . a soothing, calming influence on the mind, something like a good armchair which provides relaxation from physical fatigue.'[36] The climax of this development in his art was reached in 1916 with 'Bathers by a River' (fig.12), a painting which rivals in grandeur the monumental Bather paintings of Cézanne (fig.13), and is triumphantly classical in an avant-garde sense.

Cubism itself, despite its unprecedented outward appearance, was a manifestation of the same classicist impulse.[37] For its typical subjects are traditional and stereotyped, and treated in a suggestive, non-anecdotal and emotionally neutral way; the accent is on structure and form, both being determined by rationally conceived systems based on geometry; colour is subordinated to line and to composition; handling is impersonal, even anonymous; the effect sought is generally harmonious and contemplative. In the hands of the Salon Cubists, such as Robert Delaunay and Henri Le

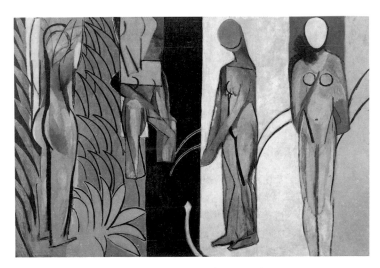

fig.12 Matisse, 'Bathers by a River', 1916, *Art Institute of Chicago*

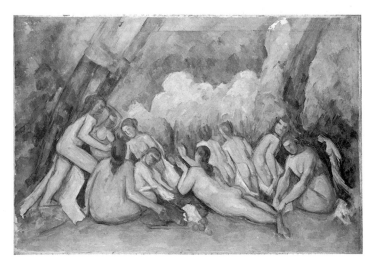

fig.13 Cézanne, 'Bathers', 1900–6, *National Gallery, London*

Fauconnier, the connections with the classical tradition of figure painting were more immediately apparent than in the more hermetic analytical works of Picasso and Braque, and references to antique sculpture or to Renaissance masterpieces were not uncommon. Delaunay, for example, referred to the famous antique group of the 'Three Graces' (fig.14) in 'The City of Paris', painted between 1910 and 1912 (fig.15).

The early defenders of Cubism stressed its opposition to Impressionism, its dependence on Cézanne, and its classical foundations, even while insisting upon its innovative character. In an essay entitled 'Cubisme et Tradition' published in 1911, Jean Metzinger emphasised the 'exemplary discipline' of the Cubist painters, who, he claimed, 'use the simplest, most complete and most logical forms.' 'Their discipline consists in their common determination never to infringe the fundamental laws of Art.'[38] The conceptual nature of Cubism led not infrequently to direct comparisons with the art of the past that was felt to possess a similar basis. Thus in 1913 Maurice Raynal (later associated with the Purist movement) contrasted Cubist painting with the 'cunning' illusionism of High Renaissance art, but compared it to the plastic 'logic' of Giotto and the Primitives, and concluded by citing Phidias, who 'did not look for his models among men but in his mind'.[39] Braque invoked the same set of assumptions when he wrote:

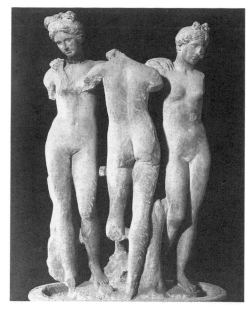

fig.14 'Three Graces', Roman copy of a Hellenistic original, *Siena Cathedral*

> 'Nobility comes from contained emotion.
> I love the rule which corrects emotion.'[40]

The language of classical aesthetics was easily appropriated by avant-garde critics and artists who supported abstraction and 'purity' in art. And the magic words 'structured', 'ordered', 'harmonious', 'constant', 'ideal', 'invariable', 'synthetic', 'calm', 'serene', and the like, ring out again and again in essays published after the war, whether written by critics in Paris for an avant-garde periodical such as *L'Esprit Nouveau*, or the less radical pro-'call to order' review *L'Art d'Aujourd'hui*. In Italy similar sentiments were expressed in the pages of *Valori Plastici*, by Carrà in his essays for *L'Ambrosiano*, and by Soffici in such important publications as *Periplo dell'arte. Richiamo all'ordine* published in Florence in 1928. The sheer generality of the principles involved meant that an immense range of styles from the figurative to the purely geometric could be accommodated and understood as representing essentially the same tendency.

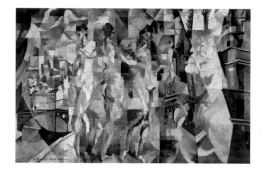

fig.15 Delaunay, 'The City of Paris', 1910–12, *Musée d'Art Moderne de la Ville de Paris*

Nevertheless, in all the writing of the period the question of the closeness of an artist's relationship to the traditions on which he drew – the issue of being neo- this or neo- that – was an acutely controversial one, as it was bound to be at a time when proximity to the old enemy of academicism induced anxiety and mistrust. For instance, it was in order to resist the current tendency to imitate past styles that Sironi and Funi launched the manifesto 'Contro tutti i ritorni in pittura' in 1920. The 'copies' that were made reflect these tensions. De Chirico, defiant in his claim to be a 'pictor classicus', made copies that were as close as possible to the originals, and earned the contempt of the Surrealists as a result (cat.32). Braque and Gris preferred the less controversial solution of the 'homage' – a free transcription in their own stylistic terms (cats.12,63). The debate is summarised in the simplest terms in an editorial published in 1926 in

the middle-of-the-road English review *Drawing and Design*, in which the modern movement is defined as a search 'to establish order and to make the canons of art much more severe.' The author continues:

> Its guiding principle may be suggested by the adjective 'classical' – which has nothing to do with the classicism of David or with the resuscitation of the art and history of the Greeks. We should not nowadays attempt heroic canvases of Thermopylae or carve the straight nose and curling lip of Phidias; we aim at being classical in the far deeper sense. The modern ideal . . . is assuming the formal, the exquisite, and passionless quality, which is the true 'classicism'. . . . An artist of the past who was classical in this definition is Raphael. The modern exemplar, we suppose, is Picasso.[41]

The reference to Picasso is significant, because the course he steered so adroitly, even in his most overtly neoclassical paintings, between outright imitation and a freely personal interpretation of the past, seemed to many an ideal solution. So much so, indeed, that his new classical paintings quickly became 'classics' in their own right, and an inspiration to many other artists, such as Campigli (cat.13), Laurens (cat.73), Togores (cat.173), and even de Chirico (cat.38). But for certain groups of artists the outward dress of classicism was not easily acceptable in post-Cubist art, and a high degree of formal abstraction was the only valid means of reconciling the avant-garde with the classical. Had not Plato himself offered the perfect justification for an art based on relationships between pure geometric forms? Accordingly Plato was often cited by the Purists when they wished to find unimpeachable support for the rigorous 'purity' of the art they promoted. And it was only by claiming that there was no difference in the degree of plastic purity between Picasso's Cubist and his neoclassical works that Maurice Raynal could defend the new orientation in the work of the artist he admired above all others.[42]

For sculptors the issue was perhaps especially sensitive, because the authority of the Greco-Roman tradition as the surest antidote to nineteenth-century naturalism and anecdotalism was even greater. Thus Christian Zervos was very careful to emphasise the formal abstraction of Maillol's work, rather than any debt to the outward forms of the antique: 'Above all Maillol sees the continuity of form. . . . There is not one work by him which is not marked by his patient search for architectural structure and geometry. . . . All his statues give the impression of mass, of the search for the beauty of volume. They are inscribed within powerful geometric forms, the square or the pyramid, and their foundations are grand and simple planes.'[43]

A solution to this delicate problem was provided by the art of the past which, though belonging to the classical tradition, was recognised as primitive. It was a solution with immense appeal because ever since the Romantic period primitivism had been associated with an avant-garde position – with the idea of purity and authenticity and the escape from the supposed decadence and over-sophistication of the present. The myth of the purity of the primitive has been the great myth of modern times, and indeed all the classical revivals that have occurred from the time of Winckelmann onwards have been intimately bound up with this ideal, for the return to the classical past is conceived as a return to origins. However, as each generation, through repetition, creates its own fixed

norms, so that what was once new comes to represent the oppressive Establishment, the succeeding generation becomes dissatisfied, demanding a renewal and a greater purity, a return to yet more 'original' forms. Thus David's followers, dubbed 'les Primitifs', demanded a severer, more archaic style. For Winckelmann, who had seen relatively few examples of classical art, Hellenistic art was the ideal, but soon Hellenistic art came to be perceived as decadent and over-sophisticated, and the earlier periods of Greek art seemed infinitely preferable. By the beginning of the twentieth century it was the relative anonymity and abstraction of archaic or fifth-century Greek art that seemed purest of all to the avant-garde: by then the fourth century (let alone the Hellenistic) seemed too sweet, too naturalistic, too individualised. Maillol's strong dislike of Praxiteles, but love for the sculpture of Olympia, was a characteristic position.

The late nineteenth and early twentieth centuries witnessed intense archaeological activity, and the boundaries of 'classical art' were stretched in every direction, permitting these major shifts in taste.[44] There was much interest in provincial forms of classical art because they, like the archaic, were not the hackneyed exemplars of the academics. Picasso's excitement at the exhibition of ancient Iberian art held in Paris in the spring of 1906 was the excitement of someone who had discovered a native classical tradition hitherto unknown and untapped, and therefore uncontaminated by official academic sanction. For Italian artists, such as Martini and Marini, the discovery of Etruscan art provided the same guarantee of authenticity, of inviolate naïveté. In a similar way, there was intense interest in the Trecento and Quattrocento, periods felt to possess a quality of sacred innocence, and a series of critical studies appeared on such artists as Giotto, Uccello and Piero della Francesca.[45] For de Chirico, Casorati and Severini the research into the 'lost' methods of the old masters was a search for a 'true' technique. For Bernard and Casanovas the direct carving of intractable local stone was synonymous with authenticity. To be a '*primitif classique*' had become the ultimate ideal.[46]

There was yet another way of combating academicism while still retaining the vital link with the classical tradition, and that was to redefine the very nature of classicism itself. A brilliant challenge to the authority of the accepted view was mounted by Friedrich Nietzsche when he published *The Birth of Tragedy* in 1872. Here Nietzsche argued that the 'serenity' claimed by Winckelmann to be at the very heart of Greek art, and which Nietzsche termed the 'Apollonian' ideal, was in reality a sublimation, a necessary antidote to the forces of terror and anarchy – enshrined in the ancient, orgiastic cults dedicated to Dionysos – which threatened at every moment to re-establish their dominion. Apollo, he wrote, is characterised by 'freedom from all extravagant urges' and by 'sapient tranquillity', and radiates 'the full delight, wisdom and beauty of "illusion".' Dionysos, on the other hand, is associated with 'procreative lust', the 'shattering of individuality', and the principle of pain. The two modes, Nietzsche argued, were antithetical but complementary, and great art resulted only from their reconciliation: 'Developed alongside one another, usually in fierce opposition, each . . . forces the other to more energetic production.' Any art devoid of the Dionysiac 'intoxication' was inevitably decadent and enfeebled.[47]

Nietzsche's influence throughout Europe was enormous: his books were widely translated and numerous studies and digests of his ideas were published. Although his concept of Greek art never displaced that of Winckelmann, it offered a stimulating alternative. Of course, Nietzsche's principles, like Winckelmann's, could be, and were, applied to the classical tradition in its broader sense. An undercurrent of anarchy not order, of anguish not serenity, could be read into certain works by, say, Raphael or Michelangelo or Poussin. Nietzsche had made the psychological interpretation of art a serious possibility. Thus Picasso could say of Cézanne – who was thought of as a 'sublime' artist in 'call to order' circles – 'It's not what an artist *does* that counts, but what he *is*. . . . What forces our interest is Cézanne's anxiety – that's Cézanne's lesson . . . that is the actual drama of the man. The rest is a sham.' Significantly, this is the conclusion to a passage from a monologue which begins: 'Academic training in beauty is a sham. We have been deceived, but so well deceived that we can scarcely get back even to a shadow of the truth. The beauties of the Parthenon, Venuses, nymphs, Narcissuses, are so many lies. Art is not the application of a canon of beauty but what the instinct and the brain can conceive beyond any canon.'[48]

In this exhibition 'Nietzschean' classicism is represented above all in certain works by de Chirico and Savinio, Picasso and Masson. Even though de Chirico was in Milan in the spring of 1910 just at the moment when the Futurist painters issued two important manifestos, he never responded positively to Futurism. Suspicious of the notion of progress, deeply ambivalent about modernity and the machine age, his attitude to the relationship of the past and the present was profoundly affected by his reading of Nietzsche and Schopenhauer, apparently undertaken while he was studying in Munich in 1906–10. De Chirico's early metaphysical paintings, executed in Paris from 1911 to 1915 (cats.30,31) present an intentionally disorienting view of classical sculpture and Renaissance buildings and piazzas through the disturbing, inexplicable confrontations he has engineered with stations, trains, factory chimneys, and so forth, through the illogical, discontinuous spaces in which they have been placed, and through the incompatible suggestions of time. The sacred laws of unity have been broken one by one. The air of enigma, nostalgia and profound malaise, which is heightened by a deadpan, pseudo-illusionistic style hovering indefinably somewhere among the academic, the naïve and the popular–illustrational, had no parallel in the various vanguard forms of classicism practised in Paris at the period, and it had no immediate repercussions there. However, it was recognised immediately by Apollinaire as a highly original redefinition of the classical: 'To depict the fateful character of modern things, this artist relies on the most modern device: surprise,' he wrote in March 1914,[49] adding a few months later that de Chirico's art 'is more severe, more subtle, more classical, and at the same time much newer than Chagall's.'[50] Irony and ambiguity also lie at the core of many of de Chirico's post-war paintings, just as they lie at the core of Savinio's work, for there seems to be an unbridgeable gap between the realities and the claims of both the past and the present. Thus in de Chirico's 'Gladiators' (cat.39) the ostensibly violent hand-to-hand battle is conducted in a kind of trance, and realised, inappropriately, in the sensual, colourist style employed by Renoir in his

paintings of peacefully basking nudes. The tension created is the result of this dichotomy, this marriage of antithetical impulses.

Another committed Nietzschean was André Masson. Disorder and insanity is the message of his work, and we know from him that these, not order and reason, were the qualities he found in the work of Poussin, and of the other 'classics' he admired. (See cats.113,114.) In the neoclassical work of Picasso intimations of dislocation and unreason are almost invariably present to a greater or lesser degree – in the inconsistencies of style, in the lack of finish, in the element of parody, in the sense of the grotesque, in the fluctuations of mood, as well as in the regular forays into the imagery of orgy and pain. Picasso had apparently first encountered Nietzsche's writings in Barcelona at the turn of the century, but it is likely that de Chirico's pre-war metaphysical paintings had some impact on him after the war. For there are similarities between his vision of brooding, classically draped female figures, trapped in a limbo between reality and art, life and death, and de Chirico's strangely animated classical statues. As in de Chirico's work, so in Picasso's, malaise results from the paradoxical blend of a sense of crisis with an image of lethargy. There is, however, no precedent in de Chirico for the savage intensity of the Tate Gallery's 'Three Dancers' (fig.16). This is perhaps the supreme statement of the Nietzschean view of tragic drama, for its composition is derived straight from that icon of 'Apollonian' harmony, the 'Three Graces' (fig.14), but its whole message is one of Dionysiac frenzy. The painting found a natural home in the pages of *La Révolution Surréaliste*, for it was only classicism with a Dionysiac dimension that could have any appeal to the Surrealist poets and painters.[51]

Whatever the approach, the most important gain for an artist from his allusions – distant or close – to the art of the past was greater depth and range of expression. The sources are intended to act like metaphors – suggestions the spectator must respond to and meditate upon if the full expressive meaning of the work is to be grasped. This system of allusion, like poetic metaphor, had the immense advantage of obviating the need for narrative subject matter - the dreaded 'literary' content of nineteenth-century *pompier* or realist art. The work suggested, but it did not describe or tell. Its ideal iconic status was secure. And even though the same conventionalised subjects are repeated again and again, variety is guaranteed by the choice of different models for different occasions. Within the classical tradition itself – whatever period, whichever great artist, we choose as our 'norm' – there is great variety and abundance. No coherent set of adjectives can ever adequately define it. A great achievement of the avant-garde classicists was to have restored to classicism the inexhaustible creative variety, the inherent ambiguity, that had been drained out of it over the years as it was first appropriated, then codified, by academic artists.

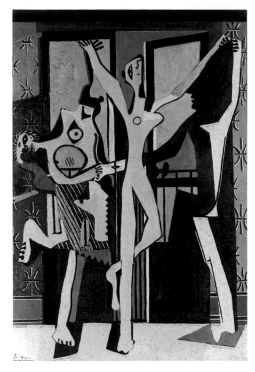

fig.16 Picasso, 'Three Dancers', 1925, *Tate Gallery*

NOTES

Author's note
Unless English-language editions are cited, the translations are my own. For more detailed discussion of the works of art in the exhibition, the reader is referred to the main part of the catalogue. Many of the issues touched on in the Introduction are explored in detail in the essays published in the enlarged version of the catalogue.

1 Picasso did not, however, cease to paint Cubist pictures: the two modes coexisted from 1917 to the mid-1920s. See 'Studies' (cat.137) where both are present simultaneously.

2 'Portrait of Jeanne' (cat.152) and 'Maternity' were both exhibited in Paris in 1916, but had no immediate sequel in Severini's work. For the next four years he practised a form of synthetic Cubism similar to that of Gris. It was only in the 1920s that he once again used figurative styles.

3 For a wide-ranging survey of the return to figuration in art in Europe, Scandinavia and America, see *Les Réalismes, 1919–1939*, Centre Georges Pompidou, Paris, 1980–81.

4 Two important recent books which address the 'call to order' movement in France are Christopher Green, *Cubism and its Enemies. Modern Movements and Reaction in French Art, 1916–1928*, London, 1987, and Kenneth Silver, *Esprit de Corps. The Art of the Parisian Avant-Garde and the First World War 1914–1925*, London, 1989. See also Malcolm Gee, *Dealers, Critics and Collectors of Modern Painting: Aspects of the Parisian Art Market, between 1910 and 1930*, PhD dissertation, University of London, 1977. For the situation in Italy, see Rossana Bossaglia, *Il 'Novecento Italiano': Storia, documenti, iconografia*, Milan, 1979, and Massimo Carrà, *Gli anni del ritorno all'ordine*, Milan, 1978.

5 General histories of twentieth-century art have given much less space to the movement than to, say, Fauvism or Futurism. It is only in the last decade that Picasso's classical works of 1917 onwards have been studied seriously; in earlier monographs they have often been passed over rapidly and unsympathetically. The case of de Chirico is similar, for the reassessment of his work of the 1920s has been conducted mainly during the last ten years. (See, *inter al.*, *De Chirico – Gli anni venti*, Palazzo Reale, Milan, 1987.)

6 See Silver, op. cit., for a wealth of quotations from contemporary critics, journalists and political figures.

7 Michael Greenhalgh, *The Classical Tradition in Art*, London, 1978, p.11. This useful survey terminates, however, with Ingres.

8 Except in those instances where artists were called upon to illustrate classical texts, references to the characters of Greco-Roman mythology were usually highly generalised: e.g. Maillol's 'Flora' (cat.89) or 'Venus with a Necklace' (cat.94), and Manolo's 'Bacchante' (cat.104). Artists who, like Picasso, de Chirico and Savinio, made more pointed mythological allusions in their paintings, tended to reinterpret the stories in an autobiographically directed way. Bourdelle was rather unusual in his predilection for subjects from mythology.

9 Pierre Camo, *Aristide Maillol et son œuvre*, Paris, 1926, p.10.

10 See Jean Cocteau, *Le Rappel à l'ordre*, Paris, 1926.

11 Thus the Purist periodical *L'Esprit Nouveau* (Paris, 1920–25) carried major articles on Fouquet, Poussin, Ingres, Corot and Seurat. See C. Green, op. cit., ch.12, 'Tradition and the progress of styles', for a discussion of the contemporary concern with the French tradition. The critic Waldemar George was among those to lay special stress on the 'Frenchness' of modern French art.

12 On Italian art during the wartime and post-war period see, in particular, Emily Braun (ed.), *Italian Art in the 20th Century. Painting and Sculpture 1900–1988*, Royal Academy of Arts, London, 1989; *Realismo Magico: pittura e scultura in Italia 1919–1925*, Galleria dello Scudo, Verona, 1988–9; Joan M. Lukach, 'De Chirico and Italian Art Theory, 1915–1920', *De Chirico*, Tate Gallery, London, 1982, pp.35–54.

13 On art in Catalonia, and Noucentisme in particular, see *Homage to Barcelona. The City and its Art 1888–1936*, Arts Council of Great Britain, 1986. The fact that Maillol was a Catalan, Cézanne a native of Provence, and Renoir had settled in the south of France, contributed to the esteem in which they were held.

14 The systematic archaeological investigation of Roman Barcelona, under the auspices of Institut d'Estudis Catalans, got under way during the Noucentista period. See Josep Guitart, 'The rediscovery of ancient Barcelona', in *Homage to Barcelona*, op. cit., pp.111–13.

15 See Eugeni d'Ors's influential novel *La ben plantada*, Barcelona, 1912, where this concept is developed in the person of the heroine, Teresa.

16 Further editions were published in 1913 and 1920.

17 For example, M. Denis, 'Cézanne', *L'Occident*, September 1907; reprinted in *Théories (1890–1910): Du symbolisme et de Gauguin vers un nouvel ordre classique*, Paris, 1912.

18 'Georges Braque', preface to *Catalogue de l'Exposition Braque*, Galerie Kahnweiler, Paris, November 1908. Quoted from L.C. Breunig (ed.), *Apollinaire on Art: Essays and Reviews 1902–1918*, London, 1972, p.51.

19 'Le Naturalisme au Salon', *Le Voltaire*, 18–22 June 1880. Quoted from Emile Zola, *Mon Salon, Manet, Ecrits sur l'Art*, ed. A. Ehrard, Paris, 1970, pp.337–8.

20 See Joel Isaacson, *The Crisis of Impressionism (1878–1882)*, Museum of Art, University of Michigan, Ann Arbor, 1980.

21 For instance, in 'Sunday Afternoon at the Island of the Grande Jatte' (1884–6; Art Institute, Chicago), Seurat drew on, and reconciled, a multiplicity of sources, including Egyptian art, the Parthenon frieze, and folk or popular illustrations. Gauguin took with him to Tahiti a mixed collection of reference photographs, on which he relied in his figure paintings: these included reproductions of Egyptian reliefs, Buddhist temple reliefs and Greek sculpture. Both were able to see underlying points of contact, formal and thematic, between these disparate sources. In the work of Picasso a similar procedure often occurs: in 'Les Demoiselles d'Avignon', for instance (1907; Museum of Modern Art, New York), the sources include Egyptian, Ancient Greek, Iberian and tribal art, El Greco, Ingres and Cézanne.

22 See Albert Boime, *The Academy and French Painting in the Nineteenth Century*, Oxford, 1971, for a thorough account of standard academic training.

23 See 'Sarah Stein's Notes', 1908, published in Jack D. Flam, *Matisse on Art*, Oxford, 1978, pp.41–6. Lipchitz describes his training at the Académie Julian in Paris in 1909, pointing out that there was in fact little difference from the training at the Ecole des Beaux-Arts. (See Jacques Lipchitz with H.H. Arnason, *My Life in Sculpture*, London, 1972, pp.3–4.

24 *Gedanken über die Nachahmung der griechischen Werke in der Malerei und Bildhauerkunst*, Dresden, 1755. Quoted from *Neoclassicism and Romanticism 1750–1850. Sources and Documents*, ed. L. Eitner, vol.I, London, 1971, pp.11, and 1. Eitner uses Henry Fuseli's translation, published in London in 1765.

Ardengo Soffici, 'Paul Cézanne', *La Voce*, June 1908; reprinted in *Scoperte e massacri*, Florence, 1919. Eugeni d'Ors, *Paul Cézanne*, Paris, 1930. These are, however, the merest sample: many hundreds of essays on modern art written by critics and artists from *c.* 1905 to 1930 allude to Cézanne in glowing terms. In Italy there was a tendency to emphasise the Italian sources of his art: e.g. M. Tinti, 'Italianismo de Cézanne', *Pinacotheca*, 1929.

25 'André Derain', *Album–Catalogue de l'Exposition André Derain*, Galerie Paul Guillaume, Paris, October 1916. Quoted from *Apollinaire on Art*, op. cit., p.444. The anti-German sentiments of the essay are in part explained by the fact that it was written in the middle of the war. However, Apollinaire had already given a chauvinist account of the 'Frenchness' of modern French art in 'The New Painting: Art Notes', *Les Soirées de Paris*, April–May 1912. (Included in *Apollinaire on Art*, pp.222–5.)

26 The same kind of pressure was felt in the political sphere. Of the major Italian cities only Milan perhaps thrived on its modernity. It became a centre and focus of avant-garde activity in the arts, as it did of industrial and economic expansion, and of political change.

27 Filippo T. Marinetti, 'Le Futurisme', *Le Figaro*, 20 February 1909. Quoted from: U. Apollonio (ed.), *Futurist Manifestos*, New York, 1973, p. 23. See Ester Coen, 'The violent urge towards modernity: Futurism and the international avant-garde', in *Italian Art in the Twentieth Century*, op. cit., pp.49–56.

28 The original of 'Homage to Rembrandt . . .' was destroyed, but was reproduced in *Cannibale*, 25 April 1920. Duchamp's 'L.H.O.O.Q.' was reproduced in *391*, no. 12, March 1920. For a full account of Parisian Dada, see Michel Sanouillet's splendidly detailed *Dada à Paris*, Paris, 1965.

29 'André Derain', op. cit., p.445. My italics.

30 'Promenade au Salon d'Automne', *Gazette des Beaux-Arts*, 1905, vol.II, p.478.

31 See M. Greenhalgh, op. cit., pp.225–33, for a useful summary of contemporary reactions to Ingres.

32 'Le Salon d'Automne de 1905', *L'Ermitage*, 15 November 1905. Quoted from Maurice Denis, *Du Symbolisme au Classicisme. Théories*, ed. O. Revault d'Allonnes, Paris, 1964, pp. 106, 108. The Douanier Rousseau was also represented in the Salon.

33 See 'Cubism', *L'Intermédiare des chercheurs et des curieux*, 10 October 1912. Reproduced in *Apollinaire on Art*, op. cit., pp.256–8. Apollinaire's admiration for Ingres is reflected in his review for *L'Intransigeant* of the *Exposition Ingres* at the Galeries Georges Petit, Paris, April–May 1911 (ibid, pp.155-7.)

34 'Aristide Maillol', *L'Occident*, November 1905. Quoted from M. Denis, *Du Symbolisme au Classicisme*, op. cit., p.140.

35 Bourdelle exhibited his 'Head of Apollo' (1900) at the Galerie Hébrard, Paris, in 1905. Rodin, recognising its classical sobriety and simplicity, is said to have commented, 'Bourdelle, you are leaving me.'

36 Quoted from J. D. Flam, *Matisse on Art*, op. cit., p.38. The essay was originally published in *La Grande Revue*, 25 December 1908.

37 The fact that Cubism could be interpreted in this way made it acceptable to the stylistically more conservative Noucentista critics and painters. See the essay by Robert Lubar in the expanded version of this catalogue.

38 Originally published in *Paris-Journal*, 16 August 1911. Excerpted in and quoted from Edward Fry, *Cubism*, London, 1966, p.66. This book is a very useful source of early critical texts on Cubism.

39 'Qu'est-ce que . . . le "Cubisme"?', *Comoedia illustré*, 20 December 1913. Quoted from E. Fry, op. cit., pp.128–30. See also the other texts by Raynal excerpted by Fry.

40 'Pensées et réflexions sur la peinture', *Nord–Sud*, December 1917. Quoted from E. Fry, op. cit., p. 148.

41 Unsigned editorial, 'The Classical Tradition in Modern Art', *Drawing and Design*, New Series, vol.I, no.5, November 1926, p. 145.

42 See Raynal's review of the *Exposition Picasso* at the Galerie Paul Rosenberg, in *L'Esprit Nouveau*, no.9, June 1921, n.p.

43 'Aristide Maillol', *L'Art d'Aujourd'hui*, 1925, pp.34–5. Moreover, those who emphasised Maillol's links with the classical tradition were careful to stress that the similarities were not the consequence of 'borrowing', but of a 'natural' predisposition. (See Pierre Camo, op. cit., and Waldemar George, 'Les Terre-cuites de Maillol', *L'Amour de l'Art*, 1923, pp.695-700.)

44 See Gerhart Rodenwaldt, *Die Kunst der Antike. (Hellas und Rom)*, Berlin, 1927, for a well illustrated and widely available handbook of the period. The first half, devoted to Greece, opens with a section on Cretan and Mycenean art and architecture; the second half, devoted to Italy, opens with the Etruscans.

45 See, for instance, Carlo Carrà, 'Parlata su Giotto', *La Voce*, 31 March 1916, and *Giotto*, Rome, 1924; Carlo Carrà, 'Paolo Uccello, costruttore', *La Voce*, 30 September 1916; Roberto Longhi, 'Piero della Francesca e lo sviluppo della pittura veneziana', *L'Arte*, 1914, and *Piero della Francesca*, Milan, 1927; Carlo Carrà, 'Piero della Francesca', *L'Ambrosiano*, 5 September 1927. Significantly, Cesare Gnudi's major monograph on Giotto (Milan, 1959) is dedicated to Morandi.

46 The phrase is Maurice Denis's: 'Aristide Maillol', 1905, op. cit., p.149. The general interest in 'primitive' art extended both to prehistoric art and tribal art. Art reviews such as *L'Esprit Nouveau* (1920–25) and *Cahiers d'Art* (founded in 1926) carried articles and illustrations of this material, which was often implicitly, or explicitly (especially in *L'Esprit Nouveau*), compared with contemporary art. The prehistoric 'Venus of Lespugue' (discovered in 1922) and Cycladic figurines had special appeal at this time of return to the 'authentic traditions of art', as the most ancient sculptures of all – the original 'classical' source.

47 *Die Geburt der Tragödie aus dem Geiste der Musik*, Leipzig, 1872. Quoted from *The Birth of Tragedy, and the Genealogy of Morals*, translated by Francis Golffing, New York, 1956, *passim*.

48 Christian Zervos, 'Conversation avec Picasso', *Cahiers d'Art*, 1935. Quoted from Dore Ashton, *Picasso on Art: A Selection of Views*, London, 1972, p.11. The text, admittedly, postdates works in this exhibition. However, it is clear from 'Les Demoiselles d'Avignon' (1907; Museum of Modern Art, New York), where the composition is closely related to that of Cézanne's late 'Bather' compositions, that Picasso was alive to a disturbing, expressive element in Cézanne's work at an early date.

49 'The 30th Salon des Indépendants', *Les Soirées de Paris*, 15 March 1914. Quoted from *Apollinaire on Art*, op. cit., p.366.

50 'New Painters', *Paris-Journal*, 14 July 1914. Quoted from *Apollinaire on Art*, op. cit., p.422.

51 *La Révolution Surréaliste*, no.4, 15 July 1925, p.17.

CATALOGUE NOTES

The artists have been arranged in alphabetical sequence, and their works listed in chronological order irrespective of medium. Artists are listed under the names by which they were known at the period covered by the exhibition. (Thus, Le Corbusier appears as Jeanneret – the name he used when signing his paintings – and Manuel Hugué as Manolo.) The Spanish, rather than Catalan, forms of names have been used when the artists concerned preferred them. (Thus, José Clará instead of Josep Clarà, Pablo instead of Pau Gargallo, and Julio instead of Juli González.) English translations of the titles have been used in almost every case. Dimensions are given in centimetres; height precedes width.

The biographies are not intended to provide a full account of the artists' lives, but to draw attention to their relationship and contribution to the new classicism. We wish to acknowledge our deep gratitude to the many scholars on whom we have depended for information about the artists and the works exhibited.

The French and Spanish works have been catalogued by Elizabeth Cowling, the Italian works by Jennifer Mundy.

Elizabeth Cowling
Jennifer Mundy

MARIANO ANDREU 1888 BARCELONA – 1976 BIARRITZ

Andreu was born and brought up next door to a theatre, the Circo Barcelonés. As a child he attended numerous performances, and as an artist he was involved directly in the theatre, designing sets and costumes for many plays and operas in Spain, France, Germany and England. He often drew upon theatrical imagery in his paintings, while his great interest in the decorative arts found expression in beautifully crafted mirrors, picture frames and *objets d'art*. Although he always remained an independent figure, he was associated with the Catalan Noucentista movement through his friendship with Eugeni d'Ors, whose *La Vie brève* he illustrated in 1928.

Having studied at the School of Arts and Crafts in Barcelona, Andreu went to London in 1907 and worked under the enameller Alexander Fisher. His own enamels were later regarded as among the best produced anywhere in Europe. Andreu's exposure to the late Pre-Raphaelite style, and especially to Aubrey Beardsley, left obvious traces on his early paintings and drawings. On his return to Barcelona he studied at the private art school of the painter and graphic artist Francesc Galí, who also taught Miró. Following his first exhibition at the Faianç Català in Barcelona in 1911 Andreu settled in Paris, which remained his home until he moved to a villa in Biarritz towards the end of his life. He travelled widely throughout Europe, visiting, in particular, Munich, where he had exhibitions in 1913 and 1915 and designed his first opera production, Offenbach's *Orphée aux enfers*, and Italy (also in 1913), where he went to the major cities to study the great Renaissance and Baroque buildings and works of art.

Andreu had by now shed the Symbolist–Art Nouveau style and tone of his early work, and his new paintings showed the influence of Noucentisme and the 'call to order', as well as of his study of the great Italian masters. From 1920 to 1935 he exhibited regularly in the Salon d'Automne, and his favourite subjects – female nudes, bathers on Mediterranean beaches, *commedia dell'arte* and circus scenes, still lifes with musical instruments – were those currently in vogue in France, so that there are many iconographic parallels with the contempor-

ary, post-Cubist work of such artists as Picasso, Severini, Metzinger and André Lhote. Andreu's reputation in Paris grew steadily, and he had a series of one-man exhibitions: at the Galerie Le Portique in 1925, the Galerie Barbazanges in 1926 and the Galerie Druet in 1927 and 1929. His contacts with literary circles in Paris resulted in several commissions for suites of illustrations, including one for Girardoux's *Amphitrion 38* in 1928. (Girardoux became a close friend, and Andreu later designed the sets and costumes for productions of *La Guerre de Troie n'aura pas lieu* and *Supplément au voyage de Cook*.) Meanwhile Andreu kept his links with Barcelona, and in 1934 had a one-man show at the foremost Noucentista gallery, the Sala Parés.

Critical response to Andreu's work in the 1920s and 1930s was variable; his virtuosity, and the piquant and idiosyncratic combination of preciousness and playfulness, repelled some and attracted others. Several prominent critics, including François Fosca, Paul Fierens, Jean-Louis Vaudoyer, Paul Sentenac and Gabriel Mourey, regularly supported his work. They praised Andreu's decorative gifts and the refinement and elegance of his draughtsmanship, and emphasised his capricious imagination and his 'stylish' ability to change his manner from 'rococo' to 'sober' as the subject required. But the main thrust of their acclaim was his 'wide artistic culture'. Vaudoyer, for instance, likened the meticulousness of his style to that of Holbein and Crivelli, and, comparing his approach to tradition with Ingres's, suggested that his main debt was to Giulio Romano and the Carracci (*La Renaissance*, April 1927). Mourey, reflecting his conversations with the artist, tended on the other hand to emphasise his admiration for the Italian Primitives (*Drawing and Design*, January 1927). Both, however, were agreed that his approach was never academic, and that his readiness to 'consult' the old masters and desire to emulate their qualities was entirely exemplary, and resulted in a rare artistic 'harmony'. 'Classicism is life. Academicism is death', concluded Mourey. 'We owe our gratitude to M. Andreu for recalling to us the necessity of classical discipline which is

The artist (Photo: Señor Andreu Marfa)

so often lost sight of nowadays.' (*Drawing and Design*) Or as P.-L. Duchartre put it, 'It may well be that it will be Andreu who, following the cul-de-sac of Cubism from which painting has emerged in such disarray . . . lands on his feet first, achieving a meaningful liaison between classicism and contemporary aesthetic tendencies.' (*L'Amour de l'Art*, 1926)

1 Women with a Bird 1925
Oil on canvas, 74.3 × 53
Private Collection

This is inscribed 'January 1925'. Andreu's sense of his relationship to the tradition of European art was highly developed, and a historical source for the imagery of his paintings can usually be found. In this case, the subject of two young women feeding a tame finch with a strawberry might appear to be of little consequence – a reworking of the kind of theme that was popular in the

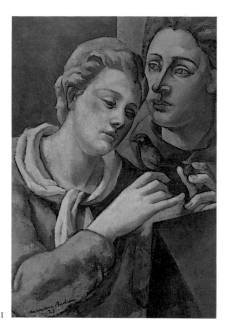

nineteenth century. But the focus on the hands, bird and fruit, and the intent, solemn expressions of the women, suggest that he had in mind the traditional symbols and stereotyped gestures of religious paintings of the Renaissance, and that he intended to convey some allegorical meaning. The composition, treatment of form and style underline this association, for there are connections with Quattroccento painting, in particular perhaps with Masaccio, Piero della Francesca and Signorelli, and with the sense of frozen drama typical of the more monumental Roman fresco paintings from Pompeii and Herculaneum, such as the great cycle in the Villa of the Mysteries. Such connections help to explain why Andreu's work found favour with French critics who supported the 'return to order'.

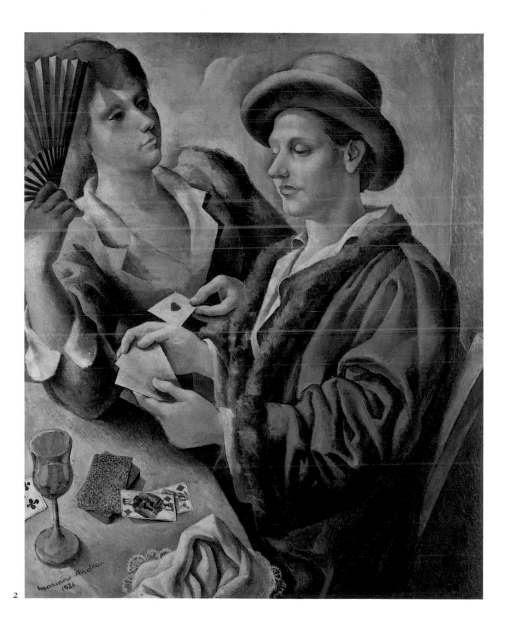

2 The Game of Cards 1926

Oil on canvas, 108 × 84
Private Collection

The pronounced mannerism characteristic of Andreu's drawings and paintings of the late 1920s onwards is already evident in this work, which has a more specifically theatrical air than 'Women with a Bird'. He admired Mannerist and Baroque painting, and here uses strong lighting, a compressed, tilted space, firm and stylish draughtsmanship and distortion of form to create a sense of drama. The subject of the lovers' card game was exactly the kind of piquant theme that most appealed to Andreu and that became his stock in trade, permitting a certain level of intriguing anecdote, lightly suggesting traditional allegorical meanings, and evoking parallels with the art of the past. Andreu's principal source here was probably Caravaggio, rather than the many Dutch seventeenth-century genre painters who depicted similar scenes. Although Caravaggio's 'Card Sharpers' had been lost since 1899, it was known from photographs and had been much imitated by his followers. Moreover Andreu knew Caravaggio's 'Gipsy Fortune Teller', which is similar in type and was in the Louvre collection.

3 Figures from the Commedia dell'Arte 1926

Oil on canvas, 126 × 120
Institut del Teatre, Barcelona

Like so many other artists in Paris who
designed for the ballet in the post-war
period, Andreu was fascinated by the *com-
media dell'arte* and quite frequently depicted
its characters in his easel paintings. The
commedia became a kind of surrogate,
modern mythology – a source that could be
tapped by any artist in search of a poetically
resonant subject, traditional enough (thanks
to the example of Watteau) to have classic
status, yet for a contemporary audience
much more genuinely popular and familiar
than Greek mythology.

First exhibited in the Salon d'Automne
in 1926, this is one of Andreu's most
ambitious essays on a *commedia* theme, and
was preceded by several meticulous and
elegant drawings of the principal figures.
The composition is based, in academic
fashion, upon a regular geometric grid
dominated by a network of crossing diag-
onals. In this respect, as well as in its
imagery, it is analogous to the paintings of
Severini (cat.155), although the poses of the
figures, the mannered style of drawing, the
use of still-life elements and animals, and
the elaborate backdrop of buildings and
landscape, strongly suggest the direct
influence of Picasso's drop-curtain for
Parade, 1917 (repr.p.14). Beyond these
contemporary analogies, the painting makes
playful use of Andreu's considerable visual
culture. The symmetrical composition, the
raked perspective, and the complex, twist-
ing poses of the figures, reflect the influence
of Mantegna, Pollaiuolo or Signorelli –
painters whose stress on draughtsmanship
Andreu would have found most congenial.
The parallels are perhaps closest with
Signorelli: with groups from the 'Resurrec-
tion' in the cathedral in Orvieto, or with
'Pan as the God of Natural Life and Master
of Music' in the museum in Berlin.

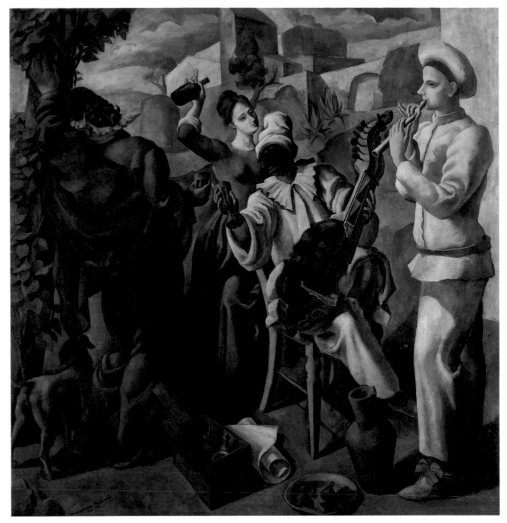

3

JOSEPH BERNARD 1866 VIENNE, ISÈRE – 1931 BOULOGNE-BILLANCOURT

Although Joseph Bernard has been largely overlooked in the major recent histories of modern sculpture, at the time of his death he was recognised as a leading independent sculptor, and his influence on younger artists was often noted. He came from a family of artisans, and his father, a stone-cutter, taught him basic carving techniques when he was still a boy. In 1882 the young Bernard won a grant to the Ecole des Beaux-Arts in Lyons, where he received a thorough academic training, and in 1887 he transferred to the Ecole des Beaux-Arts in Paris. His activities during the 1890s remain obscure, although early surviving works show that Rodin's dramatic, expressive style impressed him deeply.

Between 1903 and 1906 Bernard created 'Effort towards Nature' (Musée d'Orsay, Paris), which is now recognised as a crucial work because it was carved directly in the stone, without preliminary clay or plaster models. Representing the head of a solid young country girl, with broad features, blank almond-shaped eyes and a faintly smiling mouth, the carving has a rugged simplicity and recalls the work of the Italian Primitives. Although less frankly antique than Maillol's contemporary 'The Mediterranean' (cat.88), its anti-Rodinian, classical character is pronounced – an orientation which was confirmed in his subsequent works. From now on Bernard's preferred technique was direct carving, and he demonstrated a true craftsman's concern with the character of the chosen material, commenting: 'The artist must understand and love stone, carve it himself, and not allow the modeller to come between it and his idea.' (Quoted by 'J.M.' in *Masques et visages*, 28 September 1912.) Nevertheless he continued to model works in plaster which were intended for casting in bronze.

In 1908 Bernard had his first one-man show at the Galerie Hébrard in Paris. This coincided with the carving in stone of the huge figures for the 'Monument to Michel Servet', which was unveiled in Vienne in 1911, and at the time was regarded as an heroic achievement. Plaster casts of the figures formed the centrepiece of a special retrospective in the Salon d'Automne in 1912, the year in which he began work on a

decorative marble 'Frieze of the Dance' for the home of his patron, Paul Nocard (now in the Musée d'Orsay, Paris). This work, which expresses Bernard's intense love of dance and music, depicts classically draped and nude figures against an abstract, flat background, and is carved in low relief in a style reminiscent not only of the Singing Galleries in Florence of Donatello and Luca della Robbia, but also of the Tahitian paintings of Gauguin and recent works by Maurice Denis.

From 1913 to 1921 Bernard was largely prevented from working by a serious illness. A significant body of sculpture was created during the last ten years of his life, but stylistically it depends heavily on his pre-war achievement.

Bernard's fidelity to direct carving, his dedication to craft and his 'sincerity' were much praised by French critics, who liked to trace his lineage to Egyptian, Greek, medieval and Renaissance carvers. Albert Morancé, for example, described him as 'one of the first to be true to the character of each technique; he has influenced a group of artists, and has become as it were the leader of a school.' He goes on to quote Tristan Klingsor's comment: 'His code of beauty is not without precedent: it has an antique character. . . . It is a fact that ancient civilisations are often close to the primitives, and that our souls, weary of over-sophistication, crave the freshness of the earliest epochs. We should not be surprised to find similarities between the work of Joseph Bernard and the great masters of Egypt.' (*L'Art d'Aujourd'hui*, 1929) Admiration for Bernard was not confined to France: in Barcelona he was the subject of a series of articles published in 1916–20 by the realist painter Feliu Elias (writing under the name Joan Sacs), and there are significant similarities between his work and that of Casanovas. Bernard received wide acclaim in the 1920s, particularly after the Exposition des Arts Décoratifs in Paris in 1925 when an enlargement of his 'Frieze of the Dance', commissioned for the State, was on prominent display in a courtyard, and a number of his smaller works were exhibited in the pavilion of Emile-Jacques Ruhlmann, France's leading furniture-maker. Several

The artist in his studio in the Cité Falguière, near Montparnasse, Paris, 1907 or 1908 (Photo: Fonds Joseph Bernard, Fondation de Coubertin)

monographs were published, including Richard Cantinelli's beautifully illustrated *Catalogue de l'œuvre sculpté* (Paris and Brussels, 1928), and in 1932 came the accolade of a posthumous retrospective at the Orangerie in Paris.

4 Modern Sphinx 1908

Marble, 34 × 21.5 × 30
*Fondation de Coubertin,
Saint-Rémy-lès-Chevreuse*

This is a fine example of Bernard's early direct carving style. Choosing the traditional Salon material of marble, and exploiting in the treatment of the face its feminine qualities of grace, beauty of surface and translucency, Bernard then goes out of his way to emphasise its stony nature in his 'unfinished' treatment of the hair. In other marbles of this period he makes the same play on the dichotomy between the

raw material and the fine art of the crafts-man, whereas in popular Salon sculpture every effort was made to disguise the nature of the unworked material by feats of techni-cal virtuosity. Bernard admired Michelan-gelo, and it is likely that the sense here of the face emerging from the unworked block owes much to his example. But the uncom-promising frontality of this head, and the inexpressive, mask-like treatment of the features, are more revealing of Bernard's great admiration for archaic art. The primi-tive classicism of the piece is indeed typical of avant-garde painting and sculpture at this time, when the stars of Cézanne and Gau-guin were in the ascendant, and when a return to the 'pure' traditions of ancient art was regarded as the necessary cure for the ephemeral nature of nineteenth-century 'daguerreotype' naturalism.

5 Serenity c.1912–13

Stone, 39 × 22 × 28
Private Collection J.B.

Formerly thought to date from 1918, this is now known to have been shown in the Galerie des Arts in 1914, and may possibly have been one of the exhibits at the Salon d'Automne in 1912. It was carved by Ber-nard from a boulder found in a river, and is an excellent example of his concern with the idiosyncracies of natural materials. The extreme density and hardness of this stone is reflected in the emphatic simplification of the rounded surfaces of head and neck, and in the absence of any deep cutting: the hair, for instance, is merely incised. As in several other stone pieces, Bernard abstracts the neck into a functional, blocky plinth, carved with uncompromising gracelessness. The head – archaic in type – is given no personality, no distinguishing features: it is as if Bernard would like us to believe it were an archaeological find excavated from some provincial site.

'Serenity' is the quality which Bernard sought in much of his work, and which is traditionally associated with the true spirit of classicism: the title of this piece is surely intended to mark his identification with the sculptors of antiquity.

4

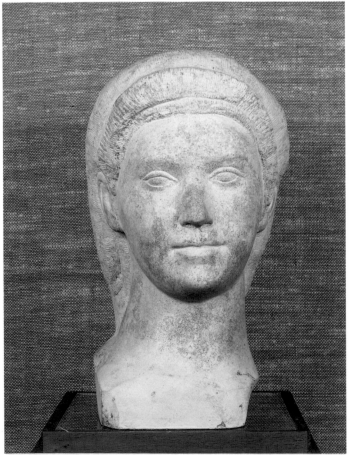

5

PIERRE BONNARD 1867 FONTENAY-AUX-ROSES – 1947 LE CANNET

Although, on the insistence of his father, Bonnard began studying law in Paris in 1885 he was always more interested in art, and two years later he attended classes at the 'free' Académie Julian. He quickly became involved in the Nabi group, and in 1891 decided finally to devote himself to painting. Active in literary, theatrical and artistic circles in Paris, a frequent contributor to Natanson's *La Revue Blanche*, represented in all the Nabis' exhibitions and regularly in the Salon des Indépendants, Bonnard attracted a good deal of critical attention in the 1890s, and was given his first one-man show by Durand-Ruel in 1896. Between 1905 and 1910 he made numerous trips abroad, visiting museums in Belgium, Holland, England and Spain. His first long stay in the south of France was in 1909, and from then on he worked regularly along the Mediterranean coast, eventually buying a house in Le Cannet, near Cannes, in 1925.

In 1906 Bonnard had the first of many one-man exhibitions at the Bernheim-Jeune gallery in Paris. The prominence of his work in the years before the outbreak of war resulted in the offer of the Légion d'Honneur in 1912, which he declined, and in a number of important decorative commissions from patrons at home and abroad. He was the subject of several long articles, and in 1919 the first monographs, by Léon Werth and François Fosca, were published. Several others followed in the 1920s.

Yet Bonnard's celebrity and success during these years, and his prolific output as a painter, print-maker and illustrator, disguise an ambiguity in his position as an artist. His work of the 1890s had been easy enough to categorise, thanks to his association with the Nabis. But after the turn of the century it began to seem as if he no longer belonged to any clearly identifiable 'party' within the avant-garde. Unlike his exact contemporary Matisse, he did not become a convert to neo-Impressionism when it was fashionable in about 1903–5; nor did he join the Fauve group, even though he was a noted and expressive colourist; and he was never influenced by Cubism or Futurism. Instead, during these years of tumultuous stylistic upheaval, he appeared to be working in a manner still derived directly from

Impressionism – a style regarded in advanced circles not only as outmoded, but as in need of overthrowing because it was deemed to be an art of and for the eye only, not of and for the mind.

During and after the war, with the 'call to order', the classical revival and Purism, Bonnard's position as an outsider, locked definitively into a *passé* style, seemed beyond recall. The fact that he refused to write about his intentions or to theorise about art merely fuelled the misconceived notion that he was a purely sensual painter. So did the writings of all those who loved and responded to his work, most of whom, like Claude Roger-Marx, were identified with the conservative wing of the French art world. For they wrote of Bonnard in rhapsodic terms as an *ingénu*, miraculously talented, who painted the beauties of the world around him thoughtlessly and instinctively, and who desired only to delight. Thus Charles Terrasse, while admitting that Bonnard himself was not a cheerful man but a 'dreamer' alert to the 'pain' all around him, wrote that as a painter he was concerned with 'nothing but joy' (*Bonnard*, Paris, 1927). And for Fosca, Bonnard was a 'magician' who offered a 'delicious' antidote to 'the disconcerting geometries' and to the abstruse metaphysical theorising of the 'deranged polytechnicians' who ran the avant-garde (*Bonnard*, Geneva, 1919). The verdict of the 'polytechnicians' was summed up by Waldemar George in a review of Bonnard's summer exhibition at the Galerie Bernheim-Jeune, published in *L'Esprit Nouveau* in July 1921. There he spoke of 'the failure of an art, which had its moment of beauty, but which suffers at present from its insouciant charm.' Bonnard, he went on, offered nothing the Impressionists had not already offered. He may have had 'a great sense of lyricism', he may have been able to delight the eye, but the modern world required something else of its artists.

In reality, however, Bonnard shared the preoccupations of his avant-garde contemporaries. In broad terms, his later work pursues the abstractionist course it had followed during the Nabi period, despite the apparent importance of the ephemeral, con-

The artist, *c*.1908

temporary subjects he usually depicted. Its relationship to avant-garde classicism before and after the war is, characteristically, veiled and oblique, but a close look reveals many points of contact. In the first place Bonnard quite often reveals his thorough classical education in the choice of subjects for his decorative paintings. Specific mythological subjects are relatively rare, but pastoral themes redolent of the ancient poets are very common, even though Bonnard often disguises his Arcadia in modern dress. Moreover there are a surprising number of quotations or adaptations from Greco-Roman sculpture in his pictures: celebrated antique sculptures like the 'Sleeping Hermaphrodite', the 'Niobid' and the 'Spinario' are direct sources for several figures, and numerous full-length nudes washing relate quite closely to Hellenistic Venuses. His admiration for Italian Renaissance painting, and especially for the Venetians, is reflected in much of his work, especially the pastoral idylls. And in general he had a strong sense

of his relationship to the French tradition from the Renaissance to Degas and Renoir.

Bonnard is, of course, widely recognised as a great painter of the Mediterranean: his journeys to the south, and his hundreds of highly unspecific and idealised paintings of the southern landscape, must be understood in the context of the notion, advanced in France in the early years of the century and regularly repeated during and after the war, that the Mediterranean was the birthplace of the classical tradition, and thus the guarantee of France's position as a supremely civilising force within the modern world.

Bonnard's working methods also reveal the underlying classicism of his art: he did not paint from life, but from memory aided by rapid sketches and by photographs, maintaining that the motif was so potent a force that he was incapable of imposing his creative vision upon it if he had it before his eyes. Moreover, he often worked over his paintings for long periods. His attitude to drawing is also indicative of his general outlook: conscious of his own powers as a colourist, and influenced by the entirely traditional prejudice against colour as the agent of merely sensual naturalism, he tried to strengthen the drawing in his paintings and paid great attention to the order of his compositions. Interestingly, his serious anxiety about an imbalance between line and colour in his work, and the tendency for his forms to 'evaporate', began to surface in 1913 just at the moment when the 'call to order' was gathering momentum. And during the war his quotations from classical art became more frequent.

Bonnard's position is thus rather similar to that of Matisse, whose post-war work also suffered an adverse reaction, and indeed the two men were on very close terms after the war, sharing a mutual admiration. To the question 'Is Pierre Bonnard a great artist?', posed by Christian Zervos in *Cahiers d'Art* shortly after Bonnard's death, and to which Zervos himself answered 'No', Matisse replied furiously, scrawling his answer over the article: 'Yes! I certify that Pierre Bonnard is a great painter, for today, and assuredly for the future. – Henri Matisse January 1948.'

6

6 Summer 1917

Oil on canvas, 260 × 340
*Fondation Marguerite et Aimé Maeght,
Saint-Paul*

It has recently been established that this great decorative painting was executed between July and October 1917, and not in 1909, as Jean and Henry Dauberville had suggested in their *Catalogue raisonné* (no.538). The painting was commissioned by Mr and Mrs Hahnloser for their home in Winterthur, and was included in Bonnard's exhibition at the Galerie Bernheim-Jeune in October 1917 before being despatched to them in Switzerland. As it turned out, however, there had been a misunderstanding about the dimensions, and Bonnard took the painting back and sold it to a collector in Paris.

Like his fellow Nabis, Vuillard and Denis, Bonnard was happy working on a decorative scale. He accepted a number of important commissions from private patrons, and frequently chose large formats for uncommissioned paintings. These decorations often took vaguely mythological or allegorical themes, no doubt because he believed that traditional subjects were appropriate for works of a public nature. For the Russian collector Morosov, for instance, Bonnard painted 'allegories' of the seasons in 1912, and for the Bernheim-Jeune family in 1916–20, four large paintings, two of which are pastoral idylls, while the other two are views, one on to the sunlit Mediterranean, the other a sharply contrasted view of the smoking suburb of the Grande Jatte at Asnières.

'Summer' is best described as a pastoral idyll although, unlike the clearly Arcadian Bernheim-Jeune decorations, the time and place are ambiguous. The nudes reclining in the middle ground suggest the Golden Age, but the children in the foreground seem to belong to the present, and the figure in the distance could be either from the modern world or from the past, while the landscape could be the garden of Eden or a beautifully landscaped 'English' park. In creating this ambiguity Bonnard's purpose was to enhance the feeling of enchantment, the dream-like quality which everything in the painting conspires to induce. The children appear to be on some kind of curved and raised bank, and one of them, the only one who faces the nudes, is asleep. (Bonnard referred to 'sleepers' in a letter to Mrs Hahnloser of 26 July 1917.) One feels that this child – who like the others is a symbol of innocence, and probably of imagination – has 'dreamt' the beautiful, richly coloured scene that opens out between the curtain of trees, while the smiling children to the left invite us in to witness it. The composition is stage-like, the trees resembling *coulisses*, the wooded hills in the distance the backdrop. And the veiled blues and greens of the children's 'terrace' and of the great swathes of surrounding foliage are the blues and greens traditionally associated with the imaginative vision or the dream.

Through such devices, and through his soft and spongy handling of the paint, Bonnard evokes the ideal of beauty, harmony and peace. The connection between these kinds of decorations and the appalling actuality of the war is not a simple one. Bonnard had painted similar scenes long before the war broke out, and it seems certain that they were not only intended to be sublimely timeless, but to offer an alternative to the cruel realities of modern life.

Bonnard's sources for 'Summer' and other decorations of a similar mythic character were traditional. Broadly symmetrical stage-like compositions, with clearly defined spaces, are, of course, typical of the Renaissance and of French classical painting of the seventeenth century. But unlike his Cubist or Purist contemporaries, who preferred Raphael, Bonnard was especially attracted to Venetian painting, venerating the work of Titian and Veronese – and sometimes, indeed, inserting subtle quotations from their works. 'Summer' could be described as Titianesque, while in its imaginative breadth it also reminds us of Rubens's grandiose landscape compositions. Similarly, while the 'call to order' critics and artists extolled Poussin, Bonnard seems to have favoured Claude, and the dream-like spaces and mood of 'Summer' are Claudian. Another source was surely the French Rococo, and there are similarities with Watteau's 'Embarkation from Cythera' (Louvre) and Fragonard's 'Fête at Saint Cloud' (Banque de France, Paris). In general terms, moreover, the painting is like a tapestry, and belongs in the long tradition of tapestry decoration. Not that any of these sources is quoted directly: it is the ambience of traditional conceptions of a romantically paradisal landscape that Bonnard seeks, and that gives this painting its extraordinary amplitude and resonance.

7 The Bowl of Milk c.1919

Oil on canvas, 116 × 121
Tate Gallery

This painting was first exhibited at the Salon des Indépendants in January 1920 under the title 'Interior'. It has also been known as 'Interior at Antibes'. Like Matisse, a close friend at this period, Bonnard would paint the same themes repeatedly, drawing on his experience of the south of France to emphasise only those aspects that mattered to him. The sunlit interior, the table tipped towards us and spread with objects, the cat, the woman absorbed in thought or in some mundane activity, the window inviting us to contemplate the great spaces beyond the confines of the room, are all favourite motifs of his, and indeed this same room at Antibes appears in several other paintings executed in 1919.

The imagery of these paintings may at first suggest relaxation and delight, and may appear to be strictly contemporary, but a mysterious, even oppressive, intensity emanates from them as we become aware of their strange stillness and silence. This is the case with 'The Bowl of Milk'. The subject is potentially anecdotal, even sentimental, and the abundance of charming things – young girl, cat, sunlight, vase of anemones – could have resulted in the tritest of metaphors for the ephemerality of youth and beauty. The strong, rich colours, at high saturation, and the loving manipulation of the medium, might have resulted in a surfeit of sweetness. But Bonnard invests the scene with a grandeur and dignity which are awesome and, initially, baffling. This is partly the consequence of the imposing scale of the canvas, and the rigorous order of the composition, which appears to be determined by a vertical–horizontal–diagonal grid quite as carefully plotted as the grids of a 'cerebral' painter such as Gris. It is also the consequence of the hieratic conception of the girl: her pose, hair and dress probably, in fact, derive from that of archaic *kore* statues, but possibly from the famous bronze Charioteer of Delphi. At any rate, immobile as a statue, and with her strangely inexpressive, unseeing face, she seems more like the priestess of a cult than a young girl about to feed her pet cat. Finally, the strange power of the picture is the result of the 'odd' placement of the objects in the composition: we do not know where to focus because of the equality of Bonnard's attention to every part, and his decision to push the apparently significant things – the girl

and the window – to the edges of the canvas. The composition, by drawing the eye here and there all over the surface, and inviting the same intense concentration from the spectator at every move, produces a deeply contemplative effect.

Bonnard admired the work of Degas very much, and his great series of nudes bathing is in a real sense a development from Degas's revolutionary handling of this classic theme. 'The Bowl of Milk' has connec-tions with a number of Degas's interiors and portraits, but is especially close to the composition, if not the mood, of the austere and mournful 'Portrait of Hélène Rouart' (National Gallery, London). In Degas, Bonnard found the perfect model for the kind of modern classicism that he aspired to – a classicism based on a synthesis of memories of the seen and of the artist's controlling and ordering conception.

7

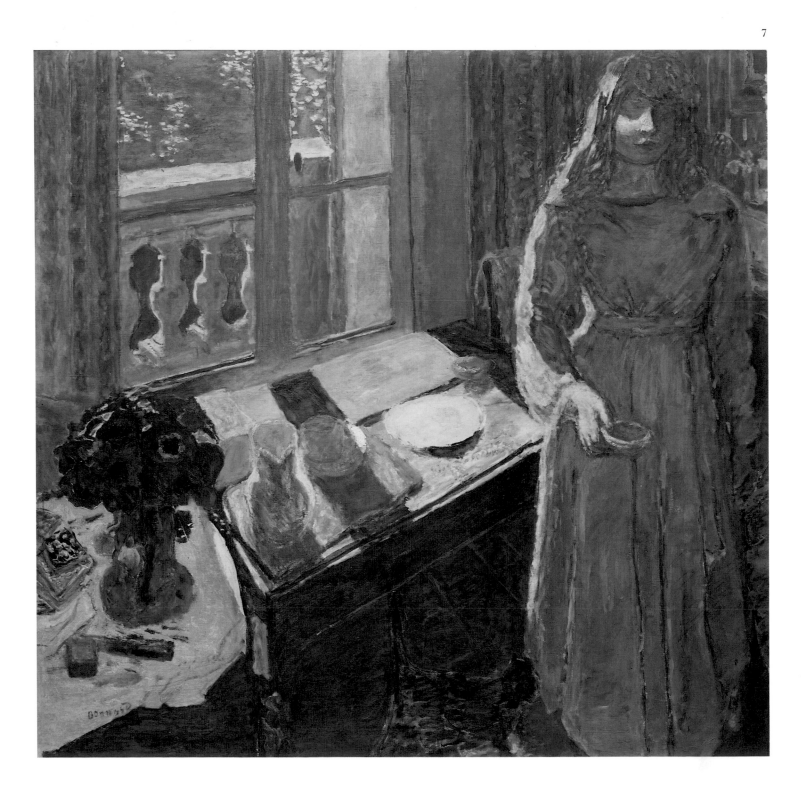

EMILE ANTOINE BOURDELLE 1861 MONTAUBAN – 1929 LE VÉSINET

Bourdelle was the most important and prolific monumental sculptor of his generation, and he exerted a considerable influence through his energy and dedication as a teacher as well as through the example of his own work. He came from a poor, artisan family, and had little formal education in his youth. On a grant from his home town of Montauban he enrolled in the art school in Toulouse in 1876, remaining there until 1884 when he moved to Paris to join the studio of the Ecole des Beaux-Arts sculptor, Alexandre Falguière. In that year he made his début in the Paris Salon, and in 1887 began the series of portraits of Beethoven on which he worked on and off for the rest of his life. Success was slow in coming, and in 1893 he began to work as a *praticien* in Rodin's studio, helping to execute the marble versions of the master's work. This hack work for Rodin, which continued until 1908, ensured him a basic livelihood without hampering unduly his independent practice as a sculptor. Although Bourdelle was undoubtedly influenced by Rodin, he was never overwhelmed by his artistic personality and was quite critical of what he saw as a lack of synthesis in Rodin's compositions.

By 1900, with his 'Head of Apollo', a new structural discipline and a new quality of calculated balance was perceptible in Bourdelle's work. It was also at this period that he began to teach, although his real fame as a teacher dates from 1909 when he joined the Académie de la Grande Chaumière. The new, more 'classical', direction announced in 'Head of Apollo' was pursued in many subsequent works, including 'Penelope' (cat. 8). A high proportion of these take themes familiar in antique and Renaissance art, although Bourdelle's interpretation of Greco-Roman mythology is personal and dramatic, and his style vigorously expressive, abstracted and anti-academic.

In 1909 Bourdelle was made Chevalier de la Légion d'Honneur. His first resounding Salon success came with 'Herakles the Archer', when shown the following year. This understandably provoked comparisons with the pedimental sculpture from the Temple of Aegina. His reliefs for the façade of Auguste Perret's Théâtre des Champs-Elysées (completed in 1913) took Greek metopes as their compositional and structural point of departure. Well-known works like these, and Bourdelle's grandiose public monuments, such as the 'Monument to General Alvéar' for Buenos Aires (completed in 1923), with its open reference to antique and Renaissance equestrian statues, led many French critics in the 1920s to see him as the ideal mediator between modernism and the Great Tradition. Waldemar George praised him for rejecting Rodin's emphasis on modelling in depth in favour of 'construction by planes' and 'the simple play of juxtaposed surfaces', and described him as 'the direct heir to the stone carvers of the twelfth century and the precursor of the so-called cubist sculpture of Jacques Lipchitz and Henri Laurens.' (*L'Opinion*, 30 January 1921) Thiébault-Sisson described the Alvéar monument as a 'masterpiece of modern sculpture saturated with the perfume of the antique.' (*Le Petit Dauphinois*, 5 July 1923) Comparisons between his works and archaic Greek and French medieval sculpture became, indeed, critical commonplaces in the 1920s, when French writers were at pains to develop the theory of a continuity between the native tradition and the classical heritage.

Bourdelle's prestige at the end of his life is reflected in his election to the presidency of the Salon des Tuileries, his elevation to the rank of Commandeur de la Légion d'Honneur in 1924, the enormous retrospective of 141 works organised at the Palais des Beaux-Arts in Brussels in 1928, and the memorial show held in 1931 at the Orangerie in Paris. According to Anatole France, writing at the time of Bourdelle's death, he was quite simply 'the most famous Frenchman of his time'.

The artist, *c*.1925 (Photo: Musée Bourdelle)

8 Penelope 1909

Bronze, 120 × 40 × 35
Bourdelle Collection

Bourdelle's practice, unlike that of many of his contemporaries, was to scale up gradually from the original small model of an individual sculpture, modifying the conception here and there as he went, until it reached its definitive, monumental state. The first, small versions of 'Penelope' date from 1905 (with a spindle) and 1907 (without a spindle). This, dating from 1909, is the intermediate size. The final, monumental version (240cm high) was exhibited in the Salon de la Société Nationale des Beaux-Arts in 1912.

The face of 'Penelope' – the long-suffering and faithful wife of Odysseus – is that of Bourdelle's first wife. Yet the original source for the pose was, ironically, a quick drawing of the woman who became her successor. Cléopatre Sevastos was a student of Bourdelle's in 1905, and in 1910 he divorced his first wife on account of her. Cléopatre Sevastos was born in Athens. Her education was extensive, and it has been said that she brought to Bourdelle a breadth of culture which he had lacked until then, in particular encouraging his interest in Greek mythology and art. Certainly works inspired by her, dating from the beginning of their association, appear to have a more pronounced classical character. In 'Penelope', for instance, Bourdelle adapts the *contrapposto* pose first developed in Greek classical sculpture, while the relationship of the head to the thickset arms is reminiscent of several of the best known Roman frescoes in the Archaeological Museum in Naples. Moreover, the treatment of the drapery and the blocky, columnar conception of the body suggest parallels with caryatid figures. But Bourdelle's approach remains independent: the proportions of the figure – short, small-breasted torso, very long legs – and the exaggerated curve of the hips, have more in common with French medieval sculpture, which French critics of the period were at pains to define as 'classical'. On the other hand, the deliberately coarse handling, which is non-descriptive and tends towards a curiously geometric, faceted surface effect, has no precedent in either of these sources. The meditative implications of the work are undermined by the style, and we experience that disturbing, contradictory mixture of structural order and expressive tension which is so typical of Bourdelle's best work.

8

9

9 France 1923
Bronze, 136 × 33 × 19
Bourdelle Collection

This is the original small model of 'France'. The French Government had commissioned the aged sculptor Albert Bartholomé to create a monument commemorating the American intervention in the First World War, to be erected on top of a lighthouse at Pointe de Grave, near Bordeaux. Bartholomé felt unequal to the task and passed the commission over to Bourdelle. Although in the event money ran out and the commission was withdrawn, Bourdelle completed the model, and exhibited a 4.60-metre version in the Salon in 1923. As a consequence of its success there, the Minister for the Arts commissioned Bourdelle to produce a 9-metre enlargement for the Exposition des Arts Décoratifs in 1925. This was Bourdelle's only commission from the French State during his lifetime. Following the exhibition of this huge version at his posthumous retrospective at the Orangerie in 1931, other casts were commissioned to serve as war memorials for the cities of Briançon and Montauban. A third cast was erected after the Second World War outside the Palais de Tokyo in Paris, where it still stands.

'France' is unashamedly patriotic – General de Gaulle owned a cast of this small version – and was created at a time of extreme nationalistic fervour following the end of the First World War. With hindsight it has a proto-Fascist look, with its declamatory gesture, its transparent symbolism, and its superficially academic use of the classical tradition. However, Bourdelle's politics were if anything left-wing, and the composition of the statue is conceived in severely abstract terms, as a play of serpentine curves and zig-zags against strictly vertical columnar forms. Bourdelle always insisted that he observed the spirit, not the letter, of classical art, and the extreme compositional order and the synthetic nature of the monument may explain why he thought of it as his masterpiece – 'the most complete and harmonious of all my conceptions' (G. Varenne, *Bourdelle par lui-même*, Paris, 1937). It is the visual equivalent to the way many critics of nationalist persuasion wrote about France as the natural and worthy successor to the culture of Greece and Rome, and about the French artistic tradition as the purest modern expression of the spirit of classicism.

GEORGES BRAQUE 1882 ARGENTEUIL – 1963 PARIS

Braque, initiator with Picasso of Cubism and inventor of the revolutionary technique of *papier collé*, was certainly one of the most radical and innovative artists of the early twentieth century. Yet by temperament he was thoughtful and disciplined, and Cubism in his hands is an art of lucid formal structure, harmonious colour and tone, delicate and restrained execution, and contemplative mood. It is not surprising that long before the end of his life he should have come to be seen as a great modern exponent of the French classical tradition.

Braque's deep interest in the art of the past developed when he was a student at the Académie Humbert in Paris at the turn of the century. He spent long periods in the Louvre, where he was particularly impressed by the galleries of Egyptian and archaic Greek sculpture. His own earliest paintings were impressionist in style, but at the Salon d'Automne of 1905 he experienced the revelation of Fauvism. Encouraged by Othon Friesz, whom he had met when living in Le Havre in the 1890s, Braque painted landscapes in a rather prudent version of the Fauve style during the next two years, working mostly on the Mediterranean coast near Marseilles. He exhibited successfully at the Salon des Indépendants in 1907, met the young German picture dealer Kahnweiler, with whom he signed a contract, and was introduced to Picasso by Apollinaire. At the end of that year, under the impact of Picasso's latest pictures (including 'Les Demoiselles d'Avignon'), and especially of Cézanne's late Bather compositions (seen in his posthumous retrospective), he began work on 'Large Nude' (private collection). Finished about six months later, this somewhat hesitantly executed painting was a watershed for Braque, effectively putting an end to his Fauve period and announcing many of the pictorial concerns of his and Picasso's early Cubist works. The landscapes he painted in the spring and summer of 1908 at L'Estaque were radical in the degree of their formal and colouristic abstraction and in their mobile conception of space. When they were exhibited that November in Kahnweiler's gallery, it was the boldly geometric treatment of natural form that prompted

Louis Vauxcelles's now famous comment: 'He reduces everything . . . to geometrical schemes, to cubes' (*Le Gil blas*, 14 November 1908). On the other hand Apollinaire, who wrote the catalogue preface, emphasised the 'synthetic' character and the 'harmony' and 'lyricism' of the paintings – a shrewd evaluation, which holds good for the greater part of Braque's œuvre.

In 1909 the friendship between Braque and Picasso deepened, and until the outbreak of the war they worked so closely together that one has to speak of a collaboration. Exhibited with Kahnweiler, rather than in the Paris Salons, their paintings developed gradually in formal complexity to the point where they appeared in 1910–11 to be almost wholly abstract, although the veiled subject matter, usually turning on the bohemian world of cafés and studios, remained an important concern. Over the next year Braque – quickly followed by Picasso – exploited increasingly the conventionalised techniques he had learned as an apprentice house-painter in the 1890s, in order both to give clues to the identity of the objects in his pictures, and simultaneously to protect their abstract character as works of art. In September 1912 he created the first *papiers collés* with strips of commercial wallpaper printed with a woodgrain pattern. His fame as a leading avant-garde figure was by now fully established, and his work was included in several important exhibitions abroad and discussed in leading international art journals.

Called up at the beginning of the war, Braque was invalided out of the army in 1915 following a very serious head wound. His convalescence was slow, and he was only able to begin painting again early in 1917, working initially in a synthetic Cubist style. That December the poet Pierre Reverdy published a series of Braque's 'aphorisms' in his avant-garde review, *Nord–Sud*. These reveal the rational and lucid turn of Braque's mind, and his debt to philosophy and aesthetics of a classical orientation. Among them we find: 'The aim is not to *reconstitute* an anecdotal fact but to *constitute* a pictorial fact.' 'The senses deform, the mind forms. Work to perfect the mind. There is no certainty except in

The artist in 1922 (Photo by Man Ray)

what the mind conceives.' 'Nobility comes from contained emotion.' 'I love the rule that corrects emotion.' His conceptualism was profoundly in tune with the ethics of the 'call to order', and some of Braque's closest friends after the war, including Reverdy, Maurice Raynal and Gris, were leading exponents of the movement, as was Léonce Rosenberg, who became his dealer in 1918. Like Picasso, Braque was now in demand with well-to-do patrons, and his work from about 1919 evolved into a much more sensual, more 'baroque' and more personal version of Cubism. Still life remained his principal theme, but large classical figure paintings entered his repertory. His still lifes often took on a grandly decorative scale and character, and reflected in the choice of objects their relationship to the great tradition of French *belle peinture*. His special love of Chardin and Corot became more obvious, while the new voluptuousness of his treatment of form and his predilection for fruit and flowers reveal his

10

11

admiration for Renoir, currently the object of great veneration in all sectors of the Parisian art world. Indeed it became a commonplace of contemporary French criticism to emphasise Braque's links with the French tradition. 'One recognises in this artist the very essence of the gifts of our race: the moderation and the severe grace which are unique to France, and equally the disdain of the merely ephemeral, and the urge towards profundity,' wrote the painter Bissière in 1925 (*L'Art d'Aujourd'hui*).

By 1928 Braque had embarked on a series of *guéridons*, still lifes mounted on pedestal tables. From these richly coloured and complex works he graduated in the early 1930s to a series of interiors with figures, which culminated after the Second World War in the renowned, poetically allusive, late 'Studios'. His lifelong interest in archaic Greek art found direct expression in plaster plaques painted black and incised in white with schematised drawings, which he began making in 1931, and in small, decorative sculptures on vaguely mythological themes made during the 1940s. His unassailable position as a great modern master was reflected in the award of many international honours, in the exhibition of his work at the Louvre in 1961 – the first time a living artist had been accorded this tribute – and in the State funeral after his death.

10 Basket Bearer 1922

Oil and sand on canvas, 180.5 × 73.5
Musée National d'Art Moderne, Centre Georges Pompidou, Paris, bequest of Baronne Gourgaud, 1965

11 Basket Bearer 1922

Oil and sand on canvas, 180.5 × 73
Museé National d'Art Moderne, Centre Georges Pompidou, Paris, bequest of Baronne Gourgaud, 1965

Although the special shape and the tall format of these two canvases might suggest that they were painted to decorate an existing space in a private house, they were created independently of any commission, and were shown alongside sixteen still lifes in the 'Salle d'Honneur' allocated to Braque in the Salon d'Automne of 1922. Braque's equivalent to Picasso's recent neoclassical paintings (for example cat.141), they attracted a good deal of critical attention at this time, and were bought from the artist by Paul Rosenberg, who shortly afterwards became Braque's dealer. Rosenberg exhibited them several times over the next few years in one-man and group shows, and singly or together they were reproduced in several important publications, including the Purist review *L'Esprit Nouveau* (no. 19, 1923) and Carl Einstein's influential *Die Kunst des 20 Jahrhunderts* (Berlin, 1926). Thus they became among the best known of Braque's works, even though the initial critical reaction to them was not uniformly favourable.

It was the frankness of Braque's approach to tradition which caused controversy at the time. For some more conservative critics his apparent abandonment of Cubism for a subject derived from Greco-Roman art, and a style which was relatively naturalistic and had certain obvious affinities with French Rococo painting and the work of Renoir, was a source of satisfaction, suggesting that the dangerous rebel had finally been tamed. But for those who believed Cubism was the great achievement of the pre-war era, Braque's new paintings seemed like a capitulation to current fads. André Salmon felt most uncomfortable in their presence: acknowledging that Braque's Cubist work had had a classical foundation, and that he was 'the Chardin of Cubism', he criticised the 'realism' of his new work as half-baked, hesitant and slack, found the colour 'disagreeable', and concluded that Braque had reverted to the preoccupations he had had as a house-painter (*La Revue de France*, December 1922).

Many nudes were painted by Braque in a very similar style over the following five or so years. All are dark and tonal, and the drawing is so supple and free-running that it looks almost automatic. The touch is caressing and painterly. The women are invariably voluptuously fleshy, and many are given fruit and flowers as their attributes and are thus associated with traditional symbols of nature's boundless fertility. Simultaneously Braque was painting numerous still lifes. Almost without exception these too are sensual, depicting ripe fruit and bouquets of flowers. He has become a painter of 'the good things of life', openly reflecting the traditional values of the post-war era in France.

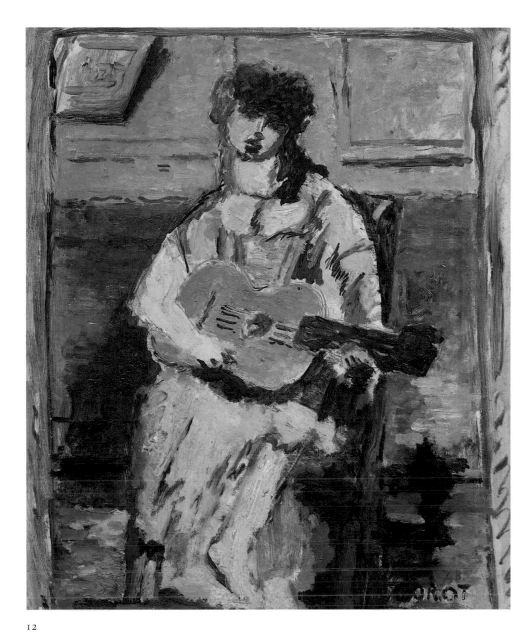

12

12 Woman with a Mandolin. Free Study after Corot

1922–3

Oil on canvas, 41 × 33
*Musée National d'Art Moderne, Centre
Georges Pompidou, Paris, gift of
Madame Georges Braque, 1963*

This little painting, executed probably
shortly after the 'Basket Bearers', remained
in Braque's personal collection until his
death, and was bequeathed by him to the
national collection. It had a special place in
his affections because it states so unequivo-
cally his sense of profound affinity with
Corot, and hence with the French tradition.

Braque's love of Corot dates back to the
beginning of his career as a painter. It was
fuelled by the exhibition of twenty-four of
Corot's figure paintings held at the Salon
d'Automne in 1909. (Following this exhibi-
tion Braque and Picasso painted many Cub-
ist pictures depicting musicians or people
musing pensively, which owe a debt to
Corot's poetic and melancholy works.) With
the reopening of the Louvre after the war
Corot's reputation rose, if anything, higher.
Picasso, Derain and Gris were all affected,
and Corot was also taken as a model by the
Purists. (Illustrated articles by Raynal and
Bissière were published in numbers 8 and 9
of *L'Esprit Nouveau* in May and June 1921.)

Braque's lifelong fidelity to Corot is
touchingly revealed by a studio photograph
taken in 1957 in which we see, prominently
displayed, two large photographs of figure
paintings by Corot. One of these is of the
'Portrait of Christine Nilsson', 1874 (Museu
de Arte de São Paolo), and historians have
suggested that Braque's 'free copy' is based
on this painting. Corot's model, however, is
only half-length, faces in the opposite direc-
tion and is seated out of doors, and slightly
earlier paintings of girls posed with musical
instruments in a studio, with frames and
canvases in the background, seem closer. In
any case Corot's style and the lyrical, tran-
quil, 'musical' quality of his work mattered
as much to Braque as his subject matter: the
restrained tonal colour, the dense, impasted
surfaces, and the beautifully poised and
meditated compositions all find an equiva-
lent in Braque's later work.

MASSIMO CAMPIGLI 1895 FLORENCE – 1971 ST TROPEZ

Campigli's career was divided into two distinct phases. The first came in the early 1920s when, living in Paris, he struggled to assimilate the formal lessons of late Cubism. The second began in the late 1920s when, with joy and a certain sense of relief, he rediscovered the ancient art of his native Italy. Both phases were dominated by a quest for classicism, or rather, classicisms: first, of order and discipline in pictorial structure, and secondly, of a return to the cultural traditions of Italy. As such, they illustrate different but related aspects of the 'return to order'.

Campigli grew up in the fast-expanding industrial city of Milan, and while still a teenager he sought out the company of Futurist painters such as Boccioni and Carrà, and contributed essays and poems to avant-garde literary reviews. During the war he fought at the front, and spent a year as a prisoner of war in Hungary. On returning to Italy he was undecided as to what career to follow, but accepted the post of French correspondent for the Milanese newspaper *Il Corriere della Sera*, and moved to Paris in 1919.

It was in Paris that Campigli decided to become a painter. Writing articles by night and painting by day, he led a life of relative poverty for many years. He was so determined to succeed, and to do so by his own efforts, that he deliberately avoided other artists while he set about the task of teaching himself how to paint. He was, however, very much aware of the new trends in contemporary art. As he later recalled, 'crystalline' or Purist-inspired Cubism dominated the galleries, and the leading critics of the day spoke of the importance of order, harmony and rules, condemning anything that smacked of narrative or sentiment. The great influences on him at this time were Seurat, Picasso in his Blue, Rose and neo-classical phases, and, above all, Léger. His Italian contemporaries also had an impact on his work: in his reminiscences of these years, Campigli recalled that the cylinder-like figures of his early paintings were inspired not only by Léger but also by Carrà – in particular, Carrà's painting 'The Drunken Gentleman' (cat.16), a work Campigli would have seen reproduced in the leading

art magazine associated with the 'return to order' in Italy, *Valori Plastici*.

Late Cubism and the renewed interest in 'classical' values of order and harmony in art were not the only influences on Campigli in these years. After his arrival in Paris, he made regular visits to the collections of the Louvre, and was particularly drawn to its holdings of Ancient Egyptian art. His passion for antique art strengthened his conviction that, however unfashionable it might be, he had to retain the human figure, with all its emotional and psychological associations, and resist the tendency towards geometric abstraction in late Cubism and Purism.

Campigli gradually became known by contributing to the two *Novecento Italiano* exhibitions held in Milan in 1926 and 1929, and through a number of shows of Italian artists working in Paris. The first of these included paintings by de Chirico, Savinio, de Pisis, Paresce, Severini and Mario Tozzi, and was held in Paris in 1928. The same year Campigli radically changed the style of his work. He returned to Italy, and while in Rome he visited the collection of Etruscan art at the Valle Giulia museum. Just when artists such as Martini and Marini were succumbing to the spell of this ancient Italian art, Campigli too became a devotee of what became known as the 'maniera etrusca'. His paintings took on a new, frank archaicism, rich in symbolic and emotional significance, and he rejected all his earlier work as being merely experimental.

Campigli's 'Etruscan' style proved extremely popular. An exhibition of his new work held at the Galerie Jeanne Bucher in Paris in 1929 was sold out, and a number of paintings passed into important public and private collections. Some critics, however, were dismayed by the 'Italianness' of his new works. Writing in *Cahiers d'Art* in 1931, Christian Zervos recognised Campigli's success but could not help condemning the overt archaicism of his work which he felt was at best incidental, and at worst a distraction from the 'pure' values of painting:

I once reproached Campigli for being too attached to the tradition of his country

The artist in his studio in Paris in the early 1920s

and particularly to the mural paintings of the Etruscans. But Campigli answered that it was merely the spirit of antiquity which entered his work and imposed on him a simplicity of form and elementary feelings. The artist forgets that this simplicity can be found equally in the spirit of truly modern art. . . . This justification by the painter is thus only a pretext . . .

Whatever the reservations of certain Parisian critics concerned to defend the legacy of Cubism, Campigli gained an international reputation through one-man shows, in Italy and other countries, achieving for himself a measure of financial security.

In common with other artists of his generation, Campigli became interested in promoting mural painting as a new, popular form of art. He signed Sironi's 'Manifesto della pittura murale', and executed a mural entitled 'Mothers, Workers and Peasants' for the fifth Triennale in Milan in 1933. His imagery became indebted increasingly to Pompeian and Byzantine, as well as Etruscan, sources, and in the early 1930s his work had a hieratic, sometimes even monumental, quality. However, these allusions to the antique world were always overlaid by a

private mythology. He later wrote: 'In every detail of my paintings I can trace the source back to my childhood. Everything is an escape from present reality. My reaching after archaicism in general and museum art, far from being an aesthetic choice, answers an emotional need' (*Massimo Campigli*, Venice, 1955).

During the 1930s, and again after the war, Campigli divided his time between Italy and France. He continued to focus in his paintings on archetypal images of women with hour-glass figures and faces inspired by Etruscan and Egyptian art, and his paintings acquired a new serenity and childlike atmosphere.

13 Woman with Folded Arms

1924

Oil on canvas, 55 × 46
Museo Civico di Torino, Turin

This painting reveals many of the conflicting influences at work on Campigli during the early and mid-1920s, which he later regarded as the period of his apprenticeship. The pink tonality of the work and its melancholic atmosphere recall Picasso in his Rose period, while the clearly defined shapes and frontal composition show the influence of Purism and the cult of order and discipline in Parisian post-war art. A similar blend of references is found in the image of the seated woman. Her hair-style, red lips and dress are modern, yet she sits as immobile and heavy-limbed as a classical statue, and appears lost in thought. As he later wrote, his works of the 1920s show a mixture of influences, but underlying them all were echoes of the art of the ancient world he saw on his frequent visits to the Louvre:

> There was something of Léger, metaphysical Carrà, of Egypt and finally of classical art; of Cubism, there was not much at all, even though I thought I was working very much in a late Cubist manner. In fact, I was then quite alone, quite cut-off. What happened was this: Cubism had brought me to the museums to see Egyptian and Greek art; but once there, I forgot Cubism, and I returned to my old ideas, and I found myself like an ancient and archaic artist, a-social and in love with the imprisoned women-idols.
> (*Massimo Campigli*, Venice, 1955)

Campigli later tended to stress his debt in this period to French rather than Italian art, but working as a correspondent for a major Italian newspaper in the early 1920s, he was firmly in touch with developments at home. His modern treatment of traditional themes was particularly characteristic of the Novecento group in Milan (this painting was first shown in the *Novecento Italiano* exhibition of 1926). The blurring of the distinction between the ancient and modern (the woman's necklace, for example, could be either), the framing of the figure within a shallow architectural space, and its air of timeless reverie, find echoes in the works of artists such as Funi and Sironi; and the bowl on the shelf above the figure's shoulder was also a favourite motif of Novecento artists, suggesting a continuity between ancient and modern times.

13

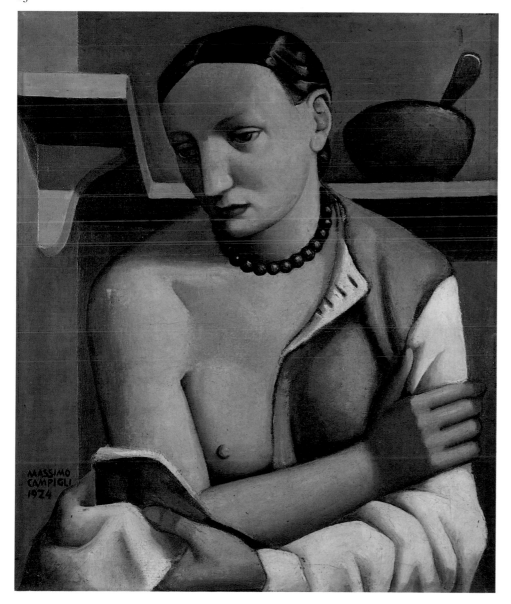

14 The Seamstresses 1925

Oil on canvas, 161 × 96.5
Hermitage Museum, Leningrad

Pierre Courthion, a French critic and one of
Campigli's earliest admirers, recalled seeing
in Campigli's studio in rue d'Alésia in Paris
paintings of 'dress makers wearing corsets
shaped like hour-glasses, strangely schema-
tised, which recalled, simultaneously,
Léger, Giotto and Chaldean art'. He might
have added as further points of reference
Seurat's pictures of corseted women (in
which the fleshiness of the female forms is
contrasted with the geometry of the comp-
osition), and the repetition of the theme of
pairs of figures in the work of Picasso in the
early 1920s.

'The Seamstresses' is one of many paint-
ings by Campigli featuring two women,
often in undergarments and engaged in
some domestic activity. The intimacy of the
scene contrasts with the balance and sym-
metry of the composition, and had a
personal significance for the artist. In his
later autobiographical writings he recorded
that as a child he had been surrounded
entirely by women, and that the hour-glass
corset which recurs obsessively in his work
was for him a symbol of femininity. In the
1920s, however, Campigli emphasised the
formal qualities of his paintings. After the
first exhibition by Italian artists resident in
Paris, a similar work by Campigli showing a
pair of corseted women playing guitars was
illustrated in *L'Amour de l'Art* in 1928, and
Campigli was quoted as saying:

> The design and composition of the
> picture is the part of the work which gives
> me the greatest satisfaction. I also have a
> strong interest in what is represented:
> these imaginary women have to be
> expressive through their shapes, their
> positions, their attributes. They are
> images, and hence to be depicted need
> clarity and clean contours. To find the
> balance between the geometric and the
> human . . . that's the problem.

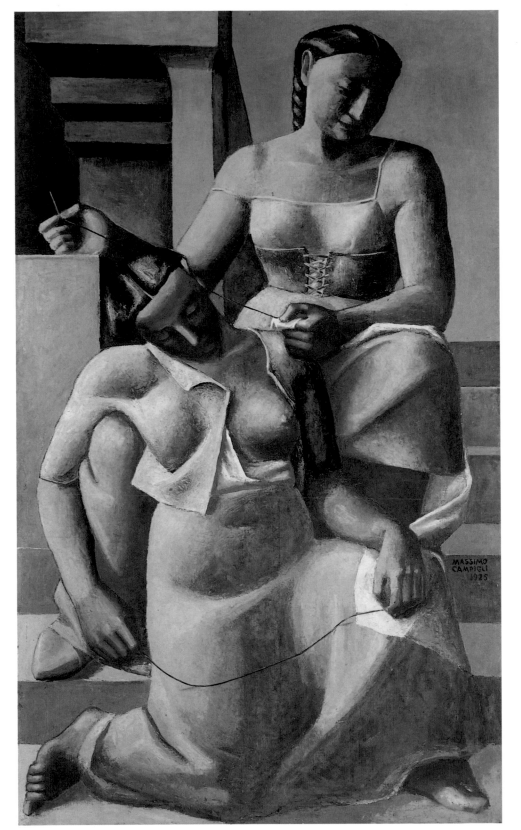

14

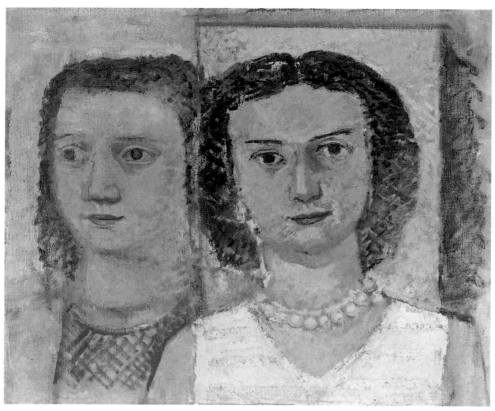

15

15 Two Sisters 1928-9

Oil on canvas, 53 × 64
Gian Ferrari, Milan

A turning point in Campigli's career came with his discovery of Etruscan art at the museum of the Valle Giulia in Rome in 1928. He abandoned his former preoccupation with the geometry and structure of his paintings, and adopted an archaic style and a subject matter rich in childhood memories and emotions.

Campigli had always loved visiting museums, which he believed offered a line of communication to other people and other times. In 1931 he said of himself, 'Campigli loves museums and necropolises. Is he attracted to them for reasons of art? Or by that most contemporary of torments, a need to escape? Campigli loves games, dreams and disguises. To be elsewhere, to be something else – that is his dream' (*Massimo Campigli*, Milan, 1931). However, it was the domestic, small-scale intimacy of the Etruscan objects at the Valle Giulia that appealed most to his imagination, in part because of the parallels he sensed between this simple ancient culture and the world of his childhood. 'I loved this small-scale, warm humanity that made you smile,' he later wrote, and 'envied the happy sleep of its sarcophagi, and the terracotta odalisques, and their representations of death. A pagan happiness entered my pictures, both in the spirit of the subject matter, and in the atmosphere of the work as a whole which became more free and lyrical' (*Massimo Campigli*, Venice, 1955).

Painted shortly after Campigli's discovery of Etruscan art, 'Two Sisters' marks his transition from a modern Parisian style to his later full-blown archaic and hieratic style. The figures appear to be portraits of living, modern women. Yet the treatment of their hair, the wide-open eyes, recalling Roman funerary portraits of the second century, and the painting's rough textures and faded tones, strongly suggest an archaic influence. This work has an intimate and personal atmosphere, typical of much of Campigli's work. In the following years, however, he became engrossed in mural art and adopted a monumental style, inspired by Rome and Byzantium.

CARLO CARRÀ 1881 QUARGNENTO, PIEDMONT – 1966 MILAN

Carrà had a great impact on Italian art as both a painter and a writer. Like many avant-garde artists of his generation, he passed through a Divisionist and then a Futurist phase. After the war he emerged as a key figure in the so-called 'Scuola metafisica', and went on to champion a revival of interest in the masters of the early Renaissance. His adoption of an archaic style after 1919 brought him much criticism, and his defence of this change in his work throws fascinating light on the ideas of the 'return to order'.

Carrà came from an artisan family, and as a young man he supported himself as a decorator while learning about art through private study and trips to the great museums of Milan, Paris and London. In 1910 he met Marinetti and became involved with the Milanese group of Futurist painters. He visited Paris several times and came to know the leading figures of the French avant-garde. As he later wrote in his autobiography, he wanted in these years 'to do something new, to knock down the old, stolid edifice of bourgeois culture, with its outdated ideas that stifled the free development of art' (*La mia vita*, Milan, 1943). However, at the outbreak of the war Carrà already felt impelled to distance himself from Futurism, and he began studying the art of the fourteenth- and fifteenth-century masters Giotto, Uccello and Masaccio. He wanted to associate his work, he wrote, with the great tradition of art, especially in Italy, although as he later explained, he did not repudiate his earlier avant-garde work. 'It hardly matters if . . . my new needs were misinterpreted, so that my new position was believed to be simply one of tiredness. Anyone who supposed that I had reconciled tradition and revolution too quickly, was also wrong. I continue to believe that my experience as a Futurist was worth while, and I am convinced that Futurism was important' (*La mia vita*). During the war the analysis of forms and the dynamism of Carrà's Futurist works gave way to a magical stillness, and a new focus on everyday objects painted in simple style. His search in these years for a spiritual dimension to art was made apparent in an article on Giotto, published in *La Voce* in 1916, in which he

wrote, 'In the magic silence of Giotto's forms, our contemplation can rest; a sense of ecstasy begins to grow, and spreads gradually through the enlightened soul'.

For a brief but crucial period of his life, Carrà turned to metaphysical painting. In the spring of 1917 he was posted to Ferrara, where he met de Chirico and Savinio. De Chirico's strange, philosophical vision of reality echoed for Carrà the spirituality he had detected in the works of the Trecento, and the two men painted together in the military hospital in the spring and summer of that year. Carrà adopted de Chirico's imagery of mannequins set in claustrophobic spaces, but his works lacked de Chirico's sense of irony and enigma, and he always retained a correct perspective, a point of contact with his beloved Renaissance art. To de Chirico's mild annoyance, it was Carrà's recent paintings, exhibited in a one-man show in Milan in December 1917, that gave rise to public discussion of a 'Scuola metafisica' in which de Chirico's pioneering role tended to be overlooked. As was often the case, Carrà's thoughts ran in parallel, or ahead of, his own work, and in the catalogue of that exhibition he described his vision of metaphysical painting in terms which were to be the touchstones of his later classical works:

> Originality and tradition are not in fact contradictory terms for those with a proper understanding. . . . We, who feel ourselves the not unworthy offspring of a great race of builders, have always sought figures and values of precision and substance, and that atmosphere of the ideal without which a painting does not go beyond technical accomplishment and fragmentary analysis of external reality.

Over the next few years Carrà elaborated these ideas in important articles in *Valori Plastici*, an art journal in which metaphysical painting, the 'return to order', and the distinctive qualities of Italian art (above all when compared to contemporary French work) were analysed and debated. Carrà reverted to his earlier conviction of the artistic and spiritual value of early Renaissance painting, and in such works as 'The Daughters of Lot' (cat. 18) he adopted an

The artist in his studio, 1922 (Photo: Massimo Carrà)

overt archaicism inspired directly by Giotto.

For Carrà, 1920 was a year of crisis in which he devoted little time to painting, and more to meditating on the future path he should follow. The critic Ugo Ojetti, writing in March 1920, criticised Carrà's vision of the 'Italianness' of Italian art and what he felt to be the latter's vague definition of classicism, but he was none the less sympathetic to Carrà's moral seriousness:

> The strain of these months and years has in fact driven him almost to seek in art solutions to non-artistic, social and moral problems. For he realises that the true artist, the 'classical' artist, is a man of order, in the sense that he imposes on the external world (which he has drawn, and so to speak, corrected) that order which he has first created in himself. (*Corriere della Sera*)

Carrà retreated for some months to the coast of Liguria where he painted 'Pine-tree by

the Sea', 1921 (repr.p.375), a work he later described as a 'mythical representation of nature' and the key to his future development. In the following years he adopted a softer style, inspired by nineteenth-century Lombard naturalism, and concentrated on painting landscapes which symbolised for him the eternal values he had previously sought in pictorial form and composition.

Although Carrà withdrew somewhat from the company of other artists, he remained engaged in the artistic debates of the day through his job as a critic for *L'Ambrosiano*, a post he held from 1922 to 1939. He exhibited in the Venice Biennale of 1922 and had an important one-man show in the Rome Quadriennale in 1925. Without in any way adhering to the movement, he participated in the first and second *Novecento Italiano* exhibitions in 1926 and 1929. In the 1930s, along with other leading artists of the period, Carrà became interested in the social and artistic possibilities of large-scale mural decoration. In 1933 he signed Mario Sironi's 'Manifesto della pittura murale', which argued that this form of art was the ideal vehicle for the new values of the Fascist state, and that same year he executed murals for the fifth Triennale in Milan. In 1941 he became a professor of painting at the Accademia di Brera. In the remaining years of his life he concentrated on landscape painting, always seeking to refine the balance between reality and its transfiguration in art.

16

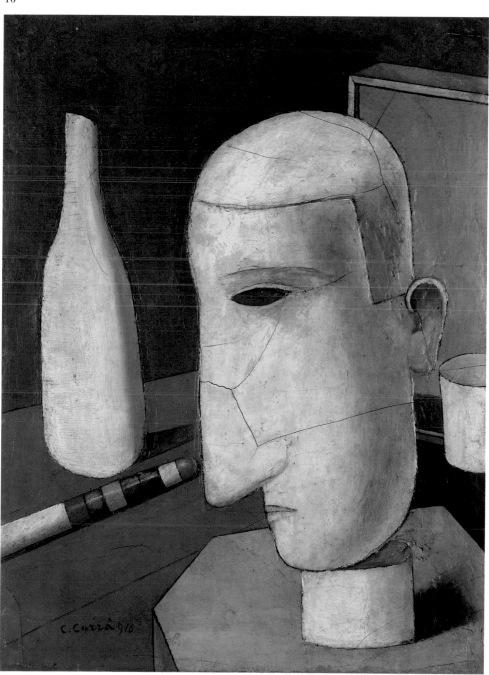

16 The Drunken Gentleman
1916
Oil on canvas, 60 × 45
Private Collection

At the time of painting 'The Drunken Gentleman' Carrà had already distanced himself from the Futurist group and begun to reflect on the relationship between modernity and tradition. He went on styling himself a Futurist – he exhibited as such in his one-man exhibition in Milan in December 1917, and signed this painting 'Carrà-futurista' – but this sprang more from a sense of his radical ambitions than from any continuing commitment to the ideas of Marinetti or Boccioni. In late 1915, inspired partly by the French naïf painter Henri Rousseau and by child art, he began to paint stylistically simple works of figures and still-life elements (or what he called 'concrete forms'), through which he sought to convey a sense of the reality of ordinary things. This was a period of uncertainty and experimentation for Carrà, and in a letter of September 1916 to his close friend, the artist and writer Ardengo Soffici, he said he was abandoning himself 'like a medium to psychic currents', with no clear idea of where he was going. 'I am not concerned with dynamism or any other theories,' he wrote. 'I would like simply to arrive at a synthesis that suits me. I believe that modernity will appear of its own accord, if there is any modernity in my soul after it has finally been freed from all its prejudices about the future. Simplicity in tonal and linear relations – that is all that really concerns me now.'

Carrà had already begun to meditate on the formal and spiritual qualities of Trecento painting. As early as the summer of

1915 he told the writer Giovanni Papini, 'I am going back to primitive, concrete forms. I feel myself to be a Giotto of my times.' In March of the following year he published an article in the Florentine journal *La Voce* entitled 'Parlata su Giotto'. In this he attacked the view that Giotto had been surpassed by later Renaissance artists, and linked the formal qualities of Giotto's work to the contemporary interest in classical values. 'Today people speak of constructing pure values. I admire these values, and consign all else to the realms of fortune telling and aesthetics. In Giotto, I admire the cubistic structure of his paintings, which I consider as formal units.' Equally, if not more, important to Carrà was what he termed the 'plastic transcendentalism' of Giotto's treatment of reality. 'In the magic silence of Giotto's forms, our contemplation can rest; a sense of ecstasy begins to grow, and spreads gradually through the enlightened soul'. He continued, 'An idea is turned from abstract to concrete through form . . . form and idea become made clear by illuminating one another.'

'The Drunken Gentleman' demonstrates Carrà's concern with the tactile quality of form, its three dimensionality and its disposition in space. At the same time, the combination of the precariously balanced plaster head, the cup, the bottle, part of a child's toy and the frame, is unexplained and mysterious, and the painting exudes the quality of 'magic silence' that Carrà identified in the works of Giotto. The direct influence of Giotto can be detected in the stylised features of the plaster head, echoed later in 'The Daughters of Lot' (cat.18). It seems likely that Carrà saw this work as a modern interpretation of the pictorial concerns of early Renaissance art. In a letter to Papini dated May 1916, he wrote, 'I believe firmly in the principle that we must rediscover *our rhythm*, and return to the spiritual strength that made Italy the first country in the world for plastic values.' He mentioned in the same letter that he was working on this particular painting, saying that he was convinced that in it he had solved important formal problems.

This work was first reproduced in 1918, along with two drawings in a similar style, in a small pamphlet on Carrà by Giuseppe Raimondi. Carrà sent this booklet to friends in Paris. Apollinaire wrote back saying that he was very interested in Carrà's new work; and André Derain, whose own pre-war paintings (partly inspired by Sienese Renaissance art) Carrà greatly admired,

wrote: 'I like your work very much, and the reproductions I have in front of me have interested me greatly. In the present horrible times it is a great comfort to think that an artist of your standing still remembers my work. I hope that soon, and in happier times, we shall be able to see each other again.'

17 The Oval of Apparitions 1918

Oil on canvas, 92 × 61
Galleria Nazionale d'Arte Moderna, Rome

This major painting from Carrà's metaphysical period has clear links with the work of Giorgio de Chirico. Carrà borrowed the metal mannequin, the copper fish, and the modern building in the background from de Chirico's repertoire; and even the tennis-playing statue in the middle distance can be seen as an echo of de Chirico's well-known fascination with classical sculpture (see, for example, 'Song of Love', cat. 31).

Carrà may have seen early paintings by de Chirico during his visits to Paris before the war; and since the two artists had friends in common, he would certainly have known of de Chirico's reputation. It was one such friend, Ardengo Soffici, who, worried about Carrà's turn to archaicism, urged him in February 1917 to seek out de Chirico, then stationed in Ferrara, in whose paintings he would see what it meant to combine 'modernity' with the 'majesty of the ancient'. The two artist–soldiers met when Carrà was posted to Ferrara, and they spent the summer together in an army infirmary recovering from nervous disorders. They were both elated at finding a kindred spirit in the midst of so much misery; and it was in this period that the idea took root of forming a group to launch their new vision of art after the war. Carrà wrote to his friend Soffici in February 1918, 'You, I, Savinio, and de Chirico, will build modern Italian art. . . . Away with those Frenchified young men with all their provincial stupidities.'

Carrà was already predisposed to the idea of an art that transcends appearance through his admiration of early Renaissance painting, and he quickly fell under the sway of de Chirico's vision of a metaphysical reality akin to dreams and visions. Although he adopted de Chirico's imagery of faceless

mannequins and strange conjunctions of everyday objects, Carrà's paintings have none of the sense of enigma and pathos that was crucial to de Chirico's work. Piqued by Carrà's critical success and the lack of recognition for his own influence, de Chirico was later to say that Carrà had merely copied him unintelligently.

'The Oval of Apparitions' is perhaps the most famous of all Carrà's metaphysical paintings, and it was reproduced in the first issue of *Valori Plastici* in November 1918. As with most of his canvases from this period, Carrà later reworked it, altering the relationship of the shapes and simplifying the imagery: the photograph in the magazine shows, for example, the copper fish resting on iron supports rather than directly on the floor. In an accompanying article in *Valori Plastici*, 'Il quadrante dello spirito', Carrà described the painting in a declamatory style reminiscent of the Futurists:

> Bouncing upwards in vertical planes, the metaphysical house of the Milanese proletariat encloses an immense silence. . . . The electric man thrusts upwards like an upturned cone. He has an hour-glass torso, and joyful circular planes, mobile, of polychrome tin, that make us look at reality as if through concave and convex mirrors; on his chest and abdomen are clean-cut shapes, and on his shoulders objects, nailed on, black with patches of white light. On the same plane, but further back, rises the archaic statue of my infancy (anonymous ghostly lover or angel without wings?); it holds in its hands a racket and tennis ball, like its rubber sister on the wall in front of me. Further back, on the right, can be glimpsed a funerary stone, which perhaps has an inscription in Latin, which, in its sweetness, is our Provençal. At the same depth, on the other side, lies the huge copper fish, flung down, spectral and motionless; it rests on two primitive iron supports (might it have escaped from a museum?). The shadows are sharp and black on the dark ground. It is the drama of apparitions.

This text does not explain the image, but it does suggest the range of sources and themes on which the painting drew: Futurism (the mechanical man and the urban dwelling), metaphysical art (childhood memories, shadows and apparitions), and the new interest in the classical (the statue, funeral monument and reference to Latin as 'our Provençal'). These manifestations of

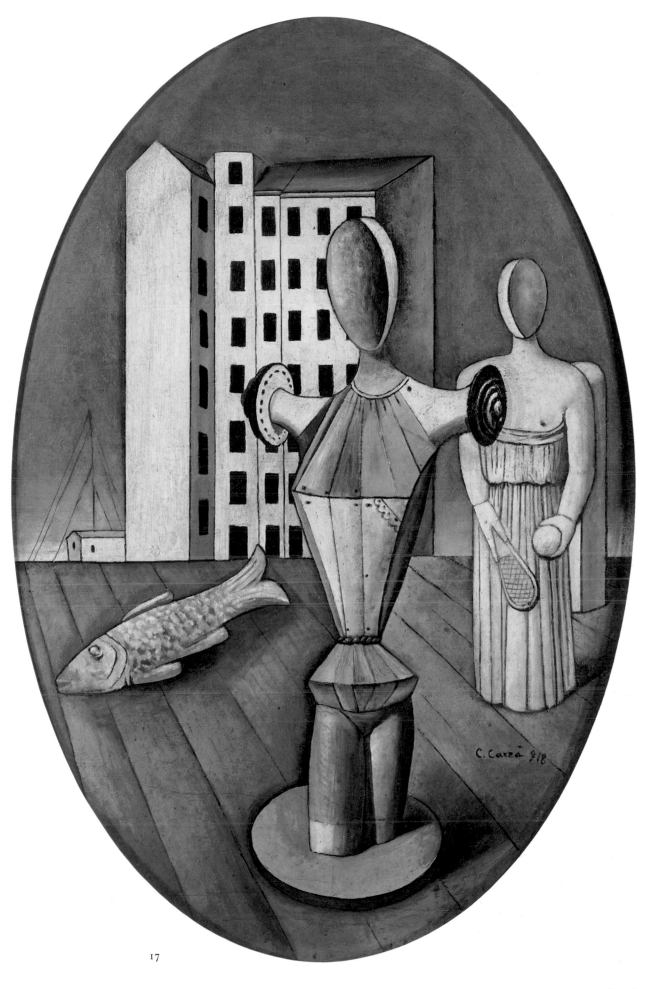

17

recent avant-garde art were very different, but all shared the notion that the artist should penetrate the hidden realities of the everyday and create a poetic or spiritual artistic order. In his pursuit of this, Carrà was to turn increasingly to the art of the Renaissance.

18 The Daughters of Lot 1919

Oil on canvas, 110 × 80
Museum Ludwig, Cologne

This work marks Carrà's move away from metaphysical painting towards an overt archaicism, inspired by the masters of the Trecento. The sweeping, symmetrical perspective seems almost to parody the technical concerns of such fifteenth-century artists as Uccello and Piero della Francesca; but other elements of the painting – the figures' immobile gestures and impassive expressions, the almost naïve handling of the bushes in the background, and the arrangement of the landscape – all suggest the influence of Giotto and his contemporaries. Carrà's admiration for Giotto went back to the early years of the war and remained an important influence on his work through much of the 1920s. In a monograph on him published in 1924 Carrà wrote that Giotto 'is the artist whose forms are closest to our manner of conceiving the construction of bodies in space'. It was his admiration for the formal and yet transcendental qualities of early Renaissance art that led Carrà to the archaic style of this painting.

'The Daughters of Lot' was first reproduced in *Valori Plastici* in November 1919 alongside an article by Carrà entitled 'Il rinnovamento della pittura in Italia', in which he noted that his defence of Giotto was almost as unpopular then as it had been in 1916. Seeing a copy of this issue of the magazine, Carrà's friend Soffici was profoundly disturbed by what he saw as a retrograde development, and wrote to him in January 1920:

> I have seen in *Valori Plastici* your Daughters of Lot, an excellent painting, but *archaic*. I would like to say many things to you on this score, but I am afraid of making you angry. But I am confident that the day will come, and soon, when you will use your *marvellous and superior gifts as a painter* more in line with our way of thinking. It will take too

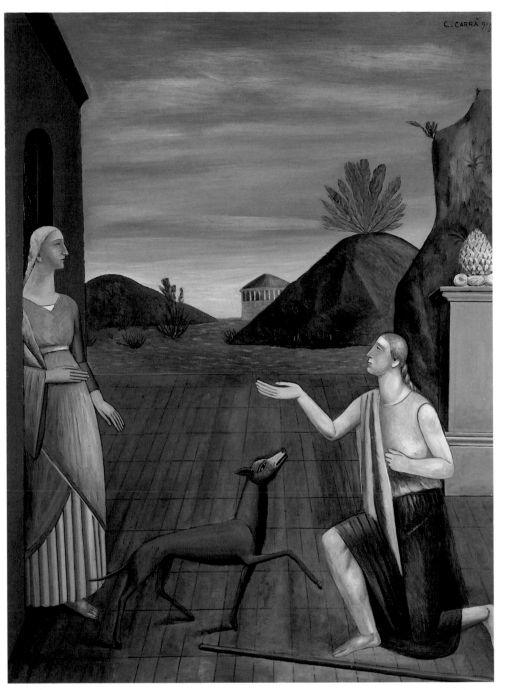

18

long to explain. I will merely say to you that as far as I am concerned, I see my work as lying, today, only in profound *reality*: without equivocation, uncertainty, or fear of seeming commonplace.

For similar reasons, the former Futurist artists Funi and Sironi were among the signatories of a manifesto called 'Contro tutti i ritorni in pittura' which, although not identifying Carrà by name, plainly condemned his new direction in its scathing reference to those who turned to past art, and in particular to Giotto, for new plastic forms. For his part, Carrà did not share their insistence on building a new style on the foundations only of modern avant-garde art. 'For true artists', he said, 'the objectives do not change, and what was the problem for the "primitives" is still a problem for us.'

The painting was bought shortly after it was finished by Umberto Notari, an important figure in Milanese art circles and editor of the newspaper *L'Ambrosiano* for which Carrà worked as a critic from 1922.

19 Woman by the Sea 1931

Oil on canvas, 71.5 × 95
Galleria d' Arte Moderna, Trieste

Carrà first turned to the imagery of the natural landscape in 1921, after a period of uncertainty about which direction to follow. The key work from this period was a painting entitled 'Pine-tree by the Sea' (repr.p.375), of which he later wrote:

I was trying, in this picture, to recreate a mythical image of nature; and since such a vision meant for me the birth of a great artistic truth, unknown in my previous works, I would regard this painting as

fundamental to the new direction that I was developing. After completing this canvas, it seemed that I now knew clearly what I could ask from nature, and that I could extract from it something enduring that would chime in with my way of conceiving the new problems that were assailing my creative faculties and potential ever more insistently. ('La mia scoperta del mare', 1940)

In the following years Carrà focused increasingly on landscape painting, and came to adopt a softer, more atmospheric style. From 1926 he spent every summer at Forte dei Marmi, Versilia, where the coastal scenery, he said, corresponded in some way

to his feelings about nature and its place in Italian art. In the late 1920s and early 1930s he concentrated on combined figures and sea-scenes, symbolic, perhaps, of a Tuscan ideal of harmony between man and nature.

In 'Woman by the Sea' Carrà has presented a modern version of the traditional theme of the relationship between woman and nature. The bronze-limbed figure gazes at the sea with a smile of happy concentration, reminiscent perhaps of an early Greek *kore*. Her clothes are modern, but also evoke classical drapes. In this light the painting can be seen as sharing the idealised vision of the Mediterranean that was explored in different ways by artists such as Martini, Maillol and Sunyer.

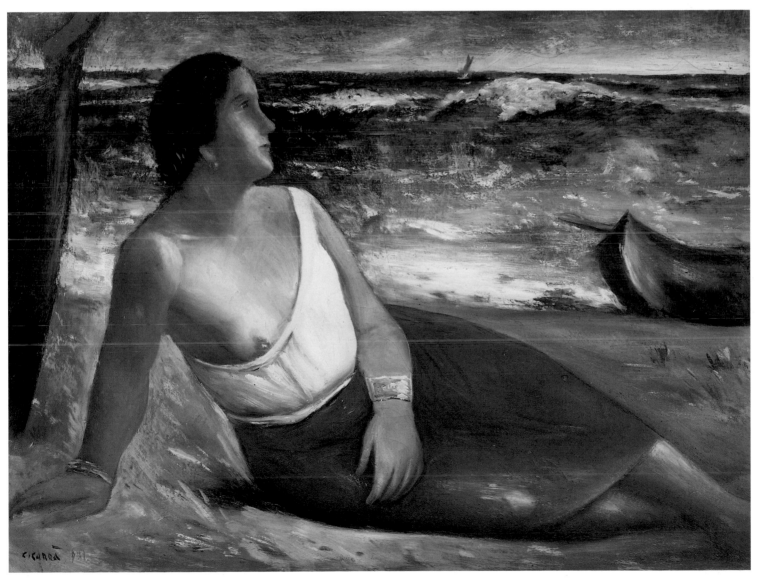

19

20 Study for 'Justinian Liberates the Slave' *c*.1933

Charcoal on paper mounted on canvas,
274 × 130
Private Collection

In 1933 Carrà signed Mario Sironi's 'Manifesto della pittura murale', along with Achille Funi and Massimo Campigli. This proclaimed mural painting to be the best vehicle for Fascist values. Carrà, like other ex-Futurists, had been sympathetic to the early Fascist movement's opposition to the Socialist party, and in 1918 had contributed articles to *Il Popolo d'Italia*, Mussolini's own newspaper. His precise feelings about the regime in its mature phase are not certain; but he clearly shared Sironi's political and social vision of mural painting and, like most of the leading artists of the day, he contributed to the fifth Triennale in Milan on the obligatory theme of Roman Italy. What excited Carrà most about murals was the prospect of renewing the great Italian tradition of fresco painting.

This cartoon-sized drawing is one of several hundred that Carrà made for the mural decorations of the Palazzo di Giustizia in Milan, begun in 1932 and completed in 1938. Like the other artists participating in this project, Carrà was given the choice of a biblical, historical or juridical theme. The figure here represents Justinian, the Roman Emperor famous for his codification of Roman law, who in the completed work stands enthroned in an Italian landscape delivering his judgments to a small group of simply dressed figures. His heroic stature and proportions resemble those of the Roman athletes and gladiators so often favoured by the regime. However, after the fall of Giuseppe Bottai, the Minister for Education, there was much criticism of this fresco by extreme right-wing elements on the grounds that it lacked obvious reference to the emblems of the Fascist regime. The mural was saved only through the decision of the Prefettura to cover it with sackcloth. In his autobiography, published in 1943, Carrà wrote about the frescoes for this project:

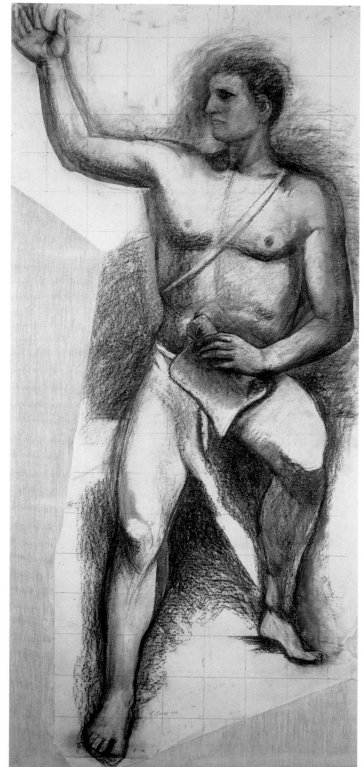

20

> My intention in these works was to stick to a simple and clear method, and to impart to the forms a chromatic, fluid transparency (which would not suppress the solidity of the volumes), so making them easy to understand. I have no illusions about current opinions on this kind of pictorial representation, which is social in character, because it is all too clear that the times are not propitious. None the less, I have faith in this particular application of figurative art. Perhaps one day mural painting . . . will rediscover its antique splendour and recover that breadth of vision that always distinguished it in past centuries.

ENRIC CASANOVAS 1882 POBLE NOU, BARCELONA – 1948 BARCELONA

Casanovas rose to prominence in the Noucentista movement in 1910–12, establishing himself alongside Clará as the most important exponent of the new classicism in Catalan sculpture. He remained faithful to classical themes and styles until his death, although after about 1918 he turned increasingly to later, more naturalistic sources.

Casanovas's training began in 1896 when he was apprenticed to the successful Barcelona sculptor Josep Llimona. Four years later he entered the La Llotja academy and became an habitué of Els Quatre Gats café, where he made friends with Picasso and Manolo, and in 1903 showed his work in one of the last exhibitions before the café closed down. His earliest work was in the currently fashionable Modernista style, loose in handling and evocative in mood. But soon after he settled in Paris in 1904 it began to show signs of a classicist orientation, under the impact of the work of Maillol and the aesthetic theories of Jean Moréas and Eugeni d'Ors. This shift coincided with changes in Picasso's painting, and in 1906 the two men were in close contact and planned to work together in Gósol, a remote village in the Pyrenees. (In the event, circumstances prevented them from being there together.) The exhibition of archaic Iberian sculpture held in the Louvre in the spring of that year, together with the excavations (from 1907) of statues of Asklepios and Venus at the Greco-Roman site of Ampurias in Catalonia, excited intense interest, and probably contributed to Casanovas's conviction that his natural roots lay in the tradition of Mediterranean classicism. At any rate by 1910 he was carving stone and marble heads in an austerely inexpressive, archaic manner. His new work, exhibited in his one-man shows at the Faianç Català gallery in Barcelona in 1911 and 1912, drew the admiring notice of d'Ors and the critic Josep Junoy, both of whom praised its lucid, architectonic structure, the command of direct carving techniques, and Casanovas's ability to synthesise the ancient and the modern in a convincing manner. Subsequent writers, such as Josep Sagarra, echoed this view, stressing the calm, formal purity, grandeur and beauty of his sculpture, and its essential identity with 'Greek

art of the best period' (*La Mà Trencada*, no. 1, November 1924).

With occasional trips back to Barcelona and to Céret to see Manolo, Casanovas remained based in Paris until 1913. Before his permanent return to Barcelona he travelled to London to study the collections of antiquities in the British Museum. Two years later he set up a studio on the island of Mallorca with his great friend Sunyer, and here created several masterly works using the hard local stone. By 1920 Casanovas's reputation was established: he had completed the commissioned monument to Narcís Monturiol for the town of Figueras; two monographs were in print (by Manuel Abril, Madrid, 1919, and by Josep Pla, Barcelona, 1920); and he was given a special room for his work in the Esposició d'Art in Barcelona (1920). The greater charm of his new work, as his style relaxed into a more 'Hellenistic', less primitivist form of classicism – in part the consequence of a change in technique, for he had now begun modelling – brought portrait commissions and greater popular acclaim.

Casanovas's leading position was consolidated in the 1920s through a series of one-man and group shows, laudatory articles, and commissions from the Barcelona authorities for major sculptures for the 1929 International Exhibition. He was awarded a gold medal for his contribution to the exhibition, and further official honours followed in the early 1930s. The triumph of Franco in the Spanish Civil War, however, led to a change in Casanovas's fortunes, for he was active on the Republican side. In 1939 he and his family went into exile in Avignon, and on his return to Catalonia in 1942 he was briefly imprisoned. Only in the 1970s was there a concerted effort to reassess his achievement as a sculptor.

The artist in his studio in Paris, 1909

21 Persuasion 1912–13
Marble, 28 × 15 × 22
Museu d'Art Modern, Barcelona

'Persuasion' is a fine example of Casanovas's early style and relates closely to other equally uncompromising classical heads executed in marble between about 1910 and 1915. Exhibited in 1914 in his third one-man show at the Faianç Català galleries in Barcelona, it became well known through reproduction in several early studies, and helped to establish Casanovas's reputation as an anti-academic classicist in the line of Maillol. For 'Persuasion' is evidently archaic in type: the smooth abstraction of the features, the symmetrical and hieratic pose, the serene smile, the formulaic handling of the hair – all imitate the standard forms of *kouros* figures of the period *c*. 520–480 BC. It may be, however, that the specific inspiration was the slightly later, celebrated

figure of Apollo from the west pediment of the Temple of Zeus at Olympia. It is at any rate clear that Casanovas was determined to eliminate all suggestions of anecdote, all emotional expression, all shades of mood, all movement, all idiosyncrasy from this work, and thus to achieve a literally timeless – and, he would have hoped, universal – statement. This represents a considerable development from his early, quasi-Symbolist style, where the handling is impressionistic and expressive.

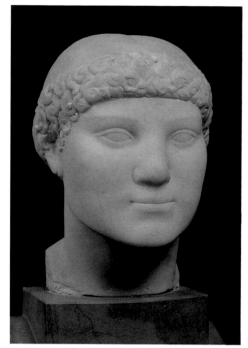

21

22 Youth and Love *c*.1914

Marble, 66 × 50 × 17
Museu d' Art Modern, Barcelona

Exhibited in February 1914 at Casanovas's show at the Faianç Català galleries, this was purchased in the same year for the city of Barcelona – a sign of the rising reputation of Casanovas as a leading Noucentista sculptor. From the outset he had worked in relief as well as in the round, preferring, like his friend Manolo, a very shallow space, and thus making a clear distinction between the nature of the two different types of sculpture. His reliefs gave him an outlet for his interest in compositional groupings and in narrative scenes, although the subjects he chose were, as in this case, standardised and familiar.

In 1913 Sunyer sent Casanovas a postcard from Rome of the relief of 'The Birth of Aphrodite' from the Ludovisi Throne. Although the subject of 'Youth and Love' is quite different, and the handling rougher, there are certain similarities between Casanovas's treatment of the female nude's torso, legs and head and the carving of Aphrodite and her servants. But although Greek relief sculpture was probably one of the sources, certain details, such as the boy's head and arms, are reminiscent of the work of Donatello, and it is likely that Casanovas was also looking attentively at the Italian Primitives. The 'primitivist classicism' of Casanovas was not, of course, unique or unprecedented in sculpture produced in France in the years before the outbreak of the war. In the case of 'Youth and Love' the parallels are not with Maillol, but with Joseph Bernard who enjoyed considerable esteem as a direct carver. The closest analogy is with Bernard's 'Feast of the Vines', an ambitious relief depicting a Bacchic scene, with smiling, youthful girls against a

22

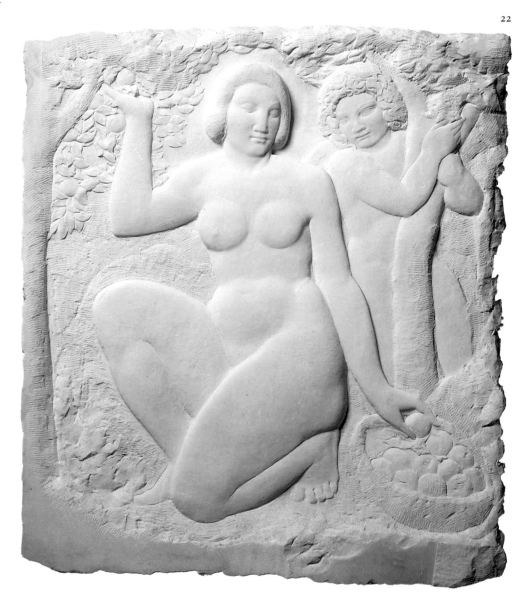

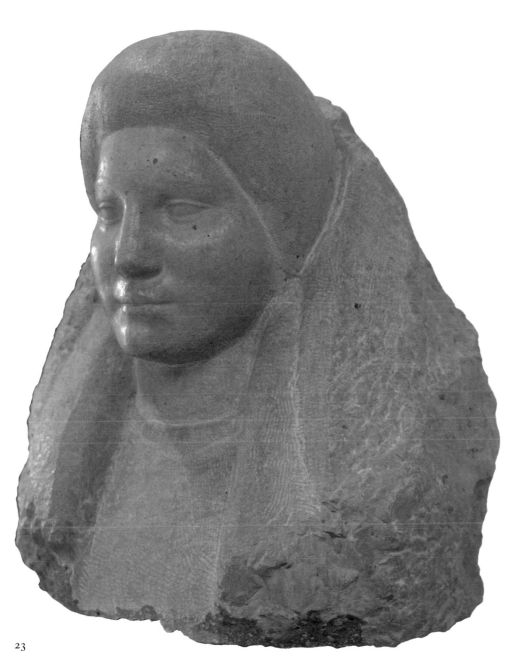

background of vine leaves, which was exhibited at his one-man show at the Galerie Hébrard in 1908. Although Casanovas's relief is less volumetric and more static in conception, the simplifications of form, the stereotyped rendering of foliage and fruit, and the flat, decorative treatment of the background are all reminiscent of Bernard's work.

23 Mallorcan Peasant Woman 1916

Stone, 50 × 47 × 40
Ayuntamiento de Tossa de Mar, Museo Municipal

In 1915–16 Casanovas went with Sunyer to the island of Mallorca, where, having toured the countryside, they set up a studio in one of the villages. Both found the experience stimulating, and each produced a series of important works there. For Casanovas, as for Picasso in Gósol and Manolo in Céret, the peasant community became the focus of attention. Using the exceptionally resistant local stone, he carved several generalised heads of women, in which the intractable nature of the material is acknowledged frankly in rough 'unfinished' passages that contrast with the relatively smooth treatment of the face. His aim was an effect of rugged but impressive dignity, and this he achieved by abstracting and synthesising the features, and – in the case of this sculpture – treating the bust as if it were a great pyramid as permanent and as solid in its immobility as the most awesome monuments of Egypt, Assyria or Greece. This conception of the peasant woman as a benign but powerful 'ancestor' is consistent with Eugeni d'Ors's notion of the strong but calm Mediterranean woman as the expression of the eternal values of the race. Two years earlier Casanovas had, in fact, been commissioned to create a work symbolising d'Ors's ideal *ben plantada* (literally, well-rooted woman) for the façade of the Societat Athenea building in Gerona, but the sculpture was never, apparently, installed there.

23

24 Youth 1917–18

Marble, 59 × 40 × 20
Museu de Valls, Valls

Casanovas's primitivism is reflected clearly in this powerfully simplified sculpture, in which there are no concessions to charm, sensuality or eroticism. The torso is treated like a massive column, buttressed symmetrically by the arms, while the head, weighted down by the solid mass of hair, resembles a boulder. The canon is that of archaic sculpture of the sixth century BC, the youth and candour of the girl being equated with, and expressed in terms of, the early history of Greek civilisation.

The sculpture was one of the last of Casanovas's works to possess this tough, austere character. In nudes carved over the following few years, even though the physical type did not alter, the poses became less rigid, the modelling of the bodies softer and more naturalistic, the expression sweeter and more tender. The essentially conservative nature of the Noucentista aesthetic surfaced: the period of radical zeal was over, and Casanovas's sculpture began to look more like the academic Salon art of the nineteenth century.

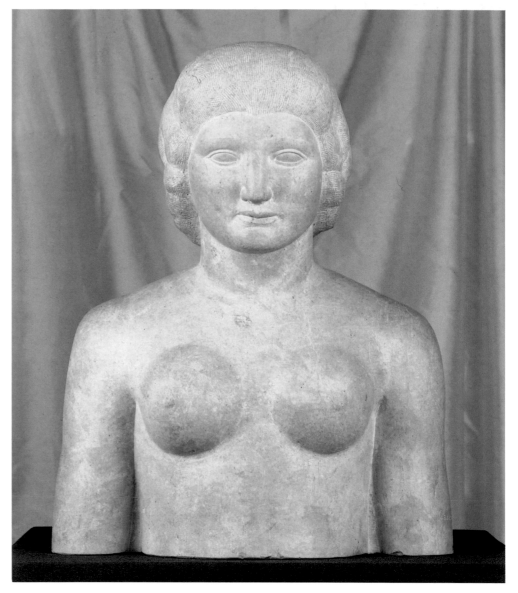

24

FELICE CASORATI 1883 NOVARA – 1963 TURIN

From the early 1920s Casorati was recognised as a highly distinctive painter whose work, with its quiet, magical quality and sense of order, reflected something of the haunting elegance of his adopted city of Turin. He shunned close involvement with any particular artistic group, but was seen as one of the major talents of the 'return to order' movement.

As a youth Casorati excelled in music, but following a bout of nervous illness he decided to become a painter. In deference to his parents, however, he studied law at the university of Padua until 1906 before embarking on his chosen career. Only a year after he graduated, he had a painting accepted for the Venice Biennale, and thereafter he exhibited regularly at the major national shows in Venice, Rome and Turin. As letters to his friends indicate, he felt torn in these years between the naturalism of Delacroix or Renoir, the order and discipline of Chardin or Cézanne, and the possibility of an altogether new path. As early as 1907 he wrote of his need 'to give things a name different from their common one', and his desire for 'artifice based on truth'. In 1910 he was greatly impressed by an exhibition at the Venice Biennale of the Austrian Secessionist painter Gustav Klimt, and began to work in a decorative, Symbolist style. He mixed with a group of radical young artists (including Arturo Martini) associated with the Ca' Pesaro in Venice, and through them learnt about contemporary art in Munich and Paris. Immediately before the war he was involved with a circle of young intellectuals in Verona, and helped to found a short-lived review of painting, music and poetry, entitled *La Via Lattea* after one of his works. Casorati had yet to find his mature style, but the dream-like and highly worked aspects of his pre-war paintings anticipate the magical air of his later works. In an excited letter dated November 1915 he wrote, 'I have become a visionary, a dreamer, and I simply paint the images that I see in dreams'.

Casorati served in the army, with brief periods at the front, until 1919, when he joined his mother and sisters in Turin. He was already well known as an artist, and in the next few years he established himself as

a leading figure in the city's artistic circles. He was a friend of the brilliant radical journalist Piero Gobetti, and joined the anti-Fascist group around the latter's review, *La Rivoluzione Liberale*. Casorati's association with Gobetti led to his arrest for a few days in 1923, but thereafter he managed to avoid open conflict with the Fascist regime. He organised many important shows of contemporary art, and in 1923 established a successful private art school which became a focus for the revitalisation of art in Turin.

Casorati had to struggle hard to find what he called his 'spiritual' vision, and his works immediately after the war reflect this in their anguished, sometimes hallucinatory qualities. However, the retrospective of Cézanne's work at the Venice Biennale of 1920 encouraged him to focus on simple subject matter and on qualities of order and balance in his compositions. He later wrote that he found he could express every emotion in still-life painting, adding, 'In the most wretched moments of my life as an artist, I have managed to reconcile myself to pictures by humbly painting a bowl, an egg, a pear' ('La crisi delle arti figurative', *La Stampa*, 1928). While searching for balance and harmony in his works, he was encouraged by the contemporary revival of interest in the Italian tradition to turn to the art of the Renaissance for inspiration. As the mysterious serenity and complex spatial relationships of his new works showed, it was Piero della Francesca who influenced him most.

Form and balance became Casorati's chief concerns in this period; and it was these qualities that Lionello Venturi singled out in his catalogue preface to Casorati's one-man exhibition at the Venice Biennale of 1924: 'Today there is a great desire for form in the air', he wrote, 'and Casorati too has focused his iron will on it, even though it is veiled by his desire for grace and elegance. Every one of his recent canvases marks a stage in the conquest of form. He bows to form as if it were law'.

Many critics, however, were disconcerted by what they saw as the cold, cerebral quality of Casorati's work, complaining that it was academic and neoclassical (a descrip-

The artist in his studio, c.1929 (Photo: Giuseppe Dell'Aquila, Courtesy of Francesco Casorati)

tion Casorati never accepted); but his position as one of the leading painters of the 'return to order' was secure. He exhibited regularly alongside such artists as Funi, Sironi, Martini and de Chirico, and was numbered among the exponents of the new trend in art in Franz Roh's book *Nach-Expressionismus*, 1925. Although he exhibited in both the first and second *Novecento Italiano* exhibitions in Milan, he was always seen as following his own path, independent of any particular ideology or grouping. In 1927 his international reputation was such that he was invited to travel to Pittsburgh in America to act as a juror for the Carnegie Prize.

During the middle and late 1920s much of Casorati's time was absorbed in teaching, stage designing, and organising exhibitions of contemporary Italian and foreign art. After this interlude, he concentrated once again on still lifes and figure studies; but by this time he was less obviously concerned to reinterpret the legacy of the Renaissance, and his later paintings are much simpler in composition and have a lighter palette.

Despite this change in his work, which was partly a response to the new artistic climate of the period, he felt obliged to defend himself against the charge of archaicism. As he wrote in his essay for the catalogue of the 1931 Rome Quadriennale:

> In taking up, against me, the old polemic of classicism and romanticism, people rail against intellectualised and scholastic order, accuse my art of being insincere, and wilfully academic – in a word, of being neoclassical. . . . since my art is born, so to speak, from within, and never has its source in changing 'impressions', it is quite natural that . . . static forms, and not the fluid images of passion, should be reflected in my works.

In 1938 Casorati won first prize at the Venice Biennale, and throughout his career received many official awards for his work. He continued to exhibit regularly, and became involved in stage design – a logical extension, perhaps, of the theatrical and unreal qualities present in many of his paintings.

25 Silvana Cenni 1922

Tempera on canvas, 205 × 105
Private Collection, Turin

'Silvana Cenni' is arguably the most famous of all Casorati's paintings. It occupied a special place in his affections, and he kept it in his studio, and later in his house, until his death.

The work was quickly recognised as one of the great paintings of the period in Italy, epitomising contemporary interest in the early Renaissance and pictorial technique. The first critical response to the work, however, was not enthusiastic. Piero Gobetti, who was a close friend of Casorati, wrote in a monograph on the artist in 1923:

> In the simple enigma of 'Silvana Cenni' the only novelties, apart from a certain taste for portraiture clearly derived from Piero della Francesca, are the decorative effects of the carpet and the studies of the folds. The solidity of the objects and the fine drawing of the hands are now quite commonplace, and the austere intentions in the background are undermined by descriptive touches.

Gobetti ended by describing 'Silvana Cenni' as an 'ill-conceived painting, weakened by too many imbalances'. Art

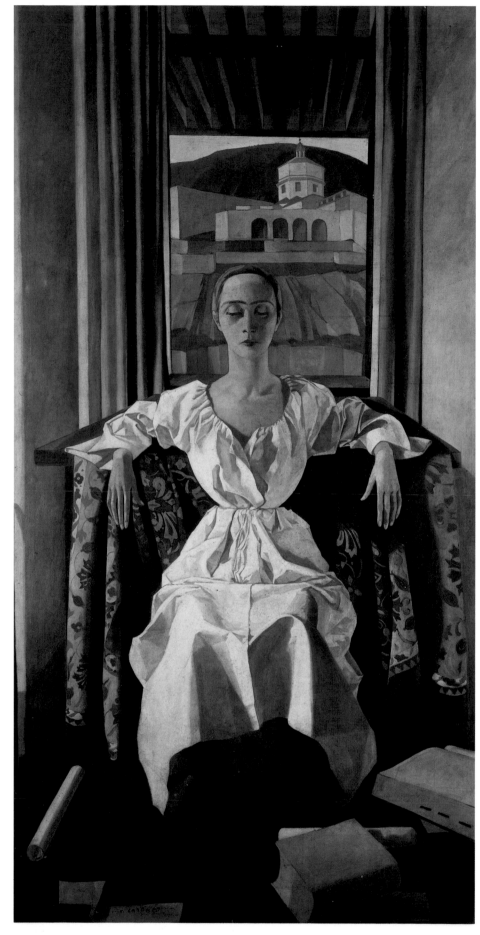

25

historians have puzzled over Gobetti's surprisingly unfavourable comments, but recent research by Maria Lamberti suggests that his judgement might have been coloured by his knowledge of the work's genesis.

The uneven margin of canvas at the back of the painting, and comments by Casorati himself in later life, suggest that 'Silvana Cenni' was originally a much broader, probably square, work. A preparatory sketch indicates that there were originally two other flanking figures in the picture. If so, it was related to a work, now destroyed, entitled 'The Studio', 1923, which depicted two female students drawing and painting a nude sitting between them. The idea that 'Silvana Cenni' was conceived as a studio scene is reinforced by the simple, almost makeshift, dress of the seated woman, which resembles the dresses worn by pupils in Casorati's school. (According to family legend, the model for the painting was Nella Marchesini, who studied with Casorati before he formally opened his school in 1923, and who worked closely with him in this period; the reason for the title, however, is not known.) Furthermore, the table and stool appear in other works showing what is evidently the interior of his studio. These details do not explain why Casorati chose to cut down the painting, but they do help to account for what Gobetti described as its spoilt lines of perspective and 'simple enigma'.

Gobetti was undoubtedly correct in seeing the influence of Piero della Francesca on this work. The seated figure, with its oval face and downcast eyes, set against a rich backdrop, recalls many enthroned Madonnas of the Renaissance; but the head and pose are specifically based on Piero della Francesca's 'Madonna della Misericordia' at Borgo San Sepolcro. The basilica and arcade seen in the distance are imaginary elements, used to echo the shape of other items within the painting, but their Renaissance character underlines the historical connotations of the painting. The scrolls and tomes scattered at the sitter's feet are represented in a modern manner with evident concern for shape and volume, but they add to the antique feeling of the work. The manner in which Casorati has printed his signature on the book at the bottom left of the painting is a further sign of this work's indebtedness to the old masters.

'Silvana Cenni' is painted in tempera, the usual medium of Renaissance artists, and this gives the work an uncommon purity of tone as well as a matt finish. Like de Chirico, Casorati believed strongly in the value of reviving old techniques and methods, and he spent much time in this period experimenting with different formulae for paints. In 1925 he defended this interest in the technical side of art:

> Craft – the great craft excites me enormously, it is true – but naturally I have never thought of it as an end in itself, nor has it concerned me in this way. If, on the other hand, you wish with the word craft to allude to the love of the pictorial *material*, to the search for the beautiful surfaces, to the rich impasto of colours, to the transparency of shades . . . then there is no one more passionate than I.
> (Margherita Sarfatti, 'Pittori d'oggi', *La Rivista Illustrata del Popolo d'Italia*, 15 March 1925)

26 Still Life with Mannequins

c.1925
Oil on panel, 87 × 68
Civico Museo d'Arte Contemporanea, Palazzo Reale, Milan

This painting has a complex composition, and skilfully extends the sense of space through carefully calculated mirror reflections. These allow the viewer to see in the background a maternity scene (a leitmotif of Novecento painting in this period) and the only known self-portrait of the artist, shown at work with his easel. The theme of illusion and reality, explored within a painting, has a long history, dating back to Velázquez and beyond; and Casorati has chosen to underline the historical allusions in this work by including the mandolin and heavy, Renaissance-style brocade in the foreground.

In his passion for geometrical composition and formal discipline, Casorati always tended to treat the human figure as if it were an element in a still life. Like de Chirico, he often injected a human presence into his paintings of this period by including plaster casts or, as here, wooden heads, amid the other elements of imagery. These strangely realistic heads, which Casorati kept in his studio throughout his lifetime, were used in a type of popular street theatre, and seem to have appealed to him not so much for their capacity to disconcert as for their invocation of the world of the imagination. The private fantasy element in Casorati's work was not, however, commented upon by contemporary critics, who were struck, and often

dismayed, by the formal complexities and cerebral qualities of the paintings. In his monograph on the artist of 1925, Rafaello Giolli explained that Casorati's highly individual treatment of form, colour, composition and subject matter did not correspond to the conservative taste for naturalism, the new neoclassicism (which called for faithful imitations of the old masters), or even to the concern for 'a modern plastic sensibility'. For these reasons, he said, Casorati lacked supporters:

> Faced with these unexpected pictures, even defenders of the 'craft' of painting are frightened, as if they were looking at painted screens. The volumes have no weight in them, and the colours no body Everything is fictitious: even the living lack all nervous vitality. The sun seems to be the moon. A mystic transparency reduces trees, naked bodies, and clothes, to the same tone, the same weight, and nothing is fixed or definite.

However, it was precisely these qualities, Giolli argued, that gave Casorati's imagery a metaphysical aspect, and made his work original.

27 Portrait of Casella 1926

Oil on canvas, 100 × 74.5
Private Collection

Partly for financial reasons, Casorati accepted many portrait commissions from wealthy industrialists and leading artistic figures in the 1920s. Of all his works, these portraits were the most highly praised by contemporary critics, who liked their slightly freer style and their obvious allusions to the traditions of Renaissance art. Margherita Sarfatti, for example, admired the firm architectural qualities of his portraits which, she said, expressed Casorati's spiritual vision and echoed the concerns of Botticelli and Mantegna (*La Rivista Illustrata del Popolo d'Italia*, March 1925). Casorati himself later acknowledged that he gravitated towards a softer style in these paintings, in which he was, he said, 'more prepared to indulge in displays of talent. In certain portraits, in particular, which I was trying to do as best as I could from a sense of obligation not to disappoint a client . . . my clearer and softer vision led me to paint pictures which were more genial and seemingly illuminated by a softer light. (Lecture given at the university of Pisa, 1943)

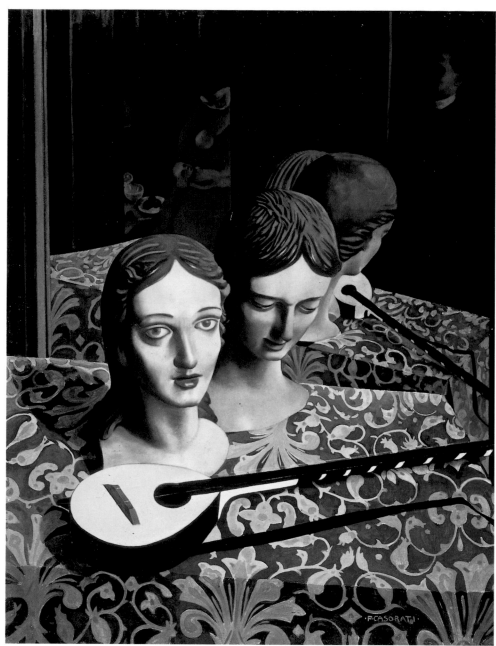

26

27

Casorati had known the Turinese composer Alfredo Casella for some years before he received the commission in 1926 (not 1929, as has often been thought) to make this portrait. Casella had studied at the Conservatoire in Paris where he met Fauré, Debussy and Stravinsky. He returned to Italy in 1916 and became a prominent figure in the movement to establish contemporary music on a classical footing, and championed the revival of interest in Italian composers of the seventeenth and eighteenth centuries, in particular Vivaldi. Casella was a keen collector of contemporary art, and chose to buy or commission works which he felt expressed the same type of modern classicism he was trying to promote in music.

When he commissioned this portrait, Casella stipulated that the work should include an allusion to music. He posed for only a few hours, which allowed Casorati to complete the face, and then left him to finish the composition on his own. Casorati used the geometrical structure provided by the table and the canvases in the background to give the work a strong architectural quality reminiscent of many Renaissance portraits. He forgot to include a reference to music, but Casella was nonetheless delighted with the picture, and in fact interpreted the hands holding the book as a symbol of 'two counterpoint voices'. In gratitude Casella dedicated his 'Concerto romano' to Casorati, and made him a present of the manuscript.

PAUL CÉZANNE 1839 AIX-EN-PROVENCE – 1906 AIX-EN-PROVENCE

Cézanne was arguably the single most important modern source for the new classicism in early twentieth-century art – ironically so, given the exceedingly hostile reaction of most of his immediate contemporaries, who regarded his work as crude, bungling and barbaric. He came from a well-to-do bourgeois family and was given a thorough liberal education. Having attended drawing classes in Aix, he went to Paris for the first time in 1861 and spent long periods in the Louvre making drawings after the old masters, a practice which he continued throughout the rest of his life. He studied at the Académie Suisse, and tried unsuccessfully to get his work accepted at the Salon. In the early 1870s, through Pissarro, whom he regarded as his mentor, Cézanne was converted to painting out of doors from the motif, and to the light Impressionist palette. The intensely expressive, romantic character of his early imaginative compositions, which owed much to his love of Delacroix, El Greco and the Venetians, gradually gave way to an increasingly objective and controlled manner. Nevertheless his subject matter remained more generalised and less dictated by transient effects than that of the other Impressionist painters, and his compositions and his brushwork reveal a deep-rooted concern with structure.

In the late 1870s Cézanne's dissatisfaction with the Impressionist emphasis on the primacy of visual sensations hardened, and his work took on a noticeably more classical appearance. His landscapes of Aix from the mid-1880s, for instance, were composed in the manner of Poussin, and his still lifes revealed his profound admiration for the art of Chardin. It was from this period, when Cézanne was living as a recluse in Aix and returning to Paris only relatively rarely, that his sense of his Provençal identity and his Mediterranean Greco-Roman heritage grew more pronounced, the Montagne Sainte-Victoire becoming in his landscape paintings a symbol of all that was enduring and dependable.

Cézanne had exhibited only very rarely since 1877, when he showed sixteen canvases at the third Impressionist exhibition, but in 1895 he at last had a major one-man

show in Ambroise Vollard's gallery in Paris. This was not a critical or popular success, but painters of the avant-garde and his old colleagues such as Pissarro hailed him as a great master. During the remaining years of his life his prestige continued to grow. Painters and writers came to see him; articles were published about him. He was honoured with a special retrospective at the Salon d'Automne in 1904, and then again after his death with a memorial show in 1907. It was through this sequence of exhibitions that the younger generation of artists fell under the influence of his work.

Cézanne's reputation as the 'father' of modern art was virtually unassailable by the time the First World War broke out. Because his work eluded easy classification it could have meaning for, and be claimed by, artists and critics of widely different persuasion. But for those committed to classical values in art, he was the perfect subject, not least because so many of his reported sayings turn on his admiration for great painters of the past, on the relationship between his painting and theirs, and on the necessary balance between perception and conception in the work of art. 'Let us read nature; let us realise our sensations in an aesthetic that is at once personal and traditional.' 'There are two things in the painter, the eye and the mind; each of them should aid the other.' 'It is necessary to become classical by way of nature, that is to say through sensation'. Meanwhile his loathing of straightforward academicism gave sanction to the ideal of innovative, personal forms of 'classicism': 'Ingres is a pernicious classicist, and so in general are all those who deny nature or copy it with their minds made up and look for style in the imitation of the Greeks and Romans.'

Emile Bernard, who published these 'Opinions' in July 1904 (in *L'Occident*), was in the vanguard of this classicist interpretation of Cézanne. So was Maurice Denis – since the turn of the century an extremely influential exponent of a classical aesthetic. A formalist approach to Cézanne's work was consistently applied by Gleizes, Metzinger, Gris and other leading members of the Cubist group, and also by the Purists. But one of the most extreme statements of the

The artist sitting in front of 'Les Grandes Baigneuses', photographed by Emile Bernard, March 1904 (Photo: Kunstmuseum, Basle, from the collection of Mary Louise Krumrine)

classicist position is found in the essays on Cézanne by Eugeni d'Ors, the principal theorist of Catalan Noucentisme and a major force behind much of the Catalan art in this exhibition. In a richly illustrated monograph published in Paris in 1930, at a period when d'Ors's thinking had taken on a hard-right complexion, he insists that Cézanne's art has little to do with the 'subjective anarchy' of Impressionism, but everything to do with 'order', 'composition', 'rationality', 'perfection'. His final chapter, resoundingly entitled 'Cézanne, classique', first defines the classicist as a 'man of culture and civilisation', before concluding that Cézanne's work 'is the very definition of classicism'.

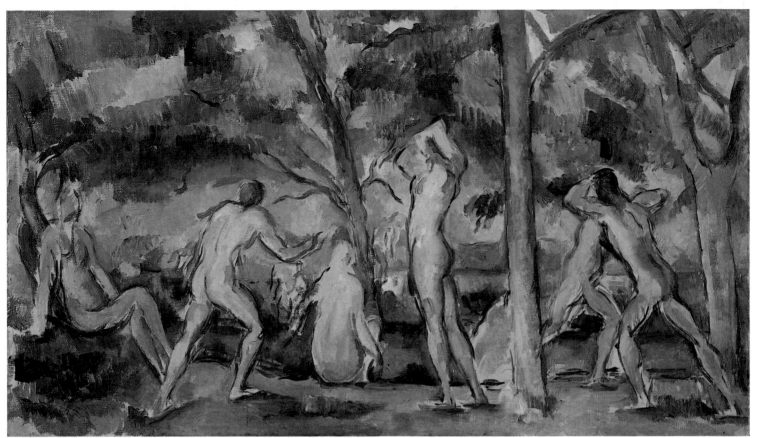

28

28 Bathers 1898–1900

Oil on canvas, 27 × 46.4
*Baltimore Museum of Art, Maryland,
Cone Collection formed by Dr Claribel
and Miss Etta Cone of Baltimore*

Exhibited in the large Cézanne retrospective of 1904, this painting was bought by Leo and Gertrude Stein from Ambroise Vollard within the next year or so, and can be seen in photographs of their famous rue de Fleurus apartment hanging with paintings by Cézanne, Renoir, Matisse and Picasso. The Stein collection was visited by great numbers of writers and artists over the years, so that this small but impressive painting was a very well-known work. When Leo and Gertrude Stein split up their collection in 1913 the painting went to Gertrude, who sold it to Etta Cone in 1926.

Cézanne had depicted the theme of the bathing party over several decades. The subject apparently had its source in his memories of bathing with his male friends as a youth in Aix, but it became an obsessive preoccupation towards the end of his life, culminating in the monumental compo-

sitions now in the Barnes Foundation, the National Gallery, London, and the Philadelphia Museum of Art. This whole sequence of paintings had enormous influence on younger vanguard artists, for whom Cézanne was the modern incarnation of the Great Tradition. Cézanne told Emile Bernard that he longed to do 'a Poussin done again entirely from nature and not constructed from notes, drawings and fragments of studies. At last a real Poussin, done in the open air, made of colour and light', but that the 'endless difficulties' of 'finding men and women who would be willing to undress and remain still in the poses I had decided upon', of transporting a huge canvas to the outdoor site, and then of uncertain weather, had, not surprisingly, obliged him to 'postpone' his plan. ('Une conversation avec Cézanne', *Mercure de France*, 1 June 1921) Although Cézanne's Bather paintings emulate many famous classical and Renaissance works of art which depict complex groups of male or female nudes outdoors, Poussin does seem to be a significant source for this particular version. The frieze-like arrangement of the figures,

the rhythmic succession of triangular shapes into which they are ordered, and the use of the trees and of bands of grass and water to articulate the space and control the composition, are clearly reminiscent of Poussin's method of composing his landscapes. But the colour, lighting and energetic, sketchy handling are, of course, the result of Cézanne's lifelong experience of working outdoors. The picture as a whole realises the synthesis of nature and art which was his goal.

29 Young Italian Woman Leaning on her Elbow *c.*1900

Oil on canvas, 92 × 73
Private Collection

'Young Italian Woman' is typical of Cézanne's late figure-painting style, possessing the profoundly meditative silence and stillness of such great contemporary works as 'Portrait of Ambroise Vollard' (1899, Musée du Petit Palais, Paris) and 'Woman in Blue' (1892–6, Hermitage Museum, Leningrad). Although the girl stares blankly into space, and we are offered nothing which might give a clue to the nature of her thoughts, it is difficult not to read her mood as melancholy, and not to see some resemblance between her and the boy who appears to be musing on mortality in 'Young Man with a Skull' (1896–8, Barnes Foundation, Merion, Pennsylvania). However, the absence of any symbol or anecdotal detail, and the indeterminate nature of the girl's dress – certainly not contemporary fashion, but not unequivocally a folk costume either – serve to establish a completely timeless, completely generalised ambience, for which the abstraction of her thoughts is an equivalent. Oppositions of dark and light, of warm and cool colours, of patterned and plain surfaces, are perfectly weighted and reconciled. This harmony, the restraint and dignity of the painting and its *gravitas*, are felt instinctively as 'classical', and it is possible that Cézanne had been influenced by Roman frescoes, as well as by mournful, pensive or resting women painted by Poussin, Vermeer and Corot.

Although there is no record of this picture having been exhibited or reproduced before the late 1920s, it is exactly the kind of Cézanne which was admired by Matisse, Derain, Picasso and their contemporaries before and after the First World War. Parallels could be drawn with, for example, Matisse's and Derain's paintings of Italian models (cats.117,48). It may well be that Picasso saw the picture in Vollard's gallery and that it influenced certain paintings of the latter part of 1906, but the depth and heaviness of mood is also echoed in the gloomy inertia of the women in some of his post-war paintings (for example, cat.136).

29

GIORGIO DE CHIRICO 1888 VOLOS – 1978 ROME

Giorgio de Chirico was one of the most original artists of this century, who pioneered the revival of interest in the classical tradition and also expanded and transformed previous definitions of classicism in radically new ways. In 1919 he declared, 'I grace myself with these three words, which I would like to be the seal of every work I have produced: namely, *Pictor classicus sum*' (*Valori Plastici*, November 1919). However, the full stature of his work of the 1920s and beyond has been recognised only recently. Taking their cue from the hostility of André Breton and the Surrealists, critics and art historians have tended to praise de Chirico's early metaphysical paintings but dismiss his works after 1918 as uninspired and repetitious. With hindsight, however, there seems to be no decline in quality in de Chirico's paintings after the 1910s; and the continuing inventiveness of his work in the 1920s and, in particular, his contribution to the concept of classicism in twentieth-century art, are now clear.

The fact that de Chirico was born and spent most of his youth in Greece was crucial to his identification with the classical tradition. His family was Italian, but his father worked as a railway engineer, first in Thessaly and then in Athens. De Chirico was born in Volos and was later to see parallels between his own peripatetic life and the story of Jason and the Argonauts who in ancient times were supposed to have set sail from this coastal town in search of the Golden Fleece. He and his brother, who adopted the pseudonym Alberto Savinio, saw each other as Argonauts, and they developed in their paintings an iconography of departures and voyages as metaphors for heroic and tragic adventure. Like many of his generation and background, de Chirico had a strongly classical education, and he is known to have visited many of the sites of Ancient Greece. However, his interest in the classical world was far from archaeological: he was concerned more with the psychological and philosophical implications of the intertwining of fragments of the past in the present.

De Chirico received an academic training in art, first in Athens and then in Munich; and he later insisted that this was a sure basis for achievement in the field. In his *Memoirs* he recalled that at the Athens Polytechnic,

> there were four years of drawing in black and white and studying prints and sculpture before working directly from living models. In the first year we copied figures from prints; in the second, sculpture, but only heads and torsos; in the third and fourth year, sculpture again, but this time the whole body, or groups of figures. Thus, by the time the student . . . had reached the fifth year (during which he drew heads from real life and did chiaroscuro work), he had a fairly good general knowledge and could draw a hand and a foot without their assuming the ridiculous aspect of a couple of forks or housekeys, as is the case in drawings of our modernistic 'geniuses'.

While many of his contemporary artists looked to Cézanne and later to Picasso for inspiration, de Chirico was firmly convinced of the decadence of French painting since Impressionism, and turned instead to recent German art and literature for inspiration. While studying at the Munich Academy de Chirico gained first-hand knowledge of the paintings of Max Klinger and the Swiss artist Arnold Böcklin, and through his voracious reading of such writers as Nietzsche and Schopenhauer he absorbed the German romantic vision of the classical world. De Chirico had probably first come into contact with this view of the classical world in Florence before he moved to Munich: both Klinger and Böcklin had had close links with the Tuscan capital, and the writer Giovanni Papini had already celebrated the work of Nietzsche and Schopenhauer, and written of a metaphysical conception of reality in his influential Florentine review *Leonardo*. But during de Chirico's years in Munich and subsequent stays in Florence and Turin these ideas took root in his mind, and the romantic themes of tragedy, enigma and melancholy were to provide the basis for the creation of what he called metaphysical painting.

De Chirico decided to join his younger brother in Paris and arrived in the French capital in July 1911. He seems to have been

The artist in his studio in Paris, 1929

unaffected by the exciting developments in contemporary French art; and, drawing on the ideas he had developed in the preceding years, and perhaps, too, on his sense of uprootedness and nostalgia for Italy, he began to paint scenes of Italian piazzas, with unreal, raking perspectives, mysterious classical statues and inexplicable combinations of objects. He abandoned his early Böcklinesque style for an inexpressive or flat manner which emphasised clarity at the expense of the sensuous or material aspects of reality. One French critic likened his canvases to scenery painting; but the Italian artist Ardengo Soffici came nearer the mark when he described them as 'dream writings' (*Lacerba*, July 1914). De Chirico exhibited in the Paris Salons, and came to know most of the leading French artistic and literary figures, including the poet Apollinaire who gave him considerable support. However, he had yet to achieve much success when, following the outbreak of war, he and his brother returned to Italy in 1915 to enlist.

De Chirico was stationed for most of the

war years in Ferrara, where, away from the front line, he was able to continue painting and maintain his contacts with the Parisian avant-garde. This period witnessed his intense, visionary treatment of his subject matter of mannequins, military maps, anatomical charts and alchemical symbols placed in claustrophobic settings. It was also a time when his contacts with painters such as De Pisis and Carrà led to the formation of what was to be known as the 'Scuola metafisica'. After the war de Chirico moved to Rome, and began to publish articles about his vision of metaphysical paintings and his new preoccupation with tradition and technique in *Valori Plastici* and other reviews. He started frequenting the Galleria Borghese, and began a dialogue with the work of the great masters which was to dominate his painting of the early 1920s. He made copies of masterpieces, seeing these not simply as studies or experiments but as proof of his skills as an artist; and he called on other artists to follow in his footsteps. He became particularly interested in Italian and French art of the nineteenth century, and his paintings of the mid-1920s reflected this in their new naturalism and echoes of the Romantic era.

In Italy de Chirico's critical and commercial success was relatively slight in these years; but in France the reputation at least of his metaphysical paintings was high. In 1922 Paul Guillaume held a show of these works for which André Breton wrote an appreciative preface. Max Ernst (who had known of de Chirico's work for some time, largely through reproductions in the magazine *Valori Plastici*) included de Chirico in a painting entitled 'The Meeting of Friends', 1922, a roll-call of the members and heroes of the nascent Surrealist group. And in 1923 Paul Eluard and his wife Gala visited de Chirico in Rome in order to buy some works (they were taken aback, however, when he offered to paint the same scenes of his early Parisian period again, only better, and sell them more cheaply).

When de Chirico moved to Paris in 1925 he had every reason to be optimistic about his prospects. He quickly held a one-man show at Léonce Rosenberg's elegant and highly prestigious Galerie de l'Effort Moderne. However, he soon found his new work mocked by his former admirers, the Surrealists. For all their advocacy of the magic in his early works, and the inclusion of some of his metaphysical paintings in the first exhibition of Surrealist art in 1925, Breton and his followers were unable to

accept de Chirico's seemingly pastiche repetition of the themes of his earlier paintings, or his vaunting of the 'conservative' values of craftsmanship and respect for the museums. After an initially cordial welcome, more or less open war ensued. The hostility of the Surrealists, however, was offset by support from other quarters. A former Surrealist, Roger Vitrac, for example, published a monograph on de Chirico in 1927, in which he said that, like Picasso, de Chirico was beyond criticism and explanation, adding that he did not 'doubt' the later works. In the same year Waldemar George began his preface to the catalogue of an exhibition at the Galerie Jeanne Bucher with the words, 'Two facts dominate the art of the twentieth century: Picasso and de Chirico'. And in 1928 the poet Jean Cocteau wrote a poetic text on de Chirico's recent works in *Le Mystère laïc*. Whatever they thought of his paintings, even the Surrealists had to admire de Chirico's dreamlike tale *Hebdomeros*, published in 1929: Louis Aragon described it as 'interminably beautiful'.

During this second stay in Paris, de Chirico dealt again with some of the themes of earlier metaphysical work; but he also began to explore new fantastic motifs, such as furniture in landscapes, Dionysiac horses on sea-shores, and gladiators seemingly frozen in lassitude. He worked on sets for Diaghilev's *Le Bal* for the Ballets Russes, and illustrated Apollinaire's *Calligrammes* in 1929. He also decorated a room in the house of Léonce Rosenberg with scenes of gladiators inspired by the mosaics of Ancient Rome.

At the same time de Chirico maintained his links with Italy, exhibiting in the first *Mostra del Novecento Italiano* held in Milan in 1926, and three years later in a show of Italian painters resident in Paris. He returned to Italy in 1932, and in 1933 executed a major mural for the fifth Triennale in Milan. He spent much of the 1930s in travels abroad, including a further stay in France and a period in New York. He returned to Rome in 1944 where he spent the rest of his life. His later years, however, were dogged by controversy as he chose to copy, with slight or no variations, his earlier masterpieces and backdated some of his works. In doing so he intended to emphasise the importance of the ideas behind his paintings over and above questions of originality and innovation, but this practice undoubtedly contributed to the decline of his reputation in the last decades of his life.

30 The Uncertainty of the Poet
1913
Oil on canvas, 106 × 94
Tate Gallery

'The Uncertainty of the Poet' and 'Song of Love' (cat.31) are among the great paintings of de Chirico's early metaphysical period. His theoretical and lyrical writings of these years show that he had rejected what he called the 'sensationism' of naturalist painting, and wanted instead to display in his work an enigmatic, immutable vision of reality, as glimpsed in moments of intense surprise or revelation. His paintings, he said, should bear the same relationship to reality as the images we have of people in dreams to their real selves.

The purpose of the many allusions to the classical world in de Chirico's paintings of this period was not to illustrate aspects of the past, but to act as tokens or symbols of the imagination and memory. He began painting scenes of Italian piazzas suffused in warm Mediterranean sunshine only after his arrival in Paris in 1911, and thus, in a sense, this whole series of works was based on fantasy rather than direct experience. It was characteristic of his ambiguous approach to the classical world that the torso in 'The Uncertainty of the Poet' was probably a modern plaster cast based on a Greek or Roman prototype. The sense of the torso being several times removed from the original is heightened by the anti-naturalist manner in which it is painted: the black outline and areas of crude hatching deliberately recall the style of academic drawing and engraving. In fact, de Chirico often took his images of classical statuary from illustrations in manuals and textbooks, and in so doing emphasised the unreality of his images. In this way his paintings suggested that the past was irretrievably lost and could only be represented by copies and pastiches.

With its starkly receding perspective, deep shadows and the regular pattern of the arcade, this painting is dominated by line and geometric shapes. De Chirico believed that great art was based not on copying nature but, as he wrote at this time, on 'dimensions, lines, and forms of eternity and the infinite'; and these, he claimed, were present above all in Greek and Roman architecture. What he valued in classical colonnades and piazzas was not so much their order and rationality as their strange lyrical beauty. He wrote in manuscripts of the period:

There is nothing like the enigma of the *Arcade* – which the Romans invented. A street, an arch: the sun looks different when it bathes a Roman wall in light. And there is something about it more mysteriously plaintive than in French architecture, and less ferocious too. The *Roman* Arcade is a fatality. Its voice speaks in riddles filled with a strangely Roman poetry, of shadows on old walls and a curious music . . . (De Chirico, *Il meccanismo del pensiero*, Turin, 1985)

During his studies in Munich de Chirico had admired Otto Weininger's writings on the philosophy of geometrical shapes; and in an article in *Valori Plastici* of 1919 he quoted Weininger's view that the arc, unlike the circle, is incomplete and fosters a sense of uncertainty and expectation. As this suggests, de Chirico's obsession with line and geometry in his compositions in this period was not mathematical: the raking perspectives and receding arcades were for him the pictorial equivalents of a projection of the consciousness or such emotional states as anticipation and nostalgia.

The irrational side to de Chirico's vision of classicism pervades almost all his work, even in this early metaphysical period. He filled his paintings with unexplained, semi-autobiographical references. The distant train in 'The Uncertainty of the Poet', for example, recalls his father's profession as a railway engineer; and, in fact, a railway track enclosed by a high wall ran through the centre of the Greek town Volos where de Chirico spent his childhood. The mast of the ship in the distance can be seen as a covert reference to the Argonauts, whom legend associated with Volos and who were the subject of a private mythology shared by him and his brother. Such hidden personal connotations reinforce the atmosphere of mystery in de Chirico's images, which defy precise interpretation. The significance of the tropical fruits in this painting, for example, is not clear; but in a lyrical text of this period he described what he termed the 'voluptuousness' and 'happiness' of bananas, and it is possible that they serve here as symbols of the sensual pleasures of life, complementing the lifeless cast and the intellectual legacy of the classical world it symbolised.

The ambiguous quality of de Chirico's metaphysical paintings, with their easily legible, often mundane images belying a sophisticated and intellectual meaning, was to have enormous impact on modern art. The central figure of Parisian avant-garde, Apollinaire, shared de Chirico's interest in the multi-valent and poetic meanings of ordinary things, and became one of his main supporters; and, following his lead, the Surrealists took de Chirico's work of these years as a model for the dream imagery they sought to cultivate. Indeed, the poet Paul Eluard bought 'The Uncertainty of the Poet' in 1922 and sold it in 1938 to the British Surrealist artist Roland Penrose.

30

31 Song of Love 1914

Oil on canvas, 73 × 59
Collection: The Museum of Modern Art,
New York, Nelson A. Rockefeller Bequest

This painting, with its mysterious combination of a classical head, a rubber glove and a ball, was typical of those metaphysical works by de Chirico that so appealed to the Surrealists. When, for example, the Belgian artist René Magritte first saw a reproduction of it in the early 1920s, he could not stop tears coming to his eyes: to *see* thought for the first time, he later said, was one of the most emotional moments in his life (*Le Patriote illustré*, 2 April 1967).

Influenced by contemporary psychology, and in particular by the idea of a stream of consciousness, the Surrealists held that, at an unconstrained or almost unconscious level, thought consisted of jumbled images and impulses; and they believed that de Chirico's early work showed him to be in touch with these lower layers of the mind, the source of verbal and visual poetry.

De Chirico, however, had a different view of his work. He talked of the importance of dreams, of a mentality of childlike innocence, and of the need to avoid logic in the creation of beautiful images; but his focus was less on his own thoughts and psychology than on revealing the strangeness of the world. In manuscripts of this period he described the experience of seeing the world as 'an immense museum of curiousness, full of odd toys', of grasping the enigma of seemingly insignificant things. The art of the future, he wrote, should

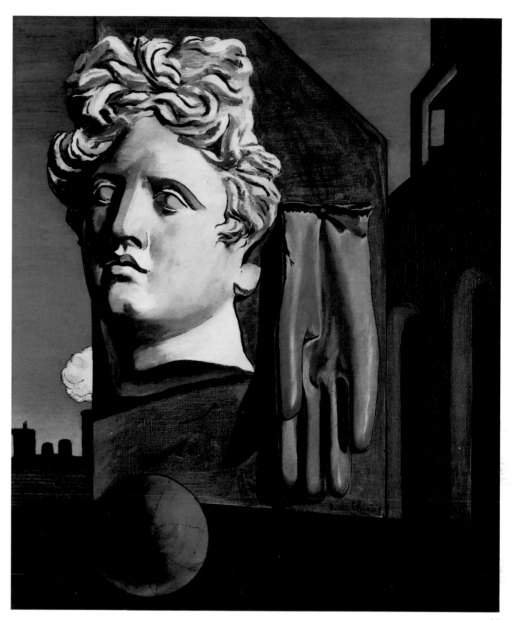

31

express sensations hitherto unknown; strip art of . . . routine, rule, and tendency towards aesthetic subjects or synthesis; expunge man as a point of reference, as a means of expressing a symbol, a sensation or a thought; be liberated once and for all from the anthropomorphism that shackles sculpture. See everything, even man, as a *thing*. This is the Nietzschean method. Applied to painting, it might produce extraordinary results. This is what I try to demonstrate in my pictures. (*Il meccanismo del pensiero*)

In 'Song of Love' de Chirico carried the idea of stripping art of convention and logic to its limits: there is no known reason for the juxtaposition of the objects in this painting, and although the works of man are present

everywhere, man himself is strangely absent. The head of the Apollo, absurdly placed next to a rubber glove, was copied from a book on classical art by the French archaeologist Salomon Reinach. As so often with de Chirico, this painting contains a number of private references. The train alludes to his childhood, and the arcades to the architecture of Italian towns; the glove evokes reference to a particular painting by Titian that de Chirico admired, and also anticipates the pointing 'hand of fate' found

in the artist's later so-called 'alchemical' works; the ball can be read as a symbol of perfection; while the inclusion of the classical head suggests an allusion to the themes of poetry and clairvoyance symbolised by the god Apollo.

The painting was first shown in New York in 1914, and again at the Galerie Paul Guillaume in Paris in 1922 in an exhibition which established the importance of de Chirico's metaphysical works in the eyes of a French post-war audience.

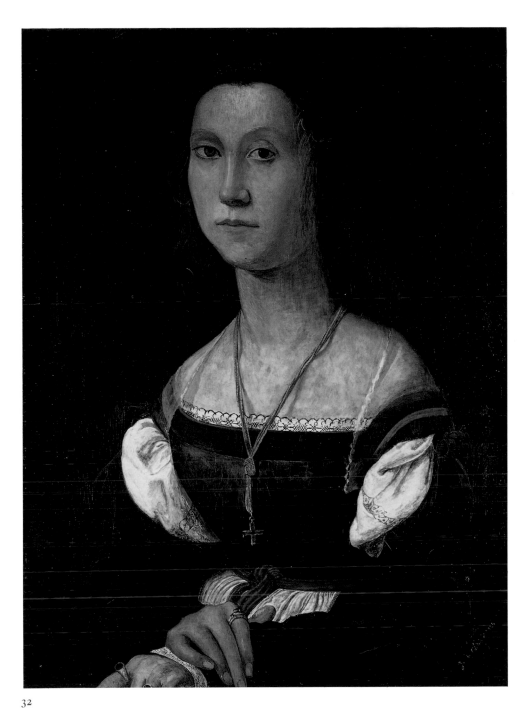

32

32 La Muta, after Raphael 1920
Oil on canvas, 65 × 47
Private Collection

'La Muta' is a copy of a famous painting by
Raphael which once hung at the Uffizzi
Gallery in Florence but which is now in
Urbino. It is one of a series of copies of
works by old masters executed by de Chir-
ico in the years following the war when he
divided his time between Rome and
Florence. The return to tradition and the
museums was a feature of avant-garde art
throughout Europe in this period. In France
Picasso looked to Ingres, Gris to Corot,
Léger to Poussin; while in Italy Renaissance
art provided inspiration for many artists.
However, de Chirico was original in one
important respect: while others were
reworking the legacy of the past, de Chirico
chose to make and exhibit *exact* copies, not
only of Raphael but also of Lotto, Carpaccio
and Michelangelo; and he saw these paint-
ings as evidence of a technical mastery
which he had come to regard as essential to
great art.

Only a few years after the Futurists had
declared their aim to be the destruction of
the museums and the severing of Italian art
from its roots, de Chirico emphasised the
importance of conventional skills in an
article entitled 'Il ritorno al mestiere' pub-
lished in *Valori Plastici* in 1919. In this he
was scathing about the 'penitents' of
modern art who were currently seeking to
revive figurative painting, and insisted that
the path to quality lay with painstaking
study of tradition and technique. He des-
cribed his own training at the Polytechnic in
Athens — the study of prints, then statues,
draped and nude, prior to working from
nature — as the best way of acquiring a
sound knowledge of the techniques of art.
Significantly, de Chirico distanced himself
from the ideas of the 'return to order' or
'neoclassicism' which were much in the air
at the time. Reviewing an exhibition by his
friend Soffici in 1920, an exhibition which
provoked much discussion about the 'return
to order' in art, de Chirico argued that the
real issue was technical competence, not
questions of modernity or classicism. 'You
used to, and still do hear', he wrote,

> people talking about *construction*, about a
> *search for volumes*, about *sincerity*, about
> *experiments and researches* etc. Let these
> people who use such words at random go
> and make copies in galleries, and then
> they will perhaps have doubts about the

meanings that they used to give these terms: *construction* and *volume*. In fact, as far as *experiments* and *researches* are concerned, the best that they could do for the time being would be to go and copy a portrait by Raphael. (*Il Convegno*, no. 6, 1920)

De Chirico had long admired Raphael, and his name features alongside those of de Chirico's other artistic heroes, Böcklin, Klinger and Poussin, in his unpublished writings before the war. Although it was de Chirico's concern with craftsmanship that led him to study and copy Raphael, his admiration went beyond the issue of mere technique. In an article of 1920, de Chirico praised the metaphysical qualities of this artist's portraits, with their unsettling combination of serenity and solemnity:

> From the cranial sphere down through the folds of the clothes and drapery, to the hands ... there is a static, immobile and intense quality, which makes us think about the eternity of matter. The image seems to have existed even before the painter had created it. This is perhaps why when we are faced for the first time with certain works of genius we find ourselves asking with amazement, 'But where have I seen this before? Where have I caught sight of that face?' And we remain disturbed, as when in life, we do something or see someone already featured in a dream. Only great paintings can awake these mysterious feelings ... (*Il Convegno*, no. 3, 1920)

Although de Chirico executed in this period a copy of another major Raphael known as 'La Gravida', or 'The Pregnant Woman', he was particularly fond of 'La Muta'. In the catalogue preface to an exhibition of his recent works held in Milan in 1921 he wrote that he was sorry not to be able to show this painting because he regarded it as very important. He had already sent the work to his dealer in Paris, Paul Guillaume, as he was anxious to show it to a French audience. In a letter, probably of late 1921, to the future leader of the French Surrealists, André Breton, de Chirico was at pains to persuade him of the importance of the art of museums and issues of technique. Attempting to explain his convictions, he wrote: '... there are people, you included probably, who, having reached the limits of their art, have asked themselves: where are we going? They have felt the need for a more solid base.' Without repudiating any of the

romanticism of his earlier works, he felt proud of his new achievements: a recent self-portrait, he wrote, could easily hang in the Louvre. The attempt to persuade Breton of the merits of this new departure in his work was, however, to fail: in 1926 Breton wrote of de Chirico's 'ridiculous copies of Raphael' (*La Révolution Surréaliste*, no. 7, 1926).

33 Roman Piazza (Mercury and the Metaphysicians) 1920

Tempera on canvas, 56 × 76
Private Collection

Confusion surrounds the precise title of this painting. It has been known as 'Roman Piazza', but the art historian Maurizio Fagiolo dell'Arco has recently identified it as one of two works entitled 'Mercury and the Metaphysicians' which de Chirico exhibited in a one-man show in Milan in January 1921. This attribution depends on seeing the figure in the lower right as Mercury or Hermes, the god of messages and surprises (the 'metaphysicians', or philosophers, being the figures in the distance). The two versions of 'Mercury and the Metaphysicians' were particularly important to de Chirico, in terms of both their technique and their subject matter. In his preface to the 1921 catalogue he wrote that he thought they were 'difficult works which few will understand, and thus of great future significance'. He did not explain in what sense they were 'difficult'; but it is evident from his writings at this time that he was trying to develop a complex vision of the relationship between a 'classical' technique of representation and an imagery inspired by the classical world.

With its clear, limpid colours, this painting reflects de Chirico's researches into traditional methods of painting. In the catalogue preface of 1921 he wrote that his recent works showed a preference for light and transparent tones and a dry finish. This style, which he dubbed 'Olympian', achieved its highest expression in Botticelli and early Raphael; but, he wrote, it could also be found in frescoes at Pompeii and in Ancient Greek painting.

The links between the art of Ancient Greece and the Italian Renaissance were explored in an article de Chirico published in *La Ronda* in 1920 entitled 'Classicismo pittorico'. In this he stressed how the

Ancient Greeks and the masters of the Quattrocento had based their work on the science of drawing, and had shared a common fascination with the spirituality that could be derived from line and simplified forms. Allied to this was a mysterious interpretation of nature, in which man was used to represent both gods and mortals. 'Men are found at the same level as the gods,' he wrote, 'and *vice versa*. Statues stand on low pedestals'. In this and other works de Chirico sought to combine a purity of line, colour and composition with an imagery recalling ancient myths of the time when the gods mingled with men.

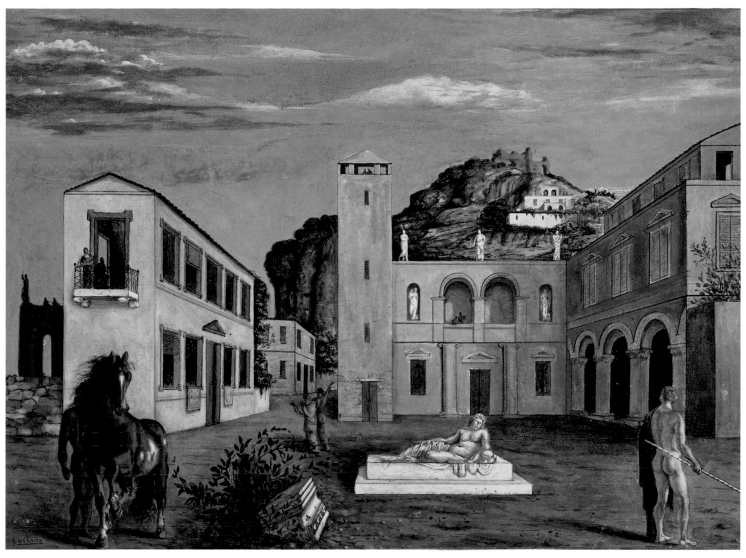

33

34 Roman Villa 1922

Tempera on canvas, 76 × 51.5
Private Collection

This work explores the idea of a mysterious
assembly of men, gods and statues found
also in 'Roman Piazza (Mercury and the
Metaphysicians)' (cat. 33). It was a standard
theme of Greek myths, but has been here
placed in a recognisably contemporary set-
ting of twentieth-century Italian buildings
and people in modern dress. Part of the
mysterious or metaphysical quality of the
scene lies in the sense of remoteness of the
figures, who seem suspended in time – a
theme de Chirico had first developed in his
pre-war paintings with mannequins and
classical statues.

This type of projection of myth and
mystery into the present age was an import-
ant aspect of de Chirico's classicism. 'A
strong current of mysticism', he wrote in
1920,

> is indispensable to the formation of clas-
> sical artists. Greek painters and the great
> Italian artists derived it from religion.
> Let us not forget that *mysteries* flourished
> at the time of Polignatius and would not
> have been foreign to his severe and
> emotional drawing, to that *ethos* which
> enveloped his figures, to that idealism so
> eulogised by Aristotle.
>
> Today let us hope to be sufficiently
> mystical for a rebirth of classicism.
> ('Classicismo pittorico', *La Ronda*, July
> 1920)

De Chirico exhibited a number of works
depicting Roman villas in the Biennale in
Rome in 1923; but his new works were not
greatly liked by critics. One of the most
hostile (who for this reason was remem-
bered by de Chirico years later in his
autobiography) was the art historian Emilio
Cecchi, who wrote: 'At first sight unpleasant
and grossly artificial, the eighteen canvases
exhibited today end up giving the unpreju-
diced visitor an impression very different
from the snobbish fervour with which de
Chirico was originally greeted'. However,
the writer continued, 'all is not, as others
claim, completely negative. It is debatable if
de Chirico is a painter in the full sense of the
word: but that he is an extravagant person, a
visionary, a *type*, and for good or ill an artist,
is beyond question' (*L'Esame*, February
1924).

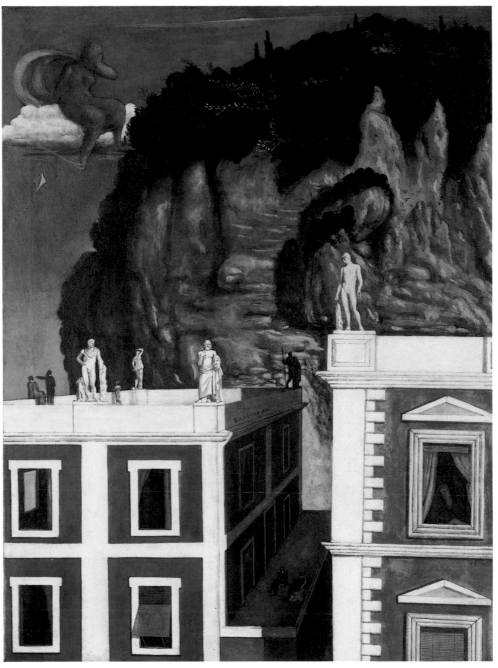

34

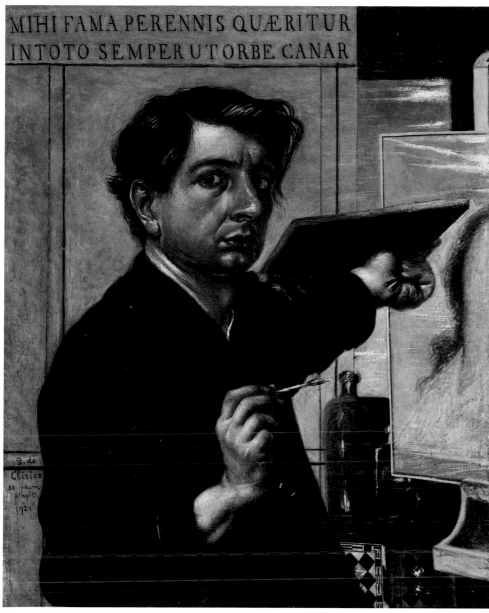

35

35 Self-portrait 1924

Tempera on canvas, 76 × 61
Kunstmuseum, Winterthur

De Chirico painted many self-portraits in
the early 1920s, showing himself alone or in
the company of his mother or brother, or
with classical busts. His obsessive depiction
of himself may have involved an element of
narcissism; but these self-portraits were also
examples of theatrical role-playing and a
means by which he expressed his view of the
artist as a heroic, visionary figure.

Here de Chirico shows himself in his
studio, pointing dramatically at a work in
progress as in a sixteenth-century Manner-
ist portrait. The well-known Latin tag in the
top left corner, which can be translated as 'I
seek enduring fame in order to be celebrated
the world over', echoes a theme common in
the Ancient Greek and Roman world, and
conveys his vision of the artist as a type of
Nietzschean 'superman'.

The mood of this and other paintings of
the period is essentially romantic, but that
was not seen by de Chirico as undermining
or contradicting the classical nature of his
work as a whole. In an essay on the French
nineteenth-century painter Courbet in
1925, the year after he painted this self-
portrait, he wrote:

> Romantic! Curious word, fragrant with
> meaning and distant dreams. Many
> uncertainties and misunderstandings
> arise from it. For us, it only signifies art
> that is both felt and inspires feeling, art
> that is firmly built on the solid founda-
> tions of reality, art which makes us aware
> of that element of the great mystery of the
> infinite, which on a moonlit night
> breathes through the slits in the scudding
> clouds.

The romantic idea of the mysterious nature
of reality was central to all de Chirico's
work, and he did not hesitate to explore
those areas of art that were traditionally seen
as opposed to or removed from classicism.

A striking feature of this work is the
artist's dramatic pointing gesture. De
Chirico was to repeat this pose in a number
of paintings in these years, including a work
called 'Ulysses', 1924 (private collection), in
which the Greek hero indicates towards the
horizon as he awaits the arrival of Mercury
who will rescue him from the island of
Calypso. This gesture recalled a famous
painting by Böcklin of the same theme, and
we know that de Chirico, a long-time

admirer of the Swiss master, made a pro-
longed study of his works in the early 1920s.
He was fascinated in particular by Böcklin's
use of tempera, and became absorbed in
these years in technical questions relating to
the preparation of paints and varnish. His
imitation of traditional styles and tech-
niques gave him a sense of affinity with the
old masters he loved so well; and although
after his move to Paris in 1925 he reverted to
painting in oils, the technical experimen-
tation of this period remained an important
aspect of the 'return to craftsmanship' that
underpinned his vision of modern classicism
throughout the 1920s.

36 The Philosopher 1924

Tempera on canvas, 76 × 63
Galleria Spazio Immagine, Milan

De Chirico visited Paris briefly in
November 1924 to work on sets for the
ballet *La Jarre*, based on a story by Luigi
Pirandello with music by Alfredo Casella.
For some time before this he had been in
touch with the Surrealists, who admired the
haunting, dream-like quality of his early
metaphysical works. The poet Paul Eluard
and his wife Gala had recently travelled to
Rome to meet him and buy some of his
works; and de Chirico painted a portrait of
them which he dedicated to 'My friends
forever and wherever'. During this stay in
Paris he was warmly received by the Surrea-
lists. He was included in a photograph of the
group reproduced on the cover of the first
issue of *La Révolution Surréaliste* in
December 1924; and in its opening section
devoted to dreams, de Chirico's text came
first, preceding even that of André Breton.
It began, 'In vain I struggle with the man
with gentle, squinting eyes . . . no matter
how tightly I grasp him, he gently frees
himself merely by moving his arms apart a
little . . . It is my father who appears to me
in my dreams, and yet when I look at him he
is not quite how he seemed when he was
alive in my childhood'.

It was no coincidence that de Chirico
wrote about his father in this piece, and he
may even have been asked to do so. Of all
his paintings the Surrealists admired most a
work owned by André Breton, entitled 'The
Child's Brain', 1914 (Moderna Museet,
Stockholm), which featured a 'father
figure'. They saw this picture as proof of de
Chirico's exploration of his own psyche (his
father had died when he was a teenager) and

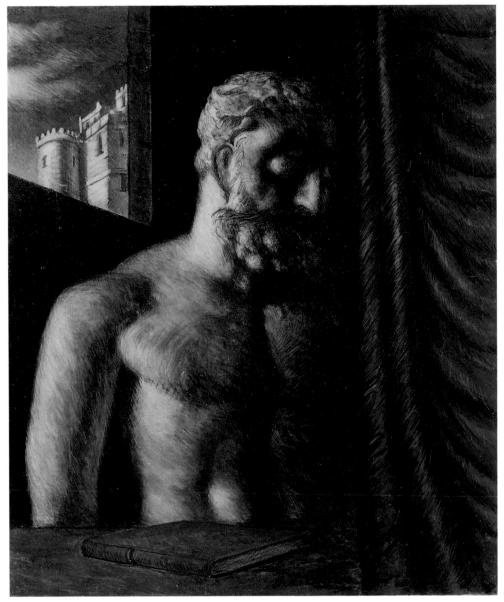

36

as a symbol of Oedipal rebellion against
their parents' generation; and Breton
recorded that it was seeing this work in the
window of the Galerie Paul Guillaume that
made him realise the Surrealist potential of
painting.

It is not known whether de Chirico
executed 'The Philosopher' before or after
his trip to Paris; but it was clearly inspired,
at least in part, by his growing contacts with
the Surrealist group, for it echoes the theme
of 'The Child's Brain'. In the latter, a grey,
corpse-like, nude figure with its eyes closed
stands behind a table on which lies a yellow
book; on the left is a curtain, while through
the window behind him on the right can be
seen a Renaissance-style building. In 'The

Philosopher' de Chirico reversed many ele-
ments, and altered others to reflect his new
concerns. Here the curtain is on the right,
and has curving rather than straight folds;
the window is on the left and beyond it lies a
late medieval building; the book is red not
yellow; the figure is not modern but is
clearly based on a classical statue; and the
whole scene, bathed in a gentle golden light,
is painted with a soft, nervous touch far
removed from the flat manner of his early
paintings.

De Chirico's recourse to the ancient
world and his adoption of a museum-
inspired style were to prove unpalatable to
the Surrealists. They continued to admire
the early paintings, but were ruthless in

their public criticism of his new work. De Chirico reciprocated their feelings, telling his brother in a letter of 1926 that the Surrealists were 'cretinous and hostile'. He later referred in his memoirs to 'that group of degenerates, hooligans, spoilt brats, loafers, onanists and wastrels who had pompously called themselves *surrealists*.'

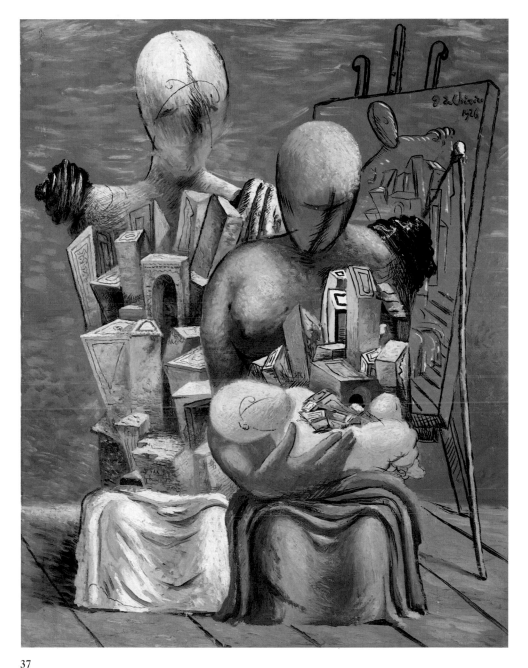

37

37 The Painter's Family 1926
Oil on canvas, 146.5 × 115
Tate Gallery

In 1925 de Chirico moved to Paris and took up residence in the Latin Quarter. Here he resurrected many of the themes that had figured in his paintings during his first stay in Paris, but he reworked them in the light of his current preoccupations. In 'The Painter's Family' the soft brushwork was typical of his new romantic style, while the unfinished picture on the easel can be seen as an allusion to studio genre scenes of the nineteenth century, or to earlier works such as Raphael's 'Saint Luke Painting the Virgin' (Accademia di San Luca, Rome), which de Chirico had reproduced in an article of 1920.

The mannequins of de Chirico's second stay in Paris had a flesh-like solidity and were less awesome than their earlier mechanical counterparts. These had been inspired originally by a play written by de Chirico's brother in which the main protagonist is a 'man without voice, without eyes or face'. De Chirico himself confirmed this when he wrote, 'The idea of these large heads shaped like an egg, which one also sees in my standing mannequins of the metaphysical type, came to me from seeing the maquettes designed by my brother who used the pseudonym Alberto Savinio. My brother, who was a writer, musician and painter, had written in 1914 a play entitled "Les Chants de la mi-mort".' De Chirico went on to say that the figures in 'The Painter's Family' were inspired by 'certain seated Gothic figures (apostles and saints)' (letter to the Tate Gallery, July 1958). A medieval source for the disproportioned figures was also suggested by one of the main collectors of de Chirico's work in the interwar years, Alfred Barnes, in an article of 1938, apparently on the basis of conversation with the artist (*L'Ambrosiano*, 16 February 1938). De Chirico had been critical of the influence of thirteenth- and fourteenth-century Italian Primitives on Carrà's work, but it seems that during this period in Paris he was struck by the metaphysical aspect of the disproportioned figures of medieval church statuary. The ecclesiastical connotations of this family group are made more evident in the title of a closely related work, 'The Holy Family'. However, the majority of paintings in this series show mannequins either singly or in pairs, and have titles of a more secular and classical character such as 'Greek Philosophers' and 'Archaeologists'.

Waldemar George, in his monograph on de Chirico of 1928, described the mannequin figures as symbols of the collapse of an over-sophisticated and exhausted European culture. 'De Chirico portrays a Western Europe conscious of its decrepitude,' he wrote, 'and which, turned upon itself, draws up a balance sheet of its glorious past. His Olympians, who are god-like mannequins, or plaster statues, animated by an extraterrestrial life-force, have their arms filled with various emblems of a civilisation, the debris of which suggests old items from a bric-à-brac store or the back of a shop.'

This painting was bought by the dealer Léonce Rosenberg, one of the main supporters of de Chirico's work in Paris. By this time, however, the Surrealists had begun to accuse de Chirico of a loss of inspiration and an ignoble attempt to cash in on his past successes, and their interpretation quickly proved influential. It was noted in a catalogue of the International Exhibition of Modern Art held in New York in November 1926, that de Chirico had 'abandoned his "metaphysical" conception and turned to a less disciplined brush stroke. His admirers could not follow him and decided that de Chirico of the second manner had lost the flame of the first.' However, the writer cautiously added, 'posterity may have a word to say'.

38 Roman Women 1926

Oil on canvas, 116 × 89
Pushkin State Museum of Fine Arts, Moscow

This painting is one of a small group of works by de Chirico showing monumental female figures inspired in part by ancient statuary or frescoes. De Chirico's wife, Raissa, was studying archaeology at the Sorbonne at this period, and it is known that the artist had many archaeological textbooks in his studio, including some by the well-known classicist Salomon Reinach. He copied many of his classical images from illustrations in these books, and although no particular source has been found for 'Roman Women', the heads and background clearly derive from Roman art, while the bodies have a fleshiness familiar from later nineteenth-century French painting.

'Roman Women' and the other related figure compositions were among the most obviously neoclassical of de Chirico's works,

and are strongly reminiscent of Picasso's paintings of the early 1920s. De Chirico envied Picasso's commercial and critical success, but always respected him as a pioneer (though, admittedly, not of a type of art he admired); and it seems likely that in using a subject so closely associated with the Spanish artist, he was deliberately attempting to emulate him.

De Chirico's pictures of 'Roman Women' and other subjects inspired by classical statuary painted at this time have a disturbing effect. The hallucinatory quality of the figures in this painting derives from their monumental scale as well as from their bold, electric colours: it was as if de Chirico wished to subvert the conventional idea of classical statuary as white by using extremely modern colour combinations. Boris Ternovetz, director of the Gallery of Modern Art in Moscow, published in Milan in 1928 a monograph on de Chirico in which he drew attention to the new stylistic qualities of recent works by the artist.

Contact with the 'School of Paris' has led him to adopt a more vivid, impetuous and violent technique . . . As de Chirico's work gets further removed from nature, both in its arrangement of colours and also in the way the colours are applied, it becomes more inspired and poetically freer. A significant part of his last series is executed using the technique of pastels; perhaps its bright tonality and a certain 'drawing' quality . . . have also influenced his oil paintings in this last period.

'Roman Women' was included in an exhibition of modern French art organised by Ternovetz in Moscow in 1928. It was bought by the State Museum of New Western Art, and passed into the collection of the Pushkin Museum in 1948.

39 Gladiators 1928

Oil on canvas, 65 × 81
Private Collection, Rome

In 1929 de Chirico published a novel in French called *Hebdomeros*, which even his most hostile critics, the Surrealists, recognised as a masterpiece of imaginative writing. In this strange dream-like tale can be found many of the motifs that recur in his paintings, including the theme of gladiators. At one stage in their travels Hebdomeros and his companions found themselves in

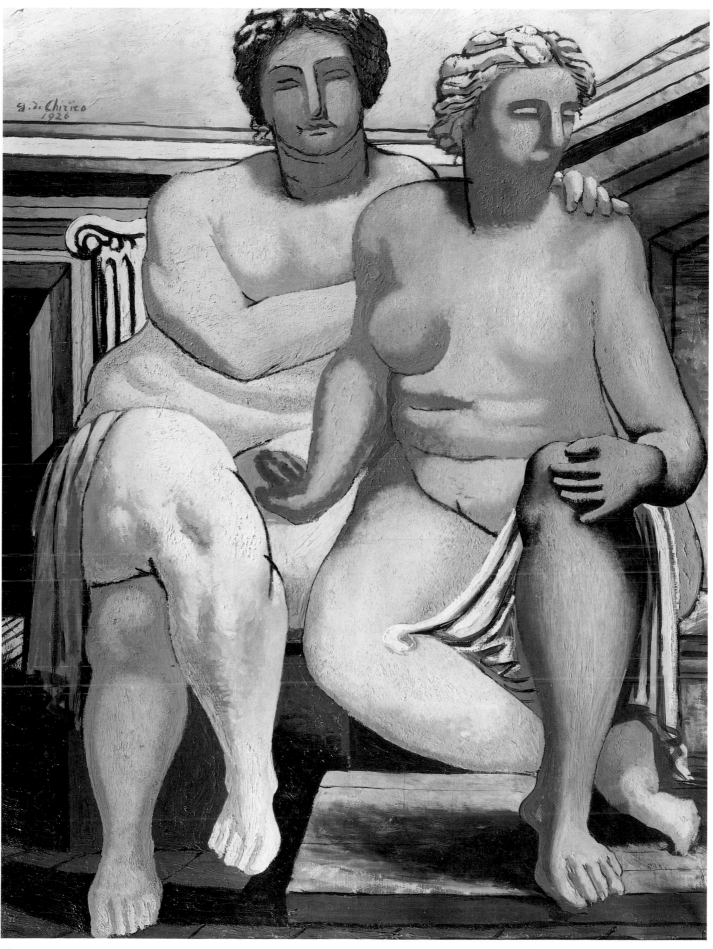

38

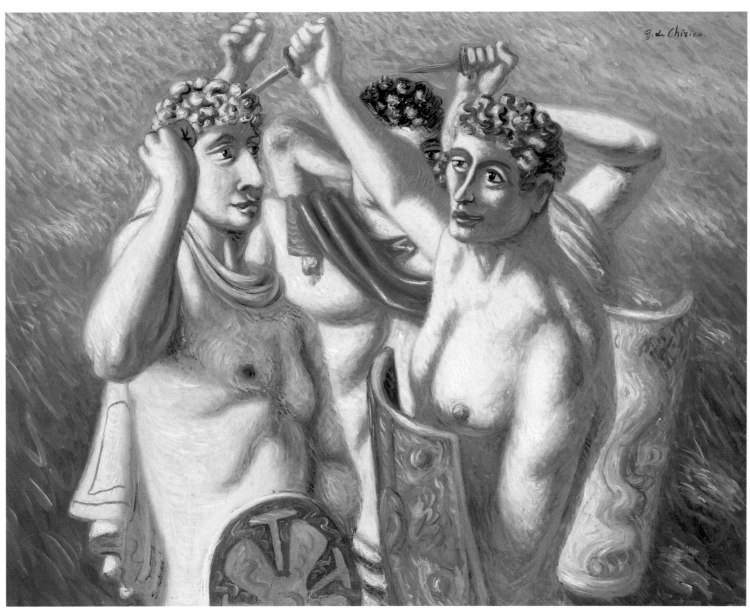

39

a vast room with a high ceiling, decorated in the style of 1880; the lighting and general atmosphere of the room, which was totally devoid of furniture, recalled the gaming rooms at Monte Carlo. In a corner, two gladiators wearing diving helmets were exercising half-heartedly under the bored gaze of a master, a pensioned ex-gladiator with a vulture-like eye and a scarred body.

'Gladiators! This word contains an enigma,' said Hebdomeros in a low voice.

The imagery and mood of the text is closely related to this painting in which de Chirico combines the normally dramatic scene of mortal combat with a feeling of boredom and lassitude, with the warriors appearing almost paralysed or suspended as in a dream. The sense of potential violence is further diminished by the golden light, the sweet colours and the almost decorative style of painting which, as in the passage quoted, suggests a place of entertainment such as a gaming room in Monte Carlo.

It is not known why de Chirico became interested in the subject of gladiators, but it clearly fascinated him: between 1927 and 1930 he painted over fifty works showing gladiators either in combat or exercising. Inevitably, however, the subject carried connotations of the classical world, and the many scenes of warriors in Ancient Greek and Roman art. Writing in 1930, Waldemar George related these paintings to classical bas-reliefs. 'De Chirico is attached to the Constantinian style', he wrote. 'Like the anonymous sculptors of sarcophagi of the late Roman period, he transubstantiates the spiritual values of art. Like the sculptors of the Lower Roman Empire, de Chirico creates the sensation of space (an ideal space) by the convergence of looks alone, by the language of the figures' eyes' ('Appels du Bas Empire', *Formes*, January 1930). Elsewhere he pointed out that no artist had dared to touch on this academic subject since the days of Sir Alma Tadema, the late nineteenth-century academic British painter.

40 Melon with Grapes and Apples 1931

Oil on canvas, 68 × 91
Private Collection, Rome

In de Chirico's work, fruit is normally associated with a celebration of the sensuous pleasures, coupled perhaps with an implicit reminder of life's transience. What is remarkable about this painting is that the melons, cut open and perhaps partly eaten, combine surreally a sense of sweetness and vitality with intimations of violence and pathos.

De Chirico always preferred the English term 'still life' to the Italian name for this genre of painting, 'natura morta' (literally, 'dead life'). He felt it expressed more appositely the silent but vigorous, living quality in all things, which was a constant theme in his work from the early metaphysi-

cal period. The sense of vitality in this work derives in part from the brushwork, which is reminiscent of Rubens and, in particular, Renoir. De Chirico wrote an appreciation of Renoir after his death in 1919, in which he described his Impressionist period as a regrettable interlude between his early 'solid' style and the great classical works of his later years. De Chirico did not approve of the absence of linearity in Renoir's paintings, but was fascinated by the strange psychological quality of what he called their suffocating atmosphere. Much of de Chirico's work in the 1920s had involved a meditation on the works of the great masters, and in adopting a Renoiresque style in the late 1920s and 1930s he chose to explore a new, and typically unexpected, path in the relationship between modern classicism and the art of the past.

40

JOSÉ CLARÁ 1878 OLOT – 1958 BARCELONA

Although now largely overlooked, Clará was by far the best known Spanish–Catalan sculptor of his generation, achieving a status not far short of that of Maillol. In Catalonia his work was regarded as the incarnation of the spirit of Noucentisme, but his reputation was truly international for he represented the acceptable face of modern sculpture. In the words of Kineton Parkes, a well-known writer of the period, 'Clará has absorbed all modern ideas on sculpture, and amalgamated them with those of the grandeur of classical work, and the work of the Renaissance. Phidias and Michelangelo are his teachers, as well as Rodin.' (*Sculpture of Today*, Vol.II, London, 1921)

Clará had a thorough academic training, beginning in the local art school in Olot, Gerona. At this stage his intention was to be a painter, and in Olot he acquired his lifelong habit of drawing intensively. In 1897 he enrolled in the Ecole des Beaux-Arts in Toulouse, and, following his success there, transferred in 1900 to the Ecole des Beaux-Arts in Paris where his master was Louis Barrias. He met Rodin, and worked for a time in his studio, and probably through Rodin formed friendships with Despiau, Bourdelle, and above all with Maillol. Rodin's influence is felt strongly in Clará's earliest sculptures, which are more emotionally expressive and 'soulful' than the classical works for which he later became famous. Certain early busts of laughing women also indicate his admiration for Medardo Rosso. Following a successful début in the Paris Salon in 1903, Clará went to London in 1904 to study the Greco-Roman collections in the British Museum, and this experience, allied with his friendship with Maillol and with the critic and theorist of Noucentisme, Eugeni d'Ors, who wrote favourably of Clará, led to a gradual reorientation in his work. A trip to Italy a few years later, during which he visited Genoa, Florence and Rome, confirmed the change, and thereafter Clará's work took on a distinctly classical character, although his source was often High Renaissance sculpture (especially that of Michelangelo), rather than Greek sculpture as such. He would later comment, 'To be classical is to contain the essential – all our

sensations, including those that are most complex.'

'Dusk' was much admired in the Salon de la Société Nationale des Beaux-Arts in 1908, and the following year 'Enigma', which depicts a crouching woman in a Michelangelesque twisting pose, won him associateship of that Salon. Slightly modified, and retitled 'Goddess' (1910), it became one of his most celebrated works, and a version was commissioned for the Plaça de Catalunya in Barcelona. Clará's reputation as a leading young sculptor was established in 1910 by a major exhibition of forty of his works held in Paris. In the same year the French State bought a bronze of 'Dusk' for the Musée du Luxembourg, and he won a gold medal at the Universal Exhibition in Brussels and first prize at the Nacional de Bellas Artes in Madrid. Although resident in Paris, Clará maintained constant links with Barcelona and helped found Les Arts i els Artistes, a group dedicated to the promotion of Noucentista ideals. Further official successes followed: he received medals in Barcelona in 1911 and in Amsterdam in 1912, and in 1917 he was made Officier de la Légion d'Honneur. After the war his success continued; he exhibited widely throughout Europe and America, and won a gold medal at the Exposition des Arts Décoratifs in Paris in 1925 and at the Universal Exhibition in Barcelona in 1929. Meanwhile in 1926 the United States Government commissioned a version of 'Serenity' for Meridian Park in Washington. (This huge sculpture, showing a classically draped and seated female figure, had been one of the successes of the Salon d'Automne of 1919.) In 1932 Clará settled finally in Barcelona, and in 1936 he was accorded a special show in the Venice Biennale. Unlike many Catalan artists, such as the other leading Noucentista sculptor Casanovas, he accepted the dictatorship of Franco, and continued to be honoured in Spain until his death.

Clará was the subject of many articles in France, where his work was generally exhibited first, as well as in Spain. Inevitably he appealed strongly to those conservative critics who favoured a 'return to order' but were opposed to straightforward academi-

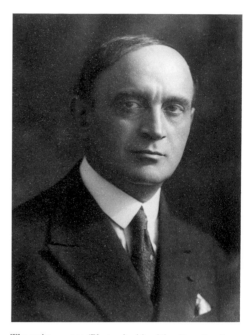

The artist, *c*.1925 (Photo: Archivo Mas, Barcelona)

cism. He was often praised for his craftsmanlike command of the techniques of both modelling and carving – several writers drew attention to his practice of direct carving – and for the thorough realisation and perfection of his sculptural ideas due to his use of drawings and preparatory sketches. (Clará himself was scornful of what he called the modern 'scourge' of the 'more or less, the hurried and the sketchy' – 'undeniable signs of decadence'.) The typical view of his supporters, who likened his work to that of Maillol, was that in having left behind the 'emotionalism' of his early 'symbolist' work Clará had attained the purity and universality of classicism. The influence on him of his Mediterranean origins was stressed – the 'happy' sea, 'fertile' land, 'harmonious' landscape, and 'splendid' women of Catalonia. 'Do not seek in the art of Clará', wrote Georges Denis-Rault, 'any literary dimension. His works are beautiful and pure forms sufficient in themselves. . . . They are completely harmonious, free and disengaged. They do not astonish; they demand no impassioned response, no initiation. They are quite simply beautiful. Because they are from every angle perfectly balanced, radiantly

and powerfully executed, they satisfy us, and give us that impression of well-being and of joy that is the legacy of beauty.' (*Art et Décoration*, April 1914) According to André Fontainas, Clará's work was distinguished by its 'majestic simplicity, absolute serenity, gracious and supple grandeur'

(*L'Amour de l'Art*, August 1927). And for Myras, 'by the gradual elimination of the inessential and of the unnecessary, he has established a veritable synthesis which accords with the inquiring but constructive spirit of the age.' (*Architectural Review*, October 1929)

41 Rhythm 1910

Bronze, 57 × 32 × 34
Museu d'Art Modern, Barcelona

'Rhythm' was one of Clará's best known and most admired pre-war works. The bronze was, for instance, reproduced by Denis-Rault in his highly complimentary article in *Art et Décoration* in 1914, and also in José Francés's monograph published in Madrid in 1921. Clará made an enlarged version in marble of the left-hand figure, and named it 'Cadence' (Museo Clará, Barcelona), and 'Rhythm' has occasionally been published under this title.

Clará had a great interest in music, an interest fostered by his relationship with Isadora Duncan. In this work, which was probably partly inspired by her, he attempted to express the impression of rhythmic physical movement without sacrificing the stability and equilibrium which he regarded as essential to sculpture. In 1927 Fontainas, no doubt reflecting Clará's own account of his intentions, described 'Rhythm' as the perfect realisation of his search for 'the law of equilibrium' based on a reconciliation of contrary impulses: 'Thus a masterpiece is born from his chisel . . . where two delightful creatures, tender and veiled, advance and yet at the same time stay still, open outwards and yet also turn inwards, pull apart and yet also come together, separate and yet also embrace, united by rhythm.' (*L'Amour de l'Art*)

Characteristic of Clará's work of this period, 'Rhythm' combines naturalistic modelling with idealisation, and expresses openly his sense of identification with the classical tradition. The two nymphs, or maenads, evoke the idea of joy in spontaneous and uninhibited movement and are associated with the ideal of Arcadian innocence. Robustly and sensuously modelled, they have a Rubensian character, although Clará was surely also influenced by fourth-century BC and Hellenistic traditions of carving, in which the accent is on naturalistically rendered movement enhanced by clinging, windswept drapery. Comparisons could be drawn with the statues of the 'Nereid Monument' from Xanthos (in the British Museum), or with the 'Victory of Samothrace' (Louvre). The contrast with the more abstracted and hieratic work of his friend Maillol is marked (compare, for instance, 'Flora', cat.89), and it was not until the 1920s and 1930s that Clará sought consistently to emulate Maillol's sobriety and simplicity.

41

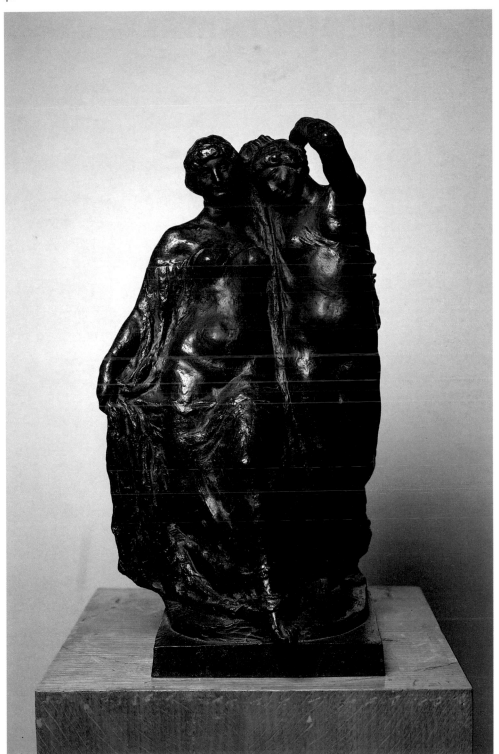

42 Isadora Duncan

 (a) **Dancing to Schubert's** *Marche Militaire* 1913–16
 Ink and watercolour on paper, 34 × 26
 (b) **Dancing to Schubert's** *Marche Militaire* 1913–16
 Ink and wash on paper, 34 × 26
 (c) **Dancing to Tchaikovsky's** *Marche Slave* 1913–16
 Ink and watercolour on paper, 34 × 26
 (d) **A Tragic Destiny** 1927
 Ink on paper, 34 × 26
 Museo Clarà, Barcelona

These drawings represent a small selection of the scores which Clará made of Isadora Duncan between about 1903 and her sudden and dramatic death in 1927, strangled by her own scarf in a motor accident on the French Riviera. His relationship with her was intimate, and both admired each other's work intensely. (She possessed a representative collection of his small bronze sketches.) In 1927 Isadora's *Ecrits sur la danse* appeared with Clará's illustrations (Grémier, Paris), and the following year facsimiles of seventy-two of his drawings of her were published in a memorial album, with a preface by Georges Denis (Editions Rieder, Paris). Three of the drawings (a–c) exhibited here are almost identical to three plates in this album, where they are identified with particular pieces of music. The fourth drawing (d) is dated 1927, and was done after her death. It commemorates Isadora as a devoted mother embracing her two children, who had both been killed in an accident in 1913. (Although this drawing does not appear in the album, the children's death is evoked by Denis in his preface, where he describes how he and Clará watched Isadora dancing with the children just two days before they were killed.)

All the drawings of Isadora are remarkable for their fluidity and spontaneity. None is highly finished, for it was clearly Clará's intention to capture in line her own ecstatic and uninhibited response to the music, and the electric thrill she produced in her spectators. Despite the rapidity and freedom of execution, throughout the series Clará's command of form is impressive, and one is frequently aware of echoes of the Greek carvings and vase paintings which were also the inspiration behind the dance movements of Isadora: like him she had carefully studied the collections housed in the British Museum when she was in Lon-

don in 1899, and claimed to have found in them confirmation for the rhythmic movements which she had hitherto expressed instinctively. Barefoot, clothed in light clinging draperies based on the traditional Greek chiton, she seemed to Clará's generation to express perfectly the living spirit of Greek dance, and contemporary descriptions of her dwell on the statuesque beauty of her body. Clará recorded his impressions not only in his drawings, but in a long and ardent entry in his diary:

> Isadora Duncan, that incarnation of rhythm and of eternal grace, comes to my studio occasionally and I go to her home from time to time, to that great enchanted palace. She is too generous in praise of my works; she is very kind. Lightly clothed, she deigns to dance for me alone in the enormous hall of her temple. I work, I sink into this pool of grace and pure beauty as into the most delightful dream. How happy I feel when far, far away from the reality of this world I experience eternally beautiful moments in those hours of dreaming which are for me divine reality. It is then that the vulgar life of this world appears to me as insubstantial and unreal. (Undated. Quoted in J. Teixidor, *La Evolución plástica del arte de José Clará*, Madrid, 1941.)

42a

42b

42c

42d

SALVADOR DALÍ 1904 FIGUERAS – 1989 FIGUERAS

Dalí's 'neoclassicism' of the mid-1920s constituted only a short phase at the beginning of his career, when he was still experimenting with a great variety of stylistic options. Nevertheless it signalled what were to be lasting preoccupations, and abiding traits of his mature work – an obsessive interest in the work of certain old masters and certain famous works of art of the past, and a dependence on the meticulous illusionistic style and technique of nineteenth-century academic painting for the expression of his highly idiosyncratic vision. The relationship between some of his classical paintings of around 1925 and much of his work from the late 1930s onwards is often surprisingly close, while the paintings he executed at the time of his closest collaboration with the Surrealist group make ironic use of an exaggerated, Mannerist form of classicism.

Dalí's father was an eminent notary in Figueras, and the family owned a holiday house on the beach near the fishing village of Cadaqués. Throughout his life, even when he reacted against Catalan nationalism and identified himself culturally and politically with conservative, central Spain, Dalí remained devoted to the Catalan landscape. Whatever his circumstances he always spent part of the year on the coast, which is the setting for very many of his paintings. This identification with his native land was something he shared with all the Noucentista poets and artists.

Dalí showed a precocious interest in art, and in 1916 enrolled in the drawing classes of an academic artist called Nuñez. Early surviving paintings already indicate his taste for nineteenth-century Salon painting, and for Dutch seventeenth-century genre painting – Vermeer had become a veritable obsession by the time he was twenty. In 1921, rather than study in Barcelona, Dalí went to the Academy of Fine Arts in Madrid, the most prestigious in Spain. While there he met García Lorca and Luis Buñuel, whose friendship proved mutually stimulating and productive. Apart from a year in 1923–4, when he was rusticated under suspicion of anarchist activities, he remained at the Academy until 1926. His final report suggests a wayward performance – failing in some disciplines, doing

well in anatomy and drawing from plaster casts, but, prophetically, excelling in the history of antique, medieval and modern art.

At the Academy Dalí was known as a radical, and from 1922 onwards he worked his way through virtually every avant-garde twentieth-century French or Italian style from Pointillism to Purism, usually practising more than one simultaneously. Dalí's sources of information were primarily *Valori Plastici*, through which he was introduced to contemporary Italian art, and particularly metaphysical painting, and *L'Esprit Nouveau*, the Purist magazine which contained many articles on the Cubists. Some of his paintings of *c.* 1923 are, however, entirely in tune with Catalan Noucentista 'classicism', in particular with the Cézannesque landscapes with nudes by Sunyer, and it is most likely that Dalí's slightly later 'neoclassical' and 'romantic-realist' phase of 1925–6 was made via this native version of the 'return to order'. Dalí's remarkable talent for assimilation was quickly recognised, and while still a student he was given a one-man show at the avant-garde Galeries Dalmau in Barcelona in November 1925, at which he exhibited recent paintings in a range of different styles. In recognition of the success of this first exhibition, Dalmau gave him a second just over a year later. In effect, his career was fully launched.

In the spring of 1926 Dalí paid his first visit to Paris, where he spent time in Picasso's studio. His work on his return instantly reflected his familiarity with Picasso's latest expressionistic, Cubist-Surrealist paintings. Influenced by the writings of Lorca and the Catalan poet and critic J.V. Foix, and by his growing knowledge of Parisian Surrealism, Dalí's own paintings in 1927–8 showed a marked Surrealist orientation as he abandoned the classical and realist styles he had practised a year or so earlier. He co-authored the iconoclastic *Manifest Groc* in 1928, and the following spring joined Buñuel in Paris for the making of the revolutionary Surrealist film *Un Chien andalou*. He remained there for a couple of months and, through Miró, was introduced to the leading Surrealist poets and painters. Dalí's impact on the group –

The artist in his studio in Paris, 1932 (Photo: Brassaï)

currently reeling from a series of violent 'defections' and 'expulsions' – was immediate and electrifying, for he offered a much needed injection of new life. *Un Chien andalou*, screened in Paris for the first time in October 1929, was an instant *succès de scandale*, and was hailed as a masterpiece by André Breton and featured in the final issue of *La Révolution Surréaliste*. From then, 1929, until the mid-1930s Dalí was one of the most prominent and active members of the movement, writing prolifically for Surrealist periodicals, and creating sensational objects and environments for group exhibitions. His self-styled 'paranoiac-critical method', developed in 1929–31, was greeted by Breton as a major contribution to Surrealist thought, and he was given important exhibitions in Paris at the Galerie Pierre Colle in 1931 and 1932.

But it was Dalí's brilliant commercial success in New York, where he had his first one-man show in 1933, that finally launched him as an international star, and that eventually led to his estrangement from Breton, who could not forgive him for what he

regarded as the vulgarisation of Surrealist
ideals. Dalí finally broke away from the
official movement in the late 1930s, but
remained for the general public the epitome
of what Surrealism in painting really meant.

43 Portrait of the Artist's Father and Sister 1925

Pencil on paper, 50 × 33
Private Collection

This is one of the finest of Dalí's classical
drawings, and an excellent example of his
ability to exploit the academic techniques of
draughtsmanship he had acquired at the
Academy in Madrid. There is an almost
identical drawing in the Museu d'Art
Modern in Barcelona, in which the shading
around the temples and cheeks of the sitters,
especially of Dalí's sister Ana María, is not
so emphatic. The heavier shading and the
crisp, firm outlining around eyes and
mouths of the drawing displayed here draw
attention to the marked physical similarity
between father and daughter. In the other
version Ana María appears more frail and
gentle.

This drawing was exhibited in Dalí's first
one-man show at the Galeries Dalmau in
Barcelona in November 1925. The exhibi-
tion also included a splendidly pugnacious
painting of his father, seated at exactly the
same angle, but holding a pipe in his left
hand (also 1925; Museu d'Art Modern,
Barcelona). The picture immediately
reminds one of Ingres's marvellous study of
a tough, domineering, middle-aged bour-
geois, 'Portrait of Monsieur Bertin'
(Louvre). The drawing is equally Ingres-
que, for it was Ingres's usual practice to
expend infinite detail on the face, but to
treat the rest of the body more rapidly and
more sketchily. That Dalí fully intended the
public to pick up these references, and that
he wanted his reliance on Ingres to be
understood as part of a total aesthetic
programme, is clear from the catalogue of
the Dalmau exhibition. There he quoted
three of Ingres's maxims: 'Drawing is the
probity of art.' (This was followed immedi-
ately by the reproduction of the drawing of
his father and sister.) 'He who will not look
to any other mind than his own will soon
find himself reduced to the most miserable
of all imitations, that is to say, to his own
works.' And 'Beautiful forms are straight
planes with curves. Beautiful forms are
those which have the firmness of plenitude

43

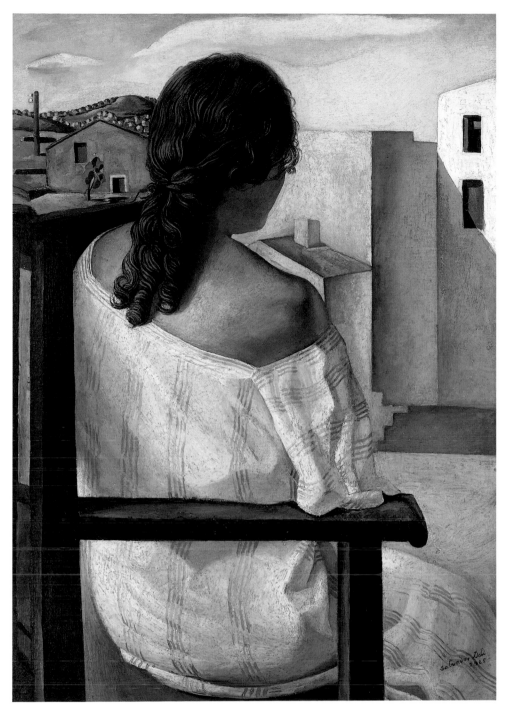

44

where details do not compromise the large masses.'

Another certain source for the drawing was Picasso, whose return to classicism was the model for Dalí's own, and whose debt to Ingres was the subject of much contemporary commentary. In composition and in its pure outline style it is very close to the double portrait of Serge Diaghilev and Alfred Seligsberg, drawn when Picasso was in London in 1919 (Musée Picasso, Paris), and reproduced the following year in the first issue of *L'Esprit Nouveau*.

44 Seated Girl Seen from the Back 1925
Oil on canvas, 103 × 73
Centro de Arte Reina Sofia, Madrid

This painting was exhibited at Dalí's one-man show at the Galeries Dalmau in Barcelona in November 1925. Regarding it as a major achievement and as representative of the new direction of his art, he chose it to go on the cover of the catalogue. During his time at the Academy in Madrid Dalí's work was remarkable for its eclecticism, and whereas the contemporary drawing of his father and sister (cat. 43) is easily classified as 'Ingresque', this painting sets up a variety of echoes, all of them broadly anti-Cubist in their implications.

In 1924 Dalí had painted a large, pastel-coloured still life in the manner of Carrà and Morandi. The legacy of metaphysical painting is felt in 'Seated Girl' in the abstracted, rectilinear treatment of the chair, balcony and right-hand group of buildings, and in the general air of stillness and enigma. On the other hand the illusionistic conception of the girl reflects the influence of the Catalan realist painter and critic Feliu Elias, and suggests that Dalí had also seen illustrations of recent German Neue Sachlichkeit and Italian Novecento painting. The back view of the girl is intentionally disorienting, but the centralised composition, the abrupt juxtaposition of foreground and background, and the strong even lighting and meticulous draughtsmanship all signal Dalí's admiration for the Flemish and Italian Primitives: turned round to face us, the girl could be the Madonna seated before an open view. This readiness to range between and combine disparate sources was Dalí's way of answering the 'call to order', while at the same time sounding a distinctive personal note.

[91]

ANDRÉ DERAIN 1880 CHATOU – 1954 GARCHES

Derain's popular fame now rests on his Fauve paintings, but he was a key figure in the whole story of the 'return to order' in French art before and after the First World War, epitomising the paradox at the heart of a movement dedicated to innovation through revival, and exerting a very widespread influence both in France and abroad during the 1920s.

In 1898, while still a student at the Ecole des Mines in Paris – his father wanted him to be an engineer – Derain enrolled in the painting classes at the Académie Camillo. Two years later he met Vlaminck. They set up a studio together in Chatou, and through Vlaminck he was introduced to Matisse. Derain began making copies in the Louvre – the start of a lifelong interrogation of the art of the past which was complemented by wide reading in literature and philosophy. Released from three years of military service, he studied at the Académie Julian in 1904, and painted with Matisse in Collioure the following summer, achieving instant notoriety with the Fauve canvases he exhibited on his return to Paris in the Salon d'Automne. In 1906 Derain's friendship with Picasso began, and his work, like that of Picasso, now showed increasing signs of his interest in Cézanne and in primitive art – he was one of the pioneer collectors of *art nègre* (African and Oceanic art).

Under contract to Kahnweiler, Derain executed thirty-two primitivist woodcuts for an edition of Apollinaire's *L'Enchanteur pourrissant* in 1909 – the first illustrated book to be published by Kahnweiler. He was also in regular touch with Picasso, Braque and their circle, but despite these contacts Derain was not seriously drawn to Cubism, although he shared many of the same formal preoccupations, and some of his paintings are touched by the early Cubist style. Instead he embarked on renewing his art by way of studying the old masters – a practice which he would pursue for the rest of his life. Among his favourite models before the war were Poussin and Cézanne, the Italian Primitives and the Douanier Rousseau, Byzantine and French Romanesque and Gothic art. The closeness of the relationship to his sources varied considerably, but the choice of model for a

particular picture was always guided by his expressive intentions.

At the outbreak of war Derain already enjoyed the reputation of a leading contemporary artist, for his work had been much exhibited abroad. During the war, however, when he was mobilised and barely able to work at all, his personal *retour à l'ordre* came to be seen by contemporary critics not only as heroic, but as prophetic. In 1916 Paul Guillaume organised an exhibition of Derain's work and invited Apollinaire, an old friend and admirer, to write the preface. This celebrated text is of significance as a kind of manifesto for the 'call to order' movement, but it has particular importance in the story of the subtle shift in critical attitudes towards Derain. Apollinaire begins by distinguishing between the 'fake classicism', promoted by the 'pernicious' Winckelmann, and the 'daring innovations' of nineteenth-century French painters who tried to 'rediscover the authentic tradition of art'. The contemporary French school, of which Derain is the 'outstanding' example, has had exactly the same aim, he goes on – that is, 'to submit itself boldly to the disciplines of the Great Tradition'. 'Derain has studied the great masters passionately', and 'by a stroke of unequalled daring, he went beyond the most audacious experiments of contemporary art in order to rediscover the simplicity and freshness of the first principles of art'. Abandoning his 'youthful earthiness' (Fauvism), he 'turned towards sobriety and measure', and his art 'is now imbued with that expressive grandeur that stamps the art of antiquity'. In his new work, which is 'both audacious and disciplined', he is 'close to attaining his aim, which is to realise a blissful harmony, at once realistic and sublime'. At a stroke Apollinaire turns upside down the modernist credo – which he himself had done much to promote in earlier writings – that innovation in art depends upon the creation of a new style. Derain is seen as a hero, not because of his role in the 'invention' of Fauvism, but because he had the courage to resist the lure of the 'experiments' of his contemporaries (the Cubists and Orphists), and to take to its natural conclusion that devotion to the 'disciplines of the Great

The artist, *c.*1924 (Photo by Man Ray)

Tradition' which, Apollinaire claims, actually prompted those very same 'experiments'. The message is clear: the time for experiments, however audacious, is past; Derain's way – back to the Great Tradition – is the right way forward.

Once demobilised, Derain found himself in the happy position of being in step with the latest developments, rather than needing to catch up. On Kahnweiler's return to Paris in 1920 Derain renewed his contract with him, but in 1923 he transferred to the more fashionable Paul Guillaume. In 1919 he was asked to design the sets, costumes and curtain for Diaghilev's production of *La Boutique fantasque*, a sure sign of his prestige. This was the first of many theatrical commissions, and he was equally prolific as an illustrator. In 1921 he went to Rome to study the work of Raphael, and painted a series of landscapes at Castelgandolfo which reveal his veneration for Corot. Another important series of landscapes of Saint Maximin in 1930 reveals that this admiration had not worn off, and it was around this time that he began to exchange some of his African sculptures for Greco-Roman and Egypto-Roman portraits (which

influenced his paintings in the 1930s).

Meanwhile he had become the subject of long articles, and between 1920 and 1931 seven monographs on him were published. In these the broad lines of Apollinaire's argument were taken up and developed. Every writer draws attention to his reverence for the Great Tradition, and everyone insists upon his 'Frenchness'. During the post-war period chauvinism was rife, and Derain's identification with the French tradition – especially the Le Nain brothers, Watteau, Chardin, Corot, Courbet, Ingres, Manet, Renoir – explicit in his paintings as well as in his conversation, made him a congenial subject. André Lhote was not alone in calling him quite simply 'the greatest living French painter' (*La Nouvelle Revue Française*, 1921). It is significant that at the Kahnweiler Sequestration sales of 1921–3 Derain's work reached high prices, and Kahnweiler was able to buy back only a handful of works.

Inevitably, there was a backlash. Although Derain's position as a great modern French master was challenged rela-tively rarely in the immediate post-war years, as the decade wore on and he resisted the new impulses within the avant-garde, voices of protest against his conservatism were more often raised. His work had become much looser in style, more decora-tive, and its eclecticism began to some critics to seem confused rather than purposeful. Such was the polarisation of critical opinion by 1930–31 that *Les Chroni-ques du Jour* ran a questionnaire entitled 'André Derain: Pour ou contre' (For or against). Predictably, those now on the politico-cultural right, such as Waldemar George, were particularly emphatic in their support for his unflinching opposition to 'modern fads' and commitment to the pre-eminently 'civilised' and 'eternal' values of French art. But some of the younger critics, among them Pierre Courthion, spoke of an 'abdication'. Nevertheless Derain remained an influential force in French realist paint-ing throughout the 1930s, the serious decline in the reputation of his post-Fauve paintings occurring only after the Second World War.

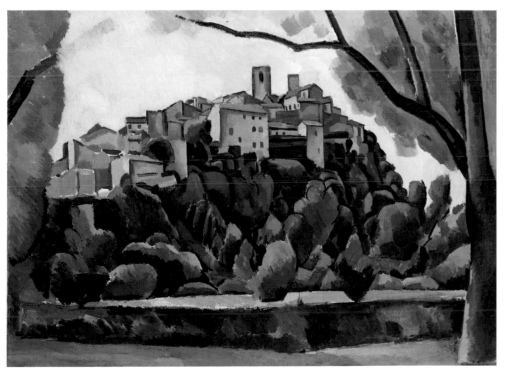

45

45 View of St Paul-de-Vence
1910

Oil on canvas, 60.5 × 81
Museum Ludwig, Cologne

Derain painted a series of views of Cagnes and the neighbouring countryside in 1910 before going to Cadaqués with Picasso. The most ambitious of these is 'The Bridge at Cagnes' in the Chester Dale collection (National Gallery of Art, Washington), which shows a statuesque peasant woman, bearing a basket on her head, in the fore-ground of the composition. With or without figures, all the paintings in the series betray Derain's classical conception of the Medi-terranean towns and landscape through his very choice of models from the past. Both this and the Chester Dale picture are par-ticularly Poussinesque in the geometrical treatment of the distant buildings, the sym-metry of the centralised compositions, and the stage-like arrangement of the view into a series of horizontal bands parallel to the picture plane. St Paul thus becomes the perfect classical landscape, the equivalent to the Roman Campagna. Cézanne's views of the Montagne Sainte-Victoire were equally important to Derain, who was evidently taking upon himself Cézanne's self-deter-mined goal of 'redoing Poussin after nature', and his technique in these pictures is par-ticularly Cézannesque. There was no doubt a degree of nationalist, as well as personal, pride in Derain's way of tracing, as it were symbolically, his artistic heritage through Cézanne to antiquity: he was laying claim to the rich expressive associations and mean-ings of his models.

It should also be noted that Derain's views of Cagnes and the region bear close comparison with the Cubist landscapes painted by Picasso and Braque in 1908 and 1909: Derain may have been spurred on to make them partly because of what his friends had achieved. But, of course, there was no incompatibility between Cubism, Cézanne, and, for that matter, Poussin. On the contrary, Cubism was regarded by avant-garde critics as a classicising move-ment. And from this point of view it is valuable to compare the later Noucentista landscapes of Miró, which depend upon the same range of sources, with these paintings by Derain. (See cat.122.)

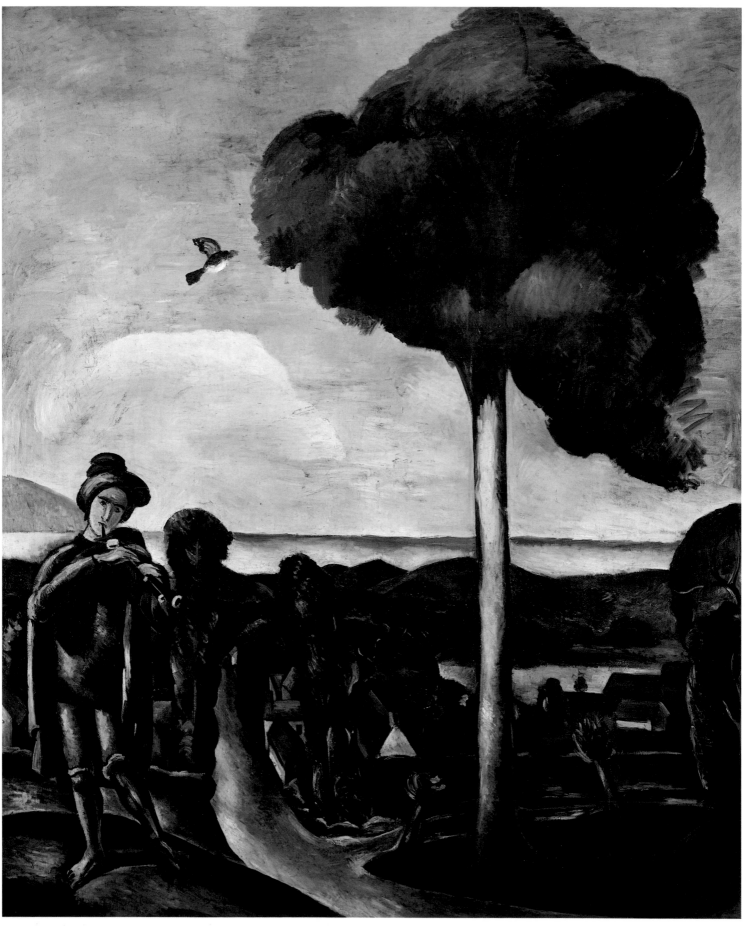

46

46 The Bagpiper 1911

Oil on canvas, 188 × 150
*Minneapolis Institute of Arts, bequest of
Putnam Dana McMillan*

Derain spent the summer of 1911 near the
village of Camiers, Pas-de-Calais. After his
return to Paris, he painted this ambitious
composition which he said had been
inspired by the memory of a shepherd piper
who had passed by him while he was
painting a view of the village below. 'The
Bagpiper' quickly became one of Derain's
best known pre-war pictures, for it was
reproduced by both Kahnweiler and
Salmon in their monographs (published
respectively in Leipzig in 1920, as by
D. Henry, and in Paris in 1924). It helped to
establish his reputation as a painter 'in the
Great Tradition' – that is, still concerned
with large formats and grandly composed
timeless subjects.

The painting was one of Derain's most
lyrical and romantic works to date, and in
that sense it anticipated the dreamy and
nostalgic subject pictures he painted after
the war, particularly the Harlequin series
which developed the theme of the alliance
between painting, poetry and music, already
so potent here. In composition 'The Bag-
piper' owes something to Cézanne, for
Cézanne would sometimes take a very high
viewpoint down on to the middle ground
and then up to the horizon. And in handling
it is still Cézannesque. The composition,
dominated by the huge tree, was also proba-
bly intended to call to mind the Arcadian
landscapes of Claude, with their shepherds
and wood nymphs. But the 'naïve' charm of
the subject speaks most strongly of folk art,
such as the traditional French *images d'Epi-
nal*, and especially of the imaginative, but
'realistic' paintings of the Douanier Rous-
seau. Rousseau, who died in 1910, had been
the subject of intense interest within the
avant-garde for some years. He was the
perfect model for Derain, because his paint-
ings of exotic forests, peopled with natives
playing pipes, with wild animals and birds,
were drawn from his imagination and pos-
sessed a powerful aura of magic and vision.
'The Bagpiper', based on the memory of an
event in itself so magical and poetic that it
must have seemed like a vision when recol-
lected in the Paris studio, may be compared
to Rousseau's 'The Snake Charmer' (Musée
d'Orsay, Paris) or 'The Toll House' (Cour-
tauld Institute of Art, London).

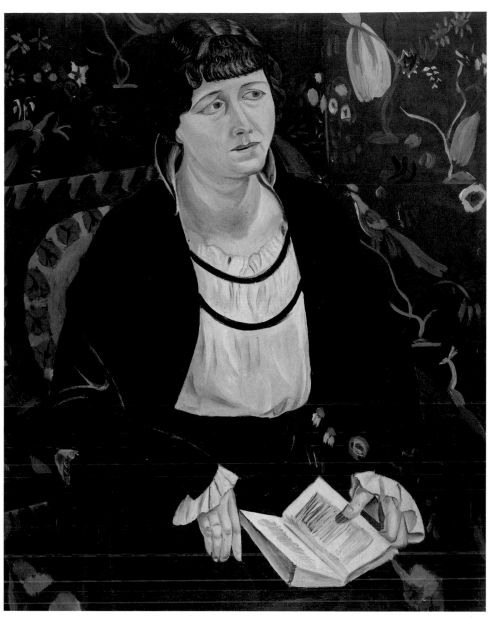

47

47 Portrait of Madame Kahnweiler 1913

Oil on canvas, 92 × 73
*Musée National d'Art Moderne, Centre
Georges Pompidou, Paris, gift of L. and
M. Leiris, 1984*

Derain first met Kahnweiler in the spring of
1907. He painted two portraits of Kahn-
weiler's wife Lucie, of which this was the
first; it was preceded by a full-size prepara-
tory drawing on canvas. At the same time
Derain also made portrait drawings of
Kahnweiler himself, perhaps originally
intending to paint a pendant portrait. The
'Portrait of Madame Kahnweiler' was
sequestered by the French authorities after
the outbreak of war, and was auctioned in
the first Kahnweiler sale in June 1921,
where it was sold for a high price (18,000
francs) to Kahnweiler's rival, Paul Rosen-
berg. In 1922 Derain painted a second
portrait of Madame Kahnweiler to 'replace'
the one sold. This shows her seated in a
Louis XV armchair, and facing in the
opposite direction.

In the twelve months before the declara-
tion of war Derain was much preoccupied
with portraiture and figure painting, and
these works tend to be of an extreme
austerity and simplicity, as he strove to
confer on his sitters some of the dignity and
severity of the Byzantine and early Italian
art he so admired. Compositions depend on

the most familiar and uncomplicated geometric formulae; space is flattened; detail is suppressed; drawing is simplified to the point of wilful naïveté; paint is applied thinly and impersonally; faces become impassive, generalised masks; individuals are turned into types. The 'Portrait of Madame Kahnweiler' is as solemn as the other contemporary figure paintings, and has an equally lucid and simple structure, but is exceptional in the emphasis on rich decorative detail. Indeed, the contrast between the brilliantly patterned tapestry or screen in the background, riotous with birds and flowers, and the sitter's mournful and weary expression gives the work a pathos which, with hindsight, seems to reflect the mood of anxious foreboding prevalent in Europe at the time.

Whatever Derain's precise expressive intentions may have been, it seems clear that he was directly inspired by the portraits of Ingres in creating this masterly painting. For Ingres loved to set up a telling play between figure and ground, to develop intricate formal relationships between plain and patterned areas, and gradually to establish a dominant linear rhythm which brought the whole of the composition into a perfect, inflexible unity. Derain's painting is less rigorous and more tentative than an Ingres, but there is no mistaking the homage to a work like the 'Portrait of Madame Rivière' (Louvre). Kahnweiler himself, writing in 1920 of Derain's studio in the rue Bonaparte before the war, commented: 'The great shadow of Ingres lives here.' ('Werkstätten', *Die Freunde*, vol.I)

In its debt to Ingres, this portrait anticipates in a remarkable way the Ingrism in French art after the Armistice, and specifically the Ingrism of Picasso. Indeed it is possible that Picasso's 'Olga Picasso in an Armchair' of 1917 (repr.p.11), in which the strangely inert and introspective model sits in a boldly decorated tapestry-covered chair, was partly inspired by Derain's painting, which Picasso must certainly have known.

48 The Italian Model 1921–2

Oil on canvas laid down on board,
91 × 72
Trustees of the National Museums and Galleries on Merseyside, Walker Art Gallery, Liverpool

Derain went to Rome in 1921 with the particular intention of seeing the work of Raphael. He wrote to Kahnweiler towards the end of September, following the trip: 'I am working again with great eagerness. . . . I must admit that I think constantly of the old masters.' Paintings like this one are the direct outcome of his visit, and the gentle demeanour of the girl, the incline of her head, the idealisation of her features, and the attention to drawing are intended as his homage to Raphael's portraits, such as 'La Donna Velata' (Pitti Gallery, Florence).

However, it is as if Raphael has been seen through the lens of French nineteenth-century painters who had made the pilgrimage to Rome and absorbed its lessons into their work. For the subject of a pensive model dressed in a picturesque Roman peasant costume immediately suggests the precedent of Corot. (The precise source for 'The Italian Model' may be Corot's 'Woman with a Pearl' in the Louvre.) After the war Corot's figure paintings were the subject of intense interest in France, and Derain himself seems to have been much preoccupied with the idea of Corot as the ideal mentor for his new paintings. While in Italy he painted landscapes of Castelgandolfo in the manner of Corot, and in 1923 he bought his first painting by Corot. He told André Breton: 'Corot is one of the greatest geniuses of the Western world. We are nowhere near exhausting the mystery of his art.' And he went on to say – heretically – that in comparison Cézanne 'hangs by a thread. His painting is as pleasing as facepowder.' ('Idées d'un peintre', *Littérature*, May 1921)

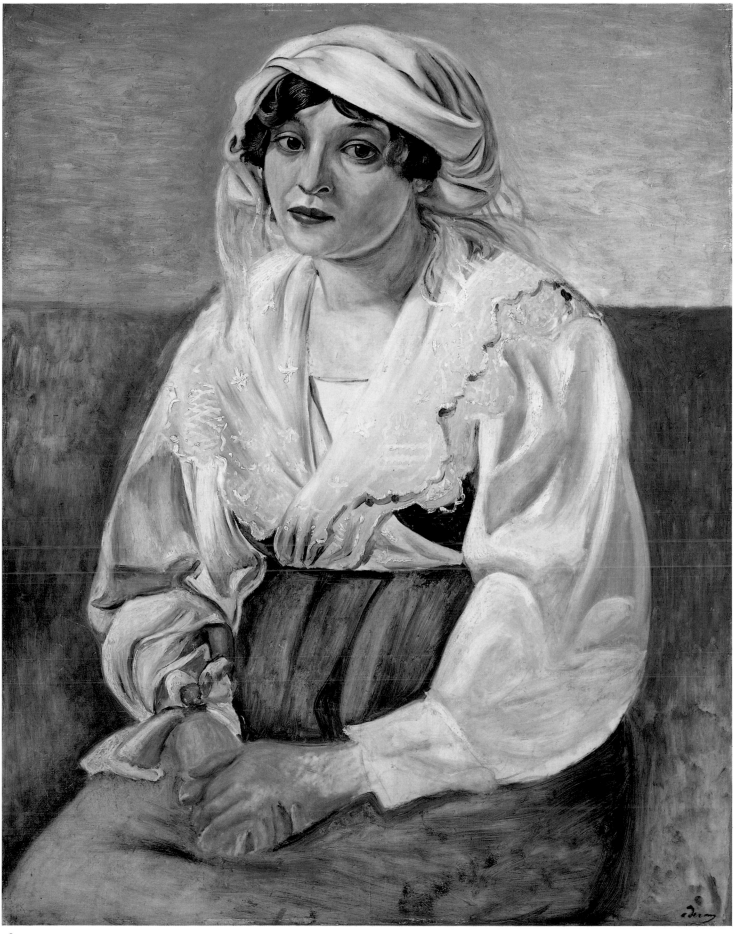

48

49 The Lovely Model *c.*1923

Oil on canvas, 115 × 90
*Musée de l'Orangerie, Paris, Collection
Jean Walter and Paul Guillaume*

Like many other artists, including Picasso,
Derain became very interested in Renoir's
work after the war, and especially after his
trip to Italy. In 1923 he painted the 'Portrait
of Madame Hessling' in exchange for four
small paintings by Renoir, and 'The Lovely
Model' may be seen as a personal act of
homage to the late nudes, which were
particularly admired at the time. Typically,
however, Derain borrowed aspects of
Renoir's work only when appropriate to his
own expressive intentions. Here, painting a
buxom, healthy peasant-type – exactly the
kind of girl Renoir liked – and seeking an
effect of frank and warm sensuality, Derain
found Renoir the ideal mediator. But when
painting, at exactly the same period, the
realist subject of a laden kitchen table
strewn with pans and dishes, Derain based
himself on Chardin and his mid-nineteenth-
century followers ('The Kitchen Table',
Musée de l'Orangerie, Paris, Collection
Jean Walter and Paul Guillaume).

Paul Guillaume, who owned 'The Lovely
Model', also bought paintings by Picasso,
and the relationship between Derain's
picture and works such as 'The Large
Bather' (cat.141) is an intriguing one. The
two artists were still on close terms, and no
doubt watched each other warily. Derain's
painting is more conventional than that of
Picasso – closer to the genuinely academic
in the pose, composition and the treatment
of space. But he may have been directly
influenced by Picasso's tendency in the early
1920s to use black or very dark grounds for
his figure paintings. The dense black
ground of 'The Lovely Model', which
shows through the flesh and the drapery,
gives it a sombre tonality very different from
the hot colour of Renoir's late work.

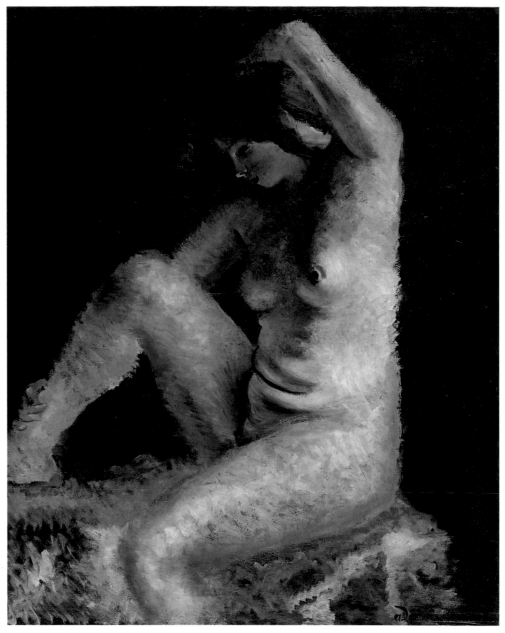

49

50 Still Life with a Melon *c.*1927

Oil on canvas, 50 × 58

Musée de l'Orangerie, Paris, Collection Jean Walter and Paul Guillaume

Except during the Fauve period, still life remained an important genre for Derain until his death. Not only did it allow him freedom to develop a pictorial idea through a subject over which he had ready control, but it became a vehicle for him to express his identification with the realist French tradition from the Le Nain brothers onwards. In this instance, the still lifes of Manet and Renoir seem to be his sources – Manet for the deft and seemingly casual way in which the fruit and leaves are painted and are displayed upon the cloth, and Renoir for the high, hot key of the colour and for the areas of soft and broken brushwork.

But over and above this, the painting is a disarmingly candid statement of the idea of the Mediterranean as a place of incomparable beauty, serenity and delight. For the fruits have been carefully selected: they are the fruits of the south – melon, grapes and peaches. They are arranged in a simple dish on a plain white cloth which glows with the warm golden reflections of sunlight. It is as if they have just been picked from the terrace outside for the simple but delicious meal that will soon be enjoyed. The vine leaves laid out at the front of the cloth lend the whole Arcadian scene a discreetly Bacchic air, with the curling tendrils and stalks setting up a dancing rhythm. This may be 'only' a still life, but it has the power of a timeless symbol of natural fertility.

50

CHARLES DESPIAU 1874 MONT-DE-MARSAN – 1946 PARIS

Despiau, with Bourdelle and Maillol, was the most admired independent sculptor of his generation in France, and exerted a strong influence on many younger artists. After his death, however, his reputation suffered a serious decline from which it has never recovered.

In 1891 Despiau arrived in Paris and began studying at the Ecole des Arts Décoratifs under Hector Lemaire, a former pupil of Carpeaux. Two years later he transferred to the Ecole des Beaux-Arts where he studied for three years under the successful academic sculptor Louis Barrias, and thoroughly familiarised himself with the collections of the Louvre and the Musée des Monuments Français. From the outset he concentrated on portraiture, exhibiting a bust for the first time in 1898 at the Salon des Artistes Français. Few commissions came his way at first, and he was forced to tint picture postcards to make ends meet. Nevertheless he exhibited regularly at the Salon de la Société Nationale des Beaux-Arts, where in 1907 his plaster bust of 'Paulette' attracted the admiration of Rodin, who immediately engaged him as an assistant. For the next seven years Despiau worked in Rodin's studio, executing several important marbles for him. This did not prevent him from producing independent sculpture, and as a mark of the esteem in which he was held he was made Chevalier de la Légion d'Honneur in 1911, the year in which the State purchased the marble version of 'Paulette'.

After the war Despiau was commissioned by his home town to create a war memorial, which he completed in 1922. His reputation grew steadily in the 1920s, and many fellow artists, whose approach was fundamentally conservative like his, commissioned portraits of their wives or daughters. (They included the painters Derain, Friesz, Lévy, Aman-Jean and de Waroquier.) Increasingly Despiau interspersed his portraiture with female nudes in classical poses and heroic male athletes, and in 1925 he was commissioned by the State to create a stone monument of his 'Female Faun' for the town of Saint-Nazaire. The following year Despiau was upgraded to Officier de la Légion d'Honneur. (He became Commandeur in 1936.) Many other honours, and various prestigious teaching posts, were conferred on him over the next ten years, and in 1937 he received a final commission from the State for the Exposition Internationale of a five-metre-high statue of Apollo, destined for the terrace in front of the Musée d'Art Moderne. (It was not ready in time for the exhibition, and remained unfinished at his death.)

Despiau was well represented at the exhibition of Independent Art held in Paris to coincide with the International Exhibition of 1937, but this marked the climax of his career. He had been friendly with the German sculptor Arno Breker – soon to become Hitler's favourite artist – when Breker was studying in Paris. During the Occupation he not only attended the exhibition of Breker's work held at the Orangerie in 1942, but went on a tour of German cities organised by Breker, and wrote, or perhaps merely signed, a monograph on him. Despiau was not forgiven for these 'acts of collaboration', and was ostracised at the end of his life. No retrospective exhibition was devoted to him in France between the modest show organised by his friends at the Cercle Volney in Paris in 1949, and the large one held in the Musée Rodin in 1974.

But when Despiau's star was in the ascendant, at the time of the 'return to order', great claims were made for him as an artist, while the 'candour' and 'modesty' of his personality were repeatedly cited. A series of admiring monographs and articles appeared by well-known and respected writers on the conservative wing of the art world. He was often likened to Corot – a great compliment at this period when Corot was regarded across the full critical spectrum as one of the greatest of all French artists. In the patriotic post-war climate Despiau was, indeed, frequently perceived as the archetype of the 'serene' and 'lucid' French artist – the Derain of sculpture – and parallels were drawn with French medieval and Renaissance art. He was praised for having avoided the modish and ephemeral 'extravagances' and 'tricks' of the avant-garde, and was defined as the perfect 'natural' classicist – that is, not an archaising 'neoclassicist' like Maillol. The

The artist at the Villa Corot, 1912 (Photo: Musées des Landes)

critic A.-H. Martinie claimed that Despiau had done for French sculpture what Moréas had done for French poetry – returning it to its pure, classic roots (*L'Amour de l'Art*, November 1929). Flattering comparisons were drawn with Egyptian and archaic Greek art, and with Donatello and the Italian Primitives. The verdict of Claude Roger-Marx, in his monograph published in 1922, is typical: Despiau, he writes, is 'always well balanced; the enemy of romanticism; faithful to the most familiar reality because that is the true, living reality; devoted to calm rhythms and stable lines; careful to circumscribe his compositions within a form that is pure and geometric, yet able to avoid systematic deformation.' 'The model chosen by Despiau', he continues, 'is no more than a pretext. . . . Like the great sculptors of all times – Egyptian, Greek of the sixth-century, Chinese, Roman – he departs from the individual to arrive at the type. . . . All his portrait busts are so generalised that they rise above their epoch. . . . achieving permanence, and transcending all that is ephemeral and fugitive'. Despiau, he concludes, 'has a divine sense of moderation, and among contemporary sculptors not one, except Maillol, is the equal of this great man'.

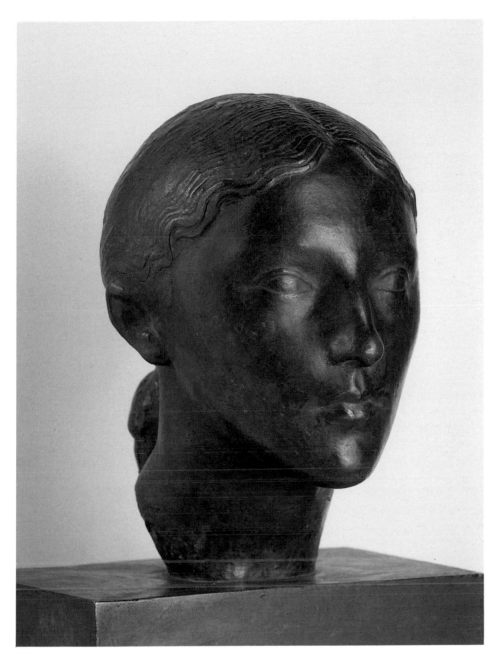

51

51 Girl from the Landes 1909

Bronze, 47.5 × 27 × 27
Musée des Beaux-Arts, Bordeaux

A plaster of the first state of this sculpture
was exhibited in 1905 at the Salon de la
Société Nationale des Beaux-Arts. Under its
definitive title, a slightly modified version
was shown in the same Salon in 1909. On
this occasion the State purchased the plas-
ter, and one of the seven bronzes cast that
year. The work became one of Despiau's
best known and most admired busts, and
was reproduced in most of the early essays
and monographs devoted to him.

 In comparison with the earlier 'Little
Girl from the Landes', exhibited in 1904
and also bought by the State, 'Girl from the
Landes' is considerably less naturalistic and
more impersonal, and several of Despiau's
admirers, including Roger-Marx, saw it as
'Egyptian' in its impassive tranquillity and
its unity of form. For Despiau has genera-
lised and idealised the head, flattening the
brow and smoothing the transition between
it and the nose into an approximation of the
unified profile of classical Greek sculpture;
the eyes are blank and perfectly shaped, and
the hair, symmetrically parted in the mid-
dle, ripples to a gentle, regular rhythm. The
identity of the model is unknown, and is in
any case irrelevant, since Despiau has
clearly wished to depict a type, and to confer
on the simple country girl the dignified
beauty of a goddess.

ANTONIO DONGHI 1897 ROME – 1963 ROME

Donghi, unlike many other painters associated with the Italian new classicism, did not pass through a phase of avant-garde stylistic experimentation. This was partly due to his relative youth – he began to make his career as an artist when the ideas of the 'return to order' were already established – and partly to the fact that by temperament and training he was drawn instinctively to a meticulous and painstaking style. He kept aloof from the main groupings of Italian artists (and, indeed, has been seen as closer in spirit to contemporary German painting), but in the early 1920s he became known as a leading reinterpreter of traditional art.

He studied at the Istituto di Belle Arti in Rome, graduating in 1916. After a period of military service during the war, he spent time studying art in Florence and Venice, particularly that of the eighteenth and nineteenth centuries. This was clearly a formative experience, as his works of the early 1920s already show his concern with strong composition, luminosity and smooth brushwork, which were the hallmarks of his mature style. In 1923 he exhibited at the second Biennale in Rome along with Carlo Socrate and Antonio Trombadori, young artists who at that time were also exploring the art of the museums. Critics were unsure what to make of these young painters' virtuosity and love of tradition, and could not agree on the significance and value of this seemingly retrograde type of art. It was only in 1924, following one-man exhibitions at the Sala Stuard and at the Casa d'Arte Bragaglia in Rome, that Donghi's career was launched. Some critics doubted whether Donghi could be bracketed with 'neoclassical artists' (one wrote that his work lacked the 'intellectual' quality of Casorati or Funi), but they were at one in praising his mastery of traditional plastic values, his meticulous brushwork and his striking scenes of popular life. The almost uniformly favourable response to the museum-inspired work of this relatively unknown artist suggests that the ideas of the 'return to order' and 'neoclassicism' were already well entrenched. Leading art critics such as Ugo Ojetti became loyal supporters, and the composer and theoretician of the 'return to

order' in music, Alfredo Casella (see cat.27), collected his paintings.

Abroad, Donghi's rise to fame was equally swift. There had been strong interest in modern Italian art in Germany ever since the successful touring exhibition of works by the *Valori Plastici* group in 1921 (a tour which incidentally encouraged the development of the style in Germany known as Neue Sachlichkeit). In his influential survey of the new European trend towards realism, *Nach-Expressionismus: Magischer Realismus; Probleme der Neusten Europäischen Malerei*, published in 1925, Franz Roh listed Donghi together with such major Italian exponents of the new 'magic realism' as de Chirico, Severini, Casorati and Funi. In 1926 Donghi took part in a mixed show of contemporary Italian art in Boston, and in the following year he held a successful one-man exhibition in New York and won first prize in an international exhibition at the Carnegie Institute, Pittsburgh. A quiet person, he was reluctant to discuss publicly the nature of his art, and seems to have wanted to disassociate himself from any particular movement (he participated only in the second of the *Novecento Italiano* exhibitions held in 1929).

Donghi's slightly humorous and sometimes deliberately naïve domestic scenes earned him a reputation as a populist artist. However, his enormous technical skills and his willingness to identify with the Great Tradition of painting were equally recognised and respected. In the catalogue to his one-man show at the Rome Quadriennale in 1935 Donghi wrote that he aimed to combine in his paintings the legacy of the old masters with a modern naturalism:

I have looked at the great painters of the past without exaggerating, in other words, without using them as reasons for composition or style. I have chosen to paint any aspect of humanity that has struck me with a simplicity of composition and colour. In executing a work I have always wanted to end up, even if it costs me great pains, with the feeling that the viewer could read clearly what I have seen and felt.

The artist, *c*.1922

Although his work went out of fashion after the Second World War, Donghi exhibited regularly, and the observation, humour and meticulous style of his pictures continued to find an appreciative audience.

52 Washerwomen 1922
Oil on canvas, 148 × 95
Private Collection

This scene of women washing and hanging out clothes combines a modern subject with echoes of traditional art. The gentle, honey-toned light emanating from the faces and limbs of the women owes something to Caravaggio and Gentileschi, while the simplified treatment of the drapery suggests a concern for 'classical' qualities of contour and volume. The figures stand immobile like statues, giving the painting its magical air of life in suspension. As one critic wrote in 1924,

Undoubtedly the most interesting element in Donghi's painting is that

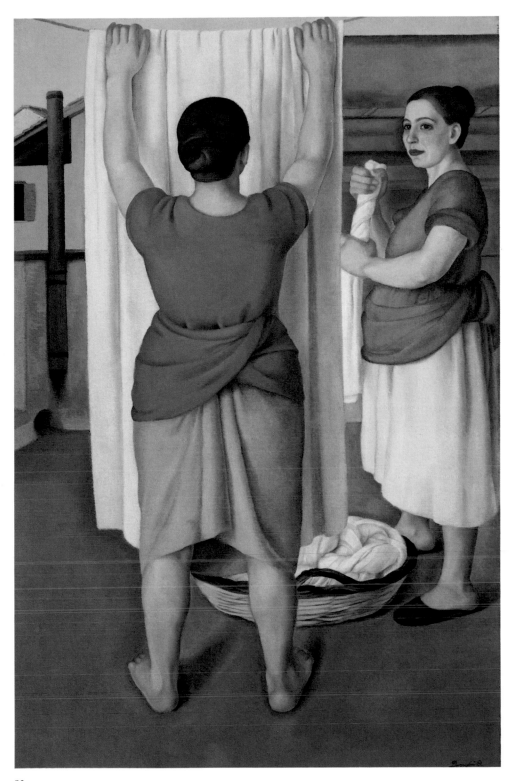

52

startling, unexpected sense of people and objects in an ordinary setting, all moving towards the centre of the earth, each one with its own particular weight, as simple and fresh as the first creations in the newly-made world. It is as if before taking up his brush, Donghi had immersed all the accoutrements of his models in a bath of quick-drying glue, so as to be able to study them better close-up, good and still, and to redo them even more solid and compact than he had found them in nature'. (R. Mucci, *Il Nuovo Paese*, December 1924)

Donghi's choice of subject matter and concern for order and geometry in painting give his works an affinity with those of the neo-Impressionist painter Georges Seurat. Seurat, with Cézanne, was seen as having pioneered a reaction against the apparent formlessness of Impressionism, and he was admired in Italian avant-garde art circles both before and after the war. The publishing house of Valori Plastici, for example, produced a monograph on him by André Lhote in 1922. In this painting echoes of Seurat can perhaps be detected in the buxom, self-possessed women and in the order and clarity of the composition.

The painting was first shown at the Galleria Pesaro in Milan in December 1924, together with works by artists such as Casorati, de Chirico, Guidi, Oppi and Socrate. It went to America in 1926 and was exhibited at the Museum of Modern Art in Boston in a show of contemporary Italian art. The catalogue essayist referred to what he called the 'New Classicism so popular in present-day Italy'. 'Something of the spirit of bygone Hellas seems to have been wafted across to the land of cypress and sun', he wrote, 'for these painters one and all worship purity of form and clarity of contour. . . . each is in some measure impelled by a well-defined impulse to renounce the accidental and superficial, and reflect the reasoned unity of sober coloration and essentially integral volume.' The painting was included in Donghi's highly successful one-man show at The New Gallery, New York, in 1927 where it was among the most expensive works on sale. It was bought by an American collector and only recently returned to Italy.

EMILE-OTHON FRIESZ 1879 LE HAVRE – 1949 PARIS

Friesz began painting under Charles
Lhuillier at the municipal art school in Le
Havre in 1896, and in 1900 graduated to the
Ecole des Beaux-Arts in Paris where his
teacher was Léon Bonnat, the fashionable
society portraitist. Bonnat's work made little
if any impact on Friesz, who was already
painting in a resolutely anti-academic,
impressionistic manner – as might indeed
be expected from a native of Le Havre,
where Boudin and Monet had painted out-
doors together some forty years before. He
began exhibiting at the Salon des Indépen-
dants in 1903, but his close association with
Matisse dates from 1905, when they both
rented studios in the old Couvent des
Oiseaux. That year he exhibited alongside
Matisse in the notorious 'cage of the wild
beasts' in the Salon d'Automne. Another
close friend was Braque, whom Friesz had
first met at the art school in Le Havre, and
he was instrumental in Braque's temporary
conversion to the Fauve style.

But although Friesz had enthusiastically
espoused the brilliant, Mediterranean col-
our and spontaneous brushwork of Fauv-
ism, and shared the Fauves' lyrical, exalted
approach to landscape and figure subjects,
he had a strong instinctive commitment to
disciplined pictorial structure and a predi-
lection for monumentality. He later com-
mented: 'We who gave birth to Fauvism
were the first to kill it. Colour ceased to
dominate the canvas. Drawing was reborn
from volume and light. Colour remained
delicious but secondary.' (Quoted in M.
Gauthier, *Othon Friesz*, Geneva, 1957.)
Like so many avant-garde artists of his
generation he venerated Cézanne, finding in
his work the synthesis between a classical
sense of construction and a deeply personal
response to nature which was his own goal.
By 1907–8 Friesz's paintings showed the
imprint of Cézanne's Bather compositions.

Friesz had spent long hours studying the
old masters in the Louvre ever since first
arriving in Paris, and his sense of the
continuing importance of the great art of the
past was further encouraged by a trip to
Italy in 1909, where he was particularly

The artist, *c*.1912

impressed by Giotto and Raphael. In Portu-
gal in 1911 he found the structure of the
landscape Poussinesque, while the rocks
reminded him of Filippo Lippi. His conver-
sation was full of such comparisons, and in
the first monograph on him, published in
1920, André Salmon quotes this typical
epigram: 'Tradition is to art what Adam and
Eve are to the tradition of mankind.'

Between 1908 and 1914 Friesz painted
many large canvases, for the most part on
Arcadian themes, and these established his
reputation after the war as a leading moder-
nist who was none the less evidently an heir
to the French classical tradition. (This, for
instance, is how Salmon characterises him
in 1920.) His work enjoyed increasing
esteem in the 1920s, and in 1925 he was
awarded the Carnegie Prize. The following
year he was created Chevalier de la Légion
d'Honneur, and scored a great popular
success with a monumental and rousing
painting of the port of Toulon.

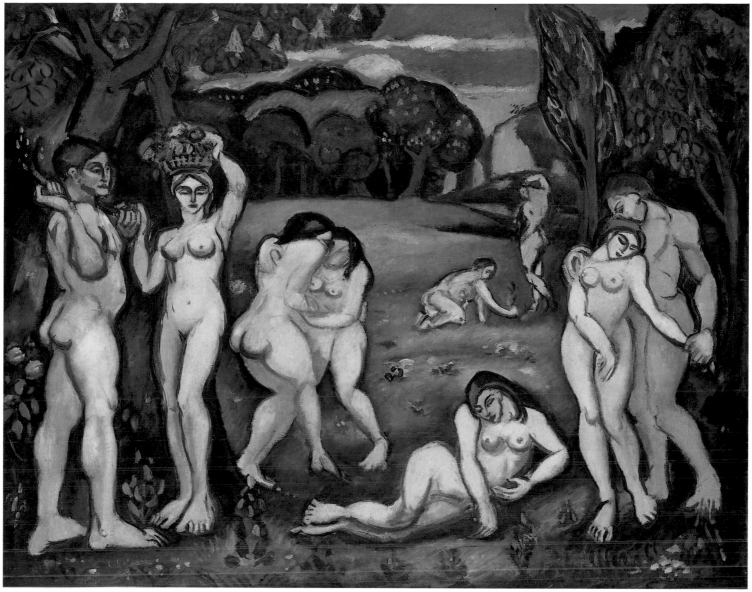

53

53 Spring 1908

Oil on canvas, 81 × 100
*Musée d' Art Moderne de la Ville de
Paris*

'Spring' was first exhibited at the Salon
d'Automne in 1908, and belongs to a series
of ambitious, quasi-allegorical canvases
executed between then and 1914. (Others
include 'Work in Autumn', 1908, 'Sum-
mer', 1910, and 'Women at the Fountain',
1912.) Idyllic in mood, their underlying
theme is the perfect harmony of man and
nature. This is expressed not only through
the familiar paradisal imagery of lush
vegetation, reclining nudes, happy lovers,
peasants labouring in the fields, mothers
suckling their babies, or statuesque women

collecting water at a well, but also through
the rhythmically conceived compositions in
which the rhyming shapes of figures and
landscape interlock in sweeping arabesques.
This kind of imagery, which resurfaced in
avant-garde art during the Symbolist per-
iod, was much favoured by the Fauves:
'Spring' contains many near-quotations
from important earlier paintings by Matisse,
notably 'Bonheur de vivre' (Barnes Founda-
tion, Merion, Pennsylvania), which was the
succès de scandale of the 1906 Salon des
Indépendants. Meanwhile Friesz's great
admiration for Cézanne's Bather paintings
is reflected in the composition and volu-
metric treatment of the bodies, although the
frank eroticism of the scene has no equiva-
lent in Cézanne's work.

Friesz was never drawn into the orbit of
Cubism, despite his friendship with Braque.
Nevertheless several major paintings by
Braque and Picasso in 1908, from which the
'analytical' phase of Cubism developed,
shared this primitivist, Arcadian subject
matter, and it was used widely a few years
later by the more theoretically inclined
'Salon' Cubists, such as Gleizes and Le
Fauconnier. For them, as for Friesz, an
obvious link with tradition and 'important'
subject matter were major concerns, and it
is probable that Friesz's compositions had
some influence on them. It is equally poss-
ible that his paintings interested Sunyer:
works such as 'Pastoral' (cat.169) are in
certain respects closer to Friesz than to
Cézanne, who is usually cited as the source.

[105]

ACHILLE FUNI 1890 FERRARA – 1972 APPIANO GENTILE

Funi was baptised Virgilio, but his absorption in classical myth led him to adopt Achille as his first name during the First World War. Such intense concern for the classical past was typical of an artist who became known for his neo-Renaissance style, and in particular for his murals, which were much influenced by Greek and Roman prototypes as well as by Raphael and Ingres.

Funi was born in Ferrara, a city which had been a major cultural centre of Italy in the fifteenth and sixteenth centuries and which boasted many artistic and architectural relics of its past. He remembered being taken regularly as a child to the Palazzo Schifanoia where he was impressed by the great fresco cycles of Cosimo Tura and Cossa (a point cited at the very beginning of Margherita Sarfatti's 1925 monograph on the artist). His father worked as a baker; and the concepts of 'trade' and 'apprenticeship' had no doubt been firmly lodged in his mind when he began studying art at the Civica Scuola di Belle Arti at the age of twelve. He was particularly keen on classical literature, especially Tacitus, as well as later writers such as Dante and Ariosto, and throughout his life he remained deeply attached to these authors.

In 1906 Funi moved with his family to Milan. He enrolled at the Accademia di Brera and studied under a master of nineteenth-century Lombard Impressionism, Cesare Tallone. After his graduation he hesitated for a while about whether to follow an academic or an avant-garde path. However, his friendship with Carrà and Boccioni inclined him, on the eve of the war, to a style inspired by Futurism. His paintings of this period, such as 'Man Getting on a Tram', 1914 (Civica Galleria d'Arte Moderna, Milan), combined abstract planes with figurative elements in a Futurist style, but also retained a sense of solid volumes and a traditional pictorial space. In 1914 he exhibited with the Futurist Gruppo delle Nuove Tendenze, and in the catalogue he emphasised his concern to 'purify' and 'synthesise' what he called the 'plastic, rhythmic and chromatic phenomena'.

Together with other Futurists, Funi enlisted in December 1914, some time before there was any obligation to do so. He spent four years in the army, during which time he saw action at the front. Although his father was a committed socialist, Funi opposed the non-interventionist line of the Italian Socialist Party. This led him (like many of his background and generation) to seek an alternative that would be both radical and nationalist, and in March 1919 he attended the famous meeting in Piazza San Sepolcro in Milan which marked the official launching of the Fascist movement.

Funi continued to support Mussolini and his Fascist government after 1922. He was a friend of Italo Balbo (the leading Ferrarese Fascist who became one of the most prominent personalities of the regime), and was regarded in the 1930s as a prominent exponent of the ideology of the government. The driving forces behind his development as a painter, however, seem to have been a profound identification with the national tradition and, above all, a love of the classical world. Like many artists and writers, he associated these attitudes with the spirit of the new regime; and by the late 1920s the regime had itself, albeit unofficially, accepted a classicising art (though not necessarily Novecento art *per se*) as perhaps the most appropriate vehicle for its ideology.

In 1919, however, Funi still identified with the Futurist movement, although he was concerned about what direction it should follow. In January 1920 he signed, along with other Futurists, including Mario Sironi, the 'Manifesto contro tutti i ritorni in pittura'. This tract argued that after the analysis and dissection of forms in the pre-war period, avant-garde art should now search for a new plastic synthesis. The Futurist work of both Funi and Sironi, unlike that of Boccioni, had been marked by its formal solidity, and in many ways the manifesto was an attempt to legitimise their own style. However, Funi began to associate in this period with the artists and writers who were to shape the Novecento movement. In the salons of the newspaper proprietor Umberto Notari and of Margherita Sarfatti he regularly met, in addition to wealthy patrons, the writer Massimo Bontempelli (who pioneered a metaphysical classicism in literature), and artists such as

The artist in his Milan studio, 1966

Sironi and Arturo Martini. Through the auspices of Margherita Sarfatti, Funi spent six months in 1920, along with Martini, at the villa near Lake Como of a Milanese industrialist. His surviving works of this year show that he hovered between a modernist style, influenced in part by the metaphysical painting of Carrà and de Chirico, and a more naturalistic one. It was not until 1921, encouraged by the interest of Milanese intellectuals in the 'return to order', that he began to adopt a style and imagery inspired by the Renaissance. He later wrote of this departure in his work: 'My love for the old masters of Lombardy, and above all for Foppa and Leonardo, and my concern with the problems of composition and plastic research, led me between 1920 and 1923 to paint a group of works ['Maternity', 'Earth', cats.54,55] that I regard as a milestone in my career' ('Auto-presentazione', *Quadriennale*, Rome, 1931).

Margherita Sarfatti had for some time hoped to organise a new artistic movement to reflect the spirit of modern Italy, and in 1922, with the help of the gallery owner Lino Pesaro, she put on an exhibition entitled *Sette pittori del Novecento*. Funi was among the artists represented. This, and later exhibitions, established the Novecento not as a particular style but as a movement

that combined the Italian tradition of art with contemporary plastic concerns or, more generally, with a sense of modernity. Funi readily responded to this, and turned to the art of the Renaissance (which he had long known and studied), filling his paintings, which were often of ostensibly modern subjects, with quotations from the old masters. In the opening paragraph of her monograph on Funi ('this patient and solid builder'), Margherita Sarfatti linked the modern plastic qualities of his work with the Renaissance heritage of his native town of Ferrara: 'a firm sense of line and strong colour, in the manner of Cosimo Tura, Costa and Cossa, whose works are for ever stamped on the luminous walls of Schifanoia, in those grand, elegant and sumptuous frescoes'.

Funi continued to exhibit with the Novecento group in the late 1920s, and even became a member of its executive committee; but by this time he had moved away from his earlier Renaissance-inspired style. He was briefly influenced by Picasso's neoclassical figures, and then by the sensuous brushwork of Derain, before becoming fascinated by the Ancient Roman frescoes of Pompeii. His paintings and murals, with their classically draped figures and rich Pompeian colour scheme, were emphatically neoclassical. Oddly enough, Sarfatti had anticipated Funi's later career when she described him in her book of 1925 as something of a natural muralist: 'His canvases, with their lack of artifice, and their sober, unadorned appearance, invite comparison with the opaque, unvarnished splendour, the uniform surfaces untouched by distortions and corrections, of good frescoes'. Funi's first mural was executed for the fourth Triennale in Monza in 1930 on the theme of the *Aeneid*. In 1931 he worked on decorations for the church of San Giorgio al Palazzo in Milan, and two years later, along with most of the leading artists of the day, he painted a fresco for the fifth Triennale in Milan, taking as his subject 'Italian athletic games'. Funi was genuinely excited by the didactic and social possibilities of mural painting, and in 1933 he signed a manifesto by Sironi which claimed that this art form embodied the ideals of the Fascist state. Funi executed many other religious and secular mural works during the 1930s, including a cycle for the Ferrara town hall on episodes from the writings of Ariosto and Tasso. He was made a professor of fresco painting at the Accademia di Brera in 1939, a post to which he returned in the late 1940s after a break of a few years. Although he did not abandon easel painting, after the war he focused largely on religious mural decorations. From 1957 until his retirement three years later, he was director of the Brera.

54

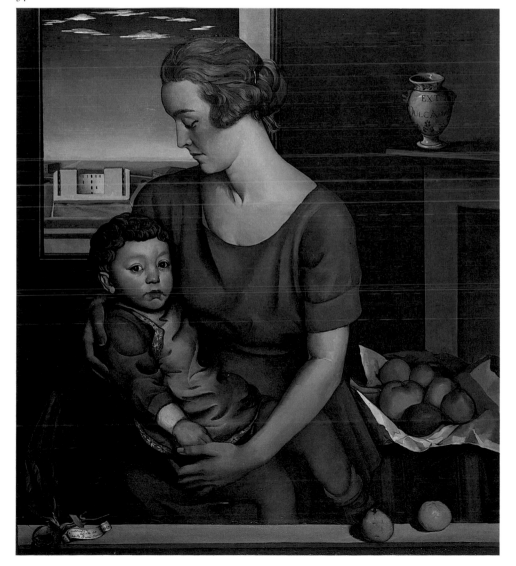

54 Maternity 1921
Oil on canvas, 100.5 × 91
Antonio and Marina Forchino, Turin

This painting, which was exhibited in 1922 at the Venice Biennale, was one of the first of Funi's neo-Renaissance works, and came to be regarded as representative of the ideals of the Milanese Novecento movement. Funi later said that even during his Futurist phase he had continued to study and admire Renaissance artists, in particular Leonardo; but his attempt to blend old and new in his works of the early 1920s was plainly encouraged by discussions in the salons of Margherita Sarfatti and Umberto Notari on the need to build a modern Italy on the foundations of her former greatness.

Using the highly traditional subject matter of a mother and child, Funi has presented here an obviously modern, and urban, maternity scene. The serene expression of the mother contrasts with the strangely adult gaze of the child in a manner which recalls Leonardo's 'Virgin of the Rocks'. The strongly architectural composition of the painting, consisting of the rectangles of a table, fireplace and window, is reminiscent of fifteenth-century art; but through the window, beneath the Mantegna-like sky, can be seen modern factory buildings, indicative of northern Italy's industrial economy.

Margherita Sarfatti, organiser of the Novecento movement, was the first owner

of this work. In her monograph on Funi of 1925 she devoted a long passage to it in which she stressed the combination of modern and traditional references:

> Here in 'Maternity' we have a young woman worker or a member of the petty bourgeoisie dressed in simple clothes. The child she holds on her knees is quite large, of the sort that Andrea del Sarto liked; he is not naked but wears a little brown suit and apron made of cheap material that can be easily washed at home. And yet the woman lowers her eyes on him with such simple purity that 'Madonna' and 'Mother of Christ' are plainly written on her face. The empty hearth beside her, and the fruit in the white greengrocer's paper in front of her, have the dignified and silent appearance of holy things. The small bright cirrus clouds beyond the frame of the window arrange themselves naturally in a circle over her head like a halo. . . . The flat, square factory – an industrial workshop or mill – is set solid and compact in the green plain with a horizon tinged with pink, like the round temple at the top of the hill from which Raphael's maidens emerge: a building of our times; holiness, greatness and redemption in our day comes with work even for those who are not always able or do not know how to pray.

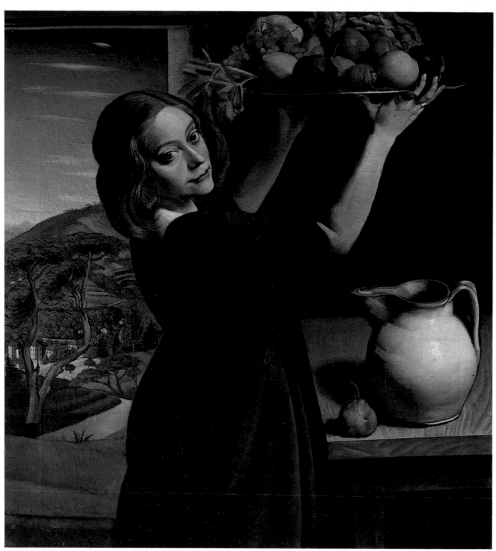

55

55 Earth 1921

Oil on canvas, 100 × 90
Private Collection

Like 'Maternity' (cat. 54), this painting draws on Funi's close study of Renaissance art (the girl's pose is often said to have been inspired by Titian's 'Lavinia', Staatliche Museum, Berlin), and reflects his love of tradition. Certain details, such as the girl's dress and physiognomy, and the work's surface qualities, give the painting a modern feel; but there is no sense of detachment in this celebratory return to the art of the sixteenth and early seventeenth centuries. As the title suggests, the painting is an allegory of natural fertility, and the girl (a portrait of the artist's sister Margherita), the fruit and the rich Tuscan landscape all contribute to the theme. Margherita Sarfatti may have been alluding to this painting

when she wrote in her monograph on the artist in 1925, 'Flora, Pomona or Diana, their arms tense and strong, hold out the fruits of the earth with the proud, controlled strength of Atalanta, who rules the world.' She went on to praise Funi's concern for detail and volume, which in her opinion were the essential qualities of modern painting. 'The fruit too, and even the flowers', she wrote, 'are drawn spontaneously within precise forms; and his clouds conform to clear-cut spatial laws'.

Sarfatti defined the ideals of the Novecento movement as the creation of a synthesis between modernity, in both art and contemporary life, and the great achievements of Italy's past:

> The drama in modern painting can be said to be this: not to renounce modernity, and to unite it to the historical climate of the eternal. To define the

contemporary state of the human soul, and our modern vision, with the same manner and accents as things that endure; to discern, amidst the tangle of fleeting, complex impressions, only that which is simple and unchanging. (*La Rivista illustrata del Popolo d'Italia*, March 1926)

The blurring of distinctions between past and present in Novecento art often created a sense of uprootedness or dislocation (not dissimilar to the 'enigma' in metaphysical painting), a symptom itself, perhaps, of modernity. Some artists, including Picasso, relished the irony and contradictions derived from the pastiche of tradition, but Funi was a whole-hearted admirer of the achievements of the past. His later works, certainly from the late 1920s, can be seen as acts of homage to ancient art and its revival in the Renaissance and neoclassical periods.

PABLO GARGALLO 1881 MAELLA – 1934 REUS

Although Gargallo was born in a village in Aragon, of Aragonese parents, his background was Catalan, for Maella is on the frontier of Catalonia and he was only seven when the family settled in Barcelona. He was, indeed, permanently influenced by Catalan traditions in decorative sculpture and metalwork. In 1895 Gargallo was apprenticed to a successful Modernista sculptor, Eusebio Arnau, and executed a number of important decorative commissions for him before, in 1900, enrolling in the La Llotja School of Fine Arts in Barcelona. He frequented the café Els Quatre Gats, where he met the leading figures of the Catalan avant-garde, including Picasso and Manolo. Thanks to a bursary Gargallo was able to spend six months in Paris from October 1903 to March 1904. The reliefs he created after his return were in the medievalising style then fashionable in Barcelona, and between 1905 and 1910 he was engaged by the celebrated Modernista architect Lluis Domènech to provide the sculptural decoration for a number of important new public buildings, including the concert hall, the Palau de la Música. Contemporary with these decorative commissions is a series of carved and modelled nudes, all of them small, mannered in style and piquantly voluptuous, which already possess many of the stylistic characteristics of his mature work.

On a brief return visit to Paris later in 1907 Gargallo made his first mask from thin sheets of metal, relying on the traditional techniques of Catalan metalworkers and jewellers. Witty and ingenious masks and portraits, often with a satirical edge, constructed from cut sheets of iron and copper, became an important part of his work from 1911 onwards, and eventually established his reputation as an innovative sculptor in Barcelona and Paris, where he returned to live from 1912 to 1914. In Paris he met leading members of the literary and artistic avant-garde, including Apollinaire, Gris and Braque. Although the masks and figures constructed in metal, which are stylistically related to synthetic Cubism, found a ready market, Gargallo never totally abandoned more conventional sculptural techniques or stopped making sculpture in the round, and

for the rest of his life he worked simultaneously in both a 'radical' and a 'classical' manner.

In 1923 Gargallo gave up his post in the sculpture department in the Escola Superior dels Bells Oficis in Barcelona and settled in Paris, which remained his permanent home until his death. Affected by the 'return to order' in Paris, and by the Noucentista doctrines of Eugeni d'Ors, Gargallo now turned his back on the decorative, Cubist-inspired style of his recent modelled sculptures, in which the volumes were hollowed out to create a complex series of craters and pits, and began producing volumetric figures of bathers, naked peasant girls and male athletes which are frankly classical in style. The climax of the neoclassical strain in his work was reached in 1928–9 with the monumental sculptures of athletes mounted on horseback and male nudes driving chariots, which were commissioned for the Olympic stadium at Montjuíc and the Plaça de Catalunya in connection with the International Exhibition held in Barcelona in 1929. But he continued to produce classicising works, mainly of female nudes academically posed, until his death.

Simultaneously, throughout the 1920s and early 1930s Gargallo created many metal and iron constructions, concentrating on themes from the *commedia dell'arte* and from dance. In the late 1920s he benefited from the expertise of González, who taught him the techniques of welding. The complex, open structure of these works was adopted in his most ambitious and celebrated piece, the monumental 'Prophet', completed in 1933. The preparations for two major retrospective exhibitions scheduled for 1934 in New York (Brummer Gallery, February) and Barcelona (Sala Parés, December) undermined his already poor health, and he did not live to see this sculpture cast in bronze. In 1935 commemorative exhibitions were held in Barcelona (Sala Parés), Madrid (Museo de Arte Moderno) and Paris (Salon d'Automne).

The artist in his studio in Vincennes, *c*.1925
(Photo: Pierrette Gargallo Anguera)

56 Torso of a Young Gipsy 1924

Bronze, 71 × 24.2 × 22
Galerie Marwan Hoss, Paris

Working from a live model, Gargallo had
originally planned this as a full-length stone
statue showing the youth with his head
thrown slightly back and to the side, and his
left arm raised and bent over his brow.
However, the stone caused him problems
and the figure was reduced to the torso only.
Casts in both terracotta and bronze were
then made.

'Torso of a Young Gipsy', which was
executed soon after Gargallo's return to
Paris following almost a decade in Barce-
lona, is noticeably less mannered and less
decorative than the male nudes he had
sculpted a few years before. It reflects his
response to the classical revival then at its
height in France, and is directly inspired by
his renewed interest in the antique. Shown
in Barcelona and Paris from 1924 to 1926,
the sculpture was one of his most admired
classicist works at the period. Tériade,
mentioning it by name, commented on this
development in Gargallo's work in an article
published in 1926:

> As if from a need for control, a regular
> return to the great sources, a rejuvenating
> thirst for established laws, Gargallo alter-
> nates his metallic constructions with
> more traditional works. . . . Moreover,
> this periodic need for control through an
> instinctive return to classical stability, as
> if it were a matter of returning to the
> earth, is a need which we also find in
> Picasso, and indeed in most of the great
> Spanish artists, who possess an intrinsic
> ability to bring their strong romantic urge
> under the sway of formal order. (*L'Art
> d'Aujourd'hui*)

However, where sculptors like Maillol pre-
ferred the 'control' of archaic traditions,
Gargallo's pronounced taste for sinuous
grace and erotic voluptuousness made him
turn to later or more naturalistic sources,
such as the works of Praxiteles (which
Maillol strongly disliked) or Lysippus, and
also Donatello's 'David' and Renaissance
depictions of the martyred Saint Sebastian.

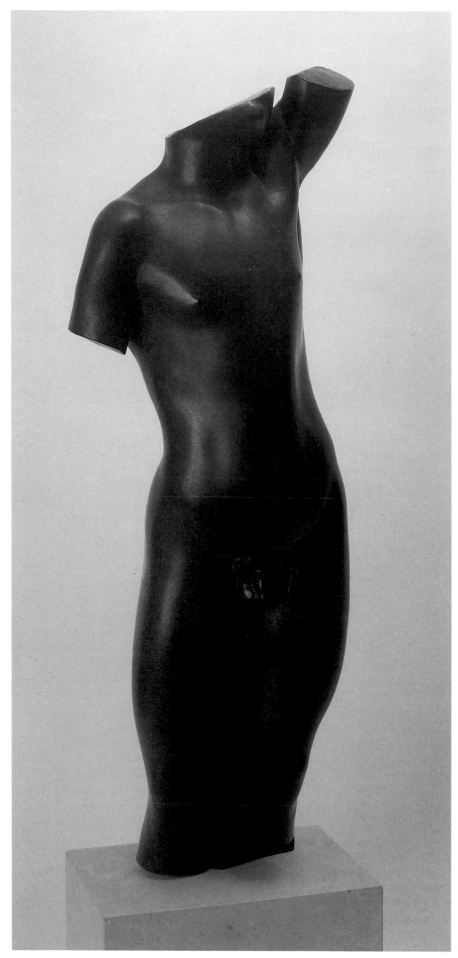

56

57 Small Torso of a Woman

1925
Terracotta, 26 × 8.5 × 7
Private Collection

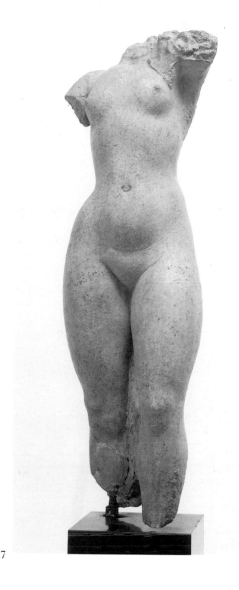

57

This small torso came about accidentally. Gargallo was working on 'The Water-carriers', which depicts two peasant girls, nude except for scarves on their heads, carrying water jars as they walk. The plaster of the slenderer girl got damaged, leaving the torso with breaks at neck, shoulders and calves. Gargallo liked the fortuitous effect of an antique statuette of Venus, and, having reworked it slightly, but leaving a tiny remnant of the headscarf on the shoulder, cast the fragment in terracotta. In 1933 he made a much enlarged version in terracotta called 'Torso of a Girl'. This also exists in bronze, and in black and flesh-coloured marble versions. Compared to the later enlargements, the 'Small Torso' is much less idealised, rougher and more earthy.

Like many contemporary sculptors in France, Italy and Spain, Gargallo loved to use terracotta, especially for his more intimate creations. The material had appealing primitive and antique connotations – some of the most ancient fertility idols were in terracotta, and third-century BC Tanagra figurines enjoyed great prestige in the early twentieth century. The material seemed ideally suited to the treatment of timeless, classical subjects such as the female nude. In Catalan Noucentisme the emphasis on unchanging patterns of peasant life and on the healthy, maternal country woman as a symbol of the ideal inevitably encouraged the use of such a rustic, unpretentious and tactile medium. Moreover its naturally blond colour pleased Mediterranean sculptors, who wanted the effect of strong even sunlight, and deliberately rounded and simplified the volumes of their figures in order to maximise the reflective surfaces.

JULIO GONZÁLEZ 1876 BARCELONA – 1942 ARCEUIL

González is now celebrated as the 'father' of modern metal sculpture, and it is the abstracted welded iron constructions, influenced by synthetic Cubism, which he made from about 1930 onwards that are invariably identified as his significant and 'mature' works. But in 1930 González was already in his mid-fifties and had a substantial artistic œuvre behind him, which, although certainly much more conventional in appearance and manufacture, provided the foundation for the imagery, style and technique of his most radical sculptures. It is in these earlier works that his closest links with Catalan Noucentisme and the 'call to order' can be seen.

González's grandfather and father ran a successful metalwork shop and forge in Barcelona, and Julio and his elder brother Joan (1868–1908) were both apprenticed to the family business while still in their teens, learning to cut, hammer and forge expertly all kinds of metals, and winning awards for their jewellery and wrought-ironwork. Both, however, aspired to be painters, and attended evening classes in drawing at the School of Fine Arts in Barcelona in 1892–3. From about 1897, the year of their first visit to Paris, the two brothers frequented the famous café-cabaret Els Quatre Gats, where they met leading members of the Barcelona avant-garde, including Eugeni d'Ors, Picasso, Sunyer, Manolo and Torres-García. Following a visit to Madrid to study in the Prado, Julio González was more than ever determined to concentrate on painting, and in 1899 he moved to Paris. For the rest of his life he lived in France, although he returned frequently to Barcelona. Many other Spaniards were attracted to Paris in 1900 by the Exposition Universelle, and González saw many of his old Barcelona circle, including Picasso and Manolo. Around 1903 he made friends with Gargallo who, like Picasso, would later benefit from González's expertise in welding.

In 1908 Joan González died. Deeply distressed by the loss of his brother, who had hitherto been his mentor, Julio became withdrawn and isolated, and according to family legend he temporarily abandoned painting. At this time he appears to have become more committed to sculpture – in

which he had had no formal academic training – and in 1910 he made his first masks in repoussé metal. His principal activity, however, remained his decorative work, and in the years before the outbreak of war he continued to make jewellery and ornamental objects in a variety of metals. In 1918 González was employed for several months in a metalworking plant at Boulogne-sur-Seine. This proved to be an important experience, for it was here that he learnt the oxyacetylene welding techniques he would employ to such outstanding effect some years later in his sculpture. In 1920 he opened a metalworking studio, and from this time on exhibited more regularly in the various annual Salons, having his first one-man show at the Galerie Povolovsky in March 1922.

González's first sculptures in iron date from about 1927, and it was then that he decided to concentrate on sculpture as opposed to decorative metalwork. In 1928 he began his highly significant collaboration with Picasso, who until 1931 created his own iron constructions with the help of González, often using González's studio and equipment. This collaboration undoubtedly greatly influenced the retiring and modest González, encouraging him in his decision to work independently as a sculptor in iron and on a more ambitious scale than hitherto.

In 1930 González had a solo exhibition at the Galerie de France, appearing exclusively as a sculptor for the first time. His association with the Cercle et Carré and Abstraction–Création groups in the early 1930s encouraged him to abstract his forms more boldly, although the link with objects in the real world was never completely broken and he remained strongly opposed to total abstraction in art. Further one-man shows at the Galerie Percier and the Galerie des Cahiers d'Art in 1934 established his reputation as a leading innovative sculptor, for in the early 1930s he had been highly productive and had created a great sequence of planar iron constructions, and the earliest of his more linear and open works which he himself defined as 'drawing in space'. But the underlying subject matter remained figurative, and in 1937 he was represented in the Spanish Republican Pavilion of the

The artist, c.1909

Exposition Universelle in Paris with a monumental realist sculpture in welded iron of a Catalan peasant woman, known as 'The Montserrat' (Stedelijk Museum, Amsterdam).

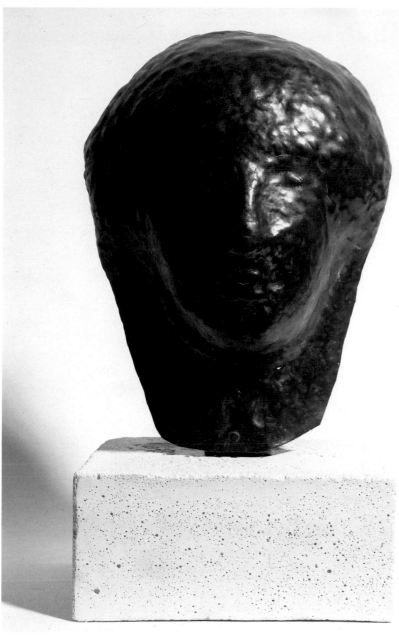

58

58 Head of a Woman *c.*1912–14

Repoussé copper, 31 × 25 × 15
Centro de Arte Reina Sofia, Madrid

This mask has also been exhibited as 'The
Egyptian'. González made the first of his
metal masks in 1910, and a small series of
them followed in the years before the
outbreak of war. Only a few of his sculp-
tures are securely dated, others, like this
one, being datable approximately by
association.

González learnt the traditional technique
of repoussé while apprenticed to his father
and applied it here to give the mask a
relatively uniform, gently pitted surface of
great sensitivity. His current admiration for
the fluid, modelled surfaces of the work of
the Italian 'Impressionist' sculptor
Medardo Rosso is clear, although the mask
is not emotionally expressive in the way
Rosso's sculptures always are. It is indeed
the inexpressiveness of the head, coupled
with its frontality, that gives it the air of a
battered antique fragment, whether
'Egyptian' or not. As a trained metalsmith
González admired the craftsmanship of
antique armour – he refers to its beauty in
his often quoted statement on the future role
of forged and hammered iron in sculpture.
(Reprinted in J. Withers, *Julio González:
Sculpture in Iron*, New York, 1978.) It is
likely that antique armour was a source for
him in this and the other bronze and copper
masks he made before the war.

In 1927–8, when he began working
seriously as an independent sculptor,
González's first works were masks. From
these developed the great sequence of
'Cubist' iron masks and heads made in
about 1930–32. The continuity between
them and the pre-war works is seen not only
in subject matter, but in the cutting and
handling of the sheets of metal, and the
sensitive treatment of the surfaces.

59 Woman Washing 1913

Oil on canvas, 110 × 60
Museu d' Art Modern, Barcelona

This has been identified as the work exhib-
ited in the Salon d'Automne in Paris in
1913. González executed numerous draw-
ings and pastels on the same theme during
the period 1906–14, which mark his
response to the pastels of Degas. Other
contemporary drawings are careful studies
of drapery, as if, in academic manner,
González were assembling the constituent
elements for a Salon painting on the trad-
itional theme of a woman at her toilette. An
undated pastel on brick-coloured paper is
very close to the painting, and was presuma-
bly the study from life which González
finally selected as the compositional sketch.
The painting follows the monochrome col-
our of the drawing and the disposition of the
highlights, but González has cropped the
edges close to the body and thus crammed
the figure into a highly compressed space,
producing an impression of monumentality
and primitive force which is wholly lacking
in the drawing itself. The flat, featureless
background from which the nude looms
towards the spectator, coupled with the
grainy surface texture and the monochrome
colour, create the effect of relief sculpture,
and it was at just this time that González
was beginning to concentrate on making
reliefs, albeit small in scale.

González's paintings have never been
valued highly by admirers of his later iron
sculpture, and are generally dismissed as
'unremarkable' and 'unoriginal'. Compari-
sons can, indeed, be drawn between
'Woman Washing' and paintings from
Picasso's trip to Gósol in the summer of
1906. And in general terms it relates to the
Gauguinesque or Cézannesque classicising
works of the period 1905–10 by such artists
as Matisse, Derain, Maillol and Maurice
Denis, and to the theory of 'modern classi-
cism' expounded by González's compatriot,
Eugeni d'Ors. However, it is also tempting
to see this painting as anticipating the return
to classicism in France of the wartime and
post-war years, and, conceivably, as having
had some impact on Picasso around 1920–
21. Picasso and González had earlier been
friends but they became estranged some
years before the outbreak of the war. They
were reconciled – exactly when is not
recorded, although it is known that it was in
Paris in 'about 1921' – and thereafter
remained on excellent terms. This picture
stayed in the artist's collection, and it is not

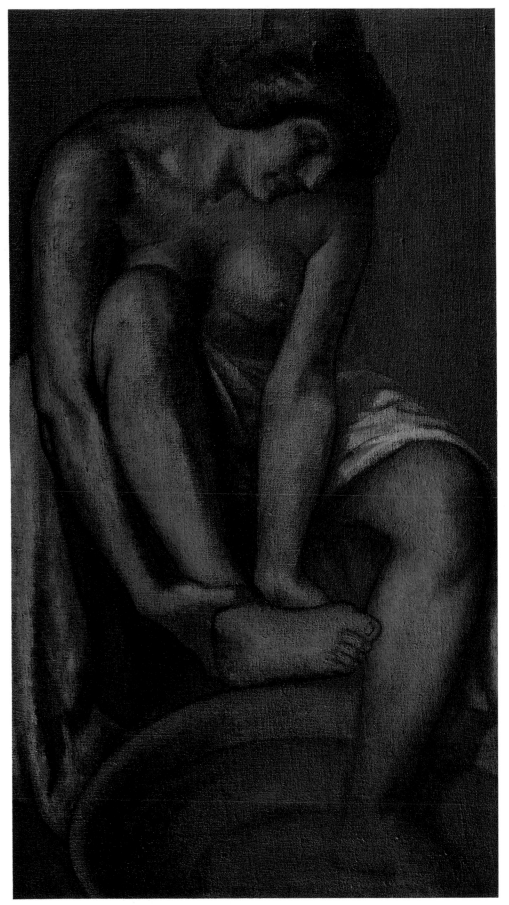

59

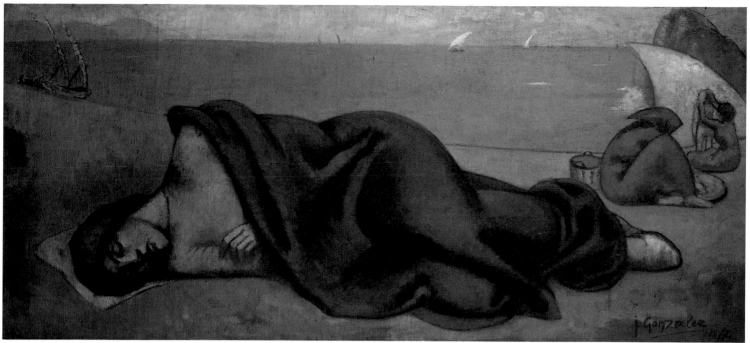

60

impossible that Picasso saw it and was impressed by the clumsiness of González's bather, which may have contributed something to his own magnificently awkward 'Large Bather' of 1921 (cat.141).

In the 1920s González painted a number of oils, and executed a large series of pastels, in a classical style recapitulating that of his pre-war work. The woman at her toilette was a favourite subject at this time too, while a number of his most abstracted iron sculptures of the mid- and late 1930s were based on the same theme.

60 Woman Sleeping on the Beach 1914

Oil on canvas, 82 × 176
Museu d'Art Modern, Barcelona

This painting is dated 1914, and was exhibited at the Salon des Indépendants in the spring of that year. There are a couple of undated surviving preparatory drawings and an oil sketch: as he worked on the composition, González gave the image a more monumental form and reduced its anecdotal, realist content, making the woman's presence more mysterious and endowing the painting with the quality of a dream.

González's pre-war paintings, with their pale colours, dry, fresco-like facture, emphasis on simplified contour, and extreme flatness, have often been compared to the works of Puvis de Chavannes. Puvis, who died in 1898, represented the acceptable face of the classical tradition to avant-garde artists of the post-Impressionist generation, and exerted a great influence on, among others, Seurat, Gauguin and the Nabis. He was the subject of much critical discussion in the first decade or so of this century, and his impact on such artists as Matisse and Picasso in about 1905–6 was considerable. He was also greatly admired in Catalan Noucentista circles. González's close friend, the painter and theorist Joaquín Torres-García, who before the war was an ardent supporter of a classical revival in the arts, was in effect an imitator of Puvis in the mural compositions he executed at the time, and it was probably through him, as well as directly, that González was influenced by Puvis. Certainly 'Woman Sleeping on the Beach' is one of González's paintings most reminiscent of Puvis, although the proportions of the figure are more 'gothic' than those of Puvis's women. Parallels may also be drawn with the paintings of Catalan peasants and fishermen executed by Sunyer from 1909 onwards.

61 Reclining Nude with a Book

1914

Bronze, 9 × 23.5 × 11
Centro de Arte Reina Sofia, Madrid

This is dated 1914. Before and during the First World War González made numerous pastel and crayon drawings of nudes in a variety of poses which reflect his admiration of Degas, and his desire to synthesise his observations from life into an idealised and generalised image. Some of the related sculptures, however, show a response to the sensitive modelling and sensuality of Rodin. This is the case with 'Reclining Nude with a Book', although the expressive intensity, drama and tension of Rodin's work are entirely lacking. González is also known to have admired the work of Despiau, whom he met before the war. In its emotional neutrality this sculpture resembles such works by Despiau as 'The Bacchante' – a small, naturalistically modelled classical nude which was exhibited at the Salon de la Société Nationale des Beaux-Arts in Paris in 1909.

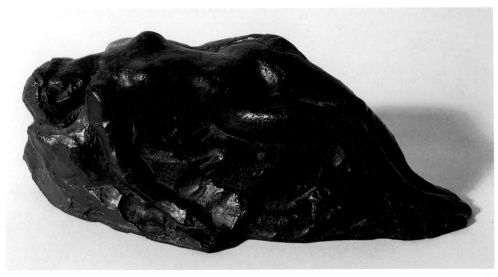

61

62 Kneeling Nude *c.*1916

Repoussé copper, 27 × 17.5 × 2.5
Centro de Arte Reina Sofia, Madrid

This relief is closely related to a larger pastel drawing executed during the war, which was, presumably, a preliminary study made from life. Other small copper reliefs of nudes were made at the same period. In these, as in 'Kneeling Nude', González explores the kinds of poses familiar from classical reliefs and free-standing sculpture, which became standardised in academic art. As in 'Reclining Nude with a Book', González emulates the restrained classicism of Despiau's pre-war work, striving for the same balance between observation and formal synthesis.

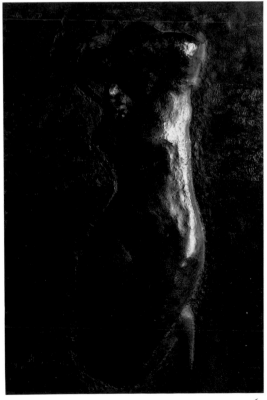

62

JUAN GRIS 1887 MADRID – 1927 BOULOGNE-SUR-SEINE

Gris occupied an important and influential position in the avant-garde wing of the 'return to order' movement in France. His lucid and systematic form of Cubism was interpreted as 'pure' and 'classical' because he gave emphasis to harmonious composition and conceptualised, rather than perceived, form. Indeed, his aptitude for mathematics and interest in questions of structure led him initially to train as an engineer. But in 1904, after two years at the Escuela de Artes y Manufacturas in Madrid, he decided to become a painter, and entered the studio of the academic artist José Maria Carbonero. Within a year he was working independently as an illustrator, in a style influenced by Lautrec and by Jugendstil. In September 1906 Gris arrived in Paris. He met Picasso, who found him a studio near his own in the Bateau-Lavoir, and mixed with Picasso's poet and painter friends, so that he observed at first hand the development of Cubism in 1907–9.

At first Gris earned his living making satirical drawings for various Parisian journals, but in 1910 he took up painting seriously, exhibiting for the first time in 1912. Works such as 'Homage to Picasso' (Art Institute of Chicago), which was shown in the Salon des Indépendants that year, quickly established him as a leading new recruit to Cubism, and he signed an exclusive contract with Kahnweiler. He mixed with the Puteaux group, meeting, among others, the Villon brothers, Gleizes, Metzinger, Léger and Picabia, and exhibited with them in the Salon de 'La Section d'Or' at the Galerie La Boétie in October 1912. His new work, which incorporated collage and *papier-collé* elements, reflected his quick response to the latest methods of Picasso and Braque.

During Kahnweiler's exile in Switzerland, Léonce Rosenberg acted as Gris's dealer, organising the first large show of his work in his Galerie de l'Effort Moderne in Paris in April 1919. The following year Rosenberg published a handsome album of twenty reproductions of Gris's paintings with a text by Maurice Raynal, the first of several important studies by avant-garde critics associated with the Purist movement. In 1921 Rosenberg gave him a second one-

man show at his gallery, and from this period onwards Gris's work became increasingly prominent: it was exhibited widely at home and abroad, and was purchased by major French and foreign collectors of Cubism. Gris was commissioned to design costumes and décors for Diaghilev on several occasions, and was also much in demand as an illustrator of the 'Cubist' poets. But his health, which had been uncertain since 1920, deteriorated rapidly in February 1926, and he was able to work only intermittently between then and his death the following May. His prestige within the European avant-garde was marked by the large memorial retrospectives held in Paris at Kahnweiler's Galerie Simon in 1928, the Galerie Flechtheim, Berlin, in 1930, and the Kunsthaus, Zurich, in 1933.

Gris's earliest Cubist paintings of 1911 already demonstrate his predilection for order, clarity, harmony and simplification, and by 1912 the regular geometric grid he employed to control his compositions was being given emphatic status on the surface of his canvases, while many of the objects depicted were frankly conceived in terms of pure geometric shapes and forms. It was only to be expected that he would find the Puteaux group of Salon Cubists congenial, for there discussions on the 'higher mathematics' were common, and Gris's naturally theoretical turn of mind found a sympathetic audience. In this way Gris, whose preferred subject matter was still life, acted as a kind of mediator between the more 'instinctive' and abstracted Cubism of Picasso and Braque and the more representational and also more 'ordered' Cubism of the Section d'Or painters. This was not lost on the Purists, Ozenfant and Jeanneret (Le Corbusier), or on the critics Reverdy and Raynal, all of whom were influenced by Neoplatonism. For them, Gris became a hero precisely because his work exhibited the abstract 'classical' characteristics they believed to be essential for the restructured and 'purified' post-war world. His influence on Purist painting and on post-war 'crystal' Cubism was considerable, while the statement he published in *L'Esprit Nouveau* in February 1921 is in its own way like a Purist manifesto:

The artist in 1922 (Photo by Man Ray)

I work with the elements of the intellect, with the imagination. I try to make concrete that which is abstract. I proceed from the general to the particular, by which I mean that I start with an abstraction in order to arrive at a true fact. Mine is an art of synthesis, of deduction. . . . Though in my system I may depart greatly from any form of idealistic or naturalistic art, in practice I cannot break away from the Louvre. Mine is the method of all times, the method used by the old masters: there are technical *means* and they remain constant.

In September 1916 Gris made a Cubist version of a well-known figure painting by Corot (Kunstmuseum, Basle). This was his first figure picture since 1913, and heralded a return to ambitious figurative subjects of a traditional kind, which were to occupy him throughout the rest of his life. Since 1915 some of his still lifes had been grandiose in scale and notably dignified in imagery, and the open window gradually became a favourite background motif uniting the objects on the table with an extensive view behind. All these developments, which

significantly enriched his repertoire, reveal
his desire to rival contemporaries such as
Picasso and Matisse, to emulate the old
masters with whom he claimed allegiance,
and to make his art timeless and universal.
It became, indeed, a critical commonplace
to allude to his connections with the Great
Tradition. Kahnweiler, for instance, con-
cluded his first monograph on Gris with
these words: 'His place is beside those
painters of the past whom he loved, beside
Jean Fouquet, Mathieu Le Nain, Boucher,
Ingres, Cézanne.' (*Juan Gris*, Leipzig and
Berlin, 1929) Two years later Waldemar
George gave a rather different list, but made
the same point: he described Mantegna as
Gris's 'spiritual father', and emphasised his
love for Raphael, Zurburan and Corot
(*Juan Gris*, Paris, 1931).

63 Bathers, after Cézanne
1916

Pencil on paper, 28 × 30
Private Collection, Switzerland

When war broke out Gris was staying in
Collioure, and there he struck up a close
friendship with Matisse who arrived in the
village in September 1914. Although he was
almost certainly working from a reproduc-
tion, the small Bather composition by
Cézanne which Gris has 'copied' in this
drawing had belonged to Matisse since
1899. (It is now in the Musée d'Art
Moderne de la Ville de Paris.) Gris did a
number of other drawings after Cézanne's
figure paintings in the same year, 1916, and
in 1918 made a painted version of a 'Portrait
of Madame Cézanne' (private collection).

Gris's identification with Cézanne's work
was entirely in line with that of the other
Cubist painters, and indeed his arrival in
Paris late in 1906 coincided exactly with the
establishment of Cézanne as the single most
important artist of the post-Impressionist
era: by 1912, when Gleizes and Metzinger
published *Du Cubisme*, it was accepted
without question that Cézanne was the
'father' of Cubism. Now, as Gris again
looked closely at Cézanne, it was with the
critical eye of one who had no intention of
'going back' on his own achievements, but
who wanted to extend them into new realms
– notably into the area of figure painting.
Thus he subjects the rather roughly
executed and awkward, but emotionally

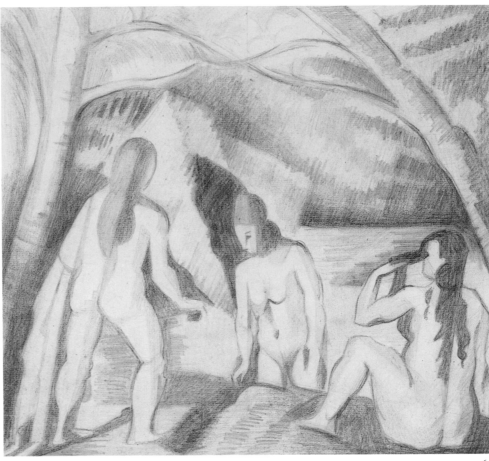

63

expressive, picture by Cézanne to a rigorous
process of straightening up. He regulates
and clarifies the contours, emphasises the
tentative geometry of the forms, imposes a
consistent pattern on the brushwork, and
generally recasts the scene into one of
complete calm and balance. The use of
pencil further abstracts the image, for the
original is vibrantly coloured.

These changes are in keeping with Gris's
personal goal of 'deduction' and 'synthesis',
and it is interesting that in the statement
published in *L'Esprit Nouveau* in February
1921 he described this in terms of an
opposition to the 'analytical' methods of
Cézanne, whose art was based on the obser-
vation of nature: 'Cézanne turns a bottle
into a cylinder, but I begin with a cylinder
and create an individual of a special type: I
make a bottle – a particular bottle – out of a
cylinder. Cézanne tends towards architec-
ture, I tend away from it. . . . This painting
is to the other what poetry is to prose.'

64 Portrait of Josette Gris 1916

Oil on panel, 116 × 73
Museo del Prado, Madrid

This portrait was painted in October 1916 in Beaulieu, near Loches, the village in which Josette had been brought up. She had been Gris's companion for four years at that time. It was preceded by a relatively naturalistic drawing of her head (Museum of Modern Art, New York), and by a painting (Rupf Foundation, Berne) of her head and shoulders, also on panel, in the synthetic Cubist style of the full-length version. The picture went to Léonce Rosenberg, and was included in Gris's one-man show at the Galerie de l'Effort Moderne in April 1919.

Although the 'Portrait of Josette' is a particularly masterly and resolved painting, apparently executed without hesitation, Gris wrote to friends at the time complaining of his inability to concentrate on his work and his deep anxiety about the war. He does not mention the portrait in these letters, perhaps because, at this stage, he regarded it not only as private but also as experimental, and was unsure what long-term significance it had for his art. For it – and the 'Self-portrait' he had just completed (private collection) – was the first portrait he had painted for several years, and developed out of the drawings he had made after the figure paintings of Cézanne (see cat.63) and Velázquez, and out of the magnificent 'Woman with a Mandolin, after Corot', painted in September 1916 (Kunstmuseum, Basle). The full-length 'Portrait of Josette' is, indeed, very close in style to this 'free copy', and it is likely that Corot's figure paintings, as well as Cézanne's inscrutable portraits of his wife, were the inspiration behind this highly impersonal painting of Josette.

The series of drawings and paintings represents an effort on Gris's part to commit himself to figure painting, and thus to come to terms with the most imposing works of his more celebrated and successful contemporaries, including Matisse and Picasso. The portrait is thus, at a certain level, a response to pressure, and an attempt to resolve the conflict, identified by contemporary critics, between the rival claims of modernist abstraction and of the figurative tradition. The 'experiment' certainly bore rich fruit, for over the next few years Gris consolidated this achievement in an impressive series of figure paintings which make few concessions to naturalism in their boldly synthetic style, but which reflect his admiration of the old masters and his identification with them.

64

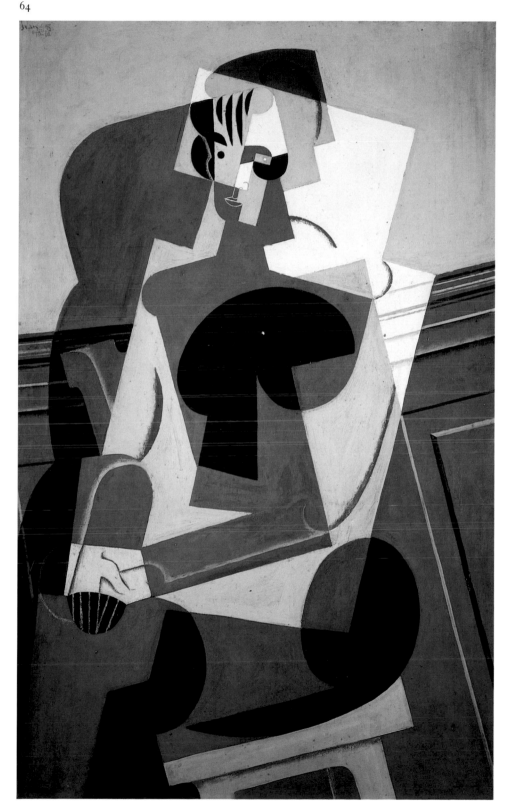

65 Portrait of Pierre Reverdy
1918

Pencil on card, 60 × 40.5
Fondation Maeght, Saint-Paul

Gris first met the poet Pierre Reverdy
(1889–1960) in 1911, and their friendship
became close when Reverdy took a studio
opposite Gris's in the Bateau-Lavoir in
1912. This drawing remained in Reverdy's
possession until his death. Over the years
Gris provided illustrations for several works
by Reverdy: *Poèmes en prose*, 1915; *Au Soleil
du plafond*, commissioned by Léonce
Rosenberg in 1916, but not published until
1955; and *La Guitare endormie. Contes et
poèmes*, 1919. In return, in 1919, Reverdy
dedicated his aesthetic *credo*, 'Self-defence',
to Gris. In 1917 Reverdy founded the
review *Nord–Sud*, which although short-
lived, was highly influential, publishing the
work of many of the leading painters and
poets of the Cubist period. His own essay,
'Sur le cubisme', published in the issue for
15 March 1917, is an intelligent exposition
of synthetic Cubism, and contains state-
ments on the importance of formal abstrac-
tion which are close to those Gris himself
would make after the war.

Under the influence of the general 'call to
order' the drawings Gris made from 1916
onwards, and especially the portraits,
became overtly 'classical' and 'naturalistic'.
Gris has not only seen his friend through
the perspective of the exquisite drawings of
Ingres, but has also been influenced by
Picasso's recent pencil portraits, such as
'Ambroise Vollard' (cat.131). Gris's line and
modelling are highly refined and systema-
tised, and although his obsession with
geometry may be less evident than in his
contemporary Cubist paintings, it is
reflected in the repetition of the triangular
shapes he finds in the head, shirt, tie, jacket
and background. Certainly the face is indi-
vidualised, but it is not expressive, and the
pose, like the clothing, is standardised. One
must, in other words, apply the term
'naturalistic' with reservations, for Gris, like
Reverdy, was adamantly opposed to the
anecdotal and the purely sensual, and thus
even his so-called drawings from life were
subjected to a rigorous discipline of rationa-
lisation and synthesis. This process was
taken even further in the still-life and
portrait drawings Gris made in 1920–21.
These are conceived in terms of pure and
elegant inflected contours, with minimal
shading, and have the appearance of
simplified tracings.

65

66

66 Portrait of Madame Berthe Lipchitz 1918

Pencil and coloured crayons on paper,
47.5 × 30.5
Musée Nationale d'Art Moderne, Centre Georges Pompidou, Paris, gift of L. and M. Leiris, 1984

This drawing commemorates the friendship between Gris and Josette and Lipchitz and his wife. They had first met in 1916, and with Lipchitz's help, Gris made his first sculpture, a painted plaster 'Harlequin' in November 1917. In the spring of 1918 the two couples met on several occasions in Beaulieu, where the portrait was drawn that May.

Like the 'Portrait of Pierre Reverdy', this drawing shows Gris at his most Ingresque. In both portraits the appearance of naturalism masks extreme schematisation: the shading is formulaic; abstract patterns detected in the folds of hair and cloth have been discreetly emphasised; the contours have been purified and follow regular, repeated rhythms; the axes of the body are echoed in the geometric shapes of the pictures seen in the background; colour is applied only sparingly. Madame Lipchitz is thus refined into a generalised type, and her face has become almost mask-like, anticipating the classical plaster busts which entered Gris's still lifes in the last years of his life.

67 The Bay 1921

Oil on canvas, 68.6 × 97.5
Private Collection

We know from a letter Gris sent to Kahnweiler on 18 May 1921 that he had already begun this picture and that he thought it 'promises quite well'; by 28 May it was finished. 'The Bay' was painted at Bandol, in Var, where Gris and Josette had been living since late November the previous year, and where they remained until July 1921. The picture may look untroubled and supremely lucid, but it was painted at a time of high tension in Gris's personal life. Josette was ill and he had fallen in love with a well-connected woman who wanted to marry him, and who promised him the kind of material ease he craved. He summed up his state of mind in a letter to Maurice Raynal, written on 1 June: 'I am more than usually conscious of the permanent and

67

unalterable misery of my life. In fact, I am so fed up, *mon vieux*, that I regret having cheated death last year.'

'The Bay' belongs to a series of paintings of still lifes before open windows which Gris had begun in January 1921. This was not the first time he had taken up a subject so closely associated with Matisse: in 1915 he had painted the splendid 'Still Life before an Open Window: La Place Ravignan' (Philadelphia Museum of Art), and in the last years of his life he returned often to the subject. The particular appeal of the window motif for Gris seems to have been that, iconographically, it permitted him to marry two subjects which preoccupied him – still life and landscape, while giving precedence to his favourite – still life. Formally, it permitted him to explore at a new level of complexity his fascination with the relationship between 'real' three-dimensional space and two-dimensional pictorial

space. In all the paintings in the series, from 1915 to 1927, Gris plans the composition so that intricate formal connections between near and far will be established and the surface design of the picture will be respected. In 'The Bay' the limited, repetitive range of colours ensures that things on different planes will link up together, numerous visual 'rhymes' – through repetition of shape – are set up, and contours not only delimit objects but unite them indissolubly to adjacent objects on different planes. The underlying grid may be much less obvious than it was before the war, but the clean, ruled lines constantly remind us of the controlling presence of a predetermined abstract plan.

It was the sheer lucidity and rationality of works like these that made Gris so attractive to the Purists. Nevertheless Gris himself was striving for much more than a perfectly articulated and harmonious formal design.

For him the difference between a 'synthetic' and an 'analytic' method was the difference between 'poetry' and 'prose', and he was on the side of the poets. All the formal devices he used were intended also to have a 'poetic' function, while his choice of objects was surely intended to be as expressive as his choice of colours – each object releasing associations in the mind of the spectator just as a word or image does in a poem. In 'The Bay', for instance, although the objects on the table are banal, the extraordinary green–blue colour is otherworldly, and the empty yacht becalmed on the sea lends an aura of mystery to the idea of a voyage. This sense of mystery is enhanced by the heavy green curtain which appears to have been pulled back to reveal not just the view through the window, but the still life too: the whole image thus becomes like the scene from a play, a momentary vision – elusive but hypnotic.

68 The Pierrot 1922

Oil on canvas, 100 × 65
Galerie Louise Leiris, Paris

'The Pierrot' is dated May 1922, and was first shown in Gris's exhibition at Kahnweiler's Galerie Simon the following March. There is a closely related gouache

68

but, as usual with Gris, that is slightly more naturalistic in the handling of detail than the oil painting.

Gris's return to figure painting dates back to 1916, and almost all these pictures are costume pieces of one kind or another. In 1918, for example, he painted two images of generalised rustic types – 'The Miller' and 'The Man from Touraine'; in 1923–4 he made a small series of 'portraits' of men and women in nineteenth-century costume; and one of his very last pictures was of a woman in classical drapery carrying a basket of fruit. His favourite figure subjects, however, were Pierrot and Harlequin. There were many promptings from within the avant-garde which help to explain this particular fascination in the middle of the war. Numerous artists in Paris, including Picasso, Derain, Severini and Lipchitz, exploited *commedia dell'arte* themes in a great variety of styles, so that Gris was tapping a currently fashionable iconography. This was the moment, too, when Watteau's work was attracting renewed interest among French critics, and his place in the tradition of French painting was being analysed. In 1923 Gris himself painted several more naturalistically conceived Pierrots, which are related closely to Watteau's 'Gilles' in the Louvre.

The 'Pierrot' shown here is not specifically Watteauesque, and is transitional between Gris's highly 'synthetic' works of 1917–18 and the more descriptive and naturalistic paintings of 1923. The architecture behind the figure is absolutely flat, and so are the face and certain areas of the body. The colour and tone are highly abstracted and relate only in the most general way to effects of stage lighting. But the undulating outline of the costume, and the modelling around the folds of the cloth, announce the return of the three-dimensional, and there is a certain softening of mood. Mood was of great concern to Gris, and there is no question but that in painting all these costume pieces he was not only striving for the timelessness and universality of traditional art, but also for a more generalised poetic and lyrical quality, conjured up by the subject of the actor–musician–dreamer. In 'Pierrot' the mysterious, almost sinister colour lends the subject a strangeness and dignity which lifts it quite beyond the level of the simply decorative. As so often in Gris's later work, the observer senses a symbolic undercurrent which is only just suppressed.

VIRGILIO GUIDI 1891 ROME – 1984 VENICE

Guidi was born and educated in Rome, and his approach to the new classicism of the 1920s was typically Roman in its emphasis on technique and form in art. His father was a sculptor and poet, and from an early age Guidi was determined to become a painter. After a period working as a restorer and decorator, he studied at the Accademia di Belle Arti in Rome where he came under the influence of the leading Italian post-Impressionist painter, Armando Spadini. Immediately before the war Guidi became aware of the work of modern French painters, Cézanne and Matisse in particular; but the opportunities for developing a profound knowledge of contemporary French art in Rome in these years were limited. Instead, Guidi studied the great works of the Italian Renaissance and set his sights on emulating the art of the past (in this he influenced other young artists such as Socrate, see cat.168). Surviving paintings of the period around 1917 show how Guidi explored the work of Caravaggio in his portrait studies, and of Vermeer and Chardin in his still lifes. He continued to study paintings in the Galleria Borghese where he would often meet de Chirico copying works by old masters (see cat.32).

From 1919 Guidi combined the structures and tonality of Renaissance art with a more obviously contemporary subject matter. Although his figures wore up-to-date, if rather simple, dress, and some of the details of his scenes were undeniably modern, Guidi deliberately chose themes which had a timeless air. His simplifying treatment of form and volume, and his placing of figures in static, almost awkward poses, recall works by early Renaissance artists, and have an affinity with the primitivist paintings of Carrà in this period and later. This new departure in Guidi's work was highly individual, but at the same time was clearly related to contemporary discussion of the 'return to order' and the need for a modern type of classical art. Guidi moved in leading artistic and literary circles in Rome, and frequented the famous 'terza saletta' of the Caffè Aragno where he met and discussed the renewal of Italian art with figures such as de Chirico, the critic Roberto Longhi and the poet Vincenzo Cardarelli.

In this context it is clear that the shift in Guidi's paintings towards a style inspired by the Renaissance reflected his vision of a modern classicism.

In the early 1920s Guidi began to achieve some commercial and critical success. In 1923 he exhibited in the second Biennale in Rome – an exhibition which prompted discussion of 'neoclassicism' in contemporary art – alongside artists such as de Chirico, Donghi, Severini and Socrate. His greatest success, however, was achieved at the Venice Biennale of 1924, at which his painting 'The Tram' (Galleria Nazionale d'Art Moderna, Rome) met with enormous critical acclaim. This masterpiece, which depicts a group of seated figures bathed in bright light, with glowing colours and clearly defined volumes, established Guidi's reputation as a leading young artist of the day. In the following year Franz Roh listed Guidi among the artists of the new international trend of 'magic realism' in his book *Nach-Expressionismus*. Guidi was represented in the first and second of the large *Novecento Italiano* exhibitions held in 1926 and 1929, and in 1927 he helped Margherita Sarfatti organise a smaller show in Rome of ten Novecento artists, himself included. Guidi later denied that he had much in common with the Novecento group, but his concern to revive the Great Tradition of Italian art through style and technique more than through subject matter was in fact close to Sarfatti's concept of Novecento art.

In 1927 Guidi accepted a teaching post at the Accademia di Belle Arti in Venice, moving on to Bologna in 1935. He held a one-man show in Florence in 1932, and in the following year made a brief first visit to Paris. It was in this period that he began to publish his thoughts on the subject of light in painting, stressing its inseparability from form and colour. He also moved towards an increasingly simplified and stylised subject matter.

Following the Second World War he changed his style radically and became a leading figure of the abstract Spazialismo movement associated in particular with Lucio Fontana.

Self-portrait, 1914 (private collection)

69 The Visit 1922

Oil on canvas, 175 × 145.5
*Civico Museo d'Arte Contemporanea,
Palazzo Reale, Milan*

This major work marks the end of Guidi's exploration of museum styles and is a confident statement of a new Renaissance-inspired realism in his art. The painting did not arouse a particularly favourable critical response when it was exhibited at the Venice Biennale of 1922, but in retrospect it can be seen as a forerunner to 'The Tram', which later established Guidi's reputation, and which this painting resembles in its command of traditional techniques and composition.

Guidi frequently used the theme of two women meeting, and in the absence of any narrative or psychological explanation for this subject, it seems likely that it is a disguised version of a Renaissance 'Visitation' or 'Annunciation' scene. The women in this painting wear contemporary dress, but in all other aspects the scene is strangely timeless: and even the loose, rustic clothes are not dissimilar to the robes of traditional Madonna figures (the blue of the coat of the standing figure and the rose pink of the skirt

of the seated figure were colours often associated with the Virgin Mary in Renaissance art).

'The Visit' is the fruit of years of attentive study of old masters, in the Galleria Borghese and elsewhere; and in this work Guidi has captured an extraordinary quality of light, reminiscent of that in the Venetian masters of the late fifteenth and early sixteenth centuries, in particular Giovanni Bellini, which makes the colours glow and animates each object. He later wrote about the magical quality of light, and its capacity to reveal reality, in the catalogue of the Rome Quadriennale in 1935: 'What I find especially pleasing is the summer midday sun which invades everything and leaves every form exposed and clear. In transposing that light on to canvas, I have a vision of that . . . architectonic and poetic atmosphere in which all real objects can live and breathe to the full.'

69

CHARLES-EDOUARD JEANNERET, known as LE CORBUSIER 1887 LA CHAUX-DE-FONDS – 1965 CAP-MARTIN

Jeanneret began to use the pseudonym Le Corbusier in 1920, but until 1928 he retained his family name when signing his paintings, when signing texts he had co-authored with Ozenfant, and when acting as editor for *L'Esprit Nouveau*.

Jeanneret enrolled as an apprentice engraver at the art school in La Chaux-de-Fonds, Switzerland, in 1901. His prodigious gifts were recognised early, and at the age of eighteen he was commissioned to build a villa for a trustee of the school. 'Arts and Crafts' in style, the Villa Fallet was completed in 1907, and on the proceeds Jeanneret travelled to Budapest, Munich and Tuscany. The following year he went to Paris, working with the celebrated architect Auguste Perret in preference to studying at the Ecole des Beaux-Arts. This proved a decisive contact, and Jeanneret's new work became noticeably more 'classical' in design and decoration. During 1910–11 he travelled widely throughout Europe, visiting numerous sites and historical buildings in Italy, Turkey and Greece, which he studied and drew systematically. In 1917, with other buildings already behind him, Jeanneret settled in Paris, where he lived for the next seventeen years.

His arrival coincided with the beginnings of the classical revival within the avant-garde, and at the end of the year he met Ozenfant, who like himself was committed to a radical formalist aesthetic based on a theory of classical order and harmony. With Ozenfant's encouragement, Jeanneret took up painting seriously in 1918, producing works of extreme austerity and rigid order. (Later he wrote of the complementary nature of painting, sculpture and architecture, and his buildings were always designed to 'be completed' by paintings, sculptures and tapestries.) With Ozenfant he wrote *Après le cubisme* in 1918. This was the manifesto of Purism, the movement they founded and coordinated, and which was a dominant force within the avant-garde for the next seven years. It was published in December 1918 to coincide with the first of three joint exhibitions of their Purist paintings, and offered a corrective to what they regarded as the 'impurity' of Cubism

proper. (Their final exhibition together, held in 1923 at Léonce Rosenberg's Galerie de l'Effort Moderne, marked the end of Jeanneret's public activity as a 'professional' painter: thereafter he painted regularly but privately.)

In 1920 Ozenfant and Jeanneret founded the review *L'Esprit Nouveau* with the poet Paul Dermée: it ran for twenty-eight issues until January 1925, and featured essays not only on contemporary artists they admired, but on such old masters as Poussin, Ingres, Corot and Seurat, whose art enshrined 'eternal' classical principles of structure and form. *Vers une architecture*, an edited version of essays already published in *L'Esprit Nouveau*, came out in 1923 under the name Le Corbusier. Recognised as a manual for the modern movement in architecture, it went through numerous reprints in France in the 1920s and was translated into German in 1926 and English in 1927. Also in 1923 Le Corbusier designed a villa for Raoul La Roche, a great patron of Purist painting, which realised fully his current ideals for domestic architecture. (It now houses the Fondation Le Corbusier.) The following year he completed a studio–house for Ozenfant, but their partnership was on the point of breaking up, and Le Corbusier's 'Pavilion de L'Esprit Nouveau', a highly controversial exhibit at the Exposition des Arts Décoratifs in 1925, was in a sense the swan-song of the Purist movement. His paintings after 1928 (now also signed Le Corbusier) were different in style and content from those of his Purist period, and show a debt to the neoclassical figure paintings of Picasso and especially to the recent work of his close friend, Léger.

In the late 1920s Le Corbusier created a number of important private houses, including the Villa Stein-de-Monzie (completed 1928), and the Villa Savoye (completed 1930), and made numerous lecture tours abroad. Although he was attacked by conservatives in the 1930s, his position as a model for the younger generation of modernist architects was never threatened, and the influence of his buildings as well as his theories became ever more widespread.

In his architectural theory and practice Le Corbusier's debt to the classical tradition

The artist, *c.*1925

was profound, and is neatly expressed in the many illustrations published in *Vers une architecture*. As well as his own designs, and numerous photographs of feats of modern engineering and industrial design which he thought exemplary, such as grain silos, bridges, motor cars, aeroplanes and ocean liners, Le Corbusier provides dozens of plans, photographs and analyses of antique, Renaissance and neoclassical buildings, drawing attention to the fundamental similarities between all these types of construction. One chapter, for instance, is entitled 'The lesson of Rome', while the chapter entitled 'Architecture, pure creation of the mind' is illustrated exclusively with photographs of the buildings of the Acropolis in Athens which he had studied on his trip to Greece before the war. The doctrine of geometrically determined structural order, austere simplicity of design and decoration, and functionalism, which is reiterated forcefully throughout the text, directly reflects Le Corbusier's interpretation of the

principles of classical architecture. His constant invocation of 'order', 'reason', 'harmony', 'peace', 'health' and 'beauty' as the proper goals of modern man and modern architecture echoes the traditional definition of the characteristics of classicism.

70 Still Life with Bowl 1919

Oil on canvas, 81 × 65
Fondation Le Corbusier, Paris

The clear separation of the various objects in this picture from one another, the relatively descriptive treatment of the roll of paper, bowl and pipe, the unambiguous articulation of the space, and the 'realistic' study of light on the objects, are typical of Jeanneret's early Purist paintings. The influence of Cubism is apparent in the shifts in viewpoint, and in the flat, *papier collé*-like treatment of the table-top and of the cream rectangle on which the roll of paper lies. But Jeanneret had also been directly influenced by the naked simplicity and clarity of Ozenfant's recent paintings, and the picture is conceived in opposition to what they both regarded as the disorder and arbitrariness of Cubism. Thus the objects are seen in terms of pure geometric forms – cube, cylinder, cone, and so on – and the relationships between them are plotted on a regular mathematical grid.

'Still Life with Bowl' is very similar in choice of objects, composition, colour and style to the metaphysical still lifes of Carrà, de Chirico and Morandi, especially Carrà's 'Still Life with a Set Square', 1917 (Civica Galleria di Brera, Milan). The other version of the composition, 'The White Bowl', also 1919 (Kunstmuseum, Saint-Gall), is even closer to Carrà's painting, for there in the same position as the cream rectangle are two triangular set-squares, neatly lined up at their longest edges. The main difference, however, is that 'The White Bowl' is free from menace, and makes no psychological impact. Nevertheless, the comparison suggests that in 1918–19 the Purists saw Italian metaphysical painting as a valid, avant-garde alternative to Cubism – one which, moreover, would not compromise their classicist principles.

Careful drawings for 'Still Life with a Bowl' have survived, reminding us of the meticulous preparation that lay behind Purist paintings: preliminary drawings were intended to guarantee a harmonious, perfectly resolved, fully meditated end result, and for Jeanneret were equivalent to the plans of the engineer–architect.

70

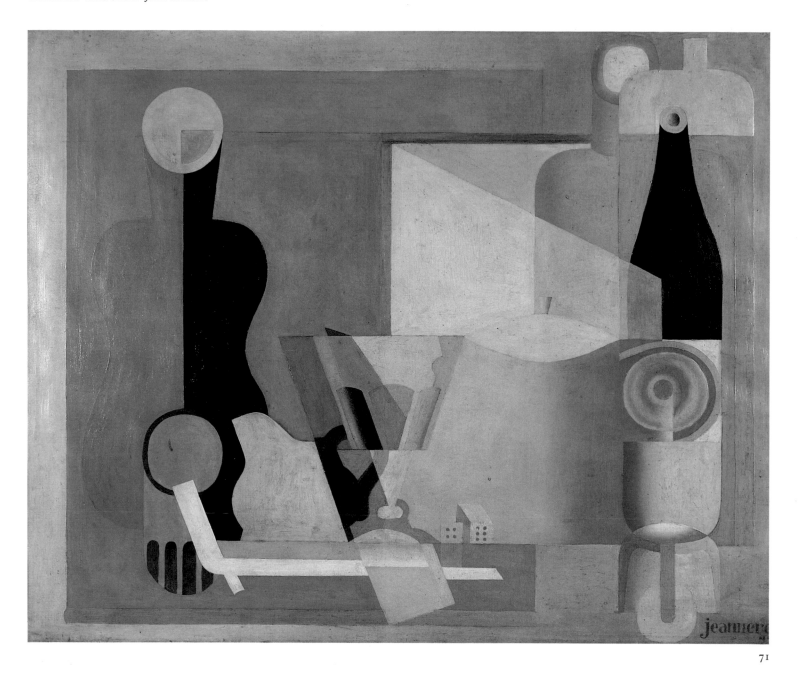

71

71 Pale Still Life with a Lantern

1922

Oil on canvas, 81 × 100
Fondation Le Corbusier, Paris

There were a number of preparatory pencil sketches for this painting, which is one of Jeanneret's most successful Purist compositions. The difference between it and 'Still Life with a Bowl' (cat.70) is striking. Now there are more objects, and the relationships between them and the surrounding space are extremely complex, while the soft nacrous lighting acts as a kind of absorbent veil, alternately hiding and revealing. Although the objects are easily identifiable as the familiar, standardised 'type-objects'

of Purism, they cease to have significance as individual items because it is the formal relationships between them that are most significant. Indeed while some of the objects, such as the central fluted wine glass, are modelled and outlined, others are merely flat shadows of themselves, or, like the teapot, become almost lost from view as they relinquish their contours to their neighbours. In this hypnotic visual play the roles of positive and negative constantly interchange, and 'reality' gives way to 'abstraction'.

The method used in this painting of binding the various parts of a composition together by elaborate sequences of visual rhymes was perfected by Gris during the

war, and exerted a great influence on Ozenfant as well. The Purists, who were influenced by Neoplatonism, felt for geometry the reverent awe usually reserved for the divine: it was Truth; it conferred Beauty. This still life is entirely dependent on geometry and on the classic geometric proportional systems: the mysterious delicacy of its colour and lighting was perhaps intended to enhance that sense of the sacred quality of abstract form.

HENRI LAURENS 1885 PARIS – 1954 PARIS

Although Laurens is widely recognised as one of the most significant sculptors of his generation, obscurity surrounds his early development and a mere handful of his pre-Cubist works is known, and those only from studio photographs. He came from a family of artisans, went from primary school to the craft school of Bernard Palissy, and by the age of about fourteen was already apprenticed to an ornamental sculptor. Later, when working as a stonemason, he had to carve directly on site, and this experience gave him the respect for materials and for craft which is a consistent feature of his mature sculpture. Meanwhile he attended the evening classes of an academic master known as 'Père Perrin'.

By about 1905 Laurens was seeking a way out of academicism and an alternative to the all-pervasive influence of Rodin. He was greatly attracted to Egyptian, Romanesque and medieval sculpture, and the very few surviving records of his work before 1914–15 suggest that he was influenced by these 'primitive' traditions. A significant event was his meeting with Braque in 1911. Madame Laurens recalls an evening, probably in the winter of 1911–12, when Braque, using diagrams, initiated her husband into Cubism, and it seems that Laurens made his first tentative Cubist polychromed terracottas in 1912–14, but all were destroyed.

Because of a disability Laurens was not mobilised, and during the war his work developed dramatically, resulting in a remarkable corpus of synthetic Cubist constructions and *papiers collés*. These certainly owe much to his close contact with Braque, Picasso and Gris, but are none the less a highly personal achievement. He met the poet Pierre Reverdy, and in 1916 regularly attended the gatherings of poets and painters associated with Reverdy's avant-garde review, *Nord–Sud*. Through Picasso Laurens was introduced to Léonce Rosenberg, who appreciated the restraint and abstract purity of his work and offered him a contract. He had several exhibitions in Rosenberg's Galerie de l'Effort Moderne before 1920, when he transferred to Kahnweiler, with whom he had a contract for a couple of years.

In 1918 Laurens ceased to make *papiers collés* and constructions, concentrating instead on polychromed terracotta and stone reliefs and free-standing figures. The effect of working in the round and carving rather than constructing resulted in simpler, fuller, more solid forms, and was accompanied by a gradual move away from the strict geometry of his wartime Cubist work towards a freer, cursive line and more naturalistic modelling. The new suppleness, naturalism and grace in his treatment of the nude reflects Laurens's recent friendship with Matisse, but also his response to the general revival of classical styles after the war. In the 1920s Laurens, whose work was already receiving attention in vanguard art reviews, began to receive commissions for decorative sculpture from wealthy patrons of advanced taste, such as the couturier Jacques Doucet, the Vicomte de Noailles and the interior decorator Franck. He also executed the monument for the tomb of the aviator Tachard in Montparnasse cemetery, and designed the décor for the Ballets Russes production of Cocteau's and Milhaud's *Train bleu* (1924). His early experience as an artisan made decorative work congenial, and in later life he accepted many monumental commissions and enjoyed working on a public scale.

Laurens had established a studio at Etang-la-Ville, outside Paris, in 1921, and he spent part of every year there until 1935. A nearby neighbour was Maillol, whom he probably first visited in 1925. This contact may well have encouraged the increasing classicism and naturalism of Laurens's work in the late 1920s, which culminated in the monumental version of 'Large Draped Woman' of 1928. It was also at this time that he began to work with the traditional material of bronze. In 1932–3 Laurens spent half a year in Etang-la-Ville, and according to his wife, the daily walks he took in the surrounding woods, where he observed the movement and interlacing of the branches and the rough patterns of the bark, help to account for the dynamism, the pronounced organic quality and the grained surfaces of many of his new works. But in the mid-1930s his sculpture, in which the female body is subjected to extravagant and richly suggestive distortions, began to assume a surrealistic character and is reminiscent of

The artist in his studio with 'Large Draped Woman' in 1928

Picasso's slightly earlier Surrealist paintings and sculpture.

Laurens won the Helena Rubinstein prize in 1935, and executed several important monumental commissions for the Exposition Internationale held in Paris in 1937. During the Occupation he lived in retirement, but thereafter enjoyed international prestige. In 1951 he was honoured with a major retrospective at the Orangerie in Paris.

72 Woman with a Basket of Grapes 1924

Stone, 75.5 × 32.5 × 27.5
Galerie Louise Leiris, Paris

The subject of this sculpture is the same as that of Braque's 'Basket Bearers', exhibited in the Salon d'Automne of 1922 (cat. 10). Laurens, who had been close to Braque since 1911, must have observed his friend's gradual evolution after the war away from the geometry and abstraction of synthetic Cubism, and towards a more sensuous and naturalistic style referring openly to the classical tradition. His own post-war work follows a somewhat similar course, and the relatively large size of this sculpture, coupled with the decision to use the permanent and timeless material of stone, indicate his readiness to measure himself against that tradition. It was in terms of the classical tradition that Christian Zervos discussed Laurens's new works in an essay published in *L'Art d'Aujourd'hui* in 1924. Emphasising the urge 'to order and to simplify' that characterises them, Zervos points to the total absence of anecdote or expressionism. Laurens, he says, attains '*le grand style*' because 'he avoids everything which suggests the individual type. . . . All the artist's effort tends to the expression of profound peace. His figures are the epitome of tranquillity and repose.'

The first clear sign of a new orientation in Laurens's work had occurred in 1919, in the more voluptuous and relaxed forms of the body of 'Woman with a Fan' and in subsequent related reclining nudes. In these, curves multiply, forms are more volumetric, and there is a general softening of mood – although the break up of the body into large areas, which are then juxtaposed against one another at different angles, betrays the continuing role of Laurens's Cubist style. Although 'Woman with a Basket of Grapes' is unthinkable without Cubism, it is none the less significantly more organic than works done slightly earlier. This may be a direct influence from Braque's 'Basket Bearers', but it is also true that in 1922 Laurens's polychromed terracottas of bowls of grapes already show an increase in linear grace and in naturalism, and possess a sensual fullness. In any case it seems certain that he intended to create an icon of fruitfulness, in which breasts rhyme with bunches of grapes and the full basket stands for the pregnant womb.

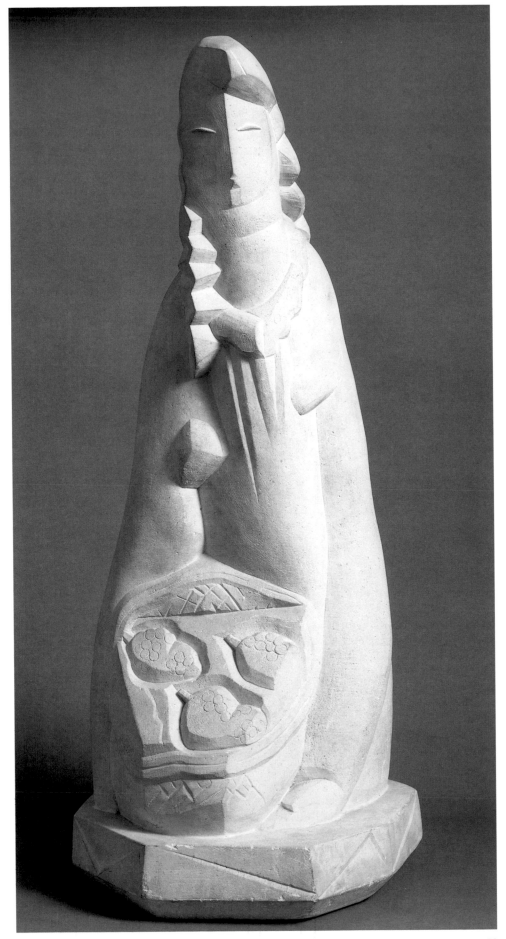

72

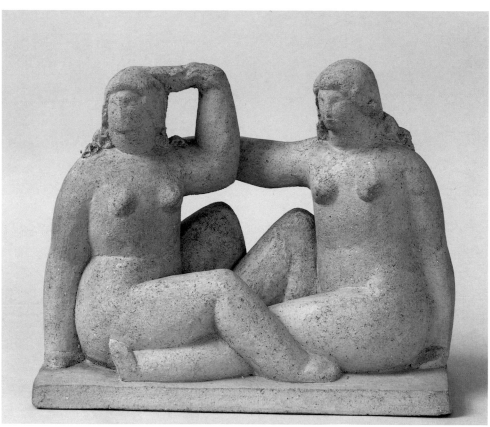

73

73 Two Women 1926
Terracotta, 20 × 25 × 12
Galerie Louise Leiris, Paris

This work shows a further move in the direction of greater naturalism from the previous carving, and anticipates the studies of nudes of the late 1920s. Terracotta was the favourite material of Laurens when he worked on a small scale. Although none has survived, we know that his earliest experiments with a Cubist style in 1912–14 were in this medium. Kahnweiler was no doubt justified in attributing his initial use of terracotta to the absence of sufficient funds for bronze-casting, but it is clear that Laurens, like Maillol and Manolo, delighted in the naturally grainy texture, the feeling of fragility, the warm colour, and the primitive, 'earthy' character of the material: sculpture and pottery are never closer than at this point. The precedent of the terracotta statuettes of antiquity gave the material added resonance at this period of 'classical revival'.

'Two Women' is a beautiful example of Laurens's ability to retain the intimacy of terracotta and yet to achieve a feeling of monumentality: within a few years, indeed, it would be his practice to work up to a large scale, destined for bronze-casting, from perfectly realised small-scale terracotta statuettes. The work's compelling monumentality, despite its diminutive size, is the result of the hieratic treatment of the figures, the symmetry of the boxy composition, the simplification and enlargement of the body forms, and the generalised and abstracted handling of the surface. Picasso was a close friend of Laurens, and it seems certain that Laurens was influenced by the heavy, primitive and sculptural quality of many of Picasso's neoclassical paintings of nudes of the early 1920s. But it is also likely that he was affected by the small-scale reliefs of Manolo, which he would have known well through his association with Kahnweiler.

74 Reclining Woman with Drapery 1927

Bronze, 28 × 84
Musée National d'Art Moderne, Centre Georges Pompidou, Paris, gift of M. Claude Laurens, 1967

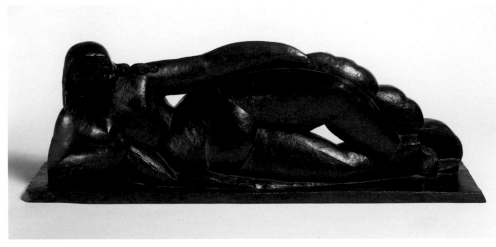

74

A long series of reclining nudes occupied Laurens from 1919 onwards. He seems to have come to the theme via that of still life – a number of his Cubist *papiers collés* had depicted 'recumbent' musical instruments, whereas his figures had all been upright. In any case, the new subject, which by its nature is more relaxed and more sensual than the upright figure, seems to have encouraged, if it did not actually precipitate, the move towards greater naturalism that is a general feature of his post-war work. Even in the earliest 'Cubist' examples the hips, thighs and buttocks are generously curved and their full forms push outwards against the taut surface. Looking at them one is reminded of certain ancient fertility figures, such as the often reproduced Hal Saflieni reclining figure from Malta, or the 'Venus of Lespugue' (discovered in 1922). To artists of Laurens's generation these primitive works had the status of the ultimate source – the beginning of the act of sculpture.

The 'Reclining Woman with Drapery' exhibited here is considerably more natura-listic than earlier examples, and if she still bears some resemblance to the fertility goddesses through her small head and large hips and thighs, she has closer contact with more recent traditions of European art. The artist who springs to mind is Ingres. Ingres was regarded in vanguard circles as a daring and revolutionary innovator, rather than a hidebound academic, and a painting which attracted intense interest was 'The Turkish Bath' (repr.p.22). *L'Esprit Nouveau* carried an important study of Ingres by Bissière in the issue for January 1921, with photo-graphs not only of the complete picture but also of details of the voluptuous reclining nude in the right foreground. She, in parti-cular, may have been an inspiration to Laurens. But there are also similarities with the sinuous, notoriously elongated 'Grande Odalisque' (also in the Louvre). Like Ingres, Laurens deforms his model's body in the interests of abstract linear grace, persuades body and drapery to echo each other, and treats the figure as a relief lying strictly parallel to the straight edge of the plinth.

Maurice Raynal, in an essay on Laurens published in *L'Esprit Nouveau* in July 1921, defined the principal characteristic of his art as 'grace', and went on to analyse the essential role played by the numerous 'slight imperfections', which gave his work its piquancy and saved it from triteness. He identified this 'flawed' gracefulness as pecu-liarly French, and Laurens as a true French master. The momentary awkwardnesses, the many little interruptions in the overall rhythmic flow, the disconcerting dispropor-tions of this seductive nude, may be seen as signs of the peculiar grace of which Raynal wrote.

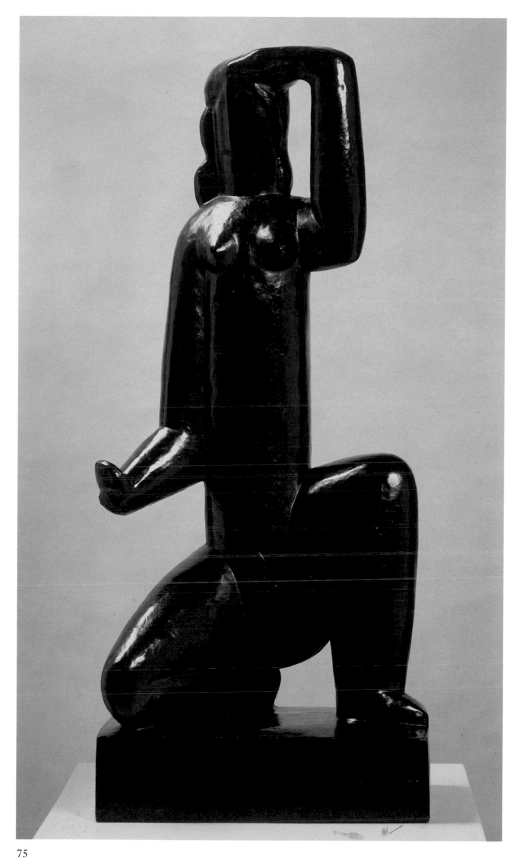

75

75 Large Woman with a Mirror
1929

Bronze, 71.5 × 30 × 19
Musée des Beaux-Arts, Nancy

In the late 1920s Laurens's work again
became momentarily more geometric and
more static, as if he wished to renounce the
graceful, organic rhythms which character-
ise the works of the middle years of the
decade. In the event the new severity was
short-lived, but between 1928 and 1930 he
produced a number of powerfully compact
and monumental pieces. This woman may
be gazing at her reflection in a mirror and
adjusting her hair – a favourite sensual
theme with artists – but Laurens does
everything possible to reduce the potential
voluptuousness and to make us realise that
the real theme is the abstract composition of
the juxtaposed and contrasted cylinders
from which the body is formed. To empha-
sise the controlling geometry he bends legs
and arms by preference at the classic angles
of 90 and 45 degrees, so that the brow and
nose are like the corner of a box and the
raised arm like the square handle of a vase.
The head, it is true, inclines slightly away
from the strictly frontal, but forms a conti-
nuous column with the torso, so that the
effect is emphatically unbending. Only the
rippling hair hints at the potential for
movement and for beauty of a more yielding
disposition. The square plinth perfectly
contains the figure and restates the blocki-
ness of the overall conception.

Laurens admired the iconic quality of
'primitive' forms of art, and there is a
general air of archaism about this work: the
abrupt angles and the frontality are some-
what reminiscent of Egyptian and archaic
Greek figure sculpture, although the pose is
classical. Like many of his contemporaries
Laurens also admired African art, and com-
parisons could be drawn with Fang or Luba
carvings of ancestor figures. The ability to
find similar conceptual principles under-
lying apparently incompatible or unrelated
cultures was something he shared with
many other radical artists of his generation:
Ozenfant and Jeanneret (Le Corbusier), for
instance, set up these kinds of parallels in
publications such as *L'Art Moderne*
(Paris, 1925).

76 Bather (Fragment) 1931

Bronze, 57 × 67 × 36
Tate Gallery

This work is the upper part of 'Reclining
Woman', a full-length figure made in 1931
(and reproduced complete in *Cahiers d'Art*
the following year), which was irrevocably
damaged by the bronze founder when the
cast was being made. Laurens was able to
save the torso and to turn it into this
wonderfully animated 'fragment'.

The sculptural fragment had been much
exploited by Rodin for its poignant expres-
sive potential. Laurens had fallen under the
spell of Rodin's work early on in his career.
But the fragments that this piece more
closely resembles are the accidental, rather
than willed, fragments of antiquity. In his
L'Esprit Nouveau essay of 1921, Raynal had
in fact suggested a parallel between the
'delicate search for imperfection', which
charmed him in Laurens's work, and those
antique fragments that are so 'strikingly cut'
that the breaks look deliberate. Indeed in
1925 Laurens imitated these effects in a
classically posed terracotta 'Torso', which is
'broken' at the arms, neck and knees.

For all this, however, the 'Bather' in her
present state has a 'baroque' quality which
is new in Laurens's work, but which is
encountered in many subsequent pieces,
where complex, off-centre, twisting poses
create a feeling of animal dynamism and
erotic energy. But as Laurens remarked to
Taillandier in 1951, his ultimate aim was a
classical serenity:

> Even when I represent movement I look
> for stability. The movement doesn't
> upset the sense of calm which my sculp-
> ture produces. . . . My statues are less
> representations of movement than com-
> positions of forms. The harmony, the
> plastic laws which regulate them, the
> arrangement of their volumes which are
> all related to one another, the fact that the
> voids count as much as the solids – all this
> tends to confer stability on them. And
> anyway, I don't have a violent tempera-
> ment.

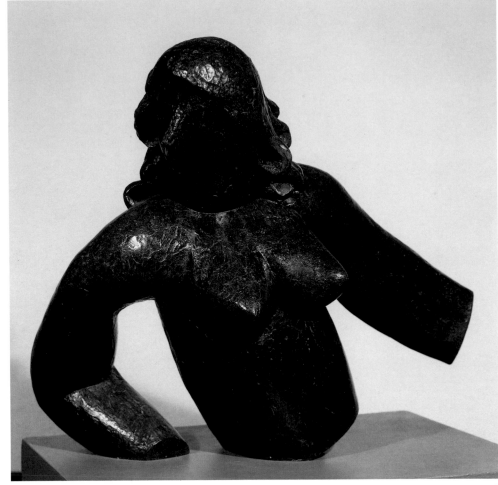

76

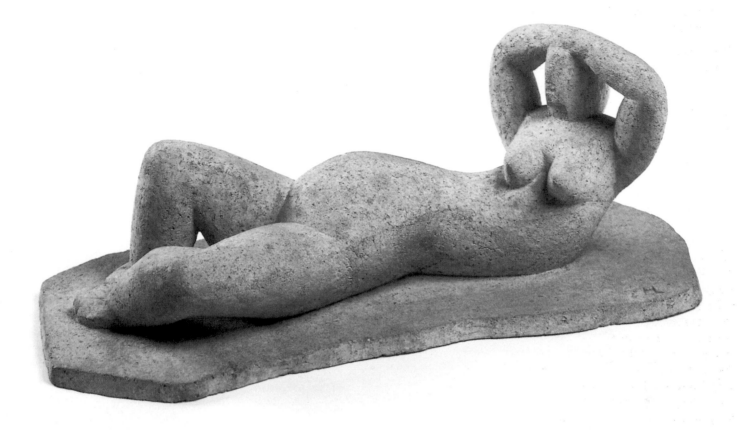

77

77 Small Maternity 1932
Terracotta, 18.5 × 47
M. and Mme Claude Laurens

Laurens's friendship with Maillol developed in 1932–3 when he spent six months working in his studio at Etang-la-Ville, not far from Maillol at Marly-le-Roi. The ample, rounded forms of this reclining nude, and the smooth, unhurried transitions from, say, hips to thighs, suggest the influence of Maillol's work, although 'Small Maternity' is more abstracted than even the most spontaneous of Maillol's terracottas. It is, indeed, almost as if her body has been formed from clay rolled between the palms of the hands, and then deftly twisted and joined.

The pose of the pregnant woman – wonderfully supple and relaxed without being in any way lethargic – is that of an odalisque, and speaks eloquently of Laurens's great appreciation of the voluptuous grace of Ingres and Matisse. The evolution in his style from 'Reclining Woman with Drapery' (cat.74) towards this organic and lyrical manner was consolidated in other works of the early 1930s, such as 'The Wave' and 'The Water Nymphs'. 'Small Maternity' itself was also realised on a large scale in bronze.

FERNAND LÉGER 1881 ARGENTAN – 1955 GIF-SUR-YVETTE

Léger's position in the 'call to order' movement of the post-war period is an idiosyncratic one. His grand figurative paintings on traditional themes, such as the nude or the mother and child, are related in imagery to the neoclassical paintings of Picasso and Braque and to the realist paintings of Derain, although his scenes are idealised visions of the modern world. On the other hand, in its boldly abstracted style his work is closest to that of the Purists and the 'crystal' Cubists supported by Léonce Rosenberg, even though he did not share their philosophical and metaphysical concerns, and was more attracted to modern technology than pure mathematics. Indeed in Léger's work the determination to forge a link between the specifically modern and the great traditions of the past, without compromising either, is expressed more distinctly and more forcefully than it is by any other artist of the period.

Léger came from a family of livestock breeders in Normandy – a background that conditioned his down-to-earth attitude to his painting, which he hoped would appeal to ordinary people. (His identification with the working classes led him eventually to join the Communist Party in 1945.) He was apprenticed early to an architect in Caen, and in 1900 moved to Paris where he was employed as an architectural draughtsman. This experience had lasting repercussions for his painting, which is solid in structure and precise in execution. Determined to become a painter, Léger attempted to gain admission to the Ecole des Beaux-Arts in 1903, but, having failed, enrolled in the Ecole des Arts Décoratifs. At the same time he attended open classes given by the academic painters Léon Gérôme and Gabriel Ferrier, frequented the Académie Julian, and studied in the Louvre. At this stage his own painting was based on Impressionism, but at the Salon d'Automne of 1907 he discovered the work of Cézanne, whose influence on him remained significant for some years.

In 1908 Léger took a studio in Montparnasse where, over the next few years, he encountered the leading avant-garde poets and painters in the circle of Apollinaire, Max Jacob and Blaise Cendrars. He

destroyed much of his early work, but what survives suggests that by 1909 he was already acquainted with the early Cubist paintings of Picasso and Braque. However, his first major painting, the monumental 'Nudes in a Forest' (Rijksmuseum Kröller-Müller, Otterlo), which was exhibited in the Salon des Indépendants of 1911, shows his allegiance to the 'Salon' Cubists, Metzinger, Gleizes, Le Fauconnier and Delaunay, who, unlike Braque and Picasso, concentrated on classically conceived, multi-figure compositions. Like them Léger was also much interested in Bergsonian concepts of simultaneity and dynamism, and he gravitated naturally to the gatherings at Puteaux held in the studio of the Villon brothers. In October 1912 he exhibited with this group at the Salon de 'La Section d'Or' in the Galerie La Boétie. In 1913 Léger signed a contract with Kahnweiler, and the complex, large-scale Cubist works of 1911–12 yielded, in 1913–14, to the virtually abstract, highly simplified style of the 'Contrast of Forms' series.

Léger's experiences at the front during the First World War convinced him that his work must in future express the concrete reality of modern life in direct iconographic terms, and not only in terms of the dynamic, but purely formal, contrasts of his pre-war 'abstract' paintings. Gassed at Verdun, he was demobilised, and was able to take up painting seriously again in 1917. 'The Cardplayers' of that year (Rijksmuseum Kröller-Müller, Otterlo) was his homage to his fellow soldiers in the trenches, and announced his return to grand figurative subjects. The bold, clean, hard-edged style reflected his intense admiration for modern industrial machinery, and the influence of illustrations of machine parts, as well as popular forms of art such as posters and advertisements. Kahnweiler being in exile abroad, Léger signed a contract with Léonce Rosenberg in 1918, and in February 1919 had his first one-man show at Rosenberg's Galerie de l'Effort Moderne.

Between 1918 and 1920 the human figures in Léger's paintings were usually, if not invariably, fragmented, and the visual effect of his stridently coloured, strongly patterned paintings was of dynamic

The artist in his studio, *c.*1928

movement. The urban subjects also implied a life of action, energy and speed, and although machines were not directly depicted, the pictures were dominated by polished, mechanistic forms. But in 1920, in paintings such as 'The Mechanic' (National Gallery of Canada, Ottawa), the human figure is unified, dominates the canvas, and is given a 'classic' status through broad references to archaic art and to the French tradition of realist figure painting from Fouquet to the Douanier Rousseau. More tranquil themes of leisure and relaxation now predominated, while the compositions were controlled increasingly by perfectly balanced oppositions of horizontals and verticals. Léger's meeting in 1920 with Ozenfant and Jeanneret (Le Corbusier) helped to confirm this new orientation, and he remained closely associated with them throughout the lifetime of their periodical *L'Esprit Nouveau*. In 1924 he set up a teaching studio, the Académie de l'Art Moderne, with Ozenfant, and from this time on teaching was an important part of Léger's activity. His friendship with Le Corbusier was even closer and longer lasting.

In 1924 Léger went to Italy with Léonce Rosenberg. He visited Ravenna and Venice and especially admired the Romanesque mosaics and the paintings of the 'Primitives', and in 1933 he accompanied Le Corbusier on a trip to Greece. Léger's identification with the tradition of the old masters never involved imitation or the appropriation of their styles, and the extent of his debt to the classical tradition was debated by French critics in the 1920s. Waldemar George minimised it (*Fernand Léger*, Paris, 1929); but Tériade analysed the 'Northern', as opposed to 'Mediterranean', character of Léger's classicism at length (*Fernand Léger*, Paris, 1928). Both were, however, in complete agreement about the classical formal qualities of his art – its ordered, constructive and lucid nature – and about the 'healthy equilibrium' of his temperament. George wrote: 'A canvas by Léger is a plastic idea thoroughly understood and clearly formulated. . . . His whole being breathes equilibrium, strength and energy . . . a strength which is instinctive and normal. . . . His happy genius has worked successfully for the clarification of contemporary art.' For Tériade, 'Léger is the great constructor', and his work possesses 'powerful stability', 'the intimacy of silence', and 'meditative peace'; it is above all an art of 'synthesis'.

In the early 1920s Léger's interest in the theatre, dance and especially the cinema resulted in commissions from the Ballets Suédois of Rolf de Maré, and in the making of avant-garde films, including *Ballet mécanique* – the first film without a scenario. His international reputation grew, and in the late 1920s and 1930s he exhibited widely in France and abroad. His energy as a teacher, writer and lecturer further contributed to the spread of his influence. His ambition to produce genuinely public art was first realised at the time of the 1925 Exposition des Arts Décoratifs, when he and Delaunay were commissioned by the architect Mallet-Stevens to decorate the entrance hall of his 'Pavilion of a French Embassy'. In the last twenty years of his life Léger received an increasing number of such commissions, culminating in his decorations for the United Nations building in New York in 1952. In 1949 he was honoured with a major retrospective at the Musée National d'Art Moderne in Paris, and after his death with a memorial exhibition at the Musée des Arts Décoratifs, where his career as a painter had begun.

78 Man with a Dog 1921

Oil on canvas, 65 × 92
Private Collection of Samir Traboulsi, Paris

This is the best known of the '*paysages animés*' (animated landscapes) Léger painted in 1921. The scenery in 'Man with a Dog' is synthetic and idealised, but probably reflects memories of the Normandy farms and villages Léger saw on his summer visits home. The idealisation of country life involves, however, no hint of nostalgia for the pre-technological age. On the contrary, the boldly coloured, geometric farm buildings resemble advanced contemporary villas and apartments, such as those designed by his friend Le Corbusier, and they coexist with iron bridges and stencilled billboards. Although no factories are specified, there is a strong suggestion of the modern industrial landscape, and the robotic men could just as easily be factory workers on a break as farm workers out for a stroll. No irony is intended in the confrontation. Léger extolled the beauty of the gleaming new agricultural machines which were beginning to

transform traditional French farming methods at this period. The perfect integration of the composition is a symbol of the harmony he hoped for in the post-war world.

Léger had met the Douanier Rousseau in 1909, and admired his paintings deeply. In its blithe acceptance of modernity as well as in its toy-like figurative style, 'Man with a Dog' is very reminiscent of Rousseau's paintings of the outskirts of Paris, such as 'Stone Quarry near the Fort de Vanves'. (Now in a private collection, this painting had been included in the Rousseau retrospective exhibition at the Galerie Bernheim-Jeune in 1912.) But beyond Rousseau, who after the war enjoyed the status of a painter in the great classical tradition of French realism, Léger's landscape seems to allude directly to the eminently ordered and lucid

classical landscapes of Poussin and Corot. Both were heroes of 'call to order' critics and painters, and both were the subject of essays in *L'Esprit Nouveau* in April and June 1921. Léger does not, however, imitate any of these artists: instead he sets up an opposition between a recognisable 'old master' composition and a resolutely modern, post-Cubist style. He wrote before and after the war of the centrality of systematic formal contrasts to his work: 'I organise oppositions of contrasted tones, of lines, of curves. I contrast curves with right angles, flat surfaces with modelled forms, pure local colours with nuanced greys . . .' ('Note sur la vie plastique actuelle', *Kunstblatt*, 1923). The opposition between traditional art and modern art is simply another aspect of Léger's system.

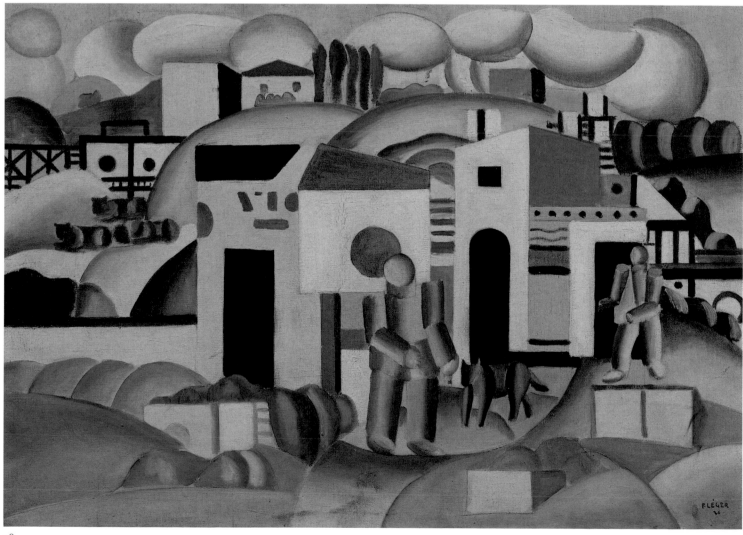

78

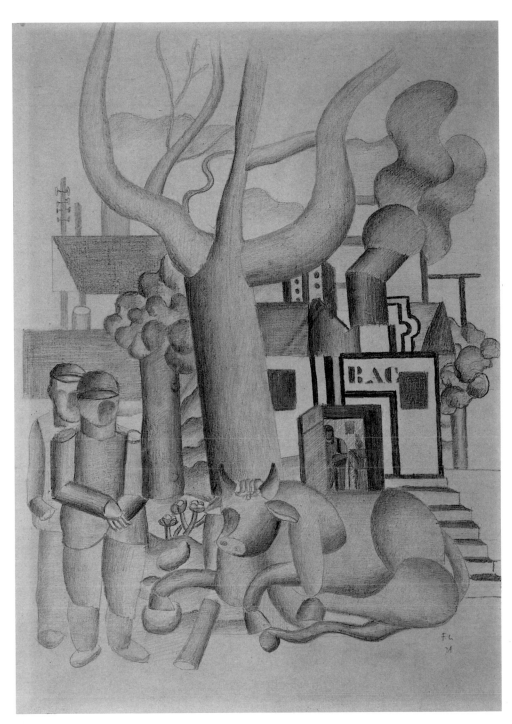

79

79 Animated Landscape 1921
Pencil on paper, 42 × 30
Rijksmuseum Kröller-Müller, Otterlo

During the Cubist period Léger had worked towards the separation of line and colour in his paintings, giving each equal weight. As a soldier at the front he had no option but to concentrate on drawing, and after the war it assumed an increasingly important role in his art. But while some of his drawings are preparatory sketches in the true sense, many – like this one – are carefully finished, high-quality works in their own right, related to, but independent from, paintings with basically the same image and composition.

In this emphasis on draughtsmanship and pre-planning, Léger betrays the impact of his early architectural training, but also the lingering influence of academic ideals and methods. Under the academic system, drawing was regarded as the essential backbone of composition in art. It represented the intellectual, as opposed to sensual, ingredient, and the young artist was supposed to gain command of drawing before progressing to the use of colour. With the 'return to order', drawing acquired some of the prestige it had enjoyed formerly, and many painters and sculptors produced extensive numbers of finished drawings – Picasso is simply the most famous instance. Léger's drawing style in the 1920s has, indeed, an academic character: the contours are clear and pure; the shading is systematic, the gradations of tone being carefully managed; moreover, he makes no attempt to substitute tone for the missing local colours – the composition is conceived entirely in terms of black and white. One is reminded of the drawings of Seurat, an artist to whom Léger was occasionally compared by contemporary critics because of their shared concern with modernity and their highly independent use of the art of the past.

80 Study for a Landscape 1921

Gouache on paper, 35.5 × 24
Galerie Louise Leiris, Paris

Although landscape so often forms the background to Léger's figure compositions, the unpeopled landscape is a rarity in his art. This gouache is the study for an oil entitled 'The Forest'. In subject and composition it is reminiscent of the early Cubist landscapes Braque painted at L'Estaque in 1908, but the sweeping, organic line which describes the trunks and branches of the trees and the undulations of the hills has a romantic lyricism similar to that of the pre-war landscapes by Derain. Although Léger was not tempted to experiment with a realist style and seems not to have been so interested in Derain's post-war work, which is more frankly reminiscent of the old masters, he appreciated the structural qualities and the formal simplifications of Derain's early paintings.

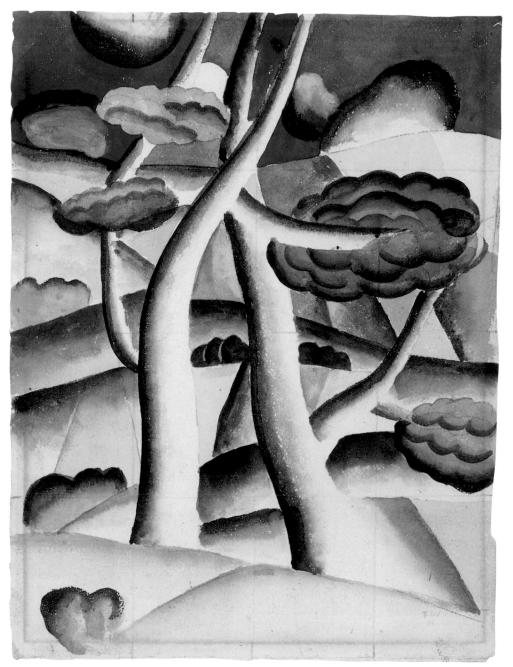

80

81 Three Women (Le Grand Déjeuner) 1921

Oil on canvas, 183.4 × 251.5
Collection: The Museum of Modern Art, New York, Mrs Simon Guggenheim Fund

This great masterpiece was first exhibited at the Salon d'Automne of 1921. It was bought by Léonce Rosenberg, but he apparently found it too 'severe', and Léger took it back. Himself dissatisfied, Léger reworked it in 1922, painting the seated figure on the right in dark flesh tones over the original *grisaille*, and making various other small adjustments to the background and furniture, most of them in the direction of greater simplification. It remained unsold until 1925, a source for many of Léger's intervening paintings.

'Le Grand Déjeuner' is Léger's equivalent to Seurat's 'Sunday Afternoon at the Island of the Grande-Jatte' (Art Institute, Chicago), for it was prepared meticulously over a two-year period, while simultaneously he worked on other related but distinct compositions with one or two nude figures. A drawing dated 1920 (in the Rijksmuseum Kröller-Müller, Otterlo) shows the whole composition more or less as it would appear in the definitive painting, and there are two considerably smaller oil versions, both known as 'Le Petit Déjeuner'. There are also separate drawings and oils of the tea-drinker on the right and of the two women on the left, all of them dated 1921. The care with which Léger prepared the huge painting shows that he thought of it as a 'masterpiece' and that he intended it to be a modern Salon '*machine*'. Consistent with this intention was his decision to exhibit it for the first time in a Salon, rather than a dealer's gallery.

In letters to Alfred Barr written in 1942 and 1943 – Barr had just purchased the painting for the Museum of Modern Art – Léger described 'Le Grand Déjeuner' as 'classical', and stressed both the universality of the subject matter and the absence of emotion. Léger's sources for the painting are indeed located in the classical tradition of French art, and he himself hints at where we should look in the 'Letter', dated 1922, which he published in the *Bulletin de l'Effort Moderne* in April 1924. There he names as his 'artistic sources' Renoir, Seurat, Ingres and David, and indeed 'Le Grand Déjeuner' could readily be compared to Renoir's 'Large Bathers' (Musée d'Orsay, Paris), Seurat's 'The Models' (Barnes Foundation, Merion, Pennsylvania), Ingres's 'Turkish Bath' (Louvre) and David's 'Portrait of Madame Récamier' (Louvre). Other artists he mentions in the

81

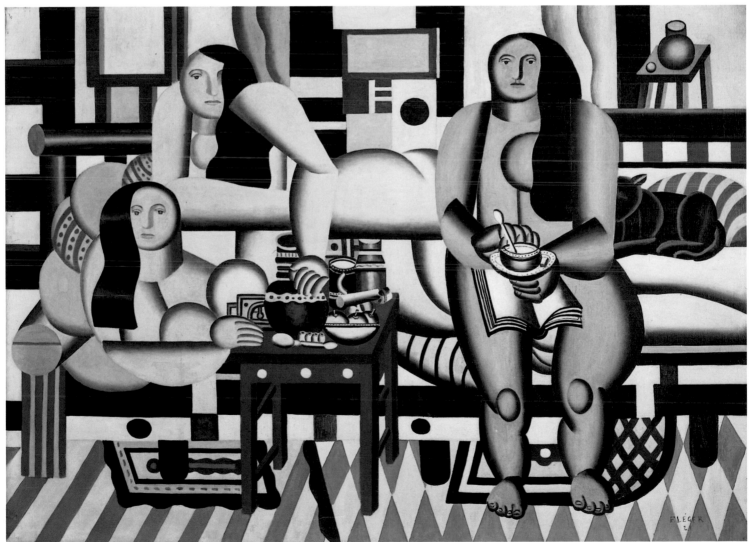

same text are Delacroix, the Le Nain brothers, Cézanne, Poussin and Fouquet – and again, iconographic, compositional or stylistic parallels could be drawn with specific works, such as Delacroix's 'Women of Algiers' (Louvre), Le Nain's 'Family of Peasants in an Interior' (Louvre), Cézanne's late Bather compositions, Poussin's 'Eleazer and Rebecca at the Well' (Louvre), and Fouquet's 'Madonna and Child with Angels' (Musée des Beaux-Arts, Antwerp). He does not mention Manet, but 'Olympia' and 'Déjeuner sur l'herbe' (both Musée d'Orsay) are among the most obvious precedents for the painting.

Over and above any specific debt to the past, however, 'Le Grand Déjeuner' is intended to be a truly humanistic work – an ideal, symbolic image of universal peace, harmony and beauty, expressing Léger's hopes for the betterment of mankind and belief in the civilising mission of art. In this respect it must be seen in the context of the more modest 'animated landscapes' he was painting at exactly the same period (cat.78), which have a similar Utopian message.

Yet everything about the painting is resolutely modern while at the same time being classical and timeless. The odalisques drink their tea and read their books in a room decorated in the hygienic post-war style advocated by Le Corbusier; they look as if they have been assembled by a machine from off-the-peg, standardised parts. We recognise the debt to the flat colours and geometry of synthetic Cubism, and we sense the relationship to the contemporary abstract paintings of Mondrian, then living in Paris. Where Picasso sometimes pretends to be an ancient artist and renounces the outward garb of modernist styles, Léger does not. He refuses to mythologise, and there is none of Picasso's poignant and uneasy nostalgia. It was this absence of moral doubt that made critics such as Waldemar George speak of Léger's art as 'healthy' and 'cleansing' (*Fernand Léger*, Paris, 1929).

82 Nudes against a Red Background 1923

Oil on canvas, 145 × 97
Oeffentliche Kunstsammlung,
Kunstmuseum, Basle

This was the one figure painting produced by Léger in 1923, a year in which he was involved in many activities other than painting – writing, designing for the Ballets Suédois, and working on Marcel L'Herbier's film, *L'Inhumaine*. It was preceded by a small oil of the torso of the larger figure, and a squared-up drawing, both of which are dated 1922.

'Nudes against a Red Background' initiated a new 'pure' manner in Léger's figure paintings. The nudes derive from those in 'Le Grand Déjeuner', but where the earlier painting had dazzled with its complex decorative patterns and its constant shifts in perspective, the later painting is dramatic in its simplicity. Although the figures are mechanistic, and lock together so tightly and so perfectly that they look like parts of the same smoothly working machine, they are less specifically modern than the nudes in 'Le Grand Déjeuner'. They are simply objects of contemplation, similar to the subject-less, timeless *académies* (life paintings) executed by every art student. Here Léger draws closer to the classicism of Picasso in 'The Large Bather' (cat.141), and away from the 'Cubist' classicism of the Purists or of Gris. Perhaps he is closest of all to Maillol in the complete absence of mood or expression, and in his pursuit of an absolute compositional and technical finality.

The picture could, indeed, be likened to an icon, the brilliant, almost magical, red standing in for the sacred gold; and like an icon it has the authority of the unalterable. Tériade hailed the new simplicity of Léger's figure paintings of 1923–4 as the climax of his classicism: 'The static, monumental figures are comparable to the figures in Greek art in their silent and inexpressive plenitude. They mark a great step towards the essential, towards definitive simplicity. They represent the abandonment of dynamism and the search for form that will be calm, stripped, secret.' He concluded: 'The admirable unity of their forms co-incides with the sobriety of their colours to convey a sensation of balance; and the style becomes that of the Great Tradition (le style devient grand).' (*Fernand Léger*, Paris, 1928) With reason, 'Nudes against a Red Background' has been compared to Roman

mosaics from the Baths of Caracalla, which show muscular, pugilistic athletes silhouetted against plain grounds. (These mosaics had been reproduced in *L'Esprit Nouveau* in December 1921.)

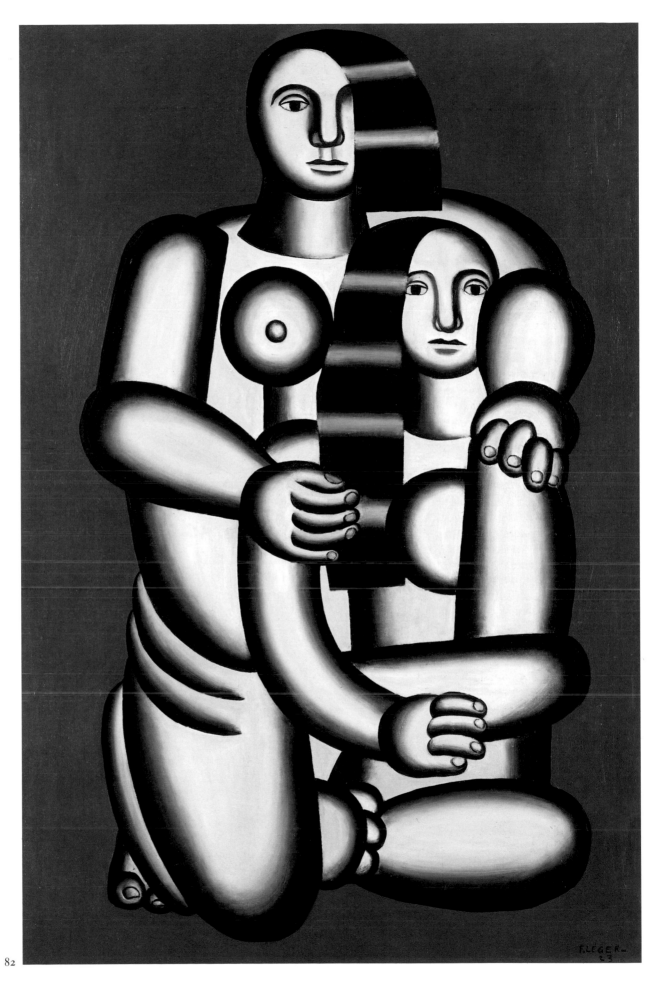

82

83 The Two Sisters 1935

Oil on canvas, 162 × 114
Staatliche Museen Preussischer
Kulturbesitz, Nationalgalerie, Berlin

The formula Léger uses here is the same as
that of 'Nudes against a Red Background' –
two powerfully modelled grey-coloured
bodies, locked together by a shared contour,
and silhouetted against a flat, coloured
ground. But the mood is much more tender
and more lyrical, and the effect much less
hieratic and severe. The differences are the
result of Léger's rejection of the strictly
frontal viewpoint, and his use of a free
organic line which follows a rhythmic
course obedient to natural laws – running
ponderously over shoulders and thighs,
faster over waving hair, and rapidly over
fingers and toes. The flowering branch is
emblematic: the girls are like nymphs of the
meadows – comparable to Maillol's 'Three
Nymphs' of 1930–38 (cat. 95) – and their
benign presence offers a message of peace
and plenty. The yellow ground shines bril-
liantly, and against it the steely bodies take
on the aspect of a vision.

The 'naturalism' of 'The Two Sisters'
and other paintings of the early 1930s had
developed gradually in Léger's work from
1927 onwards, when the organic forms of
his earlier 'animated landscapes' (see cat.
79) began to enter his still lifes, and to vie
for supremacy with the mechanistic, geo-
metric objects on which he had hitherto
focused. The change was paralleled in the
work of several of his friends, including
Ozenfant and Jeanneret, both of whom
renounced the strict formal limitations of
Purist painting at the same period and
turned to figurative subjects. The rigorous,
almost puritanical, phase of the 'call to
order' had passed.

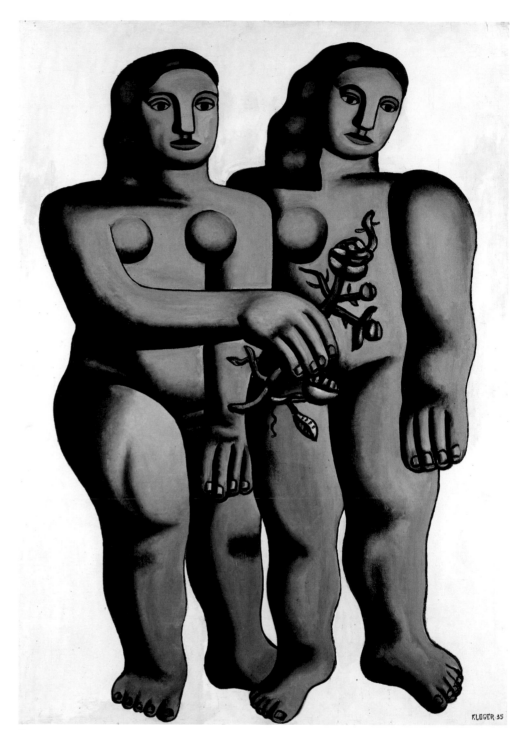

83

JACQUES LIPCHITZ 1891 DRUSKIENIKI – 1973 CAPRI

From his earliest childhood in Lithuania, Lipchitz had, he says, 'modelled continually', painting his clay sketches white to make them look like academic plaster casts (*My Life in Sculpture*, London, 1972). He remained a modeller throughout his life, never succumbing to the modernist ethos of direct carving, and using assistants whenever his works were to be translated into stone or marble.

Lipchitz went to Paris to study at the Ecole des Beaux-Arts in October 1909, but he attended the classes only briefly, preferring the more intimate atmosphere of the Académie Julian, where his teacher was Raoul Verlet. He points out, however, that the teaching there was not greatly different from that in the Ecole, and little had changed since the eighteenth century: 'Mornings were spent in the academy drawing or modelling from the model and afternoons visiting the Louvre and other museums. . . . Themes for the exercises were written out in the administrative offices of the academy, and included many subjects from the Old and New Testaments or from classical antiquity.' (*My Life in Sculpture*) He would soon reject academic standards, but this thorough training left a profound mark on both his choice of subjects and his methods. Themes from the Bible and classical myth resurfaced constantly in his mature work, long after all ostensible connections with academic art had disappeared, because he remained committed to the traditional humanist concept of art as the expression of the fundamental experiences of life. Lipchitz adds that it was at the academy that he learned the traditional method of beginning every work with a clay sketch. 'I have continued to use this method ever since that time because I believe strongly that it is superior to all others.'

Lipchitz, who lived in the artists' quarter in Montparnasse, associated closely with other Jewish expatriots like Modigliani and Chagall, and other foreigners like Picasso, Gris and Diego Rivera. It was in 1911 that he first encountered Cubism, although his own work did not begin to show Cubist influence for another couple of years. In the mean time he executed works in the

classicist style practised by Despiau, then widespread among independent sculptors. His most ambitious work from this pre-Cubist period was 'Woman and Gazelles' of 1912, which was acclaimed at the Salon d'Automne in 1913. Out of these already simplified but still naturalistic works his geometricised and stylised proto-Cubist sculptures developed.

In 1914 Lipchitz went with Rivera to Majorca and Spain, where they were caught by the outbreak of war. As a Russian national Lipchitz was not liable for call-up, and he remained in Spain until the beginning of 1915. His work became more abstract and planar, showing the influence of synthetic Cubism. Several wooden constructions date from this period. In *My Life in Sculpture* he explains that while he was then in reaction against the classical and Renaissance traditions in which he had been trained, he was nevertheless 'very conscious of the examples of Egyptian and archaic Greek sculpture', finding in these more primitive sources 'many points of relationship in [their] accent on simplicity and directness'. This awareness of the connection between his art, however radical and personal its appearance might be, and past traditions of sculpture is a constant theme of his autobiography, and helps to explain why he was never tempted by complete abstraction. 'In my Cubist sculpture I always wanted to retain the sense of *organic* life, of humanity', he records. The severe geometric clarity of Lipchitz's new work was in harmony with the rational, 'crystal' Cubism of painters such as Gris, and appealed immediately to Léonce Rosenberg, who signed a contract with Lipchitz in 1916, gave him his first one-man show at the Galerie de l'Effort Moderne early in 1920, and simultaneously published an album of illustrations prefaced by the Purist critic Maurice Raynal. The contract with Rosenberg enabled Lipchitz to employ a stonecutter, and many of his Cubist sculptures were thereafter executed in stone as well as in bronze.

Feeling the need to experiment and change direction, Lipchitz dissolved his contract with Rosenberg in 1920. Until he won a major commission from Dr Albert

The artist in his studio in Montparnasse, *c*.1925 (Photo by Marc Vaux)

Barnes in 1922 to make stone reliefs for his art gallery outside Philadelphia, Lipchitz's situation was precarious, and partly to make money he turned to portraiture. The portraits of the early 1920s, commissioned or not, represent a positive response to the classical revival of the post-war period, and, up to a point, a return to his pre-Cubist style of a decade earlier. Although his other work remained highly abstracted and essentially Cubist in its formal and spatial character, a new emphasis on the organic became increasingly obvious, and this was surely in part a consequence of his renewed interest in naturalism.

The late 1920s was a period of great fertility and experimentation for Lipchitz, and the thematic range of his work broadened noticeably, while his style became more expressive and dramatic. He had always formed close friendships with poets – his first wife, Berthe Kitrosser, was a Russian poetess – and in the propitious climate created by Surrealism, his work often took on a metaphoric resonance and a

wide range of reference. Violent and erotic themes now coexisted with the more neutral figurative subjects of earlier years. (He never had, however, any formal links with the Surrealist movement.) In 1929–31, in his sketches, Lipchitz began to explore the repertory of the Old and New Testaments and classical mythology which had been his standard sources during his student years. These themes predominated in the 1930s, and reflected not only Lipchitz's sympathy with the Surrealists' concern with mythology as an indicator of the human psyche, but his own anxiety at the worsening political situation. Alongside such biblical subjects as 'The Return of the Prodigal Son', we find 'Leda and the Swan', 'Pegasus', 'The Rape of Europa' and 'Theseus and the Minotaur', while the passionate death-struggle in 'Prometheus and the Vulture', symbolising for him man's battle against the forces of evil and oppression, became an obsession.

Lipchitz's growing reputation as a vanguard sculptor led to a major retrospective at Jeanne Bucher's Galerie de la Renaissance in 1930. At the time of the Exposition Internationale of 1937 he was featured prominently in the exhibition *Les Maîtres de l'Art Indépendant*, and was commissioned to execute a huge sculpture, 'Prometheus Strangling the Vulture'. The plaster was installed alongside the Grand Palais and, although awarded a gold medal, aroused great controversy and the hostility of conservative factions in the press and the art establishment. In 1940 Lipchitz fled to Toulouse to escape the German Occupation, and from there sailed to New York in 1941. After the war he decided to settle permanently in America.

84 Pregnant Woman 1912

Plaster, coated with shellac,
64.2 × 14.6 × 12.2
Tate Gallery

In *My Life in Sculpture* (London, 1972), Lipchitz associated this work with 'Woman and Gazelles', completed in 1912 and shown at the Salon d'Automne the following year. Both reflect the influence of the Italian Primitives, and of German Renaissance artists such as Cranach. Lipchitz himself stresses that his style at this time was very similar to that of numerous other young sculptors who were in reaction against Rodin, seeking simplified, universalised and clarified structure and form. The treatment of the nude and the gentle, almost pious mood are particularly reminiscent of the paintings of Maurice Denis, prominent since the Nabi period as a critic as well as a decorative artist, and at the height of his influence in 1912 when he published a collection of his essays under the title *Théories: Du symbolisme et de Gauguin vers un nouvel ordre classique*. (Denis's widespread influence was often noted by Apollinaire in his Salon reviews of this period.)

Lipchitz felt the 'Pregnant Woman' was his most 'significant' work of 1912. 'This, which was done without a model, since I could not afford one, has to do with the mother-and-child theme, something which – perhaps because of my close attachment to my own mother – has always been of greatest importance to me.' (*My Life in Sculpture*) His fondness for the work was, presumably, the reason for its survival, for Lipchitz destroyed much of his early work after his return from Spain in 1915. The sculpture appears not to have been cast in bronze until the end of his life.

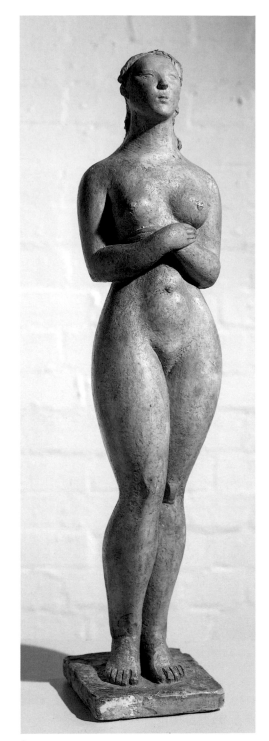

84

85 Portrait of Raymond Radiguet 1920

Bronze, 31.3 × 20 × 24
*Marlborough International Fine Art,
A.G.*

Radiguet, a brilliant young poet, was only seventeen when Lipchitz modelled his bust. The previous year, 1919, he had triumphed in the artistic and social world of Paris and become the lover and protégé of Jean Cocteau, one of the most influential writers of the period, and a leading exponent of the 'call to order' aesthetic both during and after the war. In 1920 Radiguet's book of poems, *Les Joues en feu*, was published, and this was followed by *Les Pélicans*, a two-act play set to music by Georges Auric. His most important works, however, were the novels *Le Diable au corps*, 1923, and *Le Bal du comte d'Orgel*, 1924. In these, critics recognised the qualities of simplicity, lucidity and restraint in thought, feeling and style which were the ideal of the current classical revival. Radiguet died of typhoid in 1923, a cult figure in the avant-garde.

Cocteau introduced Lipchitz to Radiguet and suggested that he make the portrait. The terracotta of the head remained in Cocteau's collection for the rest of his life. At about the same time Lipchitz also modelled the head of Cocteau in a very similar style. In *My Life in Sculpture* Lipchitz wrote:

> The young man [Radiguet] had an extremely beautiful skull structure, very crisp and clear-cut features, all of which I accentuated. In order to do so, I subordinated the mass of the hair in the plaster and even eliminated it in the bronze. This may be termed more realistic than the earlier portraits done before the war in its precision and in the fact that I sketched in the pupils of the eyes. To me, however, it is still an extremely classical work, one that has some of the qualities of idealism and repose that you find in Ancient Greek sculpture.

The classicism of the portrait was entirely appropriate to the model, and was also typical of the other portraits that Lipchitz made in 1920–22, such as those of Gertrude Stein, his first wife Berthe, and Coco Chanel. Significantly, the portraits Lipchitz made in the 1930s were much rougher in finish, less hieratic and less generalised, and were stylistically relatively close to his expressively modelled imaginative sculptures of the same date. For him, the moment of an ordered, serene, idealised classicism had lasted only briefly.

85

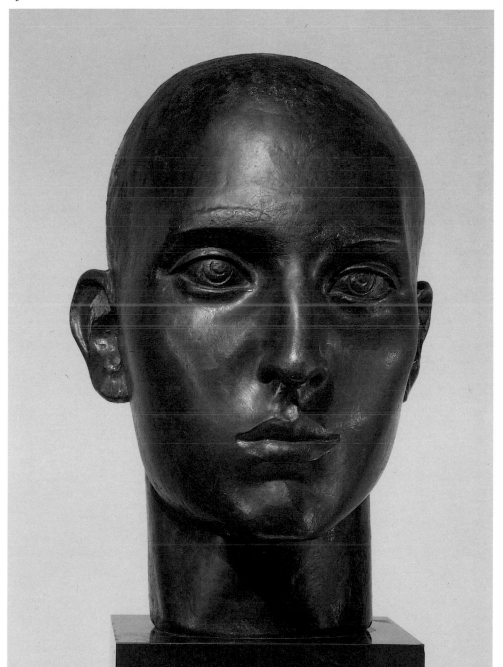

Maillol came from French Catalonia – Banyuls is a fishing village near Perpignan and the Spanish border – and his Mediterranean origins were emphasised in the 1920s by many critics, who agreed that the distinguishing characteristic of his art was its innate 'classicism'. His sense of affinity with the classical tradition is visible in his earliest sculptures and in his last works, such is the unity and consistency of his œuvre.

Maillol decided early to become a painter, and in 1881 he moved to Paris. After several attempts, he was finally accepted into the Ecole des Beaux-Arts in 1885 and studied there under the highly successful Salon painters Gérôme and Cabanel. However, he soon discovered the work of Gauguin, and decided to concentrate on tapestry design rather than painting – a move encouraged by Gauguin who shared Maillol's belief in the importance of decorative art. Maillol studied the great collection of medieval tapestries in the Musée de Cluny in Paris, and in 1893 he exhibited a tapestry at the Salon de la Société Nationale des Beaux-Arts. That year he opened a tapestry-making and embroidery workshop in Banyuls. His careful attention to the technical aspects of the work – the choice of wools and of the best plants for his dyes – led to comparisons with the craftsmanship of the Primitives, and Maillol was eventually acknowledged as the 'father' of modern French tapestry.

Maillol first began making sculpture in 1895, and it became his chief preoccupation from 1900 onwards after his deteriorating eyesight forced him to abandon his tapestry work. He was closely associated with the Nabis in the 1890s, and towards the end of the decade began to exhibit his sculptures which, at this stage, were all small in scale. Through Vuillard he met Ambroise Vollard, who arranged for some of the sculptures to be cast in bronze, and gave him his first one-man show in 1902. The exhibition was a critical success and drew generous praise from Rodin, even though Maillol's work was in every way so different from his. His career as a sculptor now launched, Maillol established a studio at Marly-le-Roi, near Paris, the following year, and for the

rest of his life he spent the summers there and the winters in Banyuls.

Maillol's first monumental sculpture, 'The Mediterranean' (cat.88), was finished in 1905 and exhibited at the Salon d'Automne, where it attracted much attention. His reputation as a major innovative sculptor grew quickly, and although his work quite often aroused controversy, he was given a series of important public commissions, beginning with 'Action in Chains', a monument to Auguste Blanqui, the Socialist revolutionary. This sculpture, depicting a powerfully muscular female nude striding forwards, her hands manacled behind her back, was greeted with outrage in Puget-Théniers when it was unveiled in 1908, but was regarded as a masterpiece by his admirers – including Matisse, who was a close friend. In 1908 Maillol travelled to Greece with his patron Count Harry Kessler to see the great works of antiquity, and was delighted to discover that he felt perfectly at home there. Later he loved to stress the identity between his native land, rich in antique remains, and Ancient Greece, and between the local Catalan girls who inspired his sculpture and the Venuses of antiquity. The belief that there was an unbroken continuity in Mediterranean culture between its origins and the present, and that he was the natural heir to this tradition, sustained Maillol for the rest of his life, and became a *leitmotif* in the writings of friends like Maurice Denis and Pierre Camo, who emphasised that his classicism was a matter of innate sympathy, not willed imitation: 'Like the master painters and sculptors of the Mediterranean basin . . . Maillol constructs ingenuously, perhaps unconsciously, classical syntheses. . . . By birth, by race, he belongs to the French Midi: he comes to us from the shores of the Mediterranean whose blue depths gave birth to Aphrodite and have inspired so many masterpieces.' (M. Denis, *Aristide Maillol*, Paris, 1925)

In 1910 Maillol's 'Pomona' scored a great popular success at the Salon d'Automne, and two years later he won the commission for a monument to Cézanne, destined for Aix. Maillol chose to commemorate Cézanne not with the usual allegorised,

The artist at Marly-le-Roi, 1937 (Photo: Dina Vierny)

heroic portrait but with a reclining female figure resembling a river goddess. He concentrated upon this statue during the war, but when he presented it to the town of Aix in 1925 it was rejected out of hand. (Following a press compaign it was purchased by the city of Paris, and eventually erected in the Tuileries Gardens in 1929.) Meanwhile, in 1912, Maillol worked on the woodcuts for a luxurious edition of Virgil's *Eclogues*, commissioned by Kessler. (Not published until 1925, this was the first of a series of illustrated editions of famous Greek and Latin texts on which Maillol worked. Others included Ovid's *Ars Amatoria* and Virgil's *Georgics*.) After the war he was commissioned to make war memorials for the Catalan towns of Céret, Elne and Port-Vendres, as well as for Banyuls.

Maillol's fame grew steadily during the post-war period, for his work was perfectly in tune with the current 'call to order' movement and with the ideal of a new, modern form of classicism. It satisfied writers such as Waldemar George, who insisted on the 'Frenchness' of his classicism

('Maillol is the heir of the artists of Versailles and the Ancient Greeks, while keeping intact his own personality. He is a true French sculptor. There is no trace of Italianism in his work, which is as nobly ordered as a composition by Nicolas Poussin.' *L'Amour de l'Art*, 1923). His work also appealed to critics associated with the avant-garde, such as Christian Zervos, who, in a long essay published in *L'Art d'Aujourd'hui* in 1925, focused on its geometric abstraction, its rigorous structure and its perfect formal purity. A series of laudatory monographs appeared, beginning with

Octave Mirbeau's in 1921, and Maillol was represented in numerous exhibitions at home and abroad, being particularly admired in America and in Germany. He was made an Officier de la Légion d'Honneur in 1932, and during the 1930s the French State bought a collection of bronzes to join the marble version of 'The Mediterranean' commissioned in 1923. Maillol's final consecration as France's leading sculptor occurred at the time of the Exposition Internationale in 1937, when three rooms were devoted to his work in the exhibition of *Art Indépendant* in the Petit Palais.

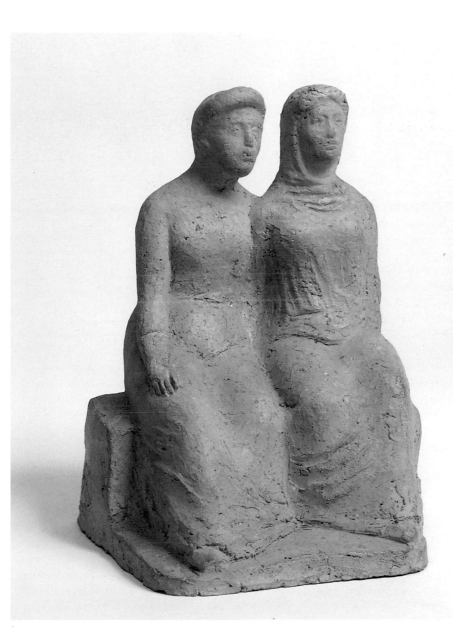

86

86 Two Seated Women 1895

Terracotta, 12.8 × 9.5 × 10
Musée du Petit Palais, Paris

This is one of Maillol's earliest sculptures, and was inspired by his future wife and her sister, both of whom worked in his tapestry workshop in Banyuls. Maillol's earliest sculptures were all intimate in scale and character. Several of his first figures and reliefs were carved in wood, but simultaneously he experimented with modelling in clay. He fired these clay figures in a primitive oven he had made himself, and many were destroyed or damaged because of his lack of expertise. Later his preferred medium for modelling was plaster.

When discussing Maillol's terracottas, several critics of the 1920s, including Waldemar George, drew attention to their general relationship to Greek terracotta figurines from Tanagra, near Thebes. These, and similar statuettes from southern Italy and Asia Minor, had been excavated in large numbers during the nineteenth century, and quickly became some of the most popular antiquities. They were domestic in imagery – the favourite subject is women going about their ordinary activities – and unpretentious in manufacture: they were invariably made in moulds, and variety was achieved through surface painting and the use of several moulds in different combinations. The figurines thus provided an antique precedent for intimately scaled sculpture of an essentially naturalistic kind. It is not certain when Maillol first became aware of 'Tanagras', but 'Two Seated Women' resembles them quite closely in its imagery, and also in such details as the drapery and hair-styles.

87 Study for 'The Mediterranean' 1902

Terracotta, 16.8 × 20.8 × 9.5
Musée du Petit Palais, Paris

This is one of the many preparatory studies for 'The Mediterranean', and post-dates the first state of that sculpture in which the woman's left arm lies across the knee of her left leg. In this study Maillol raises the left arm up to the head, but has not as yet fixed on the more compact and balanced solution of resting the elbow firmly on the knee. Compared to 'The Mediterranean', the pose is relaxed and casual: the torso turns slightly; the hair falls loosely; there is a suggestion of incipient movement. We sense the origins of the pose in Maillol's earlier studies of bathers crouched amid waves. Although Maillol laboured to achieve a definitive, abstracted statement in his monumental sculptures, his small works are often characterised by sensuality and natural-ism, and this effect is enhanced by the warm colour, grainy texture and sponta-neous handling of the fired clay, which is full of the minor imperfections and blemishes of the 'hand-made'.

87

88 The Mediterranean 1905

Bronze, 110 × 120 × 69
Fondation Dina Vierny, Musée Maillol, Paris

The plaster of this, Maillol's most cele-brated sculpture, was exhibited at the Salon d'Automne in 1905 under the title 'Femme' (Woman). There it was hailed as a great modern masterpiece by several critics committed to a classical revival in the arts, including Maurice Denis and André Gide. Denis drew attention to the difference from the dynamic, expressive style of Rodin, and went on to define Maillol's relationship to the classical tradition, comparing him not only to the Greek sculptors of the fifth century BC but also to the French sculptors of the thirteenth century, whose statues 'are as sober, have a style as chaste, and express a sense of proportion as pure as the most beautiful figures from Greece.' Comment-ing on the earthiness of his female nudes, Denis analyses Maillol's 'innocent gauche-ness', concluding that he is 'un Primitif classique'. (Essay originally published in *L'Occident*, November 1905.) Gide opens his long, lyrical appreciation of the work with the words: 'It is beautiful; it has no meaning; it is a silent work. One would have

to go a long way back to find so complete a negligence of any preoccupation foreign to the simple manifestation of beauty.' (*Gazette des Beaux-Arts*, 1905, vol. II) Given this reception, it is not surprising that 'The Mediterranean' was studied closely by many other artists, including Picasso, Manolo, Clará and Casanovas, and that it left its imprint on their work.

Count Harry Kessler, who had been introduced to Maillol by Rodin, immedi-ately commissioned a stone version of the sculpture. Maillol executed this entirely without assistance over a period of several months, even though he had had no formal training in carving techniques, and had hitherto carved and modelled only on a small scale. (The sculpture was despatched to Weimar in 1906, and is now in the Oskar Reinhart collection, Winterthur.) In 1909 Maillol gave the first of the bronze casts to the city of Perpignan, and in 1923 the French State commissioned a marble version, which was completed with the aid of assistants in 1927, and displayed initially

in the Tuileries Gardens (now in the Musée d'Orsay).

The definitive title – 'La Méditerranée' – seems not to have been settled until the late 1930s, and was one which Maillol had given in 1895 to a Nabi painting representing a naked girl standing by the seashore. Before that the sculpture was known variously, and published, as 'Crouching Woman' (Femme accroupie), 'Thought' (Pensée), 'Latin Thought' (Pensée latine), 'Statue for a Shady Garden' (Statue pour un jardin ombragé), and simply 'Nude' (Nu) or 'Figure'. The interchangeability of the titles indicates that Maillol never had any allegor-ical intention, as Gide recognised when he stressed the formal purity of the sculpture and the absence of any definable meaning or content. Indeed the titles of Maillol's sculp-tures were usually suggested by his friends.

The origins of the pose of 'The Mediter-ranean' lie in designs Maillol made in 1896 for a tapestry and a ceramic relief, both called 'Bather' or 'The Wave'. In 1900 he began work on a series of statuettes of nudes

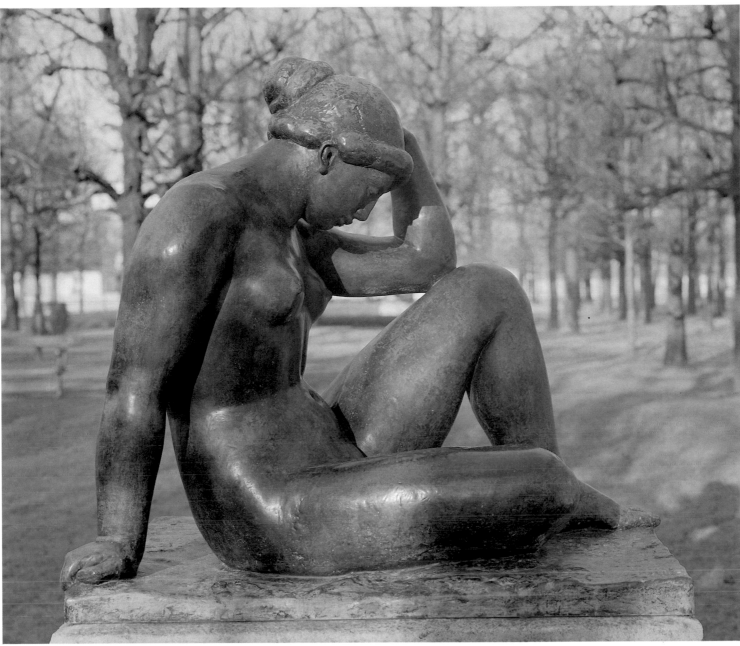

88

seated on the ground, and by 1902 he had completed a life-sized plaster of a woman whose face and figure is essentially that of the finished sculpture, but whose pose is much looser and more relaxed. Through various terracotta studies of 1902–5 (including cat.87), Maillol gradually approached the definitive solution, completing in 1905 a study of the torso, which resembles a fragment of an antique Venus. Through these preliminary sketches Maillol attained the simplified, geometric concept of natural form that was his, and Cézanne's, ideal. He told Judith Cladel, 'I always start with a geometrical figure, square, lozenge, triangle, because these are the figures that hold best

in space. My "Mediterranean" is enclosed in a perfect square.' (J. Cladel, *Aristide Maillol. Sa Vie – Son Œuvre – Ses Idées*, Paris, 1937) Other commentators noted the columnar nature of the limbs; the spherical character of the breasts, head and hair; and the delight in the play between the pyramidal forms of the legs and left arm, the cylindrical right arm, the rectangular torso, and the unseen cube within which the whole figure is inscribed. 'The Mediterranean' also reflects Maillol's essentially synthetic approach to sculpture, for although he constantly worked with models – in this case his wife – of the stocky Mediterranean type he admired, he strove to achieve a harmo-

nious, condensed image far removed from naturalism or the particularities of the individual. The satisfying and timeless pose of 'The Mediterranean' continued to fascinate him, and in 1937 he reused it in a modified and more active form in 'The Mountain'.

Although Maillol stressed his dependence on nature for his initial inspiration, he was opposed to 'copying' nature, and never attempted to conceal his admiration for the art of the past that, he felt, enshrined his own ideals and sensibility. 'The Mediterranean' bears a general resemblance to Greek sculpture, without being at all 'imitative' in the academic sense, for his purpose was to achieve the timelessness, equilibrium and

harmony of the great works of antiquity. Maillol preferred the more archaic traditions, especially Egyptian art and the sculpture of Olympia, and was highly critical of later, more naturalistic Greek sculptors, such as Praxiteles. However, he also admired those later Greek works which have a more 'archaic', because more simplified and abstracted, character. 'The Mediterranean' has affinities with the proportions and style of the 'Venus de Milo' (Louvre), of which he said: 'In Greek art, there is nothing more beautiful.'

89 Flora 1911

Bronze, h.170
Fondation Dina Vierny, Musée Maillol, Paris

In 1910 'Pomona', a plump standing nude of Renoiresque type, was exhibited in the Salon d'Automne. This scored a great success, and was bought by the Russian collector, Ivan Morosov, who commissioned three other life-sized figures to accompany it – 'Spring', 'Summer' and 'Flora'. Together the group was given the title 'The Seasons' (Pushkin Museum, Moscow). Maillol worked on the commission between 1910 and 1912, and, as was usual with him, each of the statues went through a variety of states. 'Flora' in particular exists in the form of a nude, her arms and hands in the same position, but without the garland of flowers.

'Flora' openly acknowledges Maillol's general sense of affinity with the antique. She is constructed like a perfect column, facing straight ahead, and standing firmly on her square base. Except for the fact that her weight is on one leg, so that one hip is thrown slightly out to the side, there is minimal movement in the figure, and the transparent, clinging drapery accentuates the verticality of the composition, rather than suggesting activity. Maillol told Cladel: 'For my taste there should be as little movement as possible in sculpture. It shouldn't jump around and grimace.' (*Aristide Maillol. Sa Vie – Son Œuvre – Ses Idées*, Paris, 1937) The effect is very like that of a Greek caryatid, such as those on the Erechthcion in Athens, although the comparison reveals the greater sensuality of Maillol's vision. Indeed it may be that the torso was influenced by the celebrated, thinly draped and alluring figure of Aphrodite on the Ludovisi Throne (Terme Museum, Rome). The 'Venus Genetrix' in

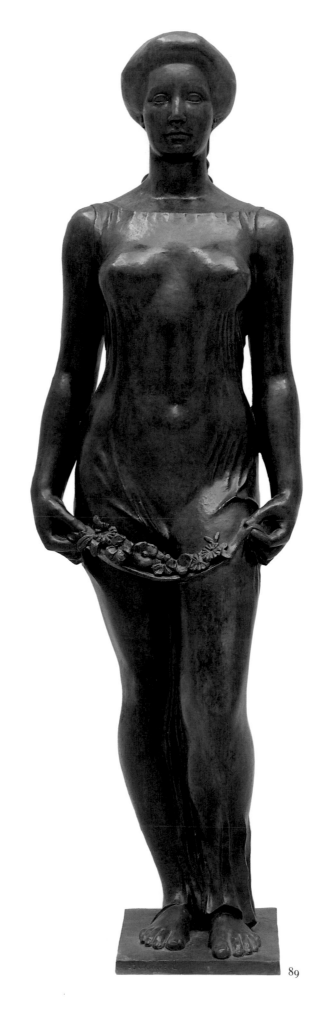

89

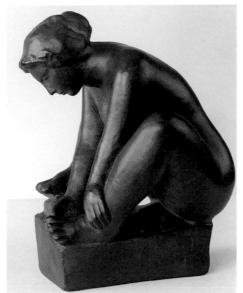

90

the Louvre may be another source. All these sculptures date from the fifth century BC – the period of Greek art preferred by Maillol.

'Flora', like all the other statues Maillol created, has no narrative content, and is only in the most general sense an allegory of natural fertility or a representation of the mythological goddess of flowers and gardens and mother of spring. Rather, she incarnates his ideal of beauty – serene, harmonious, contented, tranquil. As he told Cladel: 'I seek beauty rather than character', and for him beauty became identified with the health, youth, freshness and eagerness of the young girls of Banyuls, who reminded him of the *kores* of antiquity.

91

90 Woman with a Thorn 1920
Bronze, h. 17.8
Fondation Dina Vierny, Musée Maillol, Paris

91 Holding Both Feet 1920
Bronze, h. 18.4
Fondation Dina Vierny, Musée Maillol, Paris

92 Holding One Foot 1920–21
Bronze, h. 18.4
Fondation Dina Vierny, Musée Maillol, Paris

Maillol is best known as a monumental sculptor, but he also created many small and intimate works of great charm and vitality, in which he expressed his pleasure in natural movement. Through experimenting with a variety of figure positions in the statuettes he would finally settle upon the definitive, generalised and synthesised poses for his life-sized sculptures. These three statuettes are variations on the same theme, for they explore essentially the same un-selfconscious movement of a figure seated on the ground bending forward to examine her feet. It is as if we are observing the same woman at successive moments, and in this respect the figures are reminiscent of the great sequence of bathers by Degas, or Renoir, who was a close friend and whose own excursion into sculpture was encour-aged by Maillol. But despite the keenness of his observation, Maillol generalises his figures so that they lose any personality and approximate to types.

92

[153]

93 Torso of the Ile de France

1921

Bronze, h. 120.6
Fondation Dina Vierny, Musée Maillol,
Paris

The origins of this work date back to 1910,
when Maillol first conceived the idea for a
statue of a girl walking in water. The torso
went through three successive states before
reaching the definitive state exhibited here.
In 1925 the complete, more declamatory 'Ile
de France' figure was finished, showing the
girl with her arms thrown out behind her
back, and her head slightly raised and
looking eagerly forward as if to some bright
future. The apparently positive message of
this figure, underlined by the resonant title,
ensured the sculpture's success, and 'Ile de
France' was one of Maillol's works bought
by the French State in the early 1930s. In
purely formal terms the 'Torso' is more
satisfactory, and offers a more abstracted
visualisation of the theme of a figure moving
slowly forwards.

The model for the sculpture was a young
Parisian girl, but the idea for it may have
been inspired by recollections of watching
the girls of Banyuls walking on the beach – a
pleasure which the aged Maillol recalled in
his conversations with Judith Cladel: 'I love
the rosy freshness of very young girls who
have in their eyes that faith in life, that
confidence which no melancholy can mar. It
is always a delight to me to see them on the
beach at Banyuls, walking with the confi-
dence of the "Venus de Milo".' (*Aristide
Maillol. Sa Vie – Son Œuvre – Ses Idées*,
Paris, 1937) This simple motif was perhaps
also associated for him with the legendary
birth of Aphrodite–Venus from the waves.

The theme of a walking figure, repre-
sented by an armless, headless torso,
immediately suggests parallels with Rodin's
'Walking Man' – a craggy male torso
mounted on powerfully muscular, striding
legs. Significantly Maillol mentions this
sculpture when discussing the differences
between his work and Rodin's: 'The "Walk-
ing Man" was done in several stages; the
legs were added to the torso much later,
hence a certain lack of balance in the figure,
something of indecision.' (ibid.) Maillol
then goes on: 'In sculpture, he [Rodin]
always sees the flesh first. The Ancients saw
structure.' When the two sculptures are
compared the differences are instantly
apparent, for everything about Maillol's
work is much more tranquil and much
slower – indeed the movement seems almost

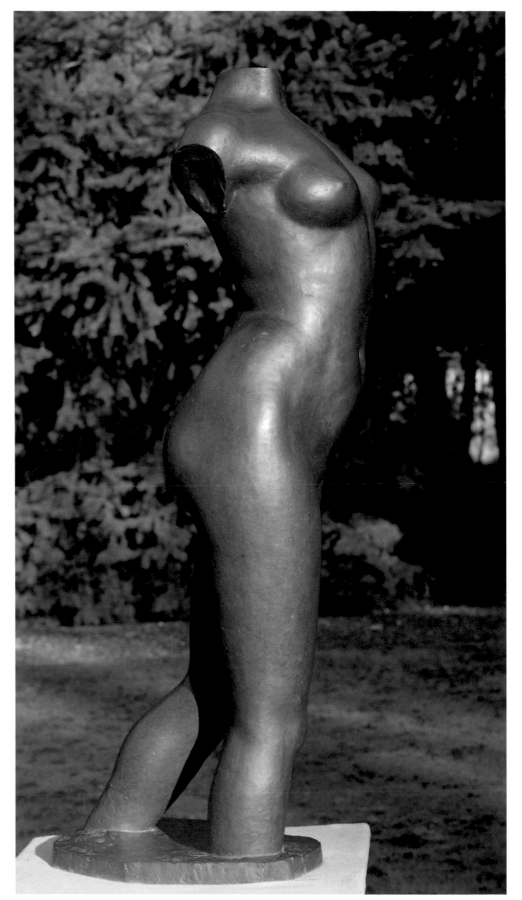

93

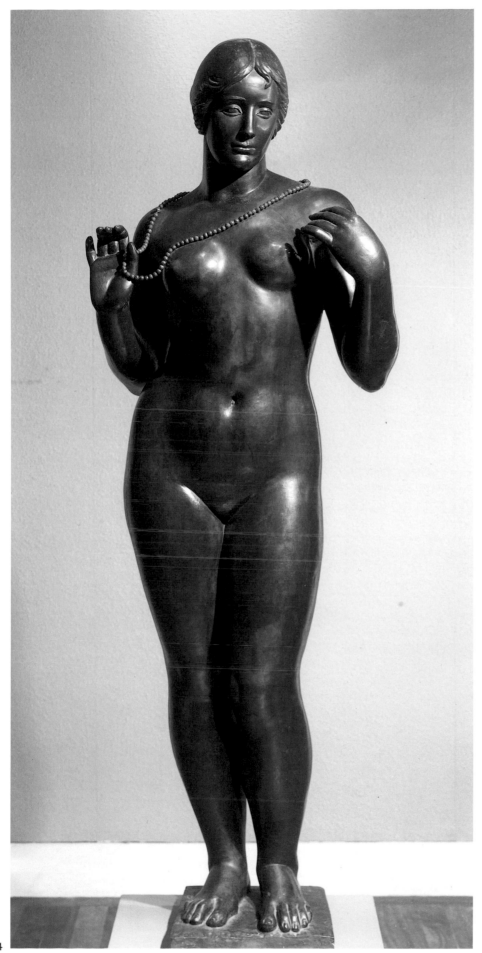

94

somnabulistic. Rodin complicates the surface of the body with innumerable 'lumps and hollows', separates the legs by a huge pyramid of space, and puts them under extreme muscular tension in order to increase the implication of passion, urgency and drama. His torso is presented as a battered fragment; the breaks at neck and shoulders are jagged and irregular, and there is no attempt to unify the legs and torso stylistically. Maillol by contrast simplifies the surface of his 'Torso', clarifies the contours, cleans and polishes the breaks, and unifies the whole piece through the presentation of a single flowing and uncomplicated movement. We are conscious of 'structure', not 'flesh'.

Another comment Maillol made to Cladel applies particularly well to the 'Torso': 'I try for a blond effect, like the sculptors of Olympia, without accent, keeping all in the same tone. I seek light, but I want it simply to rest on the sculpture, as if it were falling on a wall.' (ibid.) The reference to the sculpture at Olympia is not irrelevant in connection with 'Torso', which has the clarity of the figure of Apollo from the west pediment of the Temple of Zeus. It may be that Maillol was also attempting to catch something of the purity of movement of the archaic *kouros* figures, for 'Torso' has a comparable serene immobility in the midst of action.

94 Venus with a Necklace
1918–28
Bronze, 175.5 × 61 × 40
Tate Gallery

The model for this sculpture worked for Maillol over many years, but exclusively for this piece. The work exists in several states, of which the first, 'Birth of Venus', was completed in 1918. The same model was present in the studio when Maillol made the final corrections to the definitive plaster, which was exhibited in the Salon d'Automne in 1928. The completed statue exists in two forms, with and without the necklace. There were two different plasters, the 'Venus with a Necklace' yielding an edition of five bronzes, the 'Venus without a Necklace' an edition of twelve.

The long, slow evolution of 'Venus' is typical of Maillol's working methods, for most of his major pieces were developed over several years. His aim was not so much

variety as an ultimate, perfected statement. This, as Maurice Denis explained in his essay on Maillol, was the true classical method: 'The ideal of art is condensation – to summarise and contain within a restricted number of clear and concise forms the infinite variety that we perceive in Nature.' He went on: 'The thing that is striking about the new monuments [created since 1905] is not the novelty of the motif, or the unexpectedness of the subject. Maillol takes up the same themes and almost the same models incessantly: he perfects them; he polishes them; he brings them ever closer to his ideal.' (*Aristide Maillol*, Paris, 1925) Zervos took a similar view, and saw 'Venus' (which he knew only in an incomplete state) as the climax of Maillol's work to date: 'In the image of the goddess who possesses every perfection, the artist wanted to raise himself to the level of beauty which is beyond self-consciousness. . . . Everything is perfect, everything satisfies the eye and the mind completely.' ('Aristide Maillol', *L'Art d'Aujourd'hui*, 1925) For Denis and for Zervos Maillol did not simply emulate the antique – he equalled it. Their enthusiasm is an indication of the persistent faith during the post-war period in the continuing validity of classicism of a non-imitative, unacademic character.

95 The Three Nymphs 1930–38

Lead, 158 × 146.5 × 79.5
Tate Gallery

Maillol began work on the central figure of the group in 1930; by February 1931 it was finished and cast in plaster. From the outset Maillol planned a group of three nudes, which initially he intended as a representation of the Three Graces. As the group evolved – there are various states in plaster – his concept changed, and the mythic Three Graces became simply three nymphs, garlanded with meadow flowers. The group was, however, mistitled 'The Three Graces' when the still unfinished plaster was shown at the *Exposition des Maîtres de l'Art Indépendant* in Paris in 1937. Small alterations to the outer figures were made at Marly-le-Roi in the summer of 1938, and the group was finally finished that August.

The two outer figures are more or less mirror images of each other and are very like the central figure, so that the overall effect is of three repeated views of the same girl – an effect which is also typical of classic representations of the Three Graces. This standardisation accords completely with Maillol's overriding concern with timelessness and universality, and his desire to achieve a final, perfect summation of his artistic ideal. Indeed, the surfaces of all three figures are highly abstracted and have a roundness and tautness which is not unlike that of the immaculate, machine-finished beings of Léger. Although bronze casts were made of the group, Maillol preferred lead for it and for his other monumental works destined for outdoor exhibition, because lead is not affected by water or weather and retains its original colour.

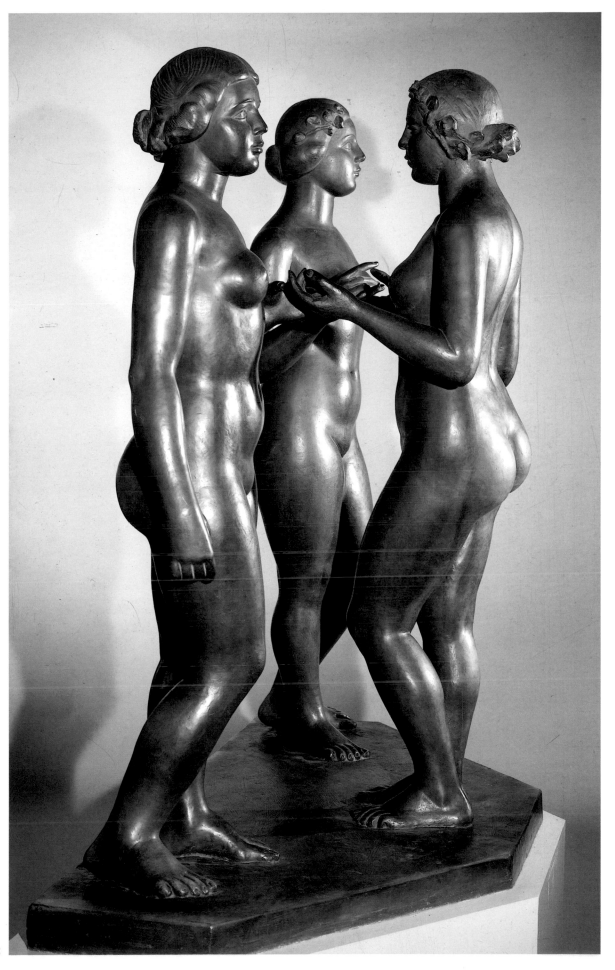

95

MANOLO (MANUEL HUGUÉ) 1872 BARCELONA −

1945 CALDAS DE MONTBUI

Estranged from his father since childhood, Manolo took his mother's surname, Hugué; but he preferred to be known simply as Manolo. In Barcelona the family was impoverished: Manolo had minimal schooling, and lived a hand-to-mouth existence on the streets. Nevertheless he took night classes in drawing in 1884, and by 1890 had decided to become a sculptor, although he received no formal training. He met the well-known Symbolist painter Joaquim Mir, and through him was introduced to the Círcol Artístic. He also became a regular of the café Els Quatre Gats, where he met, among others, Gargallo and Picasso. Little of his work of the 1890s survives, although it appears that he was an assistant to the successful decorative sculptor Eusebio Arnau.

In 1901 Manolo arrived in Paris where he remained until 1910, frequenting the circle around Picasso. Determined to educate himself, he spent long periods in the Louvre and the other museums, and, to make money, started working as a jeweller in about 1903. By 1906 he was on close terms with the Greek-born poet and critic Jean Moréas, who in 1891 had founded the Ecole Romane. Moréas's aim was the revival of the classical traditions of French medieval Romance literature, and he profoundly influenced the thinking of Manolo's compatriot Eugeni d'Ors, the theorist of Catalan Noucentisme. D'Ors later became a firm supporter of Manolo, whose work closely reflects his and Moréas's commitment to a modern, revived classicism.

In 1910 Manolo, financed by a contract with Kahnweiler, moved to Céret, an unspoilt village in the Pyrenees close to the border with Spain. Céret attracted many artists and writers, so Manolo was kept in touch with developments in both Paris and Barcelona. His life was now much more sober than it had been in Paris, where he had been legendary for his escapades, and he produced a substantial body of work. His favourite subjects were the nude and peasant life – themes which he developed over the rest of his career. Despite his friendship with Picasso and Braque, Manolo was never significantly affected by Cubism, which he professed not to understand. The main

sources for his work, apart from classical and Renaissance art, appear to have been Cézanne, Gauguin and Maillol. Maillol, who lived nearby in Banyuls, became a friend, and Manolo was always ready to acknowledge his debt to him, although his own sculpture is more primitive and picturesque in appearance. With the outbreak of war and Kahnweiler's exile in Switzerland, Manolo found himself once again in a precarious position. He spent time in Paris, but in 1916 returned to Barcelona, where he had an exhibition at the Galerías Layetanas in 1917. But he seems to have produced little new work until, once again supported by Kahnweiler, he was able to return to Céret in 1919.

Manolo usually worked on a small scale, sometimes a miniature scale, but after the war he was given two public commissions – a monument for Céret to his friend, the composer Déodat de Séverac (1923), and a war memorial for Arles-sur-Tech (1924). Both are aggrandised and ennobled versions of his intimate sculptures of local peasant women. Manolo had occasionally depicted bullfight subjects, and during this second period in Céret these featured more often in his work, complementing the many other scenes typical of Catalan peasant life. His sense of his Spanish identity was further underlined by his many representations of flamenco dancers. With the bullfight and dance subjects a greater sense of movement and drama entered his work, anticipating the more expressive style of the 1930s.

In 1927 Manolo suffered an acute attack of multiple arthritis. Although he recovered, his hands were seriously weakened, and he was forced to give up stone-carving. For the sake of his health he left Céret and moved to the village of Caldas de Montbui, which was noted for its thermal waters. He remained there for the rest of his life.

In 1923 Manolo had had two one-man shows, in Kahnweiler's Galerie Simon in Paris and the Salon d'Art Contemporain in Antwerp. The late 1920s and the 1930s brought confirmation of his status as a significant independent sculptor, and he had several one-man exhibitions in Barcelona, Zurich and Berlin. The first monographs on him appeared, including those by Pascal Pia

The artist, c.1911 (Photo: Ajuntament de Caldas de Montbui)

(Paris, 1930) and Victor Crastre (Marseilles, 1933). Although all too often it was Manolo's colourful personality that attracted most attention, his admirers were agreed that his work possessed both an earthy vitality and a genuinely classical character. The well-known writer on sculpture, A.-H. Martinie, commented, in the polemical style typical of 'call to order' critics:

> In contrast to Maillol, with Manolo everything is expansion and profusion. Rather than the perfection of a few simple rhythms, he seeks the variety that issues from life. . . . As with Derain, we appreciate in Manolo an art that is healthy and loyal, worthy of attention and esteem because it is expressive without exaggeration, lacks tricks and sensationalism, and shows an urge towards classicism which is totally opposed to the academicism of both right and left – each equally detestable.

Martinie concludes with the standard chauvinist argument that identifies the 'equilibrium' of classicism with the French tradition, and no other: Manolo, the artist if not the man, is 'French', not Spanish, because, 'There is no fever, no wildness in his art . . . he has purged it of all romanticism' ('Manolo', *L'Amour de l'Art*, 1929).

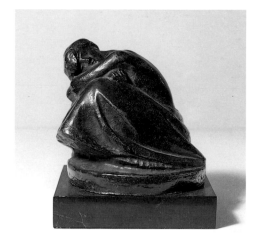

96

96 Totote 1909

Bronze, 9.5 × 10 × 9
Collection Salvador Riera, Barcelona

This is one of the few sculptures to have survived which predates Manolo's first trip to Céret. There is a contemporary and very similar nude version, and both also exist in terracotta.

Manolo met Totote – Jeanne de la Rochette – in about 1906, and she became his constant companion, his model, and eventually his wife. The tiny scale of this sculpture it can be slipped like a keepsake in the pocket or fondled in the hand – was partly a consequence of Manolo's recent concentration on jewellery design, and reflects the great tradition in Barcelona for refined and delicate decorative sculpture and *objets d'art*. The supple treatment of the slim, lithe body and the extremely sensitive modelling of the surface betray a slight lingering influence from Catalan Modernista traditions, also evident in some of the early small sculptures of González (for example, cat.62).

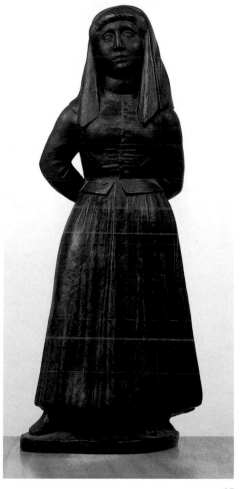

97

97 Girl from Roussillon 1911

Bronze, 27.5 × 12 × 9
Museu d'Art Modern, Barcelona

Also known simply as 'Catalan Girl', this was executed in Céret and is a fine example of the classical style Manolo developed while living there. In its simplified form and conception it is influenced by the sculpture of Maillol, whom Manolo admired greatly, and also by the Tahitian paintings of Gauguin which he saw when he was living in Paris in 1901–10. For, like Maillol and Gauguin, Manolo saw 'primitive' country people as noble and ideal types equivalent to the Ancient Greeks.

The sculpture was preceded by drawings in which Manolo explored the pose, first placing the hands folded demurely in front of the body, then in more swaggering style on the hips, before settling on the definitive solution of placing the hands folded behind the back. Although thanks to the pyramidal mass formed by headscarf, bodice and full skirt, the figure is very firmly planted on the ground, the asymmetry of the arms, and the placement of so important an element as the hands behind the back, guarantee a progression right round the sculpture. This limited degree of movement was almost always present in Manolo's work even when, as here, he was consciously seeking stillness, quietude and dignity as signs of the universality and timelessness of peasant life. There is a pair to 'Girl from Roussillon' – 'La Llovera', also 1911, which represents an aged but formidable peasant woman. Together they represent an allegory of youth and age.

98 Young Catalan Woman 1911

Bronze, h. 46.5
Städtische Kunsthalle, Mannheim

During his first prolonged stay in Céret, Manolo concentrated on the female nude and peasant themes, clearly seeing the two subjects as complementary. In the nudes his classicism is inevitably more explicit, and in this sculpture he explores the time-honoured academic pose also used by Ingres in 'The Source' (Louvre). The classicism is, however, the modern, abstracted, primitivist classicism of Maillol, and like him Manolo treats the woman's body as a sequence of spheres and cylinders. The transitions between the parts of the body are more abrupt in Manolo's work, and the separate identity of each is emphasised – a tendency which is more pronounced in the often extremely rugged and cumbersome seated nudes, and in the contemporary low reliefs. The primitivism of Manolo's conception was consistent with the major tendencies in the Parisian avant-garde before the First World War, and his nude also bears some resemblance to the stocky Tahitian nudes of Gauguin, and to the Cézannesque nudes of Derain, Matisse and Picasso in 1906–9. Like them, Manolo was challenging the academic tradition of the Salon nude by appropriating a familiar pose and interpreting it in a way that broke the accepted rules.

99 Ox and Ox-cart 1913

Bronze, 41 × 41
Collection Salvador Riera, Barcelona

Manolo made his first low reliefs in Céret, seeking in them an equivalent to the Greek metopes and early Renaissance reliefs he so admired. His earliest recorded relief, dating from 1911, depicts two archaic-style muscular male nudes with oxen, and there are several other contemporary versions of the image. The subject was inspired directly by the traditional ox-carts of the Pyrenees, and Manolo returned to it during his second period of residence in Céret, and then once or twice after his move to Caldas de Montbui. These versions of the 1920s and 1930s are, however, essentially repetitions and refinements of the pre-war reliefs.

Manolo painted and drew prolifically throughout his career, and the low relief

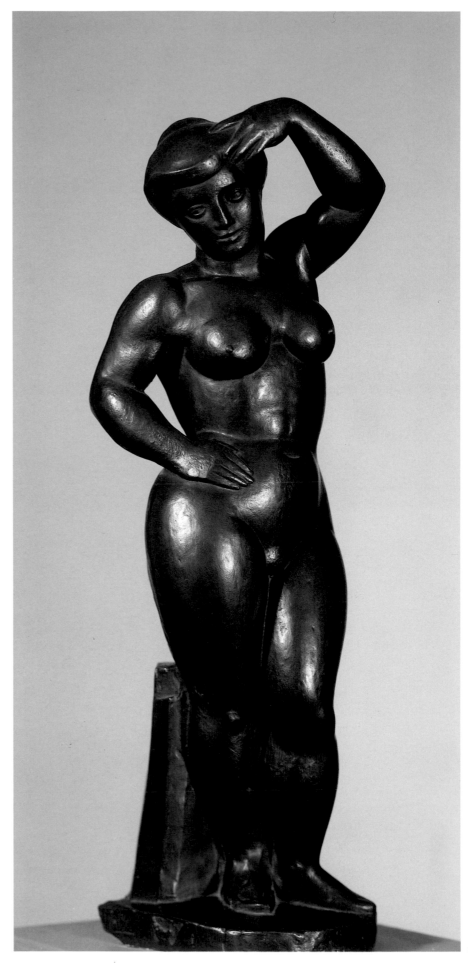

98

99

provided him with the perfect means of translating his pictorial ideas into sculpture. Besides the scenes with oxen, there are many other depictions of traditional Spanish life: the bullfight, peasant women washing clothes in a river, horses being shod, Catalan girls arm in arm, the sardana, the flamenco, and so on. Together they represent a kind of homage to and summary of a way of life that Manolo loved deeply, and that he knew was threatened by the machine age. For, unlike Léger, Manolo had the urban dweller's nostalgia for an unchanging rustic innocence, and he always distanced himself from the modern.

100 Old Peasant Woman

1913–14
Bronze, 30.5 × 11.5 × 12.5
Collection Salvador Riera, Barcelona

This sculpture developed from two earlier studies of ageing but still forceful Catalan peasant women, 'La Llovera', 1911, and 'La Cresta', 1912, and together they illustrate Manolo's conception of hieratic 'column-sculpture', in which the whole of the figure is contained within the circumference of the circular base, and looks sturdy enough to hold up a roof. The indomitable character of the peasant is Manolo's theme in this small series, and he uses the stepped layers of the costume to root the figure firmly to the ground, and the craggy features of the head as a metaphor for rock-like stability. Meanwhile the vigorous and rugged modelling of this particular sculpture – there is not a more finished version – underlines his general meaning, and gives the work considerable expressive power which far exceeds its modest scale.

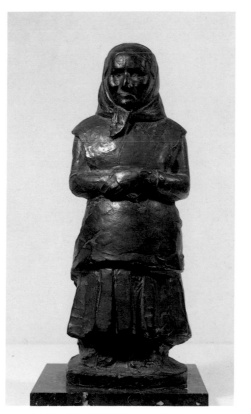

100

101 **Seated Girl** 1929

Terracotta, 35 × 39
Collection Godia, Barcelona

The theme of the seated female nude was
one to which Manolo returned again and
again in both his reliefs and his free-
standing sculptures. The earliest known
surviving examples were made at Céret in
1912 and the last at Caldas de Montbui in
about 1940. This terracotta relates closely to
the earliest versions, in particular to a well-
known stone carving of 1913 of about the
same size (Galerie Louise Leiris, Paris).
The main difference, apart from the hair-
style, is that in this terracotta the figure sits
on a circular base, which not only under-
scores the spherical nature of the piece but
encourages the spectator to turn fully round
it. In the stone, the base is a roughly hewn
rectangular block, and the work is corres-
pondingly more like a high relief, intended
to be seen only from the front.

In both works Manolo's debt to Maillol's
'The Mediterranean' (cat.88) is apparent:
the pose is not, of course, identical, but the
sense of the geometric block, of density and
weight, and of physical strength and ferti-
lity, is similar. The differences are interest-
ing and characteristic. Maillol's work is
smoother and much less 'naïve' in appear-
ance. Manolo generalises and abstracts the
various parts of the body – the breasts, for
instance, are like perfect half-spheres, with
the circular nipples at the very centre – but
there is no effort to create a harmonious and
continuous flow between them. On the
contrary, the nude body is treated like a
hilly landscape, the flesh forming into large,
rounded escarpments. The metaphor for the
female body as equivalent to an endlessly
fertile, primeval landscape – indeed, to the
Catalan countryside – is expressed almost
literally, even though Manolo refuses to fall
back on any of the usual allegorical accessor-
ies of water jars, flowing river, vegetation,
and so forth. Like the earlier versions,
'Seated Girl' is a frank translation of Eugeni
d'Ors's concept of '*la ben plantada*'. (D'Ors
had been a close associate of Manolo in Paris
before 1910.) His novel of this name –
which means, literally, 'the well-planted
one' – was published in 1912 but comprised
earlier essays, and in it d'Ors symbolised the
undying strength of the Mediterranean
tradition in the image of a peasant woman.
The book had enormous influence on Cata-
lan artists at the time, and Manolo's sculp-
tures may be compared to the contemporary
paintings of Sunyer.

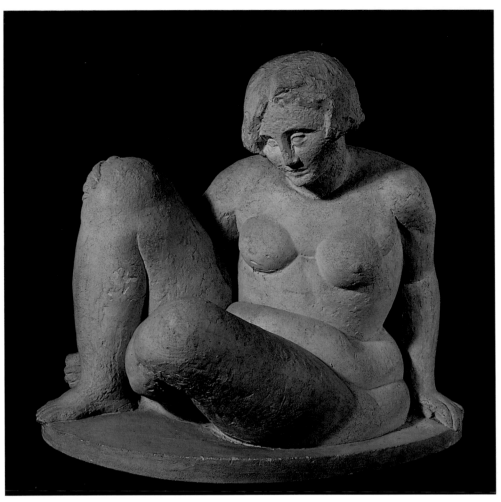

101

102

102 Woman with a Mirror 1934

Terracotta, 18.5 × 26
Collection Salvador Riera, Barcelona

While some of Manolo's figure sculptures are hieratically conceived, he was always equally interested in exploring complex, twisting poses involving considerable fore-shortening, and delighted in pressing the mass of the muscular, stocky bodies of his nudes into the very shallow space he habitually preferred for his reliefs, thus intensifying the sense of animal vitality. An immediate source for Manolo in these works was the sculpture of Michelangelo in the Medici Chapel in Florence: the body of the reclining woman assumes a position very like that of 'Day'.

'Woman with a Mirror' – the traditional *vanitas* motif – developed out of a series of drawings and reliefs of a semi-reclining nude seen from the back, which date from 1930 and culminated in a free-standing reclining nude. The same pose, signifying for Manolo sensuality and abandonment to pleasure, was also used in the contemporary 'Bacchante' (cat. 103).

103

103 Bacchante 1934

Gouache on paper, 15 × 21
Private Collection of Josep-Mª Ferrer, Barcelona

This is one of several preparatory studies Manolo made for his sculpture 'Bacchante' (cat.104). Vigorously brushed, it has the concentrated energy of the final work, although many significant modifications to the pose were made before the artist was satisfied. Thus Manolo did decide to keep this position for the figure's left arm, but in the sculpture it is bent at a right angle to form a more stable support for the body. He considerably altered the position of the legs to make the left leg play a positive and equal part in the composition, which it does not have in the gouache; and he linked the right arm back to the body by means of the bunch of grapes, thus closing the composition and tightening it.

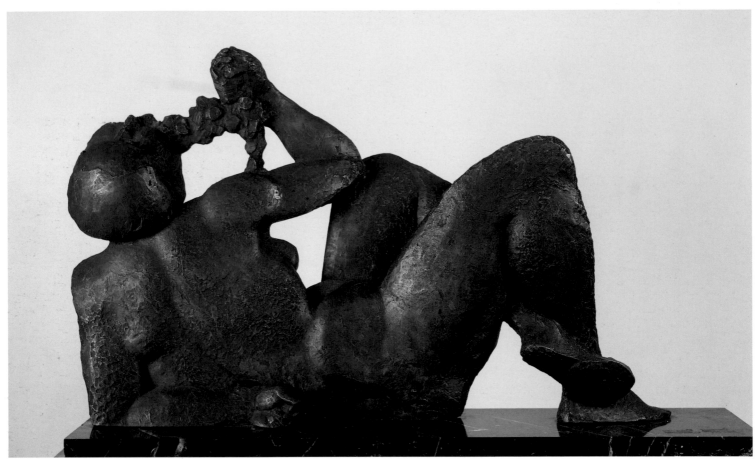

104

104 Bacchante 1934

Bronze, 50 × 80 × 16
Museu d' Art Modern, Barcelona

In 1912 Manolo made his first relief of
'Leda and the Swan': Leda sprawls with her
back towards us, her left arm crooked over
her head, her right arm embracing the swan.
He returned to the theme again in the 1920s,
and out of it he later developed the image of
a reclining woman gazing into a mirror, and
finally, that of the drunken 'Bacchante'. The
bronze was preceded by several drawings
and gouaches (including cat.103), but the
definitive solution has no exact precedent.
In all these works Manolo's principal
source for the twisting pose was probably
Michelangelo, although rather similar
drunken figures occur in the Bacchanals of
Titian.

'Bacchante' is a highly effective marriage
between relief and sculpture in the round –
a marriage Manolo had long wanted to
achieve, to judge by the many occasions he
had explored the same theme in both forms.

From a distance it gives the impression of
full volumes and three-dimensionality, but
close up we recognise it as a low relief from
which the background has been removed to
leave sharply outlined, jagged spaces that
echo the thrusting, triangular formations of
legs and arms. These triangular shapes
contrast with and complement the circular
forms of head, shoulder, hip, calf and thigh
muscles, and the long rectangle within
which the whole figure is inscribed. Because
the work has so coarse a surface and the
body is so 'deformed', one tends to assume
that the geometry was instinctive. But the
presence of all the preparatory drawings and
related works indicates that the composition
was laboured over with the utmost care and
that the impression of spontanaeity is illu-
sory. Manolo has been able to preserve and
exploit the compression and tautness
enforced by the rectangle of a true relief,
and to ally it with the natural expansiveness
of sculpture in the round, thus greatly
intensifying the sense of barely controlled
vitality. Indeed, the provocative blend of

energy and lethargy that follows from this
peculiarly active interpretation of the reclin-
ing pose is wonderfully matched to the
chosen subject. Like Picasso in 'Nessus and
Dejanira' (cat.135), Manolo feels his way
imaginatively into the mythological subject
exactly as if he had witnessed it. It is not
treated 'academically': it has reality, and one
senses his enthusiastic identification with
the classical world.

MARINO MARINI 1901 PISTOIA – 1980 VIAREGGIO

Marini was born in Pistoia in the heart of Tuscany, a region to which he always remained strongly attached on account of its Etruscan artistic heritage. Some time after the Second World War he explained, 'Here in Italy, we are entirely saturated with our artistic past, as we live in the midst of its works. I myself was born in Tuscany where, during the last fifty years, the discovery of Etruscan art has been an event of capital importance. This is why my art is based on certain themes from the past – such as the relationship between man and horse – and not on modern subjects like the relationship between man and car' (Mario de Michele, *Scultura italiana del dopoguerra*, Milan, 1958). Marini's work can be seen as an attempt to develop, in a modern idiom, certain qualities of ancient Italian art, in particular what he felt to be its profound humanism.

Marini studied at the Accademia delle Belle Arti in Florence from 1919 to 1926 He began by taking courses on painting and drawing, and only changed to sculpture in 1922. One of the few paintings to have survived from this period, 'The Virgins', *c*.1920 (Marino Marini Foundation, Florence), shows him experimenting with the linear style of the Quattrocento; but his drawings of the early and mid-1920s suggest a burgeoning interest in the sculptural qualities of the human figure. This was a confused period in Marini's life when he was uncertain about whether or not to pursue painting. However, his study of Etruscan art in the Archaeological Museum in Florence may have helped him to decide, and by 1928 he had resolved to concentrate on sculpture. That year he travelled to Paris and saw works by leading French avant-garde sculptors, but his work was unaffected by this: his first pieces, executed in terracotta and patinated plaster, were close copies of the small painted Venuses and stylised standing figures of Etruscan art.

Marini's desire to copy antique sculpture sprang in large measure from his sense of being a Tuscan artist; but he was also undoubtedly influenced by the then widespread interest, both artistic and nationalistic, in the traditions of Italian art. His work struck a chord in Milanese avant-garde

circles, and in 1928 he exhibited at the *Mostra del Gruppo Novecento Toscano* in the Galleria Milano, and the following year at the second *Mostra del Novecento Italiano*, organised by Margherita Sarfatti. The year 1929 proved crucial for Marini. It was then that he made what was seen as his first major work, 'The People' (repr.p.353), a terracotta double portrait of a man and a woman. This was inspired by Etruscan sarcophagi found at the archaeological excavations at Cerveteri and Tarquinia, as well as, perhaps, the naturalistic double portraits of ancient Roman sculpture, although the work clearly represented an ordinary modern couple. Marini's updating of the traditions of ancient Italian art brought him to the notice of the leading exponent of the so-called 'Etruscan manner', Arturo Martini, who in 1929 invited Marini to join him teaching sculpture at the art school of Monza near Milan. Marini's move to the more cosmopolitan northern city was the prelude to increased involvement in the debates and currents of national and international modern art.

During the 1930s Marini participated in most of the major national exhibitions. He had a one-man show in Milan in 1932, and three years later received first prize for sculpture at the Quadriennale in Rome. In this period Marini also travelled widely in Europe, partly to keep abreast of contemporary developments. He had long been familiar with the famous equestrian statues of Roman and Renaissance art, but only when he saw the sculptures of medieval knights in Bamberg Cathedral in Germany in 1936 did he realise the full expressive potential of this subject. The 'cavaliere' theme of a boy seated on a horse became a recurrent motif in Marini's work, symbolising for him a primeval or mythical harmony between man and nature. His other two staple subjects were female nudes and portrait busts, both of which reflected his commitment to a vision of art in which experience of life and human values were paramount. Marini was later to say that the emphasis on the intimate and personal in his work of the 1930s was the key to his rejection of the imperialistic and nationalistic ideology of Fascism.

The artist in his studio in Monza, 1930

During the Second World War Marini taught at the Accademia di Brera in Milan, but fled to the home of his wife's family in Tenero-Locarno in Switzerland after his studio was destroyed by bombing. Following the war Marini established close contacts with many of the leading artists of the day, and rose rapidly to international prominence. He held a successful one-man show in New York in 1950, and two years later was awarded a prize for sculpture at the Venice Biennale. Through subtle modulations of expression, Marini managed to reflect in his sculptures some of the new currents in post-war art, while continuing to develop the themes of ancient sculpture that had haunted him since the 1920s.

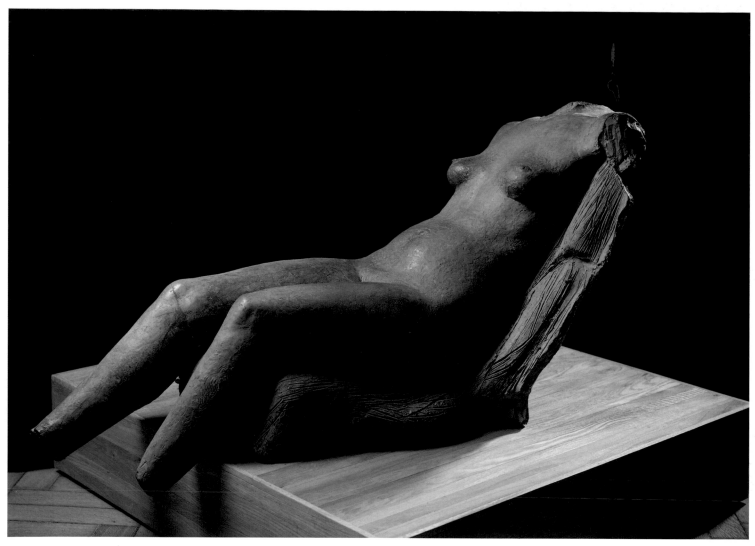

105

105 Fragment (Female Nude)
1929
Terracotta, 56.5 × 45.5 × 112
Galleria Nazionale d' Arte Moderna,
Rome

This work was made in the year that Marini
first achieved recognition as an important
young sculptor, and shows his desire to
reinterpret the legacy of ancient art in a
modern naturalistic vein. In the 1920s he
made a close study of the finds displayed in
the Archaeological Museum in Florence, in
particular the holdings of Etruscan works.
He was deeply attracted to the more primi-
tive creations of the ancient world which, he
later explained, made up in humanity for
what they lacked in poetry and idealism.
Marini's use of terracotta, rather than a
more classical medium such as marble, re-
flected his attempt to revive the sensual and
tactile qualities of Etruscan moulded sculp-
ture. In 1928–9 he made a number of works
clearly drawn from Etruscan sources, but
the subtle modulations of form and contour
in 'Fragment' reflect also his interest in the
more naturalistic sculpture of the classical
period. Marini was to develop the theme of
a reclining nude in a number of works in the
1930s, including a bronze figure of 1935
entitled 'Pomona', which has overtly classi-
cal features and hair-style.

ARTURO MARTINI 1889 TREVISO – 1947 MILAN

Martini came from a humble background and, having failed to do well at school, was apprenticed to a jeweller to learn a craft. He began making clay sculptures in his spare time and took a job at a local pottery factory in order to obtain materials free. In 1908 he enrolled at the Accademia delle Belle Arti in Venice and exhibited at the Ca' Pesaro gallery, which became a centre for a group of young artists eager to challenge the norms of academic art. The following year, with financial help from a friend, Martini travelled to Munich, at that time one of the greatest artistic centres in Europe. In the several months he spent there he explored the museums avidly and read widely. He later claimed that it took ten years to rid himself of the 'decorative fog' of Munich: if he had gone to Paris, he said, he might have met 'greats' such as Renoir, instead of which he encountered the likes of Adolf Hildebrand, whose emphasis on technique he found uncongenial. As Martini's graphic and ceramic work of the pre-war years shows, he was influenced for many years by the German Secessionist movement.

In 1912 Martini travelled to Paris with a close friend, Gino Rossi, a painter who was a great admirer of Gauguin and who encouraged Martini to simplify his style. Martini stayed in Paris for six months and exhibited a number of engravings at the Salon d'Automne, where he would have seen recent works by artists such as de Chirico, Despiau, Maillol and Joseph Bernard. This contact with Parisian art confirmed Martini in a modernist direction, but in later life he was to play down its significance. Referring to this period he said in the early 1940s: 'I had already entered into the Paris movements, but they were so naturalistic. We must not believe that everything was born in Paris. The need for the exotic, for the infantile, was felt simultaneously all over the world' (G. Scarpa, *Colloqui con Arturo Martini*, Milan, 1968).

After his return to Italy, Martini divided his time between Treviso, Venice and Rome. He became associated with the Venice group of Futurists in 1913, and the following year, in Rome, he made friends with the Futurist artist Boccioni; and like many young artists with modernist sym-

pathies, he took part in a Futurist exhibition at the Galleria Sprovieri in Rome in April 1914. However, his links with the Futurist movement as a whole were not particularly strong.

For much of the war Martini worked in an arms factory, where he learnt about casting. He suffered long periods of illness, during which he was able to keep in touch with developments in the art world and also to reflect on his future career. Like many young artists of his generation, he had associated modernity with stylisation and primitivism; but during the war years he became attracted to the new respect for technique and the classical tradition that were the hallmarks of the Italian 'return to order'. In April 1917 he wrote to his friend Giovanni Comisso (whose writings were later to inspire a number of his best known sculptures), 'I once thought that a work of art was a matter of reflex, nerves, improvisation; but I now realise it is a question of patience: going back, listening again, returning, without forcing the pace, without short-cuts; being governed by nature as nature governs itself' (*Le Lettere 1909–47*, Florence, 1967). He did not, however, change direction immediately: in 1918, for example, he published a volume of abstract drawings entitled *Contemplazione*. Not until the years following the war, when he mixed with artists and writers who were to be involved in the Novecento movement in Milan, did his style change dramatically.

In the early 1920s Martini attended regularly the famous Wednesday afternoon salons of Margherita Sarfatti, the future organiser of the Novecento movement, and came across new ideas of a modern type of classical art based on simple geometric forms and solid volumes. Through Sarfatti, Martini received the patronage of a wealthy industrialist, who provided him and the painter Achille Funi with a monthly stipend and a studio in which to work at a villa on Lake Como. It was during his six months there that Martini began to move away from Sarfatti's vision of art towards the unqualified traditionalism of those painters in Rome linked to the prestigious journal *Valori Plastici*.

Crucial to this change of direction was

The artist in his studio, c.1936 (Photo: Dott.ssa Claudia Gian Ferrari)

Martini's acquaintance with Carlo Carrà. As may be seen in works such as 'The Daughters of Lot' (cat.18), Carrà had already adopted an archaic style inspired by Giotto. In November 1920 he wrote the catalogue preface for Martini's one-man show in Milan; and it seems likely that it was with Carrà's encouragement that Martini sought to join the *Valori Plastici* group, writing to the review's editor, Mario Broglio, in January 1921, '. . . with immense joy I will be one of yours'. From this point Martini developed a simplified, archaic style, rich in echoes of Quattrocento, Etruscan, Greek and even Egyptian art, using subject matter taken from both modern life and ancient myth. In this pioneering work, he was sustained by the idea that he was feeding the flame of Italy's artistic greatness, and also by his belief that he was destined to be Italy's leading sculptor.

Martini moved to Rome in 1921 and had high hopes of critical acclaim and financial success; but these were not to be realised. He had expected Broglio to publish articles on his work, but in fact he received little attention in *Valori Plastici*, and this was one

reason for his rapid disenchantment with the group. Photographs of some of his sculptures appeared in the May–June issue of 1921 alongside the late-Cubist works of Zadkine, a Russian-born artist living in Paris. This juxtaposition was probably intended as a comment on the debate between the French critic Maurice Raynal, with his support for the plastic qualities in contemporary French art, and Carrà, with his vision of the superior values of the Italian naturalist tradition; but Martini had hoped for a more extensive appraisal of his work.

Valori Plastici was a journal written primarily by and for painters, and it had little to say about the special qualities of sculpture. It is therefore not surprising, perhaps, that Martini was the only sculptor ever associated with the group. However, although his ties with it were never very close, he was clearly influenced by its ideals. In a letter to his friend and lawyer Natale Mazzolà of June 1922, he wrote of the need to impose order on nature, of the eternal beauty beneath appearances, and of the role of the artist as an heroic adventurer, or (using a term dear to de Chirico and Savinio) an 'Argonaut':

> . . . my eye has become cautious and cold towards nature so as to better apprehend its style and rhythms without assuming its surface appearances. You have to be cunning with nature, and able to deceive it, in order then to steal its secrets stealthily. . . . The giants are not yet dead, and should my life allow it, I will be one of the greatest of them – work after work. . . . The only beauty I understand is one made from the memories of all times past. This is the sole possible beauty for the Argonaut who always imagines beyond the hedge or wall a vast sea waiting to receive him – that is beauty; the idea of a beyond existing in body and spirit. I feel I have reached it. (*Lettere*)

After the dissolution of the *Valori Plastici* group in 1922, Martini spent long periods, chiefly for reasons of economy, in a village near Rome called Anticoli Corrado. He relished the simple life of this rural community, and what he described as its magical, primitive character. He set up studio in an abandoned church ('full of ancient pictures, with a religious atmosphere that goes marvellously well with my art and helps give me inspiration' (to Mazzolà, 1925, *Lettere*), and his work took on a new lyrical quality, combining fantasy and fable with simplicity and spontaneity of execution. In 1927 Martini was back in Rome, and began making frequent visits to the museum of the Valle Giulia. He was enthralled by the Etruscan exhibits there, and his sculptures from this period, particularly those in terracotta, were much influenced by them. This new direction in Martini's work fostered a renewal of interest in Etruscan art generally.

Martini's financial position remained precarious throughout this period, and he was dependent on a series of contracts in which he assigned rights of reproduction to dealers in return for a stipend. Although a master of handling terracotta, a material which gave his sculptures a tactile and antique quality, there is evidence that Martini would have preferred, had finances permitted, to cast more of his works in bronze. However, he did achieve some success and acclaim in these years. He had a separate display of his works at the first Quadriennale in Rome in 1925, and was represented in the *Novecento Italiano* exhibitions of 1926 and 1929. A measure of financial security entered his life when he was appointed to a teaching post at Monza; and the following years were marked by a fresh burst of creativity in which he completed many large-scale pieces. In 1931 he won first prize at the Rome Quadriennale, and in the same year made a special trip to Pompeii to see the latest discoveries.

During the 1930s Martini worked on a number of important State commissions celebrating aspects of modern Italy and the Fascist regime. After the war he defended his position, saying that in his view the sculptor was like a shoemaker who makes shoes for whomever orders them: '. . . for example, I do not believe in priests, but I would very gladly make a Descent from the Cross or two . . .' (to Raffaele Levi, 1945, *Lettere*). From the late 1930s he became increasingly dissatisfied with sculpture, and turned instead to painting. In 1945 he published a book entitled *La Scultura lingua morta*, in which he attacked the whole tradition of statuary sculpture. After his death his work fell out of fashion, but he had enormous influence on a slightly younger generation of Italian sculptors, notably Marino Marini; and in recent years his status as one of Italy's most innovative and powerful modern artists has been recognised.

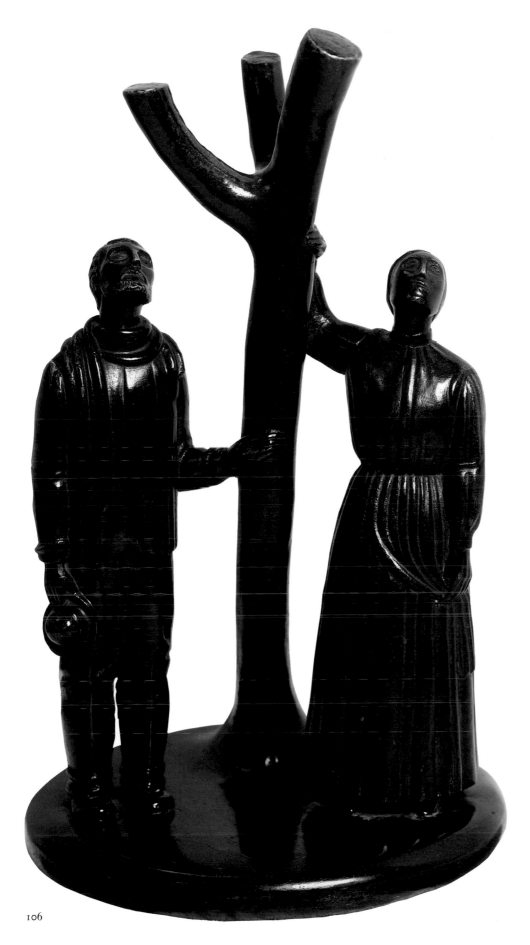

106

106 The Stars 1920
Bronze, 62.5 × 38 × 38
Private Collection

Martini's fondness for popular and archaic culture, and his belief in the artistic function of myth and fable, are well illustrated in this work. It represents a couple, gazing at the stars; and though its source of inspiration is not entirely certain, it may well derive from a tale by his friend, the writer Giovanni Comisso. The rustic clothes worn by the figures have both a contemporary and time-less quality to them: the simple, repetitive handling of the folds is reminiscent of the stylisation to be found in early Renaissance paintings.

It seems likely that this was one of the earliest works in which Martini showed his new concern for Trecento and Quattrocento art. He became interested in the so-called Italian Primitives in late 1919 and early 1920, when he and Achille Funi stayed in the home of a wealthy industrialist. His encounter with the work of Carlo Carrà was undoubtedly crucial to this change of direction; and in fact Carrà wrote the catalogue preface for Martini's one-man show in Milan in November 1920 at which the plaster version of 'The Stars' was first exhibited. Carrà said that Martini's work might appear 'archaic', but this was only because, like that of Barlach and Maillol, it embraced 'the primary forms of plastic expression'. 'Moreover it should be added that this is the general mood that is inspiring the entire modern period, and if people are still overly cautious about these forms, this is because Italy is still dominated by paltry considerations of realism, which cannot be eradicated in the space of a few years.' Carrà cited 'The Stars', among other works, as evidence that Martini could only have arrived at 'such moving and constructive poetry' after much intellectual endeavour. He added, 'Who can fail to see the signs which link this sculpture to the great Italian tradition of the Quattrocento?'

Encouraged by Carrà's support, Martini moved to Rome, and became associated with the *Valori Plastici* group of artists. The plaster version of 'The Stars' was included in the *Valori Plastici* exhibition which toured major German cities in 1921, and was also exhibited at the Primaverile show in Florence in 1922.

107 Head of a Boy 1920

Bronze, 42 × 40.5 × 6.5
*Civico Museo d'Arte Contemporanea,
Palazzo Reale, Milan*

With its frontality, simplicity of detail and
expressionless air, this sculpture recalls
fifteenth-century Italian portrait busts and
ancient reliquary statues. Its archaic quality
shows Martini to be following a path paral-
lel to that of Carrà in his fascination with the
paintings of the Trecento master Giotto (see
cat.18). However, the apparent archaicism
of the subject matter was a by-product of
Martini's desire to imitate the formal clarity
of earlier art: what mattered was the ideal
beauty of sculptured form handled instinc-
tively and unconstrained by concerns about
reproducing the appearance of the natural
world. The work's simplified treatment of
volumes was very much in tune with the
spirit of the *Valori Plastici* group as a whole.
Recalling this period of his life, Martini
noted laconically that 'the tendency to sim-
plify was in the air' (G. Scarpa, *Colloqui con
Arturo Martini*, Milan, 1968). The original
plaster version of this work was reproduced
in the magazine *Valori Plastici* in 1921 – the
first and only occasion on which Martini
received recognition from this quarter – and
was in fact owned by the editor, Mario
Broglio.

Critics were quick to recognise the refer-
ences in Martini's work to past art, but
rarely appreciated the results. In a review of
the 1922 Primaverile show in Florence (at
which 'The Stars', cat.106, was exhibited),
one critic wrote of Martini's 'new archaic
academicism', and complained that he had
been influenced by the 'primitives of Italy
and Greece without finding his own
formula' (*L'Illustrazione Italiana*, May
1922). Another accused him of a gratuitous
'love of plasticity . . . making everything
heavy, rough, and solid as in the statues of
the late Roman Empire' (*La Tribuna*,
August 1922).

108 La Nena 1928

Terracotta, 46 × 29 × 31
*Middleheim Open Air Museum for
Sculpture, Antwerp*

This is a portrait of Martini's daughter,
Maria Antonietta, known in the family as
Nena, who was born in April 1921. As is
often the case with Martini, a pictorial
rather than a sculptural source seems to lie

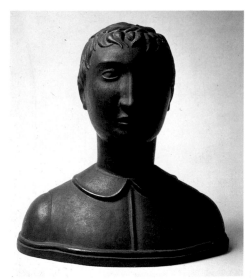

107

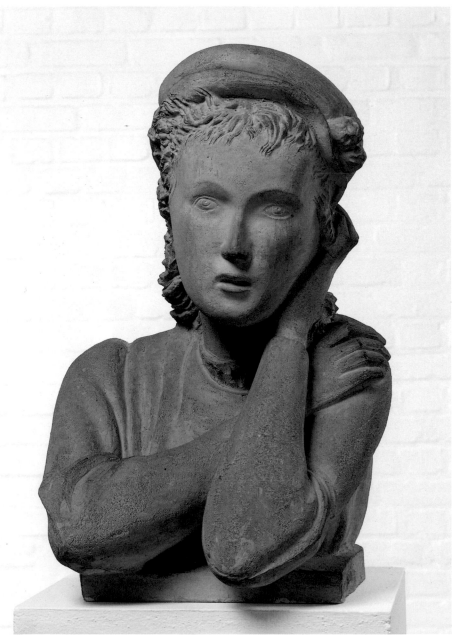

108

109

behind this work. The girl's pensive expression, and the firm modelling of her face and arms, suggests the influence of fifteenth-century fresco painting, and in particular the work of Piero della Francesca. Martini had executed a number of sculptures showing figures looking out of windows, which again have antecedents in late Roman and Renaissance painting; and the frontality of 'La Nena' suggests a similar pose. The simple, old-fashioned and slightly rustic hat worn by the girl recalls Picasso's pictures of country and petty bourgeois women painted in his neoclassical style of the early 1920s. In Picasso's work, the combination of an antique style, associated with the traditions of high art, and allusions to the life of ordinary working people had a subversive and ironic aspect. Martini, however, who saw himself as an artisan and man of the people, did not want to parody, but rather to reinvigorate the ancient traditions of art through references to the modern world.

109 Torso 1928
Terracotta, 75 × 34
Private Collection, Rome

In this work, Martini has made subtle allusions to different traditions, and in so doing has created a strikingly new and modern piece. The fragmentary form of 'Torso' recalls the broken remnants of Greek or Roman sculpture, and yet the stiffness of the boy's pose and the elongation of the torso suggest medieval rather than classical art. Many of Martini's figures reveal a fascination with the curves and contours of the human back, and it was perhaps for this reason that he has concentrated here on that aspect of the body. At the same time, the strangely carapace-like quality of the work and the emphatic modelling of the musculature evoke moulded body armour of the ancient world.

The terracotta version of this sculpture was made while Martini was staying in his wife's home town of Vado Ligure. As is so often the case with Martini's works, there are slightly different versions of this piece in plaster and bronze.

110 Leda and the Swan 1929

Stone, 198 × 52 × 72
Anna Derossi Caretta and Cristina Caretta

This massive sculpture depicts the Greek tale of Leda's seduction by Zeus, disguised as a swan, and reflects Martini's love for ancient myths which he saw as commentaries on aspects of the human spirit. (He said of himself, 'I am the man of fables, a primitive, a peasant, a mountain-dweller. . . . I need to describe the delusions, the miracles, the hopes of man'; G. Scarpa, *Colloqui con Arturo Martini*, Milan, 1968.)

Martini first began working with this theme in the early 1920s. He referred in a letter of 1922 to carving a wooden Leda, 'beautiful, like something ancient, very refined and at the same time rustic as the subject requires', and he was to make several different works on this subject. The version here was executed in 1929 with the help of students at the Istituto Superiore in Monza where Martini was teaching, and in its grand scale and lyrical quality it is typical of his works of this period. The figure's seated pose and the rounded form of the bird's body are reminiscent of a sculpture of Leda and the swan, a Roman copy of an earlier Greek work, in the Capitoline Museum in Rome. However, the piece's elongated proportions and simplification of detail (for example, in the woman's face and the folds of the cloth) have an obvious archaic or primitive quality and recall the painting of Trecento artists such as Giotto. Like Carrà, Martini associated formal simplicity with a spiritual quality, and claimed in his reminiscences, 'In me, truth just appears, like a vision. In another age I would have seen the Madonna. This is why Broglio said to me, "You are like the ancients".' (*Colloqui*)

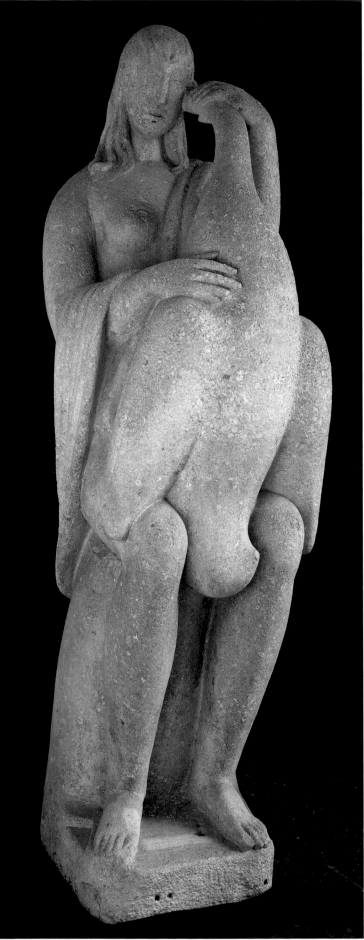

110

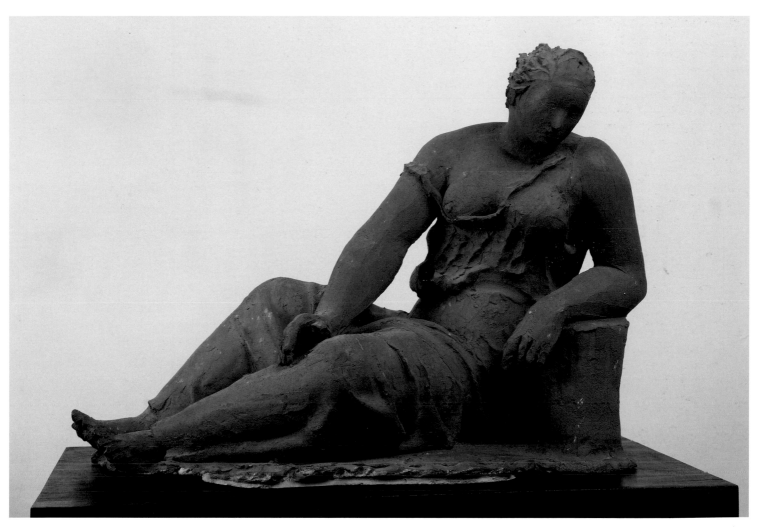

111

111 Reclining Woman 1930–31

Terracotta, 56 × 65 × 36
Galleria Arco Farnese, Rome

This reclining figure resting on the remains
of a classical pillar was plainly inspired by
Greek classicism. The pose and treatment of
the clothing is reminiscent, in particular, of
the fifth-century BC sculptures of the Fates
from the east pediment of the Parthenon in
Athens; but the theme is also found in a
number of ancient sculptures, such as that
of Ariadne reclining, represented by de
Chirico in several of his paintings of the
early metaphysical period.

Martini was later to call the years 1930–
31 his 'Etruscan period' and a 'period of
poetry', and he played down his interest in
classical sculpture. 'I did not turn to the
Greeks, who had time to exhaust all the
possibilities of their art', he said. 'It was

logical to look to the Etruscans, who had
disappeared before such exhaustion could
set in' (G. Scarpa, *Colloqui con Arturo
Martini*, Milan, 1968). Lo Duca, in his
monograph on the artist of 1933, also noted
that Martini spent hours among the Etrus-
can terracottas in the museum of the Valle
Giulia, 'feeling them with an envious hand,
contemplating them in the hope of breaking
their silence'. However, in this small but not
untypical work Martini was clearly using an
overtly classical imagery, although the air of
disorder and surprise conveyed by the pose
of the figure, together with the rough finish,
were in themselves 'unclassical'.

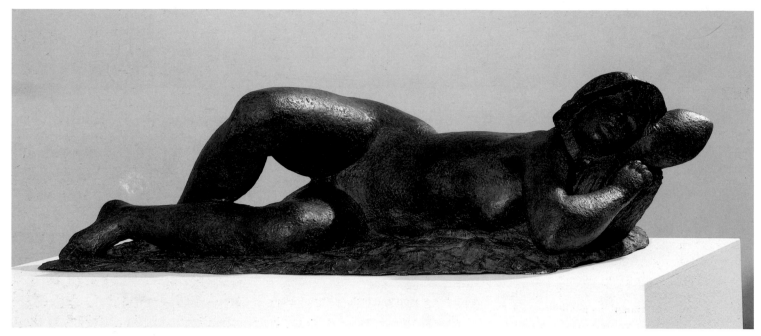

112

112 Woman in the Sun 1930

Bronze, 40 × 65 × 150
Museo d'Arte Moderna e
Contemporanea, Trento and Rovereto

The theme of the reclining nude first
appeared in Martini's work in 1928, and
allowed him to develop a new sensual
quality in his sculpture. The twisting pose
recalls the famous classical statue known as
the 'Hermaphrodite' of the second century
BC, but the figure is plainly not classical in
its proportions. With her rather battered
rustic hat, the woman appears to be a
country girl basking in the Mediterranean
sun. This theme is also found in the work of
Picasso (for example, in 'Sleeping Peasants',
1919, Museum of Modern Art, New York),
Gargallo and Manolo, as well as in paintings
of this period by Carlo Carrà (cat.19).

The terracotta version of 'Woman in the
Sun' won first prize for sculpture at the
Rome Quadriennale of 1931. The artist
Cipriano Oppo, who was one of the judges,
described it as a 'statue of such elegance and
felicity that even the untutored visitor to the
Quadriennale can enjoy [it].'

ANDRÉ MASSON 1896 BALAGNY-SUR-THÉRAIN – 1987 PARIS

Masson was one of the foremost painters in the Surrealist group, and as such his relationship to the classical tradition was inevitably far from conventional. His personal interpretation challenged the accepted identification of classicism with order, reason, harmony, serenity and beauty, and involved instead a concentration on the potent undercurrents of violence, passion, cruelty and unreason enshrined in certain myths and rituals. To borrow the terminology of Nietzsche in *The Birth of Tragedy* (1872), his was not an 'Apollonian' but a 'Dionysiac' concept of classicism. Indeed Masson's approach represents a rebellion against the status quo, whereas for many, classicism is intimately associated with an instinct towards conservatism.

Masson's rebellion was not, however, the act of one who was uncultured or ignorant of academic traditions and conventions. On the contrary, he had a thorough academic training and was passionately intellectual. Masson's childhood was spent in Lille and Brussels, and his obsession with drawing developed early. With the encouragement of his mother he gained admission to the Académie Royale des Beaux-Arts in Brussels when he was only eleven, distinguishing himself in composition and drawing, and concentrating upon mural painting. His master was the Symbolist painter Constant Montald. This exposure to Symbolist art and theory conditioned his development as an artist, and in his mature work he tended to employ a complex language of symbolic reference. The lectures on Elizabethan and Jacobean drama of the writer Georges Eekhoud, which Masson attended in Brussels, were his initiation into the 'theatre of cruelty', and nourished his already fervent literary imagination.

In 1912 Masson transferred to the Ecole des Beaux-Arts in Paris, entering the studio of Paul Baudouin, who was the only academic master still teaching fresco painting. With a state bursary he was able to study Quattrocento fresco cycles in Tuscany in the spring of 1914. As he later explained, Italy was a revelation to him, but his tastes were already marked by independence and eclecticism, for he admired Lorenzetti more than Giotto, was fascinated by Uccello's

'Flood' in the Chiostro Verde, and in the Uffizi especially admired Botticelli's 'Primavera', a late self-portrait by Rembrandt, and two huge unfinished canvases by Rubens. In Paris Masson had spent many hours in the Louvre, fascinated in particular by the gallery devoted to Poussin.

> I thought his work strange, even a little mad, in contrast to the point of view typical of the Ecole and establishment critics. For everyone else Poussin is the painter of reason and order. That doesn't prevent him from being face to face with madness. He loves panic, storms, ruins, murder, rape – all of which run through his work. . . . People have said to me: how can you, a man of vertigo (l'homme du vertige), love Poussin? But there is vertigo in him. I never copied him, but in some of my paintings there are analogies. (Jean-Paul Clébert, *Mythologie d'André Masson*, Geneva, 1971)

In Masson's perception of the 'Dionysiac' undercurrents of Poussin's work lies the foundation for his attitude to the classical tradition, while his list of Poussin's favourite themes corresponds fairly closely to his own. Significantly, it was during these two years in Paris that he discovered the writings of Nietzsche, which exacerbated his natural propensity towards exaltation and revolt.

Masson was called up in 1915. His experience of the horrors of trench warfare proved to be as significant for his formation as was his liberal education, effectively putting an end to what he described as his 'delicate and idealistic adolescence' (*Mythologie*). Severely wounded in 1917, and by now resolutely anti-militaristic, he spent the next year or so in and out of hospitals and mental asylums, before being demobilised late in 1918. The following year he began drawing and painting seriously again, settling in Céret in the spring, where he saw much of Manolo and met Soutine.

Late in 1920 Masson moved to Paris. In the winter of 1921–2 he installed himself in a tiny studio–apartment in the rue Blomet, which soon became the rendezvous of a group of young painters and poets – including Miró, Roland Tual, Georges Limbour

The artist at New Preston, Connecticut, *c*.1943
(Photo: Comité André Masson)

and Michel Leiris – who would shortly form a significant branch of the official Surrealist movement. Liberated financially thanks to a contract with Kahnweiler, Masson increased his output dramatically, and his artistic development was rapid. As a draughtsman he made a significant breakthrough in the winter of 1923–4 when he produced his first 'automatic' drawings – prior to the publication of André Breton's first Surrealist manifesto. Meanwhile in his paintings Masson moved from a style still largely dependent on Derain to one which owed much to analytical Cubism, and from 'traditional' landscape, still life and genre imagery to an emblematic manner involving irrational juxtapositions in the manner of de Chirico. His new work, shown at Kahnweiler's Galerie Simon in February 1924, attracted the attention of Breton, and Masson was drawn into the official Surrealist movement. His work was featured in all but the last issue of *La Révolution Surréaliste*, and with Ernst and Miró he remained the most important painter in the group until his expulsion in 1929.

If most of Masson's paintings of the later 1920s seem to have little or nothing to do

with classicism, his work in the 1930s makes many direct references to classical sources. An intimate friend of the 'dissident' Surrealist writer Georges Bataille, Masson was as fascinated as him by 'Greek myths of the darkest kind, in particular Dionysiac myths and the myth of the Cretan labyrinth.' (*Mythologie*) Images of ritualised violence had surfaced in some of Masson's automatic drawings and the sand paintings of 1926–7 but now became ever-present, dominating, for example, the great series of drawings entitled 'Massacres' (1932–3), which were inspired by, among other things, Poussin's 'Rape of the Sabine Women' (Louvre). It was Masson and Bataille who insisted that the new art review planned by Tériade, and founded in 1933, should have the title *Minotaure*. Masson's first allusion to the Minotaur had been made in an erotic watercolour of 1922, but references multiplied a decade later, when Ariadne, the labyrinth and the monster himself became for him obsessive subjects. Sometimes the stories were rendered almost literally, but usually Masson's method was allusive and symbolic. Favourite subjects besides the Minotaur were Daedalus and Pasiphae, and all became part of Masson's personal mythology of pain and desire, love and death. In Spain, where he lived from 1934 to 1936, he was attracted to the bullfight which he, like Picasso, saw in terms of an ancient ritual of sacrifice, and which now joined his repertoire. As Masson remarked to Clébert, his was 'not the world of harmony, the Golden Age. On the contrary.'

In the 1930s Masson achieved international status through a series of exhibitions in Paris, London and New York. He and Breton were reconciled in 1936, and after the Occupation they saw much of each other in exile in America. Masson's work attracted the intense interest of the New York school of painters, in particular Jackson Pollock, while his continuing fidelity to automatist techniques made him a natural ally of the gestural painters in France. A series of monographs mainly written by his old Surrealist friends, the growing corpus of his own critical writings and statements, and the sombre, mythic nature of his vision, made Masson one of the most highly respected members of the post-war avant-garde, although his position was always that of the outsider, resisting categorisation.

113 Women 1922

Pen and watercolour on paper,
32.5 × 28
Private Collection

This is from a sequence of erotic drawings Masson made after he settled in Paris and before he signed a contract with Kahnweiler. He had married in 1920 and his daughter had been born at the end of that year. To support his family he had to undertake a variety of menial jobs which left no time for painting, and the drawings were his only outlet. From the point of view of Masson's later development they were, however, highly significant, for the imagery of the orgy recurs throughout his career, while the flattened space, centralised oval composition and reliance on an organic,

free-flowing line directly anticipate the more abstracted 'automatic' drawings made a few years later, where breasts, hands and sexual organs emerge from the labyrinth of lines. Although not themselves automatic, the early drawings were executed spontaneously in a spirit of revolt and were a necessary stage in Masson's liberation from the academic disciplines in which he had been trained.

Although the implications of uninhibited fantasy in these drawings, and the probable debt to the writings of de Sade, might seem to rule out any influence from classicism, closer consideration reveals several points of contact. 'Women', for instance, may be intended to depict the all-female societies of the island of Lesbos, immortalised by the great lyric poetess Sappho. If not Lesbos

113

itself, the setting suggests an allusion to water-nymphs and nereids, and the poses of the women and the piling up of their ample bodies echo those of the nereids in celebrated paintings by two of Masson's favourite painters – Rubens's 'Landing of Marie de Medici in the Harbour at Marseilles' (Louvre), and Poussin's 'Triumph of Neptune' (Philadelphia Museum of Art). In this connection it is significant that ink drawings done by Masson nearly twenty years later, in 1941, which show naked bathers riding on the giant hand of Neptune, are very similar in composition to this watercolour. Thus whereas the later automatic drawings have a deliberately uncultured, mediumistic character, the erotic drawings constantly remind us of Masson's easy familiarity with the classical tradition.

114

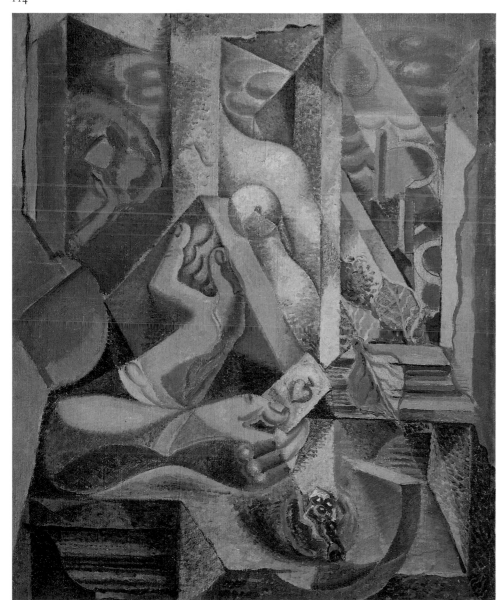

114 The Abandoned City 1923–4

Oil on canvas, 73 × 60
Galerie Louise Leiris, Paris

Alluding to his paintings of the period 1923–5, Masson speaks of 'a constellation of emblematic objects, in a mental space.' ('Etapes', in Masson, *Métamorphoses de l'artiste*, Geneva, 1956) It was also at this period that he made the transition in his painting to a style dependent upon an alliance between analytical Cubism and the metaphysical paintings of de Chirico. The structure of 'The Abandoned City' is determined by a mathematical grid as regular as that found in the works of Gris – an artist Masson greatly admired – while the overlapping and transparency of the planes, the use of stippled brushstrokes, and the chalky, monochromatic palette, are reminiscent of the work of Picasso and Braque around 1911–12. On the other hand, the various 'emblems' in the painting – the groping hands, headless female torso, open pomegranate, ace of spades, architectural features, and so on – are juxtaposed according to the dream-like 'anti-logic' of de Chirico in a painting like 'Song of Love' (cat.31). The Cubist 'scaffolding' functions as the structural control binding together the fragments of his hallucinatory vision: only later would Masson reject such forms of control as a needless inhibition.

The insistent presence of the structural grid, and the emphasis on drawing and tonal modelling rather than colour, are the legacy of Masson's classical training as a painter. It is as if he were modelling himself on Poussin – an artist who, for Masson, expressed his 'insanity' within an apparently coldly rational framework. Indeed 'The Abandoned City' appears to have been one of several paintings directly inspired by Poussin's 'Ecstasy of St Paul' in the Louvre, which had fascinated Masson ever since he first came to Paris in 1912. The huge gesturing hands, the clouds, the firmly anchored architecture, all find echoes in Masson's painting. And his alternative, rebel account of the significance of Poussin was extended to analytical Cubism, which 'call to order' critics persisted in interpreting as a rational, ordered and abstract style. For Masson, on the other hand, the open suggestive structures of analytical Cubism permitted the pictorial re-creation of a mythic reality.

HENRI MATISSE 1869 LE CATEAU-CAMBRÉSIS – 1954 NICE

Matisse took a keen and discriminating interest in non-Western art – in traditions which offer an alternative to European classicism. Some of his most radical pictorial effects are in part dependent upon his reactions to these alien sources. Yet they are assimilated fully into a vision and practice which are rooted in the classical tradition, and into works whose iconography and meaning cannot be understood except in terms of that tradition. As Apollinaire, who was reporting their conversations, remarked: 'although he is eager to know the artistic countenance of all the human races, Henri Matisse remains devoted above all to the beauty of Europe.' (*La Phalange*, 15 December 1907) Cézanne had given Matisse's generation a paradigm for a fresh and creative, rather than academic, dialogue with classicism: Matisse did the same for the next generation. For those artists who around 1914–18 yearned for a closer connection with classicism, his post-Fauve work, supported by his writings, offered a continuity with the 'new' classicism of Cézanne, and an alternative to the more outwardly radical styles of Cubism, Futurism and Orphism.

Matisse had a relatively conventional artistic training, once he had decided, in 1891, to abandon a career as a lawyer. He entered the studio of the Symbolist painter Gustave Moreau, although it was not until 1895 that he actually passed the entrance examinations into the Ecole des Beaux-Arts. He made copies at the Louvre, but his earliest independent paintings are broadly realist or impressionist in style. Moreau died in 1898, and within a year Matisse had acquired a small Bather painting by Cézanne (see cat.63), as well as a study of a boy's head by Gauguin. His new work reflected these contacts with the most radical forces in French art, and, following a summer spent with Signac in Saint Tropez in 1904, he began to paint in a bold version of neo-Impressionism. The colour theories and practice of the neo-Impressionists left a profound and lasting mark on his work, but by the summer of 1905, which he spent in Collioure with Derain, Matisse was no longer using the mosaic-like 'points' of Signac, but the loosest, freest touch. His

new paintings, exhibited in the Salon d'Automne, caused a scandal, and earned him the title of 'king' of the 'wild beasts', a reputation which dogged him for years to come.

Matisse's most ambitious Fauve painting was 'Bonheur de vivre' (Barnes Foundation, Merion, Pennsylvania), which he exhibited in the spring of 1906. This extraordinary picture was radical in its conception of space and form, in colour and in handling, but its debt to European classicism is beyond doubt. In its monumental scale, Arcadian subject matter, and concentration on nude figures seen in a variety of complex positions, it fulfils stringent academic criteria for 'history painting', traditionally considered the highest form of art. In its composition it looks back to Poussin, and beyond him to Raphael and Titian; in its swift and simplified drawing it owes much to the Greek vase painters as well as to Ingres. Very probably, the seemingly cavalier manner in which Matisse adapted these hallowed sources was responsible for much of the anger against the painting among conservatives: it looked as if he were scorning the Great Tradition, when in reality he was giving it new life.

Matisse later came to regard 'Bonheur de vivre' as the source of his entire subsequent development, and within a couple of years, under the renewed impact of Cézanne, he was moving beyond the directly spontaneous manner associated with Fauvism towards a more consistently meditated, more sober art. His trip to Italy in the early summer of 1907, when he visited Florence, Arezzo, Siena, Padua and Venice, was of great importance, consolidating his sense of continuity with the traditions of the past. In December 1908 Matisse published 'Notes of a painter' in *La Grande Revue*. It remains his most important statement on his art. He identifies 'expression' as his principal goal, but explains that he means by this pictorial, rather than emotional expression. He lays stress on the need for 'composition'; for 'condensation' achieved through frequent rethinking and reworking; on his search for the 'essential' in the motif, for 'stability' and 'a more lasting interpretation'; and adds that for him, 'all is in the conception'. Emphasising his humanistic attitude to art – 'What

The artist drawing from a model in his apartment on the Place Charles-Félix, Nice, c.1928 (Photo: Museum of Modern Art, New York)

interests me most is . . . the human figure. It is that which permits me best to express my almost religious awe towards life' – he goes on to identify 'balance', 'purity' and 'serenity' as his 'dream' for art. The very words Matisse uses here resonate with echoes of a classically based aesthetic.

In the decade that followed, 1908–17, Matisse was at his grandest and most conceptual. His reputation was established in a series of one-man shows at home and abroad, and his work increasingly found ready buyers. He had opened a school in 1908, but even after it closed three years later, he continued to exert considerable influence on younger artists, many of them foreign, who regarded him as their master. His friendship with Gris in 1914 had repercussions in his paintings, which became noticeably more abstracted and geometric, without sacrificing any of the monumentality or thematic richness characteristic of his pre-war work.

Late in 1917 Matisse moved to Nice, where he spent a large proportion of his time thereafter. His work now relaxed noticeably, as he began to paint directly

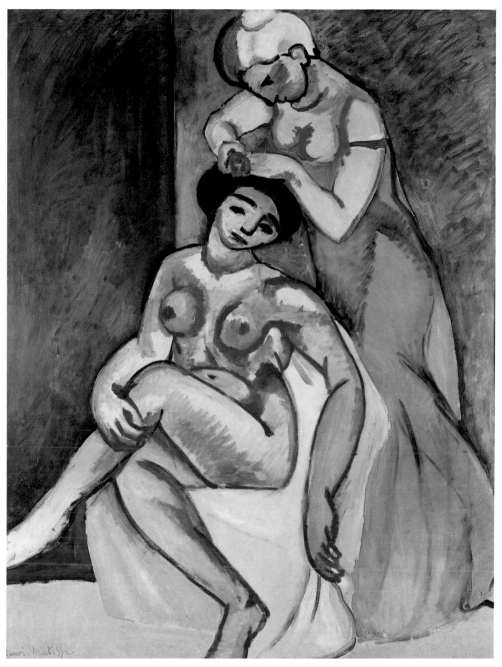

115

from nature in response to the beauty of his surroundings. Although his reputation as a great modern painter was never seriously under threat, and he was the subject of an ever-increasing number of exhibitions and critical studies, this more naturalistic style was controversial and brought accusations from certain 'call to order' critics of a decline into 'impressionism'. (In 1919, Cocteau, for instance, berated him for working without the underlying discipline of the great masters, and in April 1931 he was the subject of a 'For and Against' questionnaire published by *Chroniques du Jour*, just before the opening of his latest retrospective at the Galeries Georges Petit.) In fact, however, Matisse continued to draw upon the very kinds of sources these same critics extolled, in particular classical and Renaissance sculpture, while his favourite subjects – the odalisque, the artist and his model – reflect his sense of continuity with the European tradition. A particularly fine and bold example of the synthesis between perception and conception that he sought is 'Decorative Figure on an Ornamental Background', 1925 6 (Musée National d'Art Moderne, Centre Georges Pompidou), in which the seated nude has the hieratic dignity and abstraction of archaic sculpture, and the setting reflects the brilliance of pattern and colour of the Odalisque paintings of Ingres and Delacroix. Matisse's Mediterranean paintings, like those of Renoir and Bonnard, whom he visited in nearby Cagnes and Antibes, provide images which represent a contemporary equivalent to the myth of Arcadia, and a realisation of the classical ideal of art as a source of beauty, harmony and peace.

115 The Coiffure 1907
Oil on canvas, 116 × 89
Staatsgalerie, Stuttgart

Painted in the early summer of 1907, 'The Coiffure' reveals the increasing preoccupation with structure and three-dimensional form which marked Matisse's latest work and spelled the eclipse of the brilliant prismatic colour, decorative flatness and spontaneous handling of the Fauve style. Although the painting predated his trip to Italy, its carefully organised composition, which locks the two figures into a perfect, centralised pyramid, strongly suggests that Matisse had been looking at High Renaissance painting: Walter Pach, who first met

Matisse in Italy in 1907, drew a convincing parallel between the pose of the nude and that of Leonardo's 'Bacchus' in the Louvre. (*Queer Thing Painting*, New York, 1939) Another important source is Cézanne, whose later Bather compositions were attracting intense interest within the avant-garde at exactly this time.

It may also be that Matisse was responding to the challenge offered by a large painting on the same subject by Picasso, which dates from 1906 and was in Vollard's collection ('The Coiffure', Metropolitan Museum, New York). This, although much more clumsily executed, has a basically triangular composition and also probably derives from Renaissance prototypes. Matisse's masterly picture, while exploiting the awkward, powerful rhythms of Cézanne's drawing – which clearly also excited Picasso – is noticeably more poised and controlled, and more serene in mood. It possesses, indeed, the clarity, balance, order, grandeur and eminent reasonableness, which Apollinaire, in an attempt to overturn the popular notion of Matisse as the arch 'wild beast', and to launch him instead as the modern incarnation of the purest French traditions in painting, insisted were the distinguishing characteristics of his art. (*La Phalange*, 15 December 1907)

'The Coiffure', which was bought from Matisse by Michael and Sarah Stein, was exhibited regularly before the First World War in France and abroad. (It was included, for instance, in Matisse's one-man show at the Bernheim-Jeune gallery in Paris in 1910.) In 1920 it was reproduced in Marcel Sembat's popular monograph on Matisse published by the Nouvelle Revue Française. This wide exposure, and its marked classical character, suggest that it may have been among Matisse's most influential works after the war, when his earlier paintings were preferred by many critics and artists to his recent, more naturalistic works.

116 Bathers with a Turtle 1908

Oil on canvas, 179.1 × 220.3
St Louis Art Museum, gift of Mr and Mrs Joseph Pulitzer Jr

Finished early in 1908, 'Bathers with a Turtle' initiated that great series of primitivist figure compositions which culminated in 'Dance' and 'Music', the huge panels Matisse painted for the Russian merchant Sergei Schukin in 1909–10 (Hermitage Museum, Leningrad). It was Matisse's largest canvas since 'Bonheur de vivre', 1905–6 (Barnes Foundation, Merion, Pennsylvania) – the masterpiece from which all these figure paintings ultimately developed. Its composition, however, is essentially a reworking of the brilliantly coloured and much smaller 'Three Bathers' of the previous year (Institute of Arts, Minneapolis). All the changes Matisse made when transferring to the new grand scale were in the direction of ever greater simplification, generalisation and abstraction: the yachts sailing on the band of sea, the towels with which the bathers dry themselves, the hot colours of the Mediterranean in summer, the blithe holiday atmosphere – all these anecdotal, naturalist details present in the 'Three Bathers' have gone, and the numerous *pentimenti* visible on the surface of 'Bathers with a Turtle' testify to the intense labour of this process of purification.

The creative anxiety Matisse must often have felt has become, as it were, embodied in the central standing figure, who stares fixedly, with what seems to us irrational anguish, fear and horror, at the eager little tortoise. Cézanne's Bather paintings (especially the canvas Matisse himself had bought in 1899), and Gauguin's Tahitian paintings and wood carvings, were certainly an inspiration. But the closest analogy for this woman is perhaps the Eve in Masaccio's 'Expulsion of Adam and Eve' in the Brancacci Chapel in Florence. Matisse had been to Italy in the summer of 1907 and had, apparently, been most profoundly moved by Giotto, Piero della Francesca, Duccio and the Sienese Primitives – he mentions Giotto's frescoes in Padua in 'Notes of a painter', 1908. But it is hard to believe that Masaccio's great cycle did not also affect him deeply. In any case the Italian Primitives were clearly a significant mediating force in the process of 'condensation' and purification to which Matisse was currently subjecting his art. And it is not impossible that the sequence of highly simplified figure compositions initiated by 'Bathers with a

Turtle', which includes 'The Game of Bowls' and 'Nymph and Satyr' (both in the Hermitage Museum, Leningrad), as well as 'Dance' and 'Music', was Matisse's pagan–primitivist equivalent to the great Christian polyptychs and fresco cycles he had admired in Italy. For they all possess an aura of utter remoteness and of ritual: we feel we are present at the beginning of human society. In 1916 Matisse recaptured this spirit of atavism in the magnificent 'Bathers by a River' (repr.p.23) – itself a further development of the theme and composition of 'Bathers with a Turtle'.

The subsequent history of this painting dramatises the opposition between avant-garde and academic–reactionary notions of classicism in the post-war era: purchased early by Karl Osthaus for his Folkwang Museum (Hagen, then Essen), it was seized by the Nazis – then actively promoting neoclassicism for propagandist purposes – as a prime example of 'degenerate art', and was auctioned off in Lucerne in 1939.

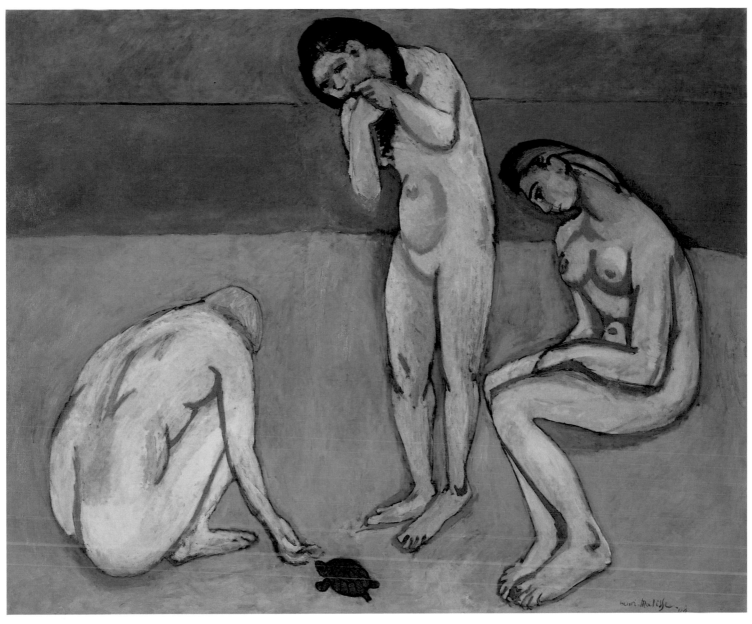

116

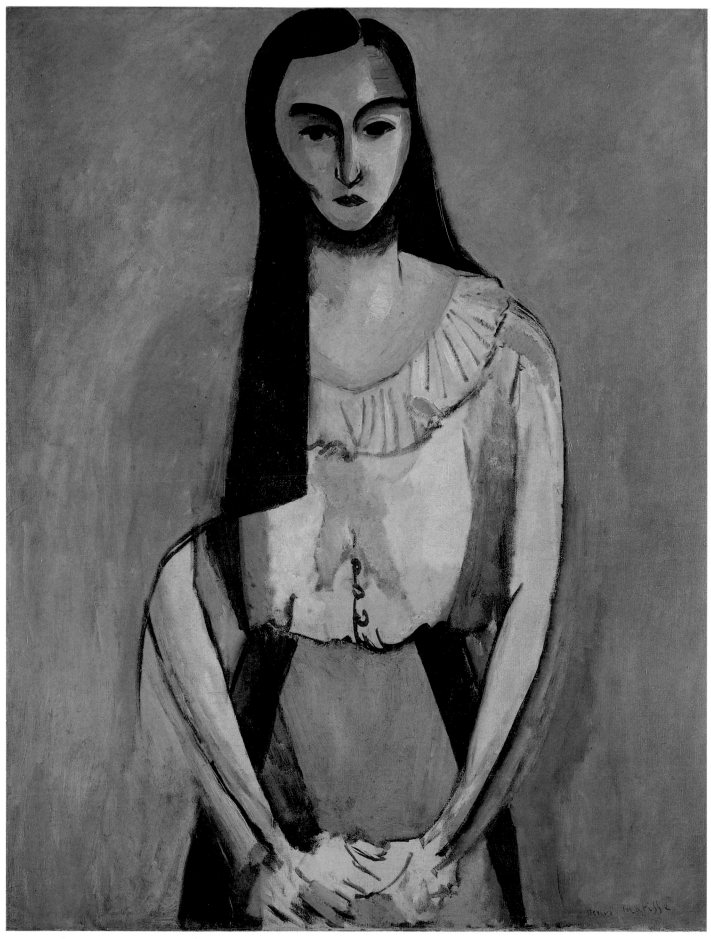

117

117 The Italian Woman (Lorette) 1916

Oil on canvas, 116.7 × 89.5
Solomon R. Guggenheim Museum, New York, by exchange, 1982

This may well be the first painting of Lorette, the Italian model whom Matisse painted again and again in 1916 and 1917. The use of an Italian model and of a costume that looks as if it derives from regional or peasant traditions, rather than contemporary fashion, link the painting with a large number of works executed by artists in France after the war when the 'costume piece' was used to achieve the desired quality of timelessness.

Unlike the other voluptuously seductive studies of Lorette, here she is hieratic and austere, like a priestess or an entranced initiate. The many *pentimenti* reveal that Matisse reached this interpretation slowly, gradually paring down the originally fuller, more sensual contours of the woman's body, and eventually choosing to make the nebulous surrounding space fold over her shoulder as if to repossess her. This absorption of the body is no doubt inspired by similar effects in the late portraits of Cézanne, especially those of his wife, and may also represent a measure of response to the challenge of Cubism: the result is a high degree of formal abstraction. But the motive was not abstraction for its own sake, rather the creation of a certain mood of mystery and symbolic resonance, bringing to mind analogies with ancient forms of religious art – archaic Greek sculpture and Byzantine mosaics in particular.

118 Plaster Torso, Bouquet of Flowers 1919

Oil on canvas, 113 × 87
Museu de Arte de São Paulo

This was painted in Matisse's studio in Issy-les-Moulineaux, between visits to Nice, but retains the brilliant, even light that drew him to the south of France. A dialogue is established between the plaster torso balanced precariously on the wooden table and the sketch of a nude pinned on the wall behind, and between them and the boldly printed fabric and the vase of flowers. But this simple formal dialogue between the two-dimensional elements in the background and the three-dimensional forms in the foreground develops into a complex and paradoxical dialogue between concepts of nature and of art. For the nude in the sketch, modelled presumably from life, is posed like an antique crouching Venus, and the plaster cast, which looks more like a limbless version of that Venus, seems more alive, more bursting with energy, than anything else in the picture. (Pierre Matisse, the artist's son, has said that, despite appearances, the torso was not a cast from the antique, but one made from life which Matisse had recently acquired.) The relationship between the fabric and the flowers offers a variation on this same theme: for the fabric is printed with a basket of flowers, and, though an abstraction, has an exuberance and liveliness that at least equals that of the 'natural' flowers arranged artificially in the shapely vase.

In his metaphysical still lifes (such as cat.31), de Chirico created ambiguous backdrops for brutal juxtapositions of the antique and the contemporary, in order to provoke a crisis of confidence in the mind of the spectator. Matisse had seen these pictures, and it is tempting to regard 'Plaster Torso' as his delectable alternative – a hedonistic bacchanal played out by studio paraphernalia, in contrast to the doomed stasis of de Chirico's nightmare visions.

118

119 The Three O'Clock Session

1924

Oil on canvas, 92 × 73
Private Collection

119

This was first reproduced in *L'Art d'Au-jourd'hui* in the summer of 1924, together with the closely related 'Morning Session' (private collection). Both were posed by Henriette Darricarrère who, from 1920 to 1927, was Matisse's favourite model in Nice. A talented young woman with a theatrical presence, she readily assumed different roles and moods in Matisse's paintings. Often he had shown himself painting his model, or his presence had been implicit in the pose of the model presented to the spectator's gaze. Now the model has turned artist, and we are offered an infor-mal, domestic variant of those nineteenth-century academic or realist paintings of the artist's studio.

Henriette is working from a nude model who is posed in academic fashion – offset by a white drape, standing on a raised plinth, and thus approximating to a classical statue. Although the model was her brother, the pose resembles an archaic prototype for that of the 'Venus pudica', and the young man makes an ambiguous, androgynous impres-sion, similar to that of archaic sculptures of youthful male nudes. This lesson in studio practice, this assertion of the value of study from the nude and of the continuing validity of the classical tradition, not only ties in with the ethic of the 'call to order', but appears to be Matisse's answer to those critics who had deplored what they saw as the 'undisciplined' descent into facile impressionism in his Nice work. André Lhote, the influential theorist and teacher, who as a painter worked in an academic Cubist style, had been particularly censor-ious in his review, published in the *Nouvelle Revue Française*, of Matisse's show at the Bernheim-Jeune galleries in 1919: 'His recent works allow us to see him abandoning himself unreservedly to his perceptions. The public loves this nonchalance, seeing in it the reflection and almost the counterpart of its own laziness in thinking and judging.' Matisse himself, at exactly the same period, was emphasising in his own writings his efforts to attain a true 'synthesis' between his response to nature and his desire for 'concentration' and 'expression'. 'The Three O'Clock Session', for all its appear-ance of casual sketchiness, its fresh and natural lighting, and its urbanity, has a most rigorously ordered composition, while the image dramatises the very process of artistic synthesis of which Matisse spoke.

JEAN METZINGER 1883 NANTES – 1956 PARIS

Metzinger began studying painting locally in Nantes in about 1900, and moved to Paris in 1903 following a successful début at the Salon des Indépendants. Thereafter he showed regularly at the Indépendants and the Salon d'Automne, quickly establishing himself as a rising young artist. From the start Metzinger was attracted to styles of an abstract and schematic orientation with a basis in geometry. His arrival in Paris coincided with a renewed vogue for neo-Impressionism, and by 1906 he was painting landscapes and seascapes in the manner of Signac, Cross and Luce – that is in bold, prismatic colours and with paint laid on in large mosaic-like slabs. Metzinger made friends with Robert Delaunay, who was currently painting in a similar style, and the two shared an exhibition at the Galerie Berthe Weill in 1907.

Like so many of his contemporaries, Metzinger was deeply affected by the post-humous retrospective of Cézanne's work held in 1907, and his own paintings began increasingly to show the impact of this new influence. He was taken to Picasso's studio in the Bateau-Lavoir, but it seems to have been via Cézanne that he came to appreciate the early Cubist paintings of Braque and Picasso. By 1909–10 he was himself practising a form of analytical Cubism dependent on their work. Metzinger, however, also associated closely with painters who, unlike Braque and Picasso, exhibited in the annual Salons, and whose work, though Cubist in style, was less abstracted, turning on traditional figurative themes of a classic character. His own work – often 'portraits' of chic contemporary types – became more legible as a consequence of these contacts, and in the spring of 1911 he was one of the principal organisers of the notorious 'Salle 41' at the Salon des Indépendants, which drew public attention for the first time to the existence of Cubism as a prominent force in the Parisian avant-garde. Together with these 'Salon' Cubists – including Gleizes, Le Fauconnier and Léger – Metzinger now began to frequent the studio of the Villon brothers at Puteaux, outside Paris. In this intellectually stimulating environment, in which discussion of philosophy and of parallels between pure science

and mathematics and the new 'pure' painting was common, his own aptitude for theoretical thinking was given full encouragement. He showed with this group in Paris in October 1912 at the Salon de 'La Section d'Or'. (The very title was intended to draw attention simultaneously to the abstract mathematical foundations of Cubism and to the underlying connections with classical and Renaissance systems of composition and spatial organisation.)

Metzinger had written perceptively of the revolutionary 'free, mobile perspective' – or multiple viewpoint – of Cubist painting as early as 1910 (in his 'Note on painting' published in *Pan* in October–November). But his most important text was *Du cubisme*, which he wrote with Gleizes, and which was published in December 1912. This was the first book on Cubism; translations followed rapidly, and it influenced critical discussion of the formal aspects of Cubism for many years to come. Metzinger's own Cubist paintings from this time onwards often display a taste for bold decorative pattern and colour, and employ clearly stated geometrical armatures to articulate their compositions – characteristics which suggest a direct debt to Gris, who emerged as a leading Cubist painter at this time.

After a brief period as a medical orderly at the outbreak of war, Metzinger was invalided out of the service in 1915. He met Léonce Rosenberg who gave him his first one-man show at the Galerie de l'Effort Moderne – a gallery dedicated to the promotion of a rigorously purified synthetic Cubism, aptly termed 'crystal' Cubism. However, in about 1919 Metzinger's paintings became noticeably more naturalistic in response to the current revival of traditional styles: the strict geometrical order of his Cubist compositions was retained, but the debt to the classical tradition which had previously been expressed in abstract terms was now expressed directly. Moreover he often settled on subjects which were currently enjoying great vogue, in particular the *commedia dell'arte* and related circus scenes, so that his work at this time bears close comparison with that of Severini.

Not surprisingly Metzinger's 'conversion' proved controversial: he had, after all,

Portrait of Metzinger by Suzanne Phocas, *c*.1926 (Photo: Musée d'Art Moderne de la Ville de Paris)

been one of the most prominent Cubist painters, and had written of Cubism specifically in terms of its formal 'purity'. In February 1922 Waldemar George was prepared to defend him against the charge of conformism, stating firmly that 'he only makes use of a repertory of recognisable elements . . . in order to make the spectator receptive to his purely constructive intentions', and describing him as 'ardently attached to abstraction in art' (*L'Esprit Nouveau*, no. 15). But the tone of the article betrays anxiety, and Metzinger's work actually became considerably more naturalistic over the next year. Within a short time Metzinger himself was arguing stoutly that an outer garb of 'realism' in art was not incompatible with formal 'purity', and implying that this new realism was to be identified with the latest phase of Cubism:

> It is now possible to go to the extreme limits of realism without falsifying the initial harmony. . . . In Cubism, which is now in evolution, our attention will be less concerned with the exterior object, and the model, than with the ensemble of forms and colours which constitute a

painting. . . . The difference which separates this sort of painting from classical painting is however much less than would appear. All true artists always attempt to construct an interior and classic vision which is based on an exclusively classic order.' (*Bulletin de l'Effort Moderne*, 1 December 1924)

Metzinger found the ideal model for this marriage of the realist, the classic and the pure in the work of Léger, and from the mid-1920s until the end of the decade his work showed clear signs of Léger's influence. He introduced the popular imagery of modern life, such as railway stations, factories, ports and sportsmen, and brashly up-to-date objects re-entered his still lifes. His works of the late 1920s often have a bizarre and exotic character thanks to unexpected juxtapositions between, say, nautical instruments, classical statues and chunks of quartz, prompting the question whether Metzinger were now trying to come to terms with the metaphysical paintings of de Chirico. In general, however, the streamlining and stereotyping of the figures and objects, outlined in thick firm contours, and the emphasis on basic geometric forms and on regular patterns, give these paintings of the mid- and late twenties an Art Deco character. They demonstrate, indeed, how the 'call to order' ethic could, in the hands of certain artists, accommodate a popular, decorative style, and remind us of the vital role played by the decorative arts – in particular design for the theatre – in the spread of the movement as a whole.

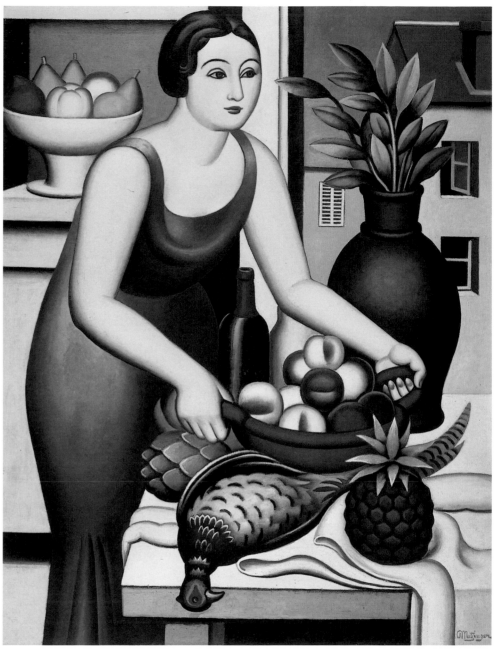

120

120 Woman with a Pheasant
1926

Oil on canvas, 116 × 89
Rijksmuseum Kröller-Müller, Otterlo

This was first reproduced in Léonce Rosenberg's *Bulletin de l'Effort Moderne* on 23 March 1926, having presumably just been completed. (Metzinger had been associated with Rosenberg since 1915, and wrote regularly for the *Bulletin* between 1923 and 1927.) It is a good example of the fusion of contemporary subject matter and the classical tradition which was currently fashionable in French and Italian painting, and which Metzinger had practised in his figure paintings since the early 1920s. The woman has an up-to-date dress and hair-style; she appears to be in a modern kitchen, and through the window we see a modern house.

Yet she also has the statuesque form and the generalised features of a 'classical' type, and, associated with the ripe fruits, the artichoke, the wine, the pheasant and the jar of laurel leaves, she becomes a personification of natural fertility – a domestic, modern equivalent of Pomona, perhaps. (The similarity with Socrate's 'Girl Carrying Fruit', cat. 168, is striking.)

Metzinger's sources are, appropriately, both modern and traditional. In about 1929 he painted a still life entitled 'Homage to Léger', and Léger's influence on this painting is obvious: in the stereotyped inexpressive face, the ample solid body, the firm

contouring and simplified modelling, the high mechanical finish, the geometrically ordered and lucid composition, and the theme of woman as a symbol of peace and plenty. Among sources from the classical tradition one could cite Poussin (a detail from, say, 'Eleazer and Rebecca at the Well', Louvre), Ingres (the great female portraits of the 1840s and 1850s), and Seurat ('Woman Powdering Herself', Courtauld Institute of Art, London). All these artists were much admired in 'call to order' circles, and were featured in illustrated articles in *L'Esprit Nouveau* in the early 1920s.

JOAN MIRÓ 1893 BARCELONA – 1983 MALLORCA

Miró is generally identified with Surrealism, but his early paintings must be understood in the context of Catalan Noucentisme, a movement which developed around the critic Eugeni d'Ors in about 1906, and had close connections with the classical revival then dominant in the Parisian avant-garde.

Although Miró had begun attending drawing classes at the La Llotja school of art in Barcelona in 1907, he was training for a career in commerce when he suffered a serious breakdown in health. Following his recuperation at his parents' newly acquired farm near Montroig, in Tarragona, his father's opposition to his desire to be a painter gave way, and in 1912 Miró enrolled in the art school run by Francesc Galí in Barcelona, remaining there until 1915. Simultaneously he attended the drawing classes at the Cercle Artístic de Sant Lluc, exhibiting with this group at the Sala Parés for the first time in 1913. Galí taught Miró to draw by touch with his eyes closed, and took him on painting trips into the surrounding mountains and villages. The family farm, the Catalan landscape and the local peasant way of life directly inspired many of Miró's early 'realist' paintings. Noucentisme was committed to Catalan nationalism in politics as well as in art, and a letter Miró wrote to the painter Enric Ricart in January 1915 shows how ardently he then subscribed to this ideology: 'Let us . . . valiantly continue our task of a truly Catalan Renaissance, truly a child of this Catalonia so chastised by the men of Iberia.'

In 1916 Miró met Josep Dalmau, who gave him his first one-man exhibition two years later. Dalmau's gallery, founded in 1906, was the focus of avant-garde activity in Barcelona, and there Miró was able to see not only exhibitions of French post-Impressionist and Cubist painting, but also the latest Parisian art reviews, such as *Les Soirées de Paris*, *SIC* and *Nord–Sud*. These introduced him to the poetry of Apollinaire, Reverdy and Whitman, among others, and thereafter poetry remained a significant stimulus for him. Through Dalmau, Miró met Picabia, who stopped long enough in Barcelona in 1917 to publish an issue of his Dada periodical *391*. Thus although Miró did not go abroad until 1920, and had still

not even been to Madrid, he was fully acquainted with the latest developments in contemporary art.

From the summer of 1918 onwards Miró began to spend longer periods painting in Montroig. The result was a sequence of highly detailed landscapes culminating in the masterpiece 'The Farm', 1921–2, which was bought by Ernest Hemingway (now in the National Gallery of Art, Washington). In the spring of 1920 Miró made his first trip to Paris. He visited Picasso, attended classes at La Grande Chaumière, studied in the museums, and was present at the notorious Dada *soirée* at the Salle Gaveau. In 1921, on a second visit to Paris, he took over Gargallo's studio in the rue Blomet, where he was a neighbour of Masson, and met Pierre Reverdy, Max Jacob, and Tristan Tzara, mastermind of the Dada movement. Dalmau organised an exhibition of Miró's work at the Galerie La Licorne that April. The catalogue had a preface by the leading critic Maurice Raynal, and the show effectively launched Miró in the Parisian art world. Henceforward he would divide his time between Paris and Montroig. Although his work in the early 1920s retained an essentially realist iconography which has much in common with that of other Catalan artists whom he knew, including Manolo and Sunyer, in style it showed unequivocal signs of his response to Cubism, Dada and abstract art, without ever being dependent upon these sources. For Miró was by then thoroughly disenchanted with the conservatism of the Noucentista ideology as expounded by d'Ors, and was determined to express his sense of his Catalan identity in terms of a recognisably avant-garde style. In his own words, he thought of himself as an 'international Catalan'.

Through his friendship with writers who were active in the newly formed Surrealist group – Robert Desnos, Michel Leiris, Antonin Artaud, Georges Limbour – Miró eventually met André Breton and Paul Eluard in 1924, and was drawn into the orbit of the movement. However, despite his prominence as a painter in the group – his work was featured in *La Révolution Surréaliste* and in exhibitions of Surrealist painting – he never signed their manifestos

The artist, *c*.1931

or submitted unreservedly to Surrealist ideology, and in 1928–9 he became estranged from Breton following the expulsion from the group of such close friends as Leiris, Desnos and Masson. Moreover, Miró's links with Catalonia always remained strong, and the paintings he produced on his annual visits to Montroig in the late 1920s revealed a continuing preoccupation with the Mediterranean landscape and the peasant way of life. In his 'surrealism' the 'real' remained a significant presence, although the means of expression were poetic, allusive and emblematic.

121

121 Vegetable Garden with Donkey 1918

Oil on canvas, 64 × 70
Moderna Museet, Stockholm

This is one of four paintings on which Miró worked during the summer of 1918 when he was staying at his family's farm near Montroig. All of them depict local places, and are rendered with meticulous and loving attention to detail. All four were shown at the Municipal Exhibition of Art in Barcelona in the summer of 1919 in a small room set apart for the 'Agrupacío Courbet', a defiantly avant-garde group which Miró and his friend Ricart had recently helped to found, in order 'to step over all the rotting bodies and corpses' (of more conservative factions) – as Miró put it in a contemporary letter.

Miró's letters written from Montroig in the summer of 1918, while he was working on these canvases, give a vivid account of his intentions: 'No simplifications or abstractions, my friend. Right now what interests me most is the calligraphy of a tree or a rooftop, leaf by leaf, twig by twig, blade of grass by blade of grass, tile by tile.' He noted, however, that the paintings might well end up being 'Cubist or wildly synthetic' – a reference to his commitment to the typical and the universal, and his hostility to the ephemerality of Impressionism. (Letter to Ricart, 16 July 1918) The synthetic character of 'Vegetable Garden with Donkey' is indeed pronounced – felt especially in the strong sense of pattern and overall rhythm, as well as in the highly schematic treatment of details like the vegetables sprouting in neat rows and the clouds strung like awning across the sky.

In a slightly later letter to Ràfols, dated 11 August 1918, Miró elaborates on his search for a 'classical' synthesis in his art, which must none the less be rooted in the close study of nature: 'I feel the need for great classicism more every day . . . that is what we should strive for – classicism in everything. I consider those who are not strong enough to work from nature to be sick spirits and I refuse to believe in them.' These ideas echo distantly some of the famous sayings of Cézanne, whom Miró, like other Noucentista artists, admired enormously. 'Vegetable Garden with Donkey' is Cézannesque in its centralised frontal composition and its raking view. But the wilful naïveté of the painting speaks more directly of Miró's response to the blend of poetry and meticulousness in the work of the Douanier Rousseau, a painter to whom he remained devoted throughout his life. But although this picture owes much to French painting, it is also marked by Miró's admiration for his compatriot, Sunyer, who had been somewhat of a mentor to him, and whose 'Pastoral' of 1910–11 (cat.169) had been hailed in Barcelona as the epitome of true modern classicism.

122 Montroig, the Church and the Village 1919

Oil on canvas, 73 × 61
Private Collection

This painting was begun in the summer or autumn of 1918, but abandoned unfinished because of the threat of the deadly Spanish influenza epidemic then ravaging the town. Miró took it up again when he returned to Montroig in July 1919, as a letter to Ricart makes clear. In this letter, dated 9 July, Miró insists that health and potency in art depend on painting from real life, and photographs taken from the same position of the view up towards the village prove how painstakingly he had studied the scene before him in order to capture as precisely as possible the spirit of the place. In a letter to Ràfols a month later he writes of his efforts to simplify and synthesise the picture, 'in order to reach a balance', and on 21 August expresses himself pleased with it. The relative abstraction of the foreground – paradoxically much less detailed than the buildings in the background – was no doubt the result of these efforts to 'synthesise'. The finishing touches to the picture were added in the autumn, and it was first exhibited at the Salon d'Automne in Paris in 1920, in a special section devoted to modern Catalan art.

As in the previous year, in 1919 Miró wrote of the need to 'move towards classicism', but not the classicism of academic imitation – not 'the sick sermons of Torres-García'. (Torres-García, a friend of d'Ors and an influential figure in the Barcelona art world, had been an exponent of a form of neoclassicism based closely on the example of the murals of Puvis de Chavannes.) The new classicism must, Miró says, be 'completely free'. 'Remember how I told you that we had to get to *classicism* via *Cubism* and to a *pure* art' (Miró's emphasis). In the same

[189]

letter he mentions Cézanne, 'our great pre-
cursor', and we find strong indications of
Miró's attentive appreciation of Cézanne's
methods of pictorial construction and his
treatment of space. Like Cézanne he piles
the landscape elements vertically upwards
towards the top of the canvas, preventing
recession by adopting a very high horizon,
flattening the sky, and emphasising the
contours of the silhouetted buildings. This
kind of composition is, of course, also
typical of early Cubist landscapes by Picasso
and Braque, such as those Picasso painted in
Horta in 1909. Miró knew these paintings,
and would surely have appreciated their
subject matter, and it is significant that in
the letter to Ricart in which he announced
that he had resumed work on 'Montroig, the
Church and the Village', he spoke of 'the
great Picasso' as the incarnation of 'a true
modern classicism'. Yet Miró's painting is a
pastiche neither of Cézanne nor of Cubism.
The obsessive interest in intricate detail, the
Persian-style delight in the abstract patterns
he has discovered in the natural scene from
his prolonged contemplation of it, and the
involvement in the play of dancing lines,
have no equivalent in either, and derive in
part at least from his knowledge of recent
Catalan art: one source may possibly be the
renowned Symbolist landscape painter Mir.

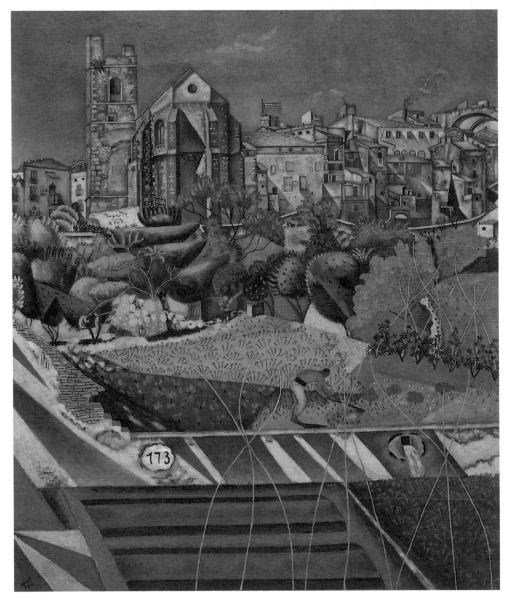

122

GIORGIO MORANDI 1890 BOLOGNA – 1964 BOLOGNA

One of the leading artists of the Italian 'return to order', Morandi became known at home and abroad for his dedication to the classical values of order and harmony in his painting. He shunned all types of archaism, or imitation of the styles and subject matter of earlier art, and focused instead on developing the formal legacy of the work of artists such as Chardin and Cézanne. Morandi's paintings combine a restraint and a delicacy which contemporary commentators attributed to a retiring and ascetic quality in the artist's personality. The writer and critic Ardengo Soffici, who had been one of the leading champions of the revival of interest in the classical tradition in the years before the First World War, was typical in presenting Morandi as a classical artist in both style and spirit when he wrote: 'The Bolognese painter Giorgio Morandi is an artist of strong, severe spiritual culture, with a gentle poetic soul, sustained by great integrity and by noble disinterestedness. . . . his painting – just like that of the ancients, and, indeed of all true masters of every period – is a mirror of the soul which reflects in turn the world' (*L'Italiano*, March 1932). Recent research, however, has shown that Morandi was very much aware of, and engaged in, the debates surrounding the modern art of his day.

Morandi's first and decisive encounter with avant-garde art came in 1909 when, as a student at the Accademia delle Belle Arti in Bologna, he came across a copy of *Gli impressionisti francesi* by Vittorio Pica in which there were many reproductions of paintings by Cézanne. In the same period he read articles by Ardengo Soffici in the Florentine intellectual journal *La Voce*, which voiced a number of the themes that were to be central in the renewal of interest in the classical tradition. Soffici stressed the extent to which Cézanne had reacted against the formlessness of the Impressionists and suggested – and this was a theme later much developed by Italian critics – that his search for the eternal values of 'pure' painting was in the tradition of the Italian Quattrocento. When Morandi visited Florence for the first time in 1910 and admired the frescoes of Giotto, Masaccio and Uccello, he did so with an eye very much influenced by the

paintings of Cézanne and by the idea of 'pure' form.

Before the war Bologna was a relatively quiet provincial city, but Morandi was able to keep abreast of the latest artistic currents by studying reproductions of contemporary art and visiting exhibitions. He was also friends with a number of young Bolognese writers who were involved in the intellectual and literary debates which were a motivating force behind the Italian 'return to order'. In 1913 he exhibited at the second Secessione Romana where he would have been able to see paintings by Matisse and Cézanne, and it seems that this may have provided the inspiration for his Cézannesque landscapes of that year. In Rome Morandi met many of the leading Italian Futurists and he exhibited alongside them in 1914. Their cult of dynamism and speed had little appeal for him, but he was interested in their analysis of pictorial form, and, on the eve of the First World War, he practised a type of Cubo-Futurism.

Morandi was called up in 1915, but severe ill-health soon led to his discharge, and the remaining years of the war were a period of reflection for him. He destroyed many of his paintings from this time, but what survives shows a stylised, flattening treatment of form and space in a manner influenced by Cubism and primitive art. Some still-life paintings of 1916–17, in particular, suggest the influence of the French naïf painter Douanier Rousseau, then much fêted in French avant-garde circles. Painted with little or no modelling and shadow, these simple flower pieces and table-top scenes show Morandi's interest in anti-naturalism, and have an almost visionary quality.

In the last year of the war Morandi painted the extraordinary series of still lifes which established him as one of the leading artists of the post-war period. By this time he would have been acquainted with the ideas of metaphysical painting, and it seems likely that his use of the disturbing imagery of dressmakers' dummy heads reflected his awareness of the mannequin paintings of de Chirico and Carrà. Yet Morandi's work remained distinct from that of the founders of the 'metaphysical school' and leading

The artist, photographed by Herbert List (Photo: Archivio e Centro Studi Giorgio Morandi, Galleria d'Arte Moderna, Bologna)

figures in the Italian 'return to order' movement, and the magical atmosphere of his works appears to have been less a goal in itself than a product of his interest at this time in geometrical composition isolated from the usual constraints of narrative and logic. Morandi later said that his paintings of this period were 'pure still-life compositions and never suggest any metaphysical, surrealist, psychological or literary considerations at all. My milliners' dummies, for instance, are objects like others and have not been selected to suggest symbolical representations of human beings' (E. Roditi, *Dialogues in Art*, London, 1960).

Morandi established personal contacts with members of the *Valori Plastici* group in the late summer of 1919. On a brief trip to Rome he met de Chirico, who was then obsessed with the importance of studying museum art (see cat. 32). Although study of the old masters was very much part of the academic training that both artists had received, it is perhaps no coincidence that shortly after this meeting with de Chirico, Morandi is known to have copied works – in particular, a portrait by Raphael – in the art gallery of Bologna. Carrà, who was curious about a painter whose work he had seen only

in reproduction, visited Morandi at his
studio in Bologna, and came away
impressed by an artist whom he recognised
to be following a similar path. At the end of
1919 Morandi signed a contract with Mario
Broglio, the editor of *Valori Plastici*, who
became his first important collector.
Morandi's works were illustrated in the
magazine and were included in the group's
major exhibitions, including the famous
tour of major German cities in 1921 which
had a great impact on what was to become
the Neue Sachlichkeit movement.

It was one of the features of Morandi's
career that just as he was becoming known
for one particular style or subject matter he
would strike out in a new direction.
Although he continued to be associated with
the *Valori Plastici* group until its demise in
1922, his painting style changed dramati-
cally in 1920–21. In place of the clear
outlines and pale colours of the immediate
post-war works, his compositions were
marked by a new naturalism and use of
everyday objects. The imagery of these
paintings – fluted glasses, curved vases,
crumpled napkins and knives resting on the
edges of table-tops – spoke of his renewed
interest in Cézanne (Morandi travelled to
Venice to see a retrospective of the latter's
works at the Biennale of 1920). This phase
was accompanied by an increasingly dark
tonality and misty atmosphere which
seemed partly to dissolve the outlines of the
objects in his still lifes. With Cézanne, the
mentors of this new phase in his work were
Chardin, and Corot in his Italian period.

Morandi was sympathetic to the Fascist
party, certainly throughout most of the
1920s, but had no interest in the nationalist
ideology or type of classicism championed
by Margherita Sarfatti and the Novecento
movement; and, in a sense, the intimacy and
non-declamatory purity of his work can be
seen as being opposed to the ethos of the
regime. However, like many of the leading
artists of his generation he exhibited works
in the *Novecento Italiano* exhibitions of 1926
(at which Mussolini bought one of his still
lifes) and of 1929. His landscape paintings
of the late 1920s, which rigorously excluded
any signs of modern life, were much praised
by writers associated with the *strapaese*
movement which, although distinct from
Fascism, was politically conservative and
celebrated the regional and rural traditions
of Italy. Although it is far from clear to what
extent, if any, Morandi shared the ideals of
this movement, the support of writers such
as Mino Maccari ('the art of Morandi is an

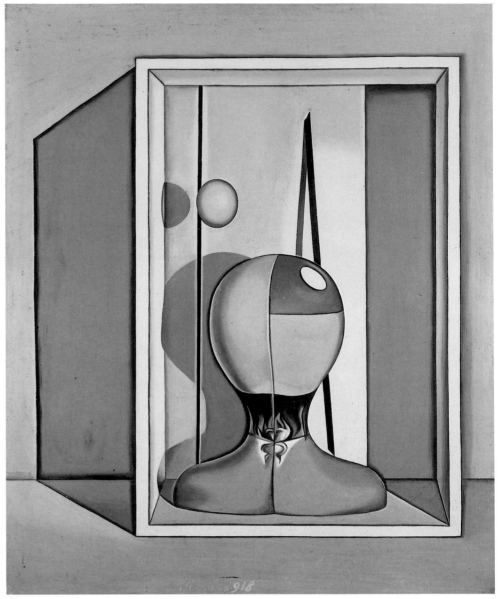

123

extremely Italian form of art, which is deeply rooted in our traditions', *Il Resto del Carlino*, 8 June 1928) served to underline Morandi's position as a major Italian artist in the inter-war years.

Morandi had worked since 1914 as a teacher of drawing in the primary schools of Bologna, but in 1930 he was given the chair of printmaking at the art school in Bologna, a post he was to hold until 1956. Throughout his life he shunned publicity, and was later to claim that the quiet life he led in Bologna brought its own advantages, certainly in the years between the wars. 'When most Italian artists of my generation were afraid to be too "modern" or "international" and not "national" or "imperial" enough, I was left in peace,' he said, 'perhaps because I demanded so little recognition. In the eyes of the Grand Inquisitors of Italian art, I remained but a provincial professor of etching at the Fine Arts Academy of Bologna' (*Dialogues in Art*, London, 1960). However planned or accidental was his reputation as a reclusive figure, Morandi remained very much in touch with both national and international developments in art, which were expressed in subtle changes in the still lifes and landscapes, the staple themes of his œuvre.

123 Still Life 1918

Oil on canvas, 71.5 × 61.5
Hermitage Museum, Leningrad

This is one of the series of still-life paintings executed in 1918 which marked Morandi's emergence as a leading artist in the new Italian 'return to order' movement. The clarity and geometry of these works struck contemporary observers as proof of a classical restraint and concern with rule and order; and from the evidence of the first article to be devoted to him it seems that Morandi also viewed his work in this way. The article was written by Riccardo Bacchelli, who was an active figure in the circle of writers associated with the Bolognese intellectual review *La Raccolta*, in which many of the ideas of the new artistic climate in Italy were aired at the end of the war. He was also a friend of Morandi, and it seems likely that his review reflected the artist's own understanding of his painting. In this article, which was published in March 1918,

Bacchelli announced that Morandi's art, 'frankly modern, has refound classical values':

his sensibility is not artificial or forced, but is restrained and disciplined, and consists of a certain bareness and desolation, with dry colours, and an atmosphere that shows no concern for light but only forms and colours. . . . [Morandi] portrays each object with the impartiality of Chardin, but his painting has a very different character. He uses the round or oblong forms of trays, undulating porcelain, curling wooden frames, clocks, bottles and jugs, which scattered, spaced out or together, form one unit on opaque, uniform backgrounds. (*Il Tempo*)

Like nearly all later writers, this critic emphasised the formal purity and austere character of Morandi's works. Bathed in a hyper-real light, with seemingly no element of autobiography, narrative or symbolism, Morandi's imagery of bottles, scrolls and rubber or leather-like mannequin heads seemed remote from the romantic expressiveness of the paintings of de Chirico or Carrà. Yet Morandi certainly knew of their works, at least from reproductions, and this still life incorporates certain hallmarks of metaphysical painting: the unexplained conjunction of objects, for example, and the exaggerated use of perspective, which both affirm the three-dimensional existence of the objects and, at the same time, make the scene appear unnatural, were devices used by de Chirico in his pre-war paintings. Writing on a related still life of 1918, the critic Raffaello Franchi stressed that, although allied in some respects to metaphysical painting, Morandi's work was essentially quite different: 'the objects are presented with primitive simplicity, without the painting being in any sense metaphysical. They have all the charm of an apparition, such is the harmony of the composition, and so well concealed is the art behind this harmony. Criticism is disarmed before such beauty' (*Valori Plastici*, April–May 1919). However, de Chirico, Carrà and the dealer and editor Mario Broglio had no difficulty in recognising Morandi as a major contributor to the new type of classical art they sought to promote. The issue of the magazine in which the Morandi still life of 1918 was reproduced was the first number to be devoted to metaphysical art, with important texts by de Chirico, Carrà and Savinio, and this confirmed Morandi as a key figure in the group.

124 Still Life 1921

Oil on canvas, 44.7 × 52.8
Museum Ludwig, Cologne

In 1920 Morandi visited the major retrospective of Cézanne's work held at the Venice Biennale. Before the war Morandi, like many artists, had been fascinated by Cézanne's stylised treatment of form and space, but afterwards he became attracted by the naturalistic qualities of the work of the French master. His new works of 1920–21 focused on everyday objects, and had a more serene atmosphere based on delicate tonalities and colour harmonies.

Many themes are brought together in this still life of 1921. Although Morandi shunned all forms of archaism in art, the dominant terracotta colour together with the presence of the classical amphora suggest a reference to the art of the ancient world, while the curious half-dissolution of the amphora hints, perhaps, at a sense of the passage of time. At the same time the painting has a magical atmosphere, like many of his immediately post-war works.

Morandi's new preoccupation with tonality and subject matter may have replaced the hard outlines and bright light of his earlier works, but he was still regarded at this time as a major figure in the *Valori Plastici* group. In the catalogue of the Florentine Primaverile of 1922 in which the artists of *Valori Plastici* exhibited together, de Chirico noted Morandi's technical competence and vision of what he called the eternal qualities of everyday objects, and described these as the essential attributes of a classical artist. Morandi, he wrote:

mixes his colours, prepares his canvases, and looks at the objects that surround him, from his sacred palette, dark with thick cracks like an ancient rock, to the clean forms of his cups and bottles. He looks at a group of objects on a table with the same emotion that struck the heart of an Ancient Greek traveller when he gazed at woods, valleys and mountains which were held to be the haunts of the most beautiful and strange divinities.

He looks with the eye of a man who believes; and the skeleton that lies within these things that seem to us to be dead because they are immobile, appears to him in its most consoling aspect: in its eternal aspect.

In this way he partakes of that great lyricism that was sought by the last profound phase of European art: *the metaphysics of the commonest objects.*

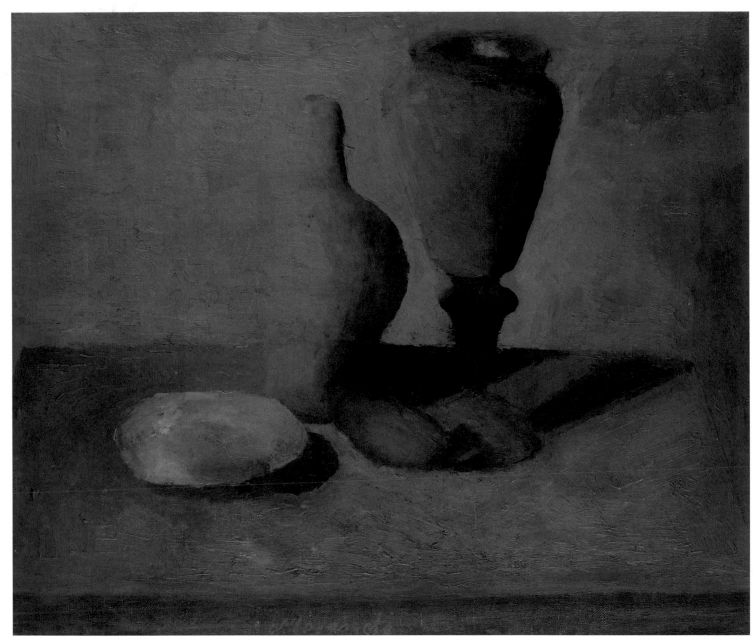

124

De Chirico had made the transition from a metaphysical to a new form of classical art which combined a sense of the potential strangeness of ordinary objects with a new respect for pictorial technique, and saw Morandi as having followed a similar path. For de Chirico, Morandi's preoccupation with colour tonalities and an atmospheric handling of form and light were signs of the new classicism of his work.

UBALDO OPPI 1889 BOLOGNA – 1942 VICENZA

Oppi was among the most highly regarded artists of the Novecento movement in the 1920s, and produced some striking reinterpretations of classical themes in a modern vein. His fame, however, was short-lived, and it is only in recent years, with the reassessment of this period in Italian art, that his work has been re-evaluated.

Oppi was sent by his family to Vienna to study for a career in business, but while there, in 1907, he took courses in life drawing and in anatomy. A critic named Ugo Ojetti later claimed that Oppi had been a pupil of Gustav Klimt, one of the leading artists of the Viennese Secession. Whether or not this was the case, it is true that Oppi's pre-war works were marked by a stylised, linear treatment of form that closely resembles that of Secessionist art. After travelling around Eastern Europe, Oppi stayed in Venice in 1910, where he exhibited at the Ca' Pesaro. He moved to Paris in 1911 and met other Italian artists such as Severini and Modigliani; and in 1913 and 1914 he exhibited at the Galerie Paul Guillaume. He became nostalgic for Italy and its art, and regularly visited the Trecento and Quattrocento holdings at the Louvre. He later explained that his discovery of 'the men of the Quattrocento' marked the beginning of a new spiritual life for him: 'Paris, with the Louvre, compensated me for my spiritual bewilderment and my indifference to all the *isms*, by revealing to me my humanity and my homeland' (letter to Edoardo Persico, *c*.1930, *Il 'Novecento' milanese*, Galleria Arco Farnese, Rome, 1987).

Oppi served in the Italian army during the war as an officer in the Alpine Corps, and spent a few months as a prisoner in Mauthausen in Germany. Here he executed drawings and watercolours of thin, elongated figures in a manner which recalled both German Gothic and Sienese art of the early Renaissance. He returned to Paris in 1921, exhibiting in the Salon des Indépendants and the following year in the Salon d'Automne. Once again he frequented the Italian rooms of the Louvre, showing no interest in contemporary French avant-garde art. His works of the period were notable for their linearism and clarity, and invite comparison with the 'objectivity' of

German Neue Sachlichkeit artists such as Otto Dix and Georg Schrimpf; but it seems likely that his debt was not to them but to the 'return to order' movement in Italy, with its re-evaluation of early Renaissance artists such as Piero della Francesca, Giotto and Masaccio.

Oppi returned to Italy in late 1921, and quickly came to the attention of Margherita Sarfatti, who was trying to organise a group of artists whose work expressed what she saw as the new cultural and political spirit of the times. In 1923 Oppi exhibited alongside painters such as Funi and Sironi in the first group show of the movement, *Sette pittori del Novecento*, held at the Galleria Lino Pesaro in Milan. However, Oppi broke ranks with the group in the following year, accepting the offer of a one-man exhibition at the Venice Biennale of 1924.

The critic Ugo Ojetti, who for some years had been associated with nationalist calls for a reappraisal of the Italian tradition, wrote a text for the catalogue. In this he praised the technical qualities of Oppi's works and their expression of warm, simple emotions in a language accessible to all: 'Here is an art which takes truth as its starting point, but which dominates, selects, and orders it to create something that is more lasting and reassuring than fleeting reality.' Oppi's success continued when he won second prize in 1925 at the Carnegie Institute, Pittsburgh.

Despite his earlier 'betrayal', Oppi was included in the first *Mostra del Novecento Italiano* held in Milan in 1926. However, the mid-1920s saw him moving away from his Renaissance-inspired linear manner towards a more polished style, reminiscent of Ingres. He became less interested in reconciling tradition and modernity, and focused increasingly on fashionable society portraits. In 1926 he was at the centre of an acrimonious controversy when it was discovered that he had copied the figure in a painting, which an important Milan public collection had agreed to buy for a large sum, from a turn-of-the-century manual of academic art. There was nothing new in a painter using photographs as a basis for his compositions, but Oppi was accused by his detractors of practising a sterile *pompier*

The artist painting a fresco, *c*.1930

style, and he finally withdrew the work.

In the same period Oppi turned to Catholicism, and was soon concentrating almost exclusively on sacred themes and commissions for church decorations. Oppi himself interpreted his return to religion as a logical culmination of his engagement with the classical tradition in art. As he wrote in the catalogue of his exhibition at the Galleria del Milione in Milan in 1930, 'Spiritual waverings and doubts, and the spectacle of contemporary art and life, made me realise that it was necessary to live on a moral plane where every action and thought could be controlled by divine laws.' He exhibited regularly at the Venice Biennale until 1932, but thereafter became less and less interested in modern art and led an increasingly isolated life.

125 Portrait of the Artist with his Wife (The Double Portrait) 1920

Oil on canvas, 110.5 × 90.5
Private Collection

This is one of Oppi's most remarkable works, not least because, despite its obvious debt to the Renaissance, it was painted outside Italy and at a time when the 'return to order', with its reappraisal of such early masters as Cosimo Tura and Piero della Francesa, was barely under way. It is one of the first works executed by Oppi following his return to Paris after the war, and the inscription in French on the back of the canvas, 'Le double portrait', suggests that he may have intended it for the Salon des Indépendants exhibition of 1921, although it does not appear in the catalogue.

The pure light, warm colours, simple forms and architectural composition of this painting are strongly reminiscent of the Italian masters of the Quattrocento, and in particular, perhaps, of Piero della Francesca. The profile portrait of the wife, with her strangely unemotional gaze, seems directly inspired by similar representations by mid- to late-fifteenth-century Tuscan artists (the idea of a 'double portrait' might be an echo of Piero della Francesca's famous panels of Federigo da Montefeltro and his wife). In an article of 1924 in *Daedalo*, Ugo Ojetti underlined Oppi's debt to the Renaissance, writing, 'The brushwork is always smooth and hidden, as it was, except in Venice, until well into the sixteenth century, and gives these unvarnished canvases a suggestion of tempera or fresco'. However, the pose of the artist, his disproportionate size, and the fact that the figure of the wife appears superimposed upon the scene, gives the picture a modern, almost surreal, quality.

Oppi included in this work elements which were characteristic of Novecento art. The earthenware jug in the corner of the room, for example, is a motif which first appeared in his work in 1918; but, with its timeless appearance and function, and suggestion of continuity between ancient and modern times, it was used by many

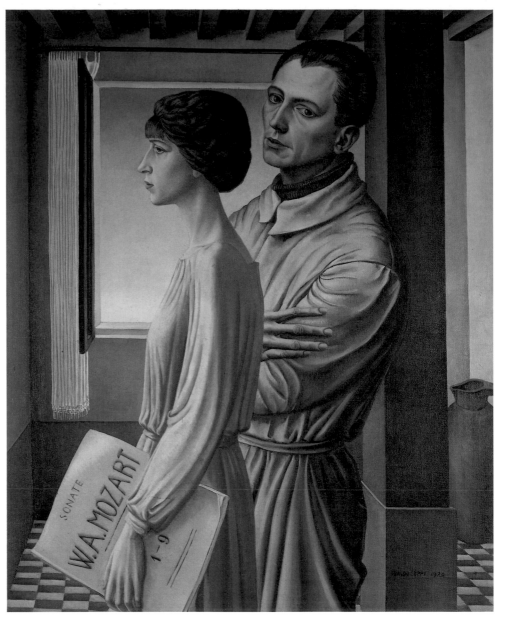

125

Italian artists in the early 1920s. The reference to Mozart in the music score carried by Oppi's wife can be seen as suggesting a parallel between the abstract harmonies of music and the search for order and structure in painting; the evocation of the classical purity and deceptive simplicity of Mozart's piano sonatas is particularly apposite in this highly structured work.

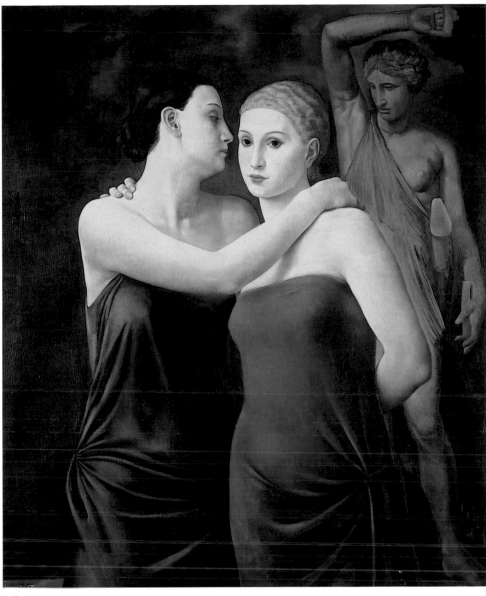

126

126 The Friends 1924

Oil on canvas, 129.5 × 101
Private Collection

This painting is one of the best known and most accomplished of Oppi's works of the period. It was included in the artist's one-man exhibition at the Venice Biennale in 1924 and was reproduced in Franz Roh's account of 'magic realism' in *Nach-Expressionismus* of 1925.

In 1924 Oppi began to adopt an overtly museum-based style, rich in quotations from the works of the old masters. The references here, with the intertwining of the bodies, the use of the bent arm as a rhythmic motif, and the dramatic colouring, are chiefly to the Mannerist painters of the late Renaissance, and in particular, perhaps, to Pontormo. The statue in the background, with its obvious allusion to the contemporary revival of interest in classicism, is based on the Mattei Amazon sculpture.

Contemporary critics either praised or criticised Oppi's homage to tradition, but tended to pass over the essential modernity of his work, with its almost surreal assemblage of quotations of style and subject matter from different movements of past art. The draped female figures with their marble-like flesh and air of immobility recall old master paintings, but their clothes, gathered at the hip, suggest a 1920s style of dress. The juxtaposition of living figures with antique statues, with the attendant connotations of dislocation and nostalgia, was a theme associated with de Chirico, and, in different ways, with Sironi and Casorati; but in this stylish rendition of the theme, Oppi has combined an air of mystery and suspense with a sensuality rare in the new classicism of the period.

AMÉDÉE OZENFANT 1886 SAINT-QUENTIN – 1966 CANNES

Ozenfant, with Jeanneret (Le Corbusier), was the founder of the Purist movement, and an extremely influential figure in the Parisian avant-garde between the wars. He was not only an active painter, but a prolific writer, an efficient and tireless editor, and an energetic teacher.

After attending drawing classes in Saint-Quentin, Ozenfant went to Paris to study decorative art in 1905. Within two years he had moved to the Académie de La Palette, where his master was Jacques-Emile Blanche. He began exhibiting at the Salon de la Société Nationale des Beaux-Arts in 1908, and in 1910 at the Salon d'Automne. Meanwhile he travelled widely abroad – to Holland, several times to Russia, and in 1912 to Italy, where he visited all the major art centres. He read voraciously, in literature, philosophy and the sciences, attended Poincaré's lectures at the Collège de France, studied the history of music, and made repeated visits to the museums in Paris, where he was especially attracted to Egyptian and Greek art, and to such painters as Poussin, Claude, Chardin, Ingres and Corot. All this gave him an impressively broad general culture, which provided the foundation of his later, notably erudite, theoretical writings and art criticism.

It was not until the war, however, that Ozenfant entered the milieu of the avant-garde: in April 1915 he founded an art review called *L'Elan*, the purpose of which was to provide a link between writers and painters who had been mobilised and those who had not. His editorial activities brought him many new contacts among the Cubists, and he became particularly close to Gris and Severini, who shared his philosophical turn of mind. In the final issue of *L'Elan* (December 1916), he published a text on Cubism which contains the germ of the Purist aesthetic: there, for example, Cubism is castigated for its lack of precise rules, although it is identified as a 'movement of purism'. A crucial event was his meeting, sometime towards the end of 1917, with Jeanneret. From their friendship and collaboration the Purist movement developed, and it was Ozenfant who encouraged Jeanneret to take up painting. In November 1918 they published, under their joint sig-

natures, *Après le cubisme*, and the following month they held their first joint exhibition of painting.

Après le cubisme was the founding manifesto of Purism, and its title alone indicates the authors' conviction that Cubism belonged to a past age. The term Purism was carefully chosen, signifying that the post-war world required a new moral order and that the new art must play a significant part in the necessary process of purification. In line with their Neoplatonic, Enlightenment philosophy, they criticised what they regarded as the free-wheeling, instinctive and over-decorative character of Cubism, and proposed instead an art constructed on strict and rational laws; an art in which composition and form would be primary, colour secondary; an ordered and harmonious art of universal validity. The work of art, they wrote, 'must not be exceptional, impressionist, inorganic, picturesque, but on the contrary generalised, static, expressive of the invariable.' Their paintings of 1918–19 are clearly indebted to Cubism, but are noticeably simpler and more legible, and are executed in a dry and 'mechanical' manner.

The first number of *L'Esprit Nouveau* appeared in October 1920. Initially under the direction of the poet Paul Dermée, it was soon taken over by Ozenfant and Jeanneret, and became an avant-garde review of international significance, disseminating the Purists' formalist aesthetic and publishing hundreds of illustrated articles on a variety of subjects, all viewed from their 'call to order' standpoint. Among the most important articles, in the context of the present exhibition, are those devoted to contemporary artists such as Braque, Picasso, Léger, Derain and Gris, to recently dead masters such as Seurat and Cézanne, and to the classical tradition of European art – Greek pottery, Roman mosaics, Fouquet, the Le Nain brothers, Poussin, Corot and Ingres are among the featured subjects.

For the Purists, as for many of their avant-garde contemporaries, a return to the classical 'constants' – a catchword of theirs – was synonymous with a return to the purity of the primitive, and through a judicious selection of photographs they

The artist (left) with Jeanneret in a hot-air balloon, *c*.1921

liked to draw attention to the supposed similarities between, say, a Cycladic figurine, a painting by Seurat, a recent still life by Gris, and an African mask. For them what mattered were the abstract qualities assumed to be the essence of the classical, not the outward dress of the tradition at a given time or in a given place, and they readily extended the usual parameters of 'classicism' to make room for forms of art that were popularly thought of as its antithesis. Thus Mondrian's totally abstract De Stijl paintings found a place in the review, even though Ozenfant and Jeanneret were not prepared to remove all reference to the material world in their own pictures.

A second joint exhibition was held at the Galerie Druet in Paris in 1921, and a third and final one at Léonce Rosenberg's Galerie de l'Effort Moderne two years later. In January 1925 the final issue of *L'Esprit Nouveau* appeared, marking the end of the close collaboration between the two men and the beginning of the end of the

dominant position of Purism as a movement. In 1927 Ozenfant broke with the exclusively still-life iconography and with the strict formal principles of Purism, and in 1928 he had his first one-man show. The later 1920s saw the beginning of his activity as a teacher: he joined the Académie de l'Art Moderne founded by Léger; he visited the Bauhaus and lectured in major German cities; and in 1932 he opened his own Académie Ozenfant in Paris. (This moved with him when he settled in London in 1936, and then in New York in 1939.) His considerable personal contribution was recognised officially in 1932 when he was made Chevalier de la Légion d'Honneur.

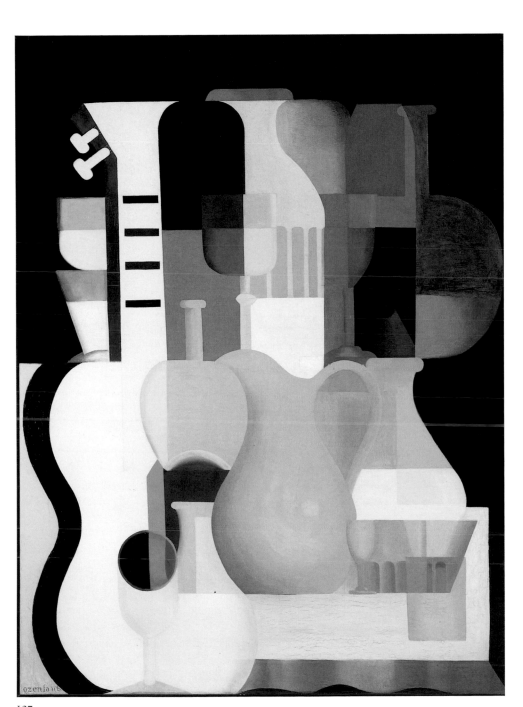

127

127 Fugue 1922

Oil on canvas, 130 × 97
Honolulu Academy of Arts, Hawaii,
gift of John Gregg Allerton, 1967

Also known as 'Accords', 'Fugue' is a rare instance of a painting by Ozenfant which alludes in its title to his ideal of a pictorial harmony analogous to that of music. It was widely reproduced in the mid-1920s, not only in Purist publications (for instance, *L'Esprit Nouveau*, no. 27, November 1924), but also in more broadly based critical studies (such as M. Raynal's *Anthologie de la peinture en France de 1906 à nos jours*, Paris, 1927). It is a fine example of the visually more complex compositions of the Purists in 1922–3, in which the overlapping and transparency of the still-life objects is a major preoccupation, and the handling of colour and lighting is more sensual and painterly than in earlier works. It is very similar to Jeanneret's exactly contemporary 'Pale Still Life with a Lantern' (cat.71), and the comparison reveals the Purists' desire to achieve a true, exemplary 'house style'. Purist painting is repetitive from conviction, for Ozenfant and Jeanneret saw standardisation as a means to, and expression of, absolute purity of form. Indeed it was like a sign for the 'Platonic' essence which was their ultimate goal. Ozenfant often painted near-replicas of his compositions, and 'Fugue' is a close variant of 'Still Life' of the previous year (private collection, Switzerland). The earlier picture is the same size, but is spatially somewhat simpler.

The classicism of Purist painting resides primarily in the abstract qualities sought – order, balance, serenity, quietude, timelessness, and so on – and in the use of certain mathematically based compositional formulae, such as the golden section. But discreet allusions to classical art are allowed a limited place: amid the 'modern' imagery of guitars, wineglasses, jugs and carafes we find the familiar fluting of Greek columns, doubling here as the moulding on mass-produced glass.

PABLO PICASSO 1881 MALAGA – 1973 MOUGINS

In 1914, at the height of synthetic Cubism, Picasso began once again to draw and paint in a naturalistic manner. Three years later, when he was working for Diaghilev on the ballet *Parade*, the number of these naturalistic works increased. This was, however, Picasso's second 'classical' period, for the Rose period of 1905–6 was in many respects a first run. Indeed the peculiar course of Picasso's evolution serves as a reminder that the wartime and post-war 'call to order' was not a new phenomenon, produced by the war, but a resurfacing within the avant-garde of a classicist movement which had been dominant at the beginning of the century, and whose own origins went back as far as the post-Impressionist 'call to order' of the 1880s. Viewed from this perspective, Picasso's Cubism could be seen as a kind of temporary interruption within the continuity of his classicism. Less perversely, it could be seen as another form of classicism – a revolutionary, 'abstract' form of classicism. This was, in effect, the line taken by those critics and artists, such as the Purists, who wanted to bring system and order to Cubism through referring back to the 'constants' of classical art. That Picasso himself – at any rate after 1914 – did not see Cubism and classicism as incompatible, is suggested by the ease with which he switched between the two manners. For they always coexisted in his work, and were employed by him simultaneously as the subject or the mood demanded. Picasso was not unique in this ability to juggle avant-garde and classical styles. But he was unique in his flexibility, and in the sheer variety of classical styles which he commanded at any given time.

Picasso had a thorough academic training, at a very young age. His first teacher was his father, himself a painter, but in 1892 Picasso enrolled in the art school in La Coruña where the family had moved the previous year. By 1894 he was executing accomplished academic drawings from antique casts, and when his father accepted a teaching post at the La Llotja school of art in Barcelona the following year, he had no difficulty in gaining admittance to the advanced classes. 'Science and Charity' of 1897 (Museu Picasso, Barcelona) was a

precocious essay in academic moral narrative, and won official honours when it was exhibited in Madrid and Malaga. After a brief period at the Royal Academy of San Fernando in Madrid, Picasso abandoned his studies, and by the spring of 1899, back in Barcelona, he had become a regular at the bohemian café and art centre Els Quatre Gats, and was painting and drawing in the abstracted, Symbolist style of Catalan Modernista artists like Santiago Rusiñol and Ramon Casas. There he met the critic and philosopher Eugeni d'Ors, future theorist of Catalan Noucentisme, and, among many others, Julio González and Manolo. Through these contacts Picasso became conversant with contemporary Parisian art, and his work began to resemble that of Toulouse-Lautrec, Forain and Steinlen.

In October 1900 Picasso made his first trip to Paris. He had a début exhibition the following year at Ambroise Vollard's gallery, and met the poet and critic Max Jacob, who became a lifelong friend. In Barcelona in 1902 the dominant blue tonality of his recent canvases was confirmed, and Parisian night-life subjects yielded to tragic scenes of beggars and prostitutes. In the spring of 1904 Picasso left Barcelona and settled in a dilapidated building in Montmartre, nicknamed the Bateau-Lavoir, where there was a thriving artists' community. From this point on he returned to Spain relatively rarely, and although he continued to mix with the large group of expatriate Spaniards in Paris, he also became a close friend of Apollinaire, André Salmon and Maurice Raynal. He made frequent visits to the nearby Cirque Medrano, and gradually the blue tonality of his work gave way to a predominant pink, and Harlequin and Saltimbanque subjects began to dominate his repertoire. Simultaneously the 'gothic' character of his Blue period gave way to a style derived from classical art, a change that owed much to his contacts with Apollinaire and with Jean Moréas, founder of the Ecole Romane which was dedicated to the revival of the Greco-Roman roots of French culture.

Towards the end of 1905 a new objectivity entered Picasso's work, displacing the sentimentality of his Saltimbanque paint-

The artist in his studio, 1922 (Photo by Man Ray)

ings. This development was encouraged by the Ingres retrospective exhibition held in the Salon d'Automne, and by the neoclassical work of rising artists such as Maillol (see cat.88). During the course of 1906, especially during his four-month stay in the village of Gósol in the Pyrenees, this classical tendency in Picasso's work was confirmed. His paintings took on a terracotta and grey tonality, forms were treated more volumetrically, and the references to archaic and classical Greek sculpture, to Ingres, and now also to Cézanne, increased. His subject matter simplified as he focused on timeless and traditional themes derived from antiquity, such as male nudes with horses and women doing their hair. After his return to Paris in the autumn, his paintings of nudes took on a more monumental and more primitive form: the influence of the archaic Iberian sculptures he had seen in an exhibition in the Louvre was now reflected in the stylised treatment of faces, and became blended with a more pronounced influence from the late figure paintings of Cézanne,

and the Tahitian paintings and sculptures of Gauguin. All these sources, together with those of El Greco and *art nègre* (African and Oceanic tribal art), coalesced in the extraordinary 'Demoiselles d'Avignon' (Museum of Modern Art, New York). This huge canvas, which occupied Picasso for many months during 1907, was revolutionary in the degree of its formal abstraction, but none the less referred to academic traditions of portraying the nude. In a real sense it was his answer to the call for a renewed, anti-academic classicism in art, although its expressionistic, 'Dionysiac' character indicates clearly Picasso's rejection of the generally accepted equation of classicism with 'Apollonian' serenity.

Braque had been taken to Picasso's studio late in 1907. During the course of the following year the two men saw much of each other, and Braque's assimilation of the conceptual aspects of Cézanne's work affected Picasso, who reduced the confrontational and dramatic tone of the 'negro' paintings which followed 'Les Demoiselles d'Avignon'. Paintings such as 'Three Women' (Hermitage Museum, Leningrad), completed after considerable revision in the winter of 1908–9, show the influence of Braque's recent geometrical landscape paintings. From their collaboration over the next five years the Cubist style evolved. Gradually Picasso became recognised as a leader of the Parisian avant-garde: although, like Braque, he never exhibited in the annual Salons in Paris, he showed his recent Cubist canvases at the Galerie Notre-Dame-des-Champs in May 1910. And, thanks to the network of international contacts of Kahnweiler, dealer to both Picasso and Braque, their analytical Cubist paintings were included in many important exhibitions abroad. Thus the influence of the style spread rapidly. In 1912 Picasso made his first collages, or constructions, and, in response to Braque's initiative, his first *papiers collés*. These new methods, which ushered in the 'synthetic' phase of Cubism, resulted in a move away from the abstraction and mysteriousness of their recent 'hermetic' works towards greater legibility and formal clarity.

When war was declared in August 1914 Picasso was in Avignon. During his five-month stay there his work became extremely varied in style: he produced richly coloured, decorative synthetic Cubist paintings, drawings which with hindsight seem to anticipate his surrealistic works of the late 1920s and 1930s, and some exquisite naturalistic drawings in a style related to that of Ingres. The oil version of 'The Painter and his Model' (cat.130) was left unfinished, but was prophetic of the classicism of his art in the coming years. Two years later he agreed to collaborate with his new friend the poet and critic Jean Cocteau on *Parade*, an experimental ballet with music by Erik Satie, which Cocteau had devised for Diaghilev. In February 1917 Picasso accompanied Cocteau to Rome, to meet the Ballets Russes and to work on his designs. He remained in Italy for two months, visiting some of the major museums and churches and going to Florence, Naples and Pompeii. This was his first trip to Italy, and it contributed significantly to the resurgence of classicism in his work. Although the sets for *Parade* and his costumes for the Managers were Cubist in style, the huge drop-curtain, depicting performers backstage, was in a 'baroque' style of naturalism playfully derivative of the art he had seen in Rome and Naples (repr.p.14). It also distantly recalled the Harlequin and Saltimbanque paintings of 1905. The first performance of the ballet at the Théâtre du Châtelet in Paris in May 1917 provoked scandal and controversy, and alerted critics and artists to the changes in Picasso's work.

In Rome Picasso had met Olga Koklova, a ballerina in Diaghilev's company, and in June he followed her to Spain, where the Ballets Russes were performing. They remained in Barcelona until November, and Picasso saw much of his old Catalan friends. The classicist aesthetic of Catalan Noucentisme helped to confirm the new tendencies in his art. So also did his contacts with the ballet world and its high-society entourage, for he designed other ballets for Diaghilev over the next few years. In July 1918 Picasso and Olga were married, and spent their honeymoon in Biarritz, where he made many elegant Ingresque portrait drawings. From this time onwards he usually spent the summer in the south of France, claiming that in this Mediterranean ambience mythological subjects came naturally to him. On his honeymoon Picasso met Paul Rosenberg, who became his dealer, found an apartment for him and Olga next door to his gallery on the rue La Boétie, and organised regular exhibitions of his latest work over the coming years.

In February 1921 Olga gave birth to a son, and numerous images of mother and child, in a great variety of classical styles, occupied Picasso for the next couple of years. The family spent the summer of 1921 in a villa at Fontainebleau, and there Picasso painted several monumental neoclassical paintings partly inspired by the Renaissance works in the palace. At the same time, however, he completed two large, dazzling synthetic Cubist canvases representing 'Three Musicians' (Museum of Modern Art, New York, and Philadelphia Museum of Art). His ability to work simultaneously in these two apparently antithetical modes caused much controversy, and in an interview given to Marius de Zayas Picasso commented in some detail on the relationship in his work between mood and subject, and choice of style:

> The several manners I have used in my art must not be considered as an evolution, or as steps towards an unknown ideal of painting. All I have ever made was for the present and with the hope that it will always remain in the present. . . . I do not believe that I have used radically different elements in the different manners I have used in painting. If the subjects I have wanted to express have suggested different ways of expression I have never hesitated to adopt them. . . . This does not imply either evolution or progress, but an adaptation of the idea one wants to express and the means to express that idea. (First published in *The Arts*, New York, May 1923, as 'Picasso speaks'.)

The year of this interview, 1923, was also the year in which Picasso's friendship with the Surrealist poet and theorist André Breton became closer, and in December 1924 Picasso was represented in the first issue of *La Révolution Surréaliste* with a sheet-metal construction. Although he did not officially join the movement, his work was included in the Surrealists' exhibitions and magazines, and from the mid-1920s it showed many signs of his sympathy with their fundamental concerns. His subject matter did not alter radically as a consequence of this new allegiance, but the violent and expressive distortions to which he subjected the human body were limitlessly inventive, and metaphoric allusions and private symbols gave his work a poetic, imaginative and dream-like character. The brashly coloured, wilfully ugly and disturbing, *collage*-style 'Three Dancers' of 1925 (repr.p.28) dramatically registers the new orientation, since the subject and composition – derived directly from the traditional motif of the Three Graces – had been explored in many of his earlier elegant classical drawings of dancers.

Despite appearances, however, the ties with the classical tradition held fast during the late 1920s and 1930s when Picasso was in closest touch with the Surrealists: many of his most grotesquely distorted figures adopted classical poses, and in the use of line and tonal modelling he pastiched academic techniques. Moreover, some of his contemporary drawings were executed in a pure, linear style derived from Greek vase painting, for it was primarily in his graphic work that his absorption in the idea of the classical world and in classical mythology was expressed. It seems, indeed, that rather than discouraging this dialogue with classicism, the Surrealists' obsession with myth and myth-making stimulated Picasso's increasingly mythic concept of the relationship between the artist and his world, and his special identification with the legendary Minotaur. These concerns were expressed in the etchings he made to illustrate a new edition of Ovid's *Metamorphoses* (published by Albert Skira in 1931), and came to a climax in the great suite of etchings, executed in 1933–4, on the theme of the sculptor's studio and the loves of the Minotaur, which became part of the renowned 'Vollard Suite'. In 1930 Picasso had bought the Château de Boisgeloup, north-west of Paris, and there he was able to install large sculpture studios. The busts and nudes he created in the early 1930s vary greatly in their degree of naturalism, but in all of them he pursued his exploration of the many 'voices' of the classical tradition, without, however, being at any time tempted to work in a straightforward neoclassical manner.

Since the end of the First World War Picasso had been the subject of many critical studies. (The first substantial monograph, by his old friend Maurice Raynal, was published in Munich in 1921 and in Paris the following year.) His consecration as a living great master came in 1932 with the huge retrospective exhibition held in Paris at the Galeries Georges Petit, which afterwards travelled to the Kunsthaus in Zurich. In the same year the first volume of Christian Zervos's catalogue raisonné of the paintings and drawings was published, and in 1933 Bernard Geiser produced a catalogue raisonné of the engravings and lithographs. In 1936, on the outbreak of the Spanish Civil War, Picasso was elected by the Republicans as director of the Prado Museum. His opposition to Franco was expressed directly in the suite of satirical etchings, 'The Dream and Lie of Franco', and in metaphorical terms in the great

mural 'Guernica' painted for the Spanish Republican pavilion at the Exposition Internationale of 1937. In 'Guernica' (Museo del Prado, Madrid), as in so many of his other most important works of the inter-war years, Picasso's typically free and inventive approach to the classical tradition finds expression once again, for although the style is essentially that of synthetic Cubism, the imagery, the composition and even the drawing make use of a variety of 'classic' sources, including paintings of 'The Massacre of the Innocents' by Guido Reni and Poussin. The classical tradition remained for him a stimulus and a resource; but his immersion in it never involved uncritical imitation, and his own powers of creativity were never crippled by the weight of its authority.

128 Two Nudes 1906

Oil on canvas, 151.3 × 93
*Collection: The Museum of Modern Art,
New York, gift of G. David Thompson
in honour of Alfred H. Barr Jr, 1959*

'Two Nudes', which was painted in the autumn–winter of 1906, is the culmination of a great series of drawings and paintings on the theme of a pair of women which had begun to fascinate Picasso during his trip to Gósol earlier in the year. In 'La Toilette' (Albright-Knox Art Gallery, Buffalo), their relationship had apparently been that of mistress and servant; in 'Two Nude Women' (private collection, Zurich), that of friends or sisters. Here, and in the many related studies (including cat.129), the meaning of the gestures and the impassive but significantly angled faces, remains ambiguous, although there is a slight hint of narrative – some kind of dialogue between them, perhaps a proposal. Two of these studies depict the two women in a curtained interior, accompanied by, in one case, a seated nude, and in the other, a seated and a standing nude. Both are more suggestive than is 'Two Nudes' itself of the enclosed and draped interior of a harem or a brothel. Picasso had sketched out a large oil of a harem that summer (Cleveland Museum of Art), and in his notorious 'Demoiselles d'Avignon' (Museum of Modern Art, New York) of the following year he depicted a brothel. But although 'Two Nudes' is obviously directly related to 'Les Demoiselles', and can with hindsight be described

as in some sense a 'study' for it, it is distinctly more generalised in its meaning, less of a 'subject' picture, and more of a simple exercise in the traditional genre of the *académie* – the life painting or drawing, which was the foundation of every art student's training.

Picasso's sources for this imposing painting underline its relationship to the *académie*, rather than to any narrative tradition of painting. For whereas 'Les Demoiselles' has sources in religious, mythological and naturalist paintings on the theme of the display of naked women, 'Two Nudes' is more closely related to ancient traditions of sculpture – both Iberian and archaic Greek – to the monumental Bather paintings of Cézanne, and to the squatly proportioned early sculptures of standing nudes by Maillol. So, although one can interpret the painting as the image of one woman ushering another through the curtain into the unseen room (or stage) beyond, Picasso also invites us to interpret it as a study of the same model from two different angles, and to see it as a sculptural relief without any specific meaning. His use of monochrome heightens our sense of everything depicted being formed of the same rough, tactile substance, whether terracotta or stone, for like several of his other contemporary paintings, this was a substitute for the carvings he hankered to make. (In Gósol Picasso had hoped to be able to carve alongside his friend, the sculptor Casanovas, but in the event they did not coincide there.)

In the context of the artistic debates of the period, 'Two Nudes' is best understood as an outstanding example of the 'primitive classicism' which Maurice Denis had identified as the goal of the best radical artists of the day in his review of the Salon d'Automne of 1905 – classical in its synthetic character and its attention to form rather than anecdote, primitive in its dependence on artistic traditions untouched by academic taste, and therefore pure and fresh.

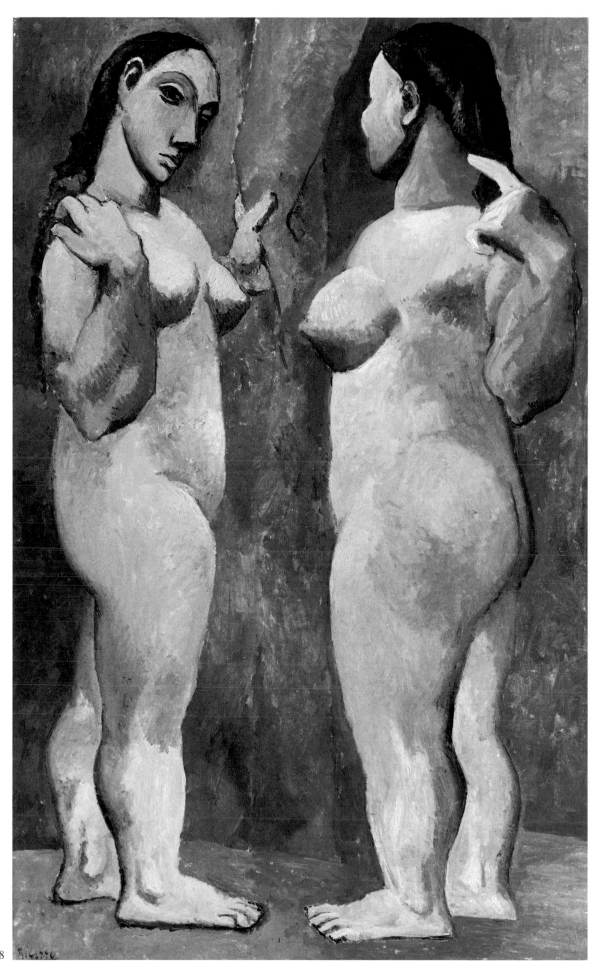

128

129 Seated Nude and Standing Nude 1906

Charcoal on paper, 63.6 × 47.6
*Philadelphia Museum of Art, The
Louise and Walter Arensberg Collection*

The precise date of this drawing is uncertain, although historians are agreed that it was done between the autumn or winter of 1906, when Picasso painted 'Two Nudes' (cat.128), and the spring of 1907, when he began work on 'Les Demoiselles d'Avignon' (Museum of Modern Art, New York). There are many related preparatory sketches for the drawing, which is quite as finished and masterly as any of the contemporary oils.

The drawing epitomises Picasso's response to the exhibition of ancient Iberian sculpture excavated from Osuna in southern Spain, which was held in the Louvre in the spring of 1906. (In March 1907 Picasso bought two Iberian stone heads which, unknown to him, had been stolen from the Louvre.) From the Iberian carvings he derived the large, heavy-lidded eyes, the strongly marked brows, the long ears, and the inscrutable, mask-like cast of the features. But, to judge from the hieratic pose of the standing figure and the position of the bent arms of both figures, he was looking just as attentively at archaic Greek sculpture. For it was primitive, not sophisticated, forms of classicism that attracted him at this period, when he wanted to emulate the purity, anonymity and iconic power of great classical art, but to avoid academic naturalism and anecdote at all costs.

130 The Painter and his Model 1914

Oil and crayon on linen, 58 × 56
Musée Picasso, Paris

Although painted on a linen drying-up cloth (the red borders are still visible under the white priming), and although very modest in size, unfinished, not catalogued by Zervos, and not published until several years after Picasso's death, 'The Painter and his Model' is historically most important. For it was probably the first naturalistic painting Picasso had made since 1906, and it therefore anticipates the return to classicism of 1917 onwards.

Picasso had gone to Avignon, where the picture was painted, in June 1914, and he returned to Paris in late October or early

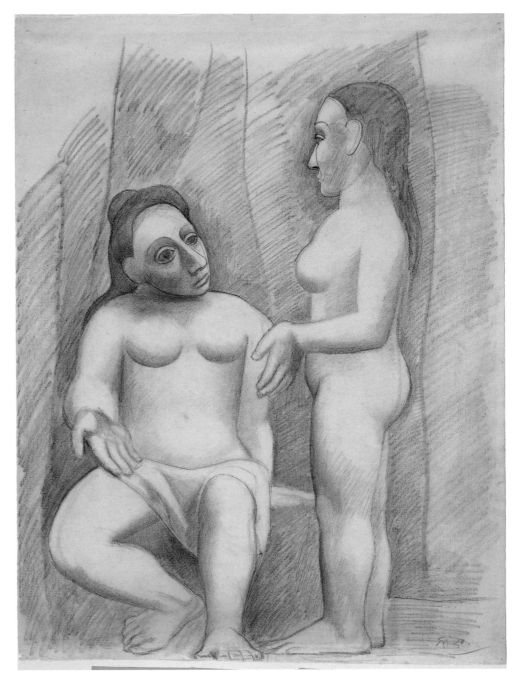

129

November. His companion was Eva Gouel, and the picture has been interpreted as a kind of private double portrait, as well as an essay on a traditional theme, prevalent in French art at least since the time of David. In its fragile delicacy, and in the subject of a naked girl observed by a man, it recalls Picasso's Harlequin pictures of 1905, such as 'The Harlequin's Family' (private collection). But its immediate origins lay in a series of line drawings Picasso made in

Avignon of a seated man, some of which are in a highly abstracted, synthetic Cubist style. Other exquisite naturalistic drawings Picasso made in Avignon were of fruit or biscuits on comports or plates, and the table to the right of the girl has the bare outlines of just such a still life.

Some of Picasso's drawings show the man in a cap, and in a pose even closer to that of Cézanne's 'The Smoker' (Pushkin Museum, Moscow), which was certainly

one of his sources. The figure of the nude has also been convincingly compared to a small Hellenistic bronze from Smyrna in the collection of the Louvre. Other parallels spring to mind, such as Seurat's 'The Models' (Barnes Foundation, Merion, Pennsylvania), although the tightly drawn, curiously proportioned body of the nude is perhaps closer to the Odalisques of Ingres. Picasso's seemingly abrupt return to naturalism, and to the tradition of French painting (Ingres, Seurat, Cézanne), has been related to the 'call to order' preoccupying many French critics (and politicians) at around the time war was declared, although the resilience of the Cubist style in numerous other works suggests that he was unaffected by the extreme chauvinist attacks on Cubism as a degenerate alien style corrupting the purity of French classical culture. Possibly, moreover, the immediate stimulus behind his return to naturalism in 1914 was not so much this general 'call to order' as the example of the contemporary work of Derain, an old and close friend, who was staying nearby at Montfavet that same summer.

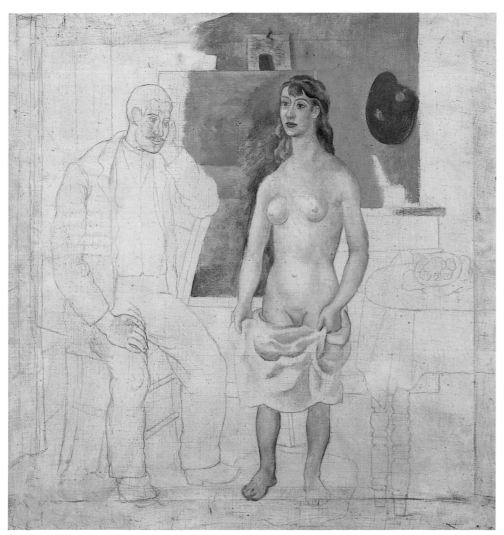

130

131 Portrait of Ambroise Vollard 1915

Pencil on paper, 46.7 × 32
Metropolitan Museum of Art, New York, The Elisha Whittelsey Collection, Elisha Whittelsey Fund, 1947

Ambroise Vollard was one of the first Parisian dealers to recognise Picasso's promise as an artist. In 1901 an exhibition of Picasso's work was put on in his gallery, and he continued to buy paintings from Picasso periodically over the next ten years. He was responsible for the casting of Picasso's early sculptures, including 'The Jester', 1905, and he always took a great interest in Picasso's graphic work, publishing, for instance, a de luxe edition of the 1905 drypoints and etchings of Saltimbanques in 1913, and in the 1930s purchasing the copperplates of the etchings which, grouped together, form the celebrated 'Vollard Suite'.

From the inscription we know that Vollard sat for this portrait in Paris in August 1915, and the panelling behind him identifies the setting as Picasso's studio on the rue Schoelcher. That January Picasso had

drawn Max Jacob in a similarly meticulous naturalistic style (private collection), and over the coming years he would make many other fine and accurate portrait drawings. Picasso's primary model in both the Jacob and the Vollard portraits was Ingres, who had been an inspiration to him throughout the Rose period and who began seriously to interest him again while he was living in Avignon in 1914. Ingres's portrait drawing of 'Comte Louis de Bombelles' has been suggested as the specific source for the Vollard portrait, and there are indeed striking similarities in the pose and the setting.

This was not Picasso's first portrait of Vollard. In the spring of 1910 he had completed a magnificent bust-length portrait in the analytical Cubist style and in a shimmering *grisaille* palette (Pushkin Museum, Moscow). The drawing done five years later was at one level a means by which Picasso could mark the distance between his work then and now, between his Cubism and his re-found classicism. At the same time, however, it was a means for him to explore the underlying structural relationship between the two manners, for there is no doubt that certain devices in the drawing closely parallel the devices of Cubism. For instance, in the drawing Picasso locks Vollard into the surrounding space through the vertical and horizontal lines of the panelling, rather as he does in the painting through the elaborate scaffolding of lines linking figure and background. The lighting in the drawing has an arbitrary character which produces a rhythmically dispersed pattern of tone, as does the lighting in analytical Cubist paintings. One might add that both works are equally abstracted – for despite its remarkable accuracy of detail, the drawing is no more 'life-like' than the painting, and is just as obviously a construction gradually assembled by the artist on the blank sheet of paper.

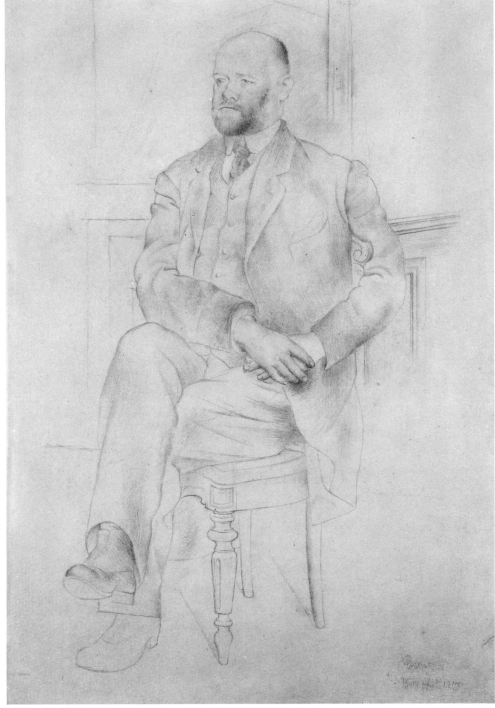

131

132 Harlequin 1917

Oil on canvas, 116 × 90
Museu Picasso, Barcelona

This 'Harlequin' was painted in Barcelona. Picasso had gone there in June 1917 to be close to his future wife, Olga Koklova, who was a dancer with the Ballets Russes, and he remained there until after the performance of *Parade* on 10 November. It is a generalised portrait of Léonide Massine, at the time Diaghilev's principal dancer and chor-eographer. Picasso first met Massine in Rome in February 1917 when they worked together on *Parade*, for which Massine devised the choreography. The two quickly became close friends, and photographs show them together among the ruins in Pompeii. Picasso made several drawings of Massine in Rome, including an idealised study of his head and one of him full-length in Harlequin costume dancing on stage. These are the immediate sources for the painting.

From them and other equally generalised portrait drawings done on later occasions it is apparent that Picasso responded to Massine as a poetic figure, tending to see him in terms of his theatrical roles and as an embodiment of the legendary characters in the *commedia dell'arte*. There was also an element of personal identification, for he had often before painted himself as Harlequin. The present painting is, therefore, a 'secret' self-portrait too – a romantic

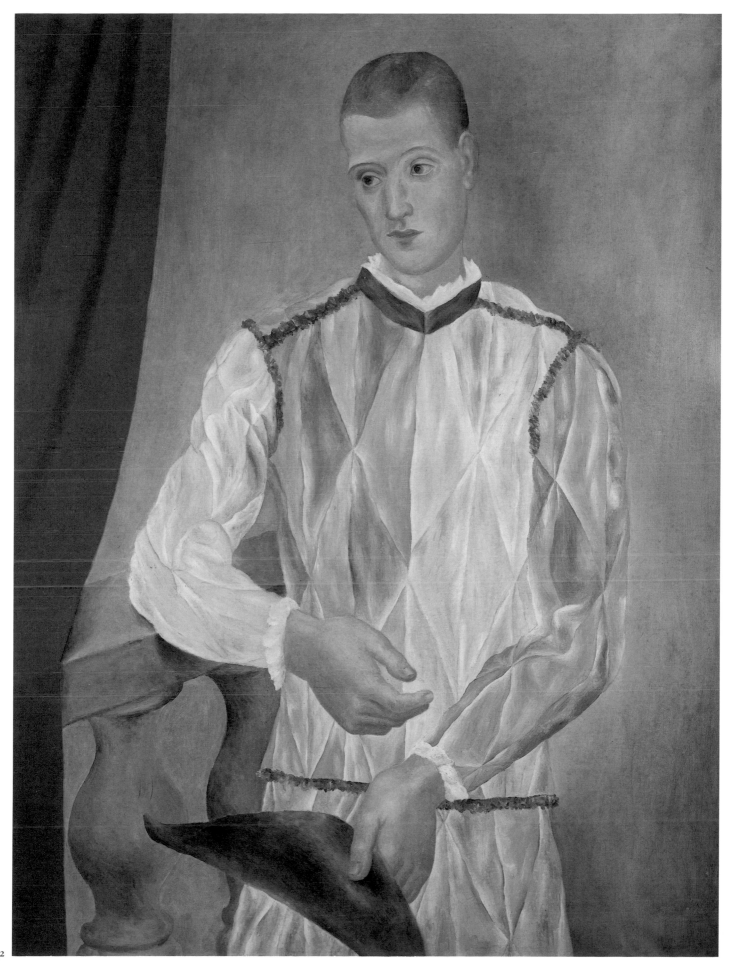

132

representation of the eternal artist–per-
former as a pensive and isolated dreamer.

One iconographic source for the Harle-
quin and Pierrot paintings and drawings
Picasso made at this period seems to have
been the popular Neapolitan art he saw in
Italy, and he was even prepared to repro-
duce its sentimental tone. This Harlequin,
in particular, looks as if he has been posed in
a photographer's studio beside a fake balus-
trade, perhaps for the kind of Italian tourist
postcard of girls and boys in folk costume
that Picasso took back with him to Paris.
(See also cat.133)

However, 'Harlequin' also has a genera-
lised relationship to the late figure paintings
of Cézanne, and specifically to his 'Pierrot
and Harlequin' (Pushkin Museum, Mos-
cow). It is significant that in Barcelona
Noucentista painters, such as Picasso's
friend Sunyer, admired Cézanne deeply,
and had based their art to a considerable
extent on his. In close contact with Catalan
artists once again, Picasso was given encour-
agement to pursue the return to modern
forms of classicism which he had under-
taken more tentatively in 1914 in works such
as 'The Painter and his Model' (cat.130).
The connections between his new paintings
and art in Barcelona were spelt out when
several of them, including 'Harlequin', were
exhibited in 1919 with the Noucentista
group Les Arts i els Artistes.

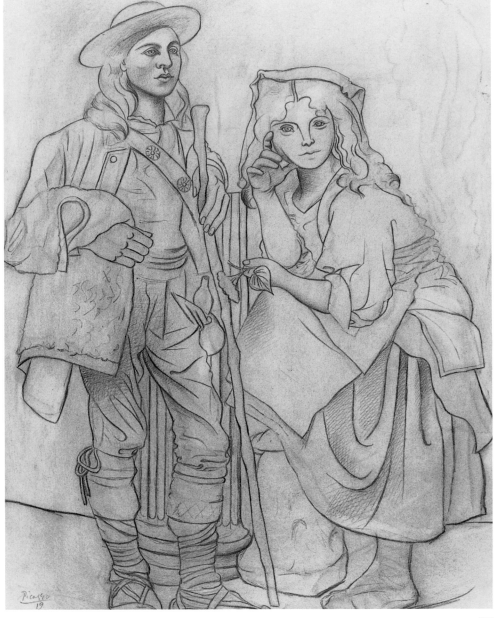

133

133 Italian Peasants, after a Photograph 1919

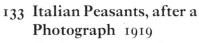

Conté crayon on paper, 61.3 × 49.5
*Santa Barbara Museum of Art, gift of
Wright S. Ludington*

This was one of a series of drawings of
Italian peasants in traditional costume
which Picasso made in 1919 from photo-
graphs and postcards he had bought while
he was in Italy two years before. At the same
time he made other drawings after photo-
graphs, including several versions of
Renoir's 'Portrait of Sisley and his Wife',
one of the family of Napoleon III, and
several of members of Diaghilev's *corps de
ballet* posed for a publicity still. The
common ground – apart from the photo-
graphic source – was fancy costume. This
interest in costume was certainly stimulated
by Picasso's experience of the theatre and

his work as a costume-designer, but it was
also connected with his current concern
about the relationship of his own art to the
art of the past. In Italy he had spent a good
deal of time in museums and churches, and
after the war the gradual reopening of the
Louvre created an ambience of rediscovery
and reassessment. One of the French artists
to attract particular attention was Corot,
whose paintings of girls in Italian folk
costume probably acted as a catalyst for
Picasso at this time. (He made a rapid copy
of one of them early in January 1920.)

In his concentration on folk costume and
peasant themes after the war Picasso was not

alone: many artists exploited this relatively
simple means of access to universalised and
idealised imagery – Severini, Gargallo,
Gris, Derain, Andreu, Manolo, Guidi,
among them. Where Picasso does seem to be
unusual is in his frank reliance on photo-
graphs. The importance for him of photo-
graphy was that it is a realistic medium with
fixed conventions of its own, and therefore
offered yet another representational style
which he could plunder for his own expres-
sive purposes. The frozen, static quality of
the posed photograph seems to have fasci-
nated him, as did the standardised surface
and simplified tonal range. Paradoxically,

rather than imitate the descriptive detail of photographs, he preferred to abstract from them – as in this drawing, which is exactly like a tracing – and thus to play off extreme stylisation against the extreme 'realism' of the source image.

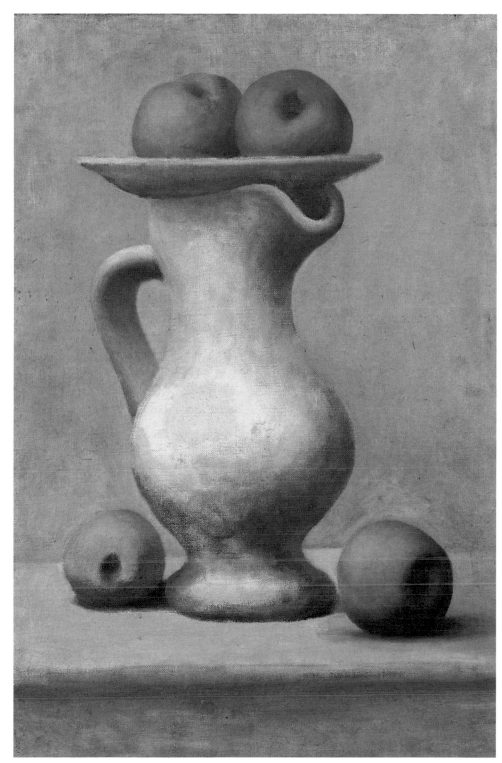

134

134 Still Life with Pitcher and Apples 1919
Oil on canvas, 65 × 43.5
Musée Picasso, Paris

The same pitcher appears in contemporary drawings, and from them we know it was in reality a much more elegant object – ribbed, with a high, tight-waisted base, and possibly made of glass. In the painting Picasso has simplified it and turned it into the kind of rustic pottery ewer that could have been made anywhere in Europe at any time. One of the drawings is oval-shaped and has an elaborate composition, complete with wineglass, tall comport piled with fruit, mirror and rumpled cloth – the sort of composition favoured by Chardin. All this has been eliminated from the present painting, and we are left with the simplest plate, four apples and a plain ledge, expressed in an earthy colour-scheme of extreme restraint. Nothing reveals more forcefully Picasso's desire to achieve the spare, dignified monumentality of great classical art, and comparisons with the noblest frescoes from Pompeii and Herculaneum (which Picasso had seen in 1917) are not beside the point.

During the Cubist period it was often difficult, and irrelevant, to tell Picasso's still lifes and figure paintings apart: still life was in no sense a minor genre. This still life is as impressive as Picasso's contemporary figure paintings, and as several critics have remarked, it has a potent anthropomorphic presence – it is almost impossible not to see a woman here. One is strongly reminded of the full-blown, drowsy sensuality of the Bathers of Renoir (cat.147) and of the peasant girls of Courbet and Millet, who often inspired Picasso's paintings of women at this period. In 1920–22 Picasso made several large pastels of girls in big, soft hats, and the 'woman' hidden in this still life is like a sister to them. Although in colour and imagery, and in its quality of absolute stillness and silence, the painting is very like contemporary metaphysical still lifes, especially those of Morandi (cat.124), its sensuality makes it ultimately very different from them.

135 Nessus and Dejanira 1920

Pencil on paper, 20.9 × 26
Collection: The Museum of Modern Art,
New York, acquired through the
Lilli P. Bliss Bequest

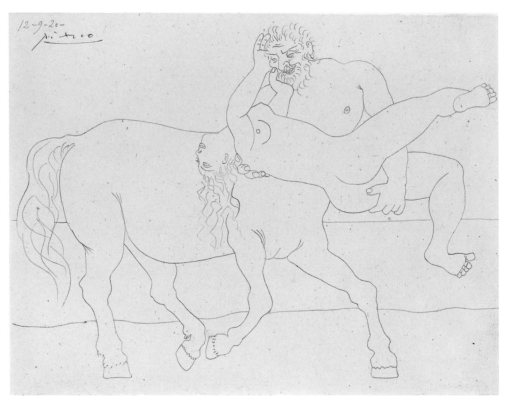

135

Dated 12 September 1920, this is one of a series of drawings on the same theme which Picasso made while he was holidaying in Juan-les-Pins. The story comes from Ovid's *Metamorphoses*, and tells of how the centaur Nessus attempted to rape the bride of Hercules, Dejanira, while ferrying her across the river Evenus. The first of these drawings is dated 11 September, and although executed in pure line, it is much more brutal and rough than this drawing, which captures so wittily the insouciant elegance and refinement of Greek vase paintings on erotic themes. Related to the series is the beautiful Poussinesque tempera called 'The Rape', also dated 1920 (Museum of Modern Art, New York), which is more heroic and serious in mood, and imitates the hieratic structures of Ancient Greek relief sculpture. All these mythic scenes anticipate the Minotaur images of the 1930s.

Picasso himself later said that it was only when he was staying in the south of France, in direct contact with ancient Mediterranean culture, that fauns, centaurs and mythical heroes occurred to him. His readiness to use classical mythology as a source corresponds to contemporary developments in the Parisian literary avant-garde. For example, in September 1919 André Gide had published an essay in *La Nouvelle Revue Française*, entitled 'Considérations sur la mythologie grecque', in which he described the continuing relevance of Greek myths, expressing as they did the universal impulses of the human psyche. Picasso's friend Jean Cocteau also based several texts on mythology: *Antigone*, 1922 (for which Picasso designed some of the scenery), *Orphée*, 1926, and *Oedipus Rex*, the opera-oratorio he created with Stravinsky in 1926, which was performed in Latin at its première in Paris the following year.

It was usually only in his small-scale works, especially in his drawings and etchings, that Picasso indulged his gifts as a narrative artist, and created complex compositions. His large paintings of the 1920s and 1930s (with the exception of 'Guernica') have few figures and no story as such – as if he felt that narrative was inappropriate to work on a more public scale, but quite acceptable in the kind of picture which might go in a book or be looked at in private. This attitude is entirely consistent with the intense hostility to 'literary content' in painting in vanguard circles before and after the war, where the nineteenth-century Salon tradition of narrative painting was still regarded as a latent menace, and where 'pure' formalist considerations were held to be paramount, whatever the style adopted. Waldemar George, for instance, felt it necessary to defend Picasso from possible criticism on this score, and carefully excluded any 'compromising' narrative drawings from the illustrations in his monograph: 'Picasso has painted and drawn portraits and compositions which are classical in spirit. . . . But these drawings, pastels and paintings . . . are just as much pure creations of the mind as his Cubist paintings of the most modern type. . . . Figurative themes for Picasso are simply props for his plastic concepts.' (*Picasso*, Rome, 1924)

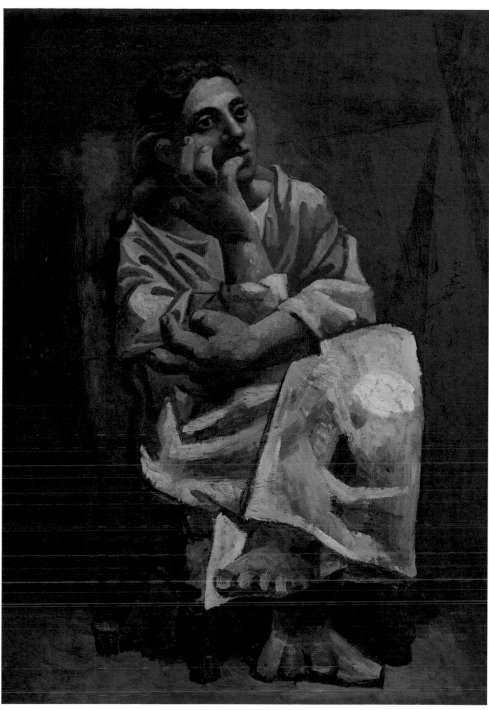

136

136 Seated Woman 1920

Oil on canvas, 92 × 65
Musée Picasso, Paris

This was painted in Paris in the autumn of 1920 after Picasso's return from Juan-les-Pins. It appears to originate in several sketches he made there of Olga resting or reading in an armchair, so that although it has the monumentality of the antique, it has also a domestic and contemporary context – as the chair reminds us.

The motif of the woman seated in an armchair was one Picasso used again and again in the 1920s and 1930s. He relished its intrinsic simplicity and sheer commonness, because those qualities guaranteed him complete freedom to explore the expressive possibilities of the great range of styles he chose to use at different moments. Here, even though the pose is casual, not hieratic, it seems likely that Picasso was drawing on archaic sculpture, or provincial forms of Greco-Roman sculpture, which lack the grace, naturalism and sophistication usually associated with classical art. (The Archaeological Museum in Madrid has substantial collections of these 'rustic' or 'primitive' forms.) Moreover 'Seated Woman' is akin to paintings done in 1906 after Picasso's return from Gósol when he was under the direct influence of Iberian sculpture, for it too is wilfully blocky, rough and primitive in appearance.

'Seated Woman' is sombre and gloomy in mood, for Picasso has done everything to dramatise the deep shadows from which the figure emerges. The hot pinks and the whites are laid over layers of grey–black, so that the painting is unified by the darks rather than the lights. Although nothing is happening we cannot help but associate the figure with tragedy, and thus with classical sources which depict death or mourning. We could compare her, for instance, with statues of grieving women of the so-called 'Penelope' type, or with the heavily draped figure of the mourning Agamemnon in the fresco depicting the 'Sacrifice of Iphigenia' in the Archaeological Museum in Naples. Where Renoir saw only joy in the classical world, Picasso as often as not saw tragedy.

137 Studies 1920

Oil on canvas, 100.5 × 81
Musée Picasso, Paris

According to Zervos in his catalogue raison-né, this extraordinary picture was painted in the winter of 1920–21. It looks like an inventory of Picasso's latest works – as if it were a painting of a wall of his studio – and it flaunts his ability to work simultaneously in Cubist and classical styles. Underneath what we see is a quite faithful copy of Rembrandt's 'Resurrection of Lazarus' in the Rijksmuseum, Amsterdam: perhaps Picasso found it especially piquant to paint in two different manners on top of yet another. At any rate the picture seems to illustrate his contention that there is no progress in art, that great art has no date, that style should be expressive and should vary according to the idea or feeling to be expressed ('Picasso speaks', *The Arts*, May 1923). In this painting he seems to imply that Cubism is especially suitable for still life, classicism for figurative painting – and in practice this is usually, but not invariably, how Picasso split up his work stylistically at the time he painted this picture. But the equality of the two 'antithetical' styles, as far as he was concerned, is reflected in the carefully engineered balance of the composition.

'Studies' also gives a clue to one of the origins of his stylistic diversity after the war: it looks rather like a collage, and it was in his *papiers collés* and collages of 1912 onwards that Picasso first began to mix together elements which were stylistically 'incompatible' – such as wallpaper printed with an illusionistic design, newspaper, sheet music, plain paper, and Cubist drawing. The different meanings possessed by all these different 'languages' must have struck him forcibly at that moment, and encouraged the desire to exploit the remarkable versatility he had manifested even as a boy, but which he had curbed for many years.

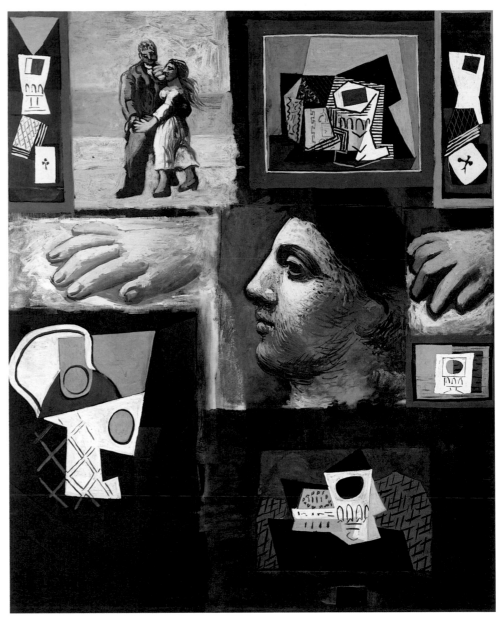

137

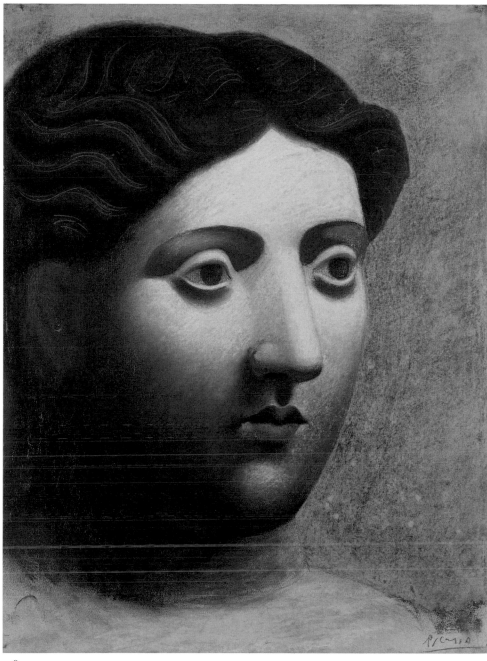

138

138 Head of a Woman 1921

Pastel on paper, 63.5 × 48
Collection Beyeler, Basle

This powerful work was one of a group of
large pastel drawings Picasso made in Fon-
tainebleau in the summer of 1921. They are
all closely connected to the great painting
'Three Women at the Spring' (Museum of
Modern Art, New York), for which he made
numerous preparatory sketches and a full-
sized oil and sanguine cartoon (Musée
Picasso, Paris). This one relates to the
standing figure on the left, but, like the
other pastels, looks like a postscript rather
than a study. Because of the difference of
medium, the pastels are more sensual and
more refined in effect than the painting
itself, which is freely and boldly painted,
and gives the illusion of a roughly carved,
even unfinished, stone relief or a damaged
fresco.

All these works in pastel and oil are
neoclassical: the volumes of the head are
simplified and idealised; the nose and fore-
head are continuous; the hair is arranged in
the traditional Greek manner; the eyes stare
blankly; the expression is impassive. In
general terms Picasso refers to Greek sculp-
ture: among the surviving academic draw-
ings after plaster casts that he made as a boy
are two views of the archetypal classical eye
and brow, and a copy of the Venus de Milo
facing in the same direction as this pastel.
He also refers to the bold simplifications of
form and tone in Pompeian frescoes. Simul-
taneously, however, he acknowledges the
neoclassical tradition from Poussin to Puvis
de Chavannes, as if to insist on its living
continuity from its origins to the present.
'Head of a Woman' also refers back to his
own primitivist–classicist paintings done in
late 1906 – so that his earlier work is
considered as another stage in that tradition.
It is particularly close to the head in the
'Portrait of Gertrude Stein', which Picasso
completed after his return from Gósol
(Metropolitan Museum, New York).

139 The Source 1921

Oil on canvas, 64 × 90
Moderna Museet, Stockholm

This was painted in Fontainebleau in the summer of 1921. In its general theme of natural fertility and woman as the source of life it is related to 'Three Women at the Spring' (Museum of Modern Art, New York), the largest and most ambitious neo-classical painting he made there. 'The Source', however, belongs to a series of its own. There is a much larger version of the same image in crayon on grey canvas in the Musée Picasso, and there are several drawings depicting a naked nymph holding a water jar with a dog to the left which laps from the stream. The whole group was probably inspired by a sixteenth-century painting by Rosso Fiorentino known as 'The Nymph of Fontainebleau', which is in the château there. But the classical theme of the river god or nymph was a standard one, and Picasso would have known many versions in Renaissance and post-Renaissance art.

The neoclassicism of 'The Source' is expressed in an extremely abbreviated style which announces itself as 'modern': the modelling of the body, the amphora and the foreground rocks is so simplified that the illusion of three-dimensionality is only momentarily sustained, while the background is registered instantly as flat. There is still a debt to the abstraction of the neoclassical murals of Puvis de Chavannes, while the geometric conception of the mass of the figure suggests parallels with the sculpture of Maillol. But only Picasso would attempt to unite an impression of completely impersonal abstraction with the hint of erotic energy: the uncovered breast, the 'baroque' rhythms of the drapery over the torso, the velvety shadows on the flesh, all counteract the austerity of the composition.

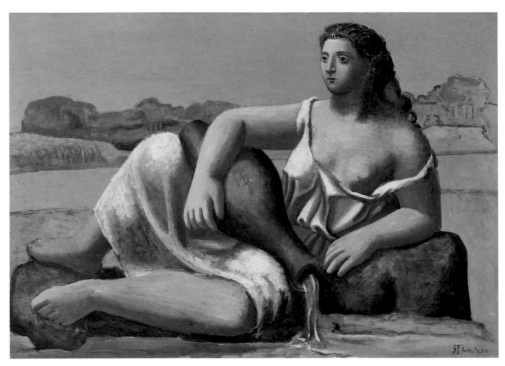

139

140 Maternity 1921

Oil on canvas, 162 × 97
Collection Bernard Picasso, Paris

The subject of the mother and child was common in art during the post-war 'call to order' period. Severini, for instance, had registered his conversion to classicism in 1916 with a large and handsome neo-Renaissance 'Maternity' (repr.p.12). The desire to emulate the great masters of the past was, of course, a strong motive, but historians have also pointed to the propaganda campaigns mounted in Europe after the war, urging couples to procreate to replace the generation lost on the battle-fields. Picasso had, too, a personal motive: his first son, Paulo, was born in February 1921, and the great series of paintings and drawings on the theme of the mother and child date from this event. Most were, none the less, impersonal, for he employed the language of classicism to objectify the private subject and to confer on it an austere, iconic dignity.

Roughly painted, with harsh contrasts of light and dark, boldly simplified drapery, and strong, raw colour, this version has the primitive character of 'Seated Woman' of the previous year (cat.136), and depends on similar antique sculptural sources. It is as if Picasso were determined to avoid the seduc-tive, serene beauty of Raphaelesque paint-ings of the Madonna and Child which the subject itself, and the arrangement of the figures, inevitably call to mind. In his Maternities of the Harlequin and Saltim-banque period Picasso had reproduced the sweetness of Raphael's Madonnas, and they had been perhaps too wistful and too senti-mental. Here he borrows the standard gestures of maternal tenderness – the absorbed expression as she gazes at the child, the encircling, protective arms, the gentle touch of the fingers – but the massive figures are clumsy and the overall effect awkward. The painting is in fact close in composition to a distinctly caricatural draw-ing of Olga, in ordinary daytime clothes, seated in a chair with Paulo on her lap. Picasso's aim in the painting here is not so much caricature as the disquieting forth-rightness of the naïve.

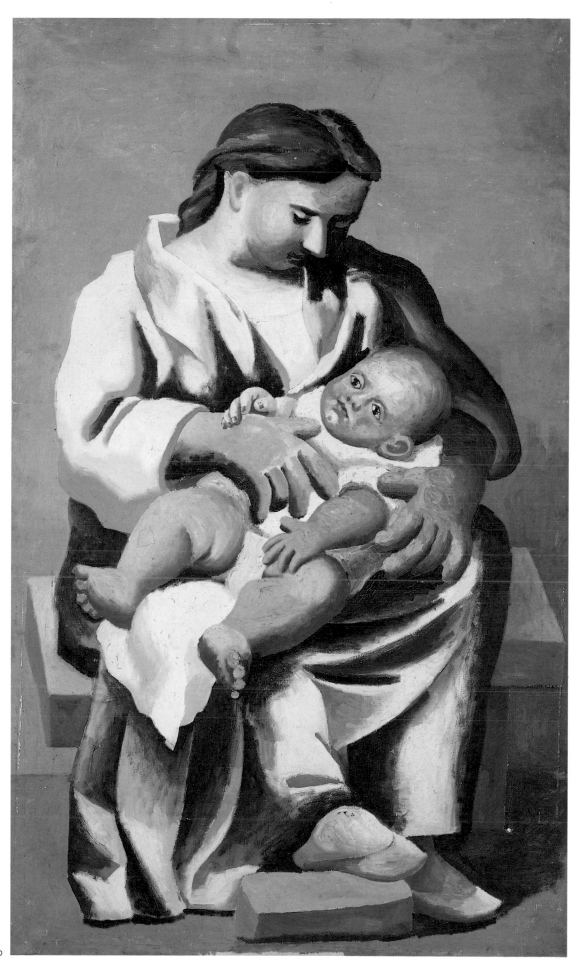

140

141 Large Bather 1921

Oil on canvas, 182 × 101.5
Musée de l'Orangerie, Paris, Collection Jean Walter and Paul Guillaume

This is dated 1921 on the back of the canvas, and was probably painted in Paris after Picasso's return from Fontainebleau in September. It was acquired by Picasso's dealer Paul Rosenberg, and quickly became well known through reproductions (for instance in Pierre Reverdy's *Pablo Picasso*, Paris, 1924).

'Large Bather' is one of relatively few paintings by Picasso in which the figure is well over life size, and because she is crammed into a space which seems barely large enough to accommodate her, the effect of monumentality is greatly increased. Indeed her physical presence looms so powerfully that it is almost oppressive and claustrophobic. Various explanations for Picasso's current obsession with gigantic, swollen human forms have been given – Olga's pregnancy in 1920–21, and recurrent dreams he had had as a child in which limbs swelled and retracted irrationally and frighteningly. But the works of art he had recently been looking at may be a more significant factor. For instance, it is hard not to believe that this wonderful painting was not directly inspired by the massive headless figures of the 'Three Fates' from the east pediment of the Parthenon (in particular the upright figure), or by the huge statue of Demeter from Cnidos: the unusually crisp folds of the drapery in the painting imitate the drapery of these sculptures. (Picasso had spent three months in London in 1919 while he was working on his designs for the ballet *Le Tricorne* and would have seen all these figures in the British Museum.) The sense of massive size and cumbrous weight is equally potent in some of the greatest frescoes from Herculaneum and Pompeii (such as the 'Herakles and Telephus' in the Archaeological Museum in Naples, and the great cycle in the Villa of the Mysteries, Pompeii), for in these the brightly lit life-sized bodies of the women push out from flat backgrounds. Picasso must also have been impressed by similar effects in the great fresco cycles of Michelangelo and Annibale Carracci that he saw in Rome.

Renoir and Maillol were modern artists who interested Picasso greatly after the war, for, like him, they approached the classical tradition in an inventive spirit as a resource that was still alive and rich with meaning. 'Large Bather' owes much to the monumen-tality they sought in their representations of the female nude as a kind of earth-goddess. For at one level that is what the imagery of his painting alludes to – the female nude as the traditional symbol of nature and fertility. The sense of warm earthiness is increased by the soft Renoiresque modelling of the bather's body, and its hot, luminous colour glowing against the steely grey drapery.

However, comparison with the works of Renoir and Maillol instantly highlights the great gulf that lies between their vision and Picasso's: there is none of the uncritical sensuality of Renoir revelling in his dream of a sunny Arcadia inhabited by willing, buxom girls; there is none of the architectural firmness or the physical self-confidence of Maillol's women. For this woman who offers her body to us looks awkward and lethargic, and her far-away expression suggests apathy. The effect of the painting is not only physically overbearing but also sad and mournful. As with 'Seated Woman' (cat.136) we sense an elegiac, nostalgic meaning. The allusions to the classical tradition demand the spectator's recognition, but it is only the outward shell of that tradition, manipulated and distorted, not its moral core, that is retained. This suggests that it was actually the difference between the present and the past that preoccupied Picasso. Did he perhaps feel that the health, sanity, equilibrium, harmony, and so forth, which classicism was traditionally supposed to enshrine, could not have any real meaning in the post-war world? Was he using the classical tradition in order to express this conviction, through the irony of the comparisons he had deliberately set up? Whatever the answer to these questions, it seems evident that the painting has a profound expressive content; it is not straightforwardly 'aesthetic'.

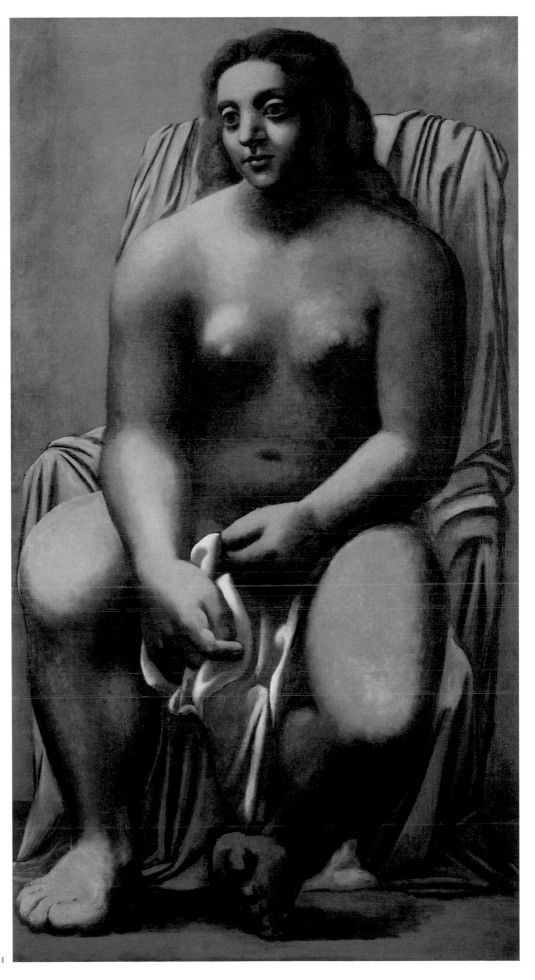

141

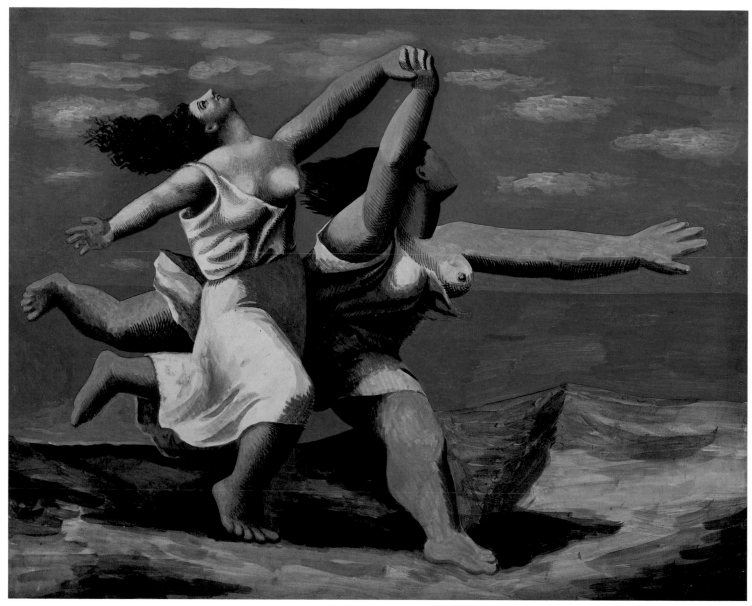

142

142 Two Women Running on the Beach (The Race) 1922

Gouache on plywood, 34 × 42.5
Musée Picasso, Paris

In June 1922 Picasso went to Dinard in Brittany with his wife and son, remaining until the end of September. This little panel was painted there. Although diminutive in scale, it is as monumental in effect as anything Picasso painted, and, greatly enlarged, it was used for the curtain of *Le Train bleu*. This was a new ballet, with a chic and amusing story-line by Cocteau, scenery by Laurens, costumes by Coco Chanel, and music by Milhaud, and it was first performed by Diaghilev's company at

the Théâtre des Champs-Elysées on 20 June 1924. The theme was games on the beach – hence the choice of Picasso's painting for the curtain. In 1928 when he was in Dinard again, and after he had begun his liaison with the much younger Marie-Thérèse Walter, Picasso painted a series of pictures of bathers in striped swimsuits playing ball on the beach, provoked partly perhaps by his memories of the ballet. They, like this painting, allude humorously to the cult of sport and fitness prevalent in the 1920s.

The classical sources of 'The Race' have often been discussed, and it has been pointed out that the two girls rushing wildly along the shore are maeneds in ecstasy, based either on antique originals (reliefs on

Bacchic sarcophagi or similar scenes on Greek vases), or on neoclassical derivatives (such as Poussin's paintings of Bacchanalian revels). Most of the neoclassical paintings Picasso made after the war were absolutely static, in imitation of the famed calm, serenity and order of classical art. However, a substantial body of his 'minor' works – whether small paintings or drawings – depicted unleashed frenzy and passion, of the kind identified as quintessentially 'Dionysiac' by Nietzsche in *The Birth of Tragedy* (1872). (Nietzsche had described this 'Dionysiac' strain as the ever-present counterpart to 'Apollonian' serenity, and argued that the Greek cult of reason and serene beauty was a sublimation of the dark,

143

anarchic forces of the human psyche released in the Dionysiac cults.) In 1925 Picasso gave his most memorable and alarming statement of the Dionysiac impulse, this time in a large painting, 'Three Dancers' (repr.p.28). The middle and left-hand figures there are based on the two women in 'The Race'.

143 Studio with Plaster Head

1925
Oil on canvas, 97.9 × 131.1
Collection: The Museum of Modern Art, New York, purchase 1964

Picasso spent the summer of 1925 with his wife and son in Juan-les-Pins, where this was painted. Like 'Three Dancers' (repr.p.28), which he completed just before travelling south, 'Studio with Plaster Head' looks both back to the classicism of his work since the war and forward to the more obviously surreal tenor of his work of the late 1920s. The painting, dominated by academic plaster casts, belongs in the traditional genre of the still life symbolic of the

arts. Direct parallels may be drawn with the iconography of the various 'Attributes of the Arts' painted by Chardin, and it is quite as symmetrical in composition and as tautly organised as them. (Favourite Chardinesque devices for creating the illusion of rationally conceived space, such as objects which project over the edge of the supporting surface or lie at measured angles to the picture plane, are aped by Picasso, but within the context of a resolutely flat, non-illusionistic space.) In structure and design Picasso's painting is a model of rationality and cool control. Yet everything else about the painting is contrived to create a sense of imminent melodrama and nightmare – the plaster limbs are uncannily animated; the

bust, which is seen from three angles, and becomes progressively more ghostly as it turns from profile to full view, is disturbingly changeable; the juxtaposition of the yellow apple and the toy theatre seems bizarre; in this 'learned' context, the bold contrasts of colour and pattern seem inappropriately garish and crude; and the harshly theatrical contrasts between light and dark are dazzling and dissonant. It is apparent that if Picasso was thinking of Chardin, he was also thinking of de Chirico, and adopting not only the favourite imagery and compositional devices, but also the alarming mood, of de Chirico's metaphysical paintings. (See cats.30,31.)

Picasso had known de Chirico before the war and would certainly have been familiar with his early still lifes. But it is likely that they particularly attracted him in 1925, when de Chirico returned to live in Paris, because they were both currently the focus of the Surrealists' attention. (Breton published the first instalment of 'Le Surréalisme et la peinture' in *La Révolution Surréaliste* that July, and there discussed Picasso's key role as the catalyst for the movement as a whole. He saw de Chirico as the other exemplary source for Surrealist painting – not the new de Chirico, however, but the de Chirico of the metaphysical period.) Meanwhile the co-existence in 'Studio with a Plaster Head' of geometric and architectural elements and a pulsing organic line which threatens to run out of control, suggests some reaction from Picasso to the automatic drawings and the first Surrealist paintings of Masson, which were reproduced in the early numbers of *La Révolution Surréaliste*. (Compare cat.114.)

This, then, is a picture which reflects Picasso's new orientation, and the return of an overtly expressive and dramatic mode in place of the almost somnabulistic lethargy of some of the greatest of his neoclassical paintings of the early 1920s. It makes more explicit the 'Dionysiac' undercurrent present in some of them, and bears witness to his acute sense of the adaptability and the emotional range and power of the classical tradition when it was not regarded as incompatible with both formal and psychological tension.

144 Seated Woman in a Red Armchair 1932

Oil on canvas, 130 × 97.5
Musée Picasso, Paris

This was painted in Boisgeloup, and is contemporary with the great series of sculptures which Picasso made there. It is very like some of them, although the loose separation of the parts of the body, defiant of gravity, was something he could barely achieve in his actual sculpture (except in the welded iron constructions). Its origins lie in the long sequence of paintings and drawings of grotesquely distorted bathers he made in the late 1920s, and specifically in the extraordinary, volumetric 'bone drawings' of 1928, which culminated in 1932 in the drawings after Grünewald's 'Crucifixion'.

At first sight 'Seated Woman in a Red Armchair' might seem to have nothing to do with classicism, and indeed it could easily find a place in any discussion of Picasso's relationship to the Surrealist movement, so irrational is the anatomy of this strange being, who seems to be as much vegetable and mineral as animal. Nevertheless there are many points of contact between the painting and Picasso's 'straightforward' classical works. In the first place the subject is both entirely traditional and had been a favourite one with him for years. Then, too, the figure is placed exactly in the centre of the canvas, and symmetry is carefully observed throughout the composition to produce a feeling of balance and order. Each form is treated as a solid volume, limited by a contour, and the system of light and shade is more or less consistent with a single light source. The figure is certainly bizarre, but she is as placid and serene as a Madonna, and with her white veil and red cloak-like chair she looks like a mutation of Picasso's Raphaelesque 'The Italian Woman' of 1919 (Marina Picasso collection). Throughout, in fact, the handling is softly caressing, as in Picasso's most Renoiresque bathers of the post-war years, while the lyrical rhythms set up by all the alternating curves betray his continuing fascination with the linearism of Ingres – and of Raphael himself.

The relationship between a work like this and the classical tradition is hard to define, because paradox is central to it, and one is tempted to see the irony as critical, even satirical. But the painting is so beautifully and seriously executed, and so impressive, that such an interpretation cannot be sustained for long. In the end the differences between it and, say, the poignant 'Still Life

with Pitcher and Apples' and 'Large Bather' (cats.134,141) seem entirely superficial, and the degree of irony little different. All of them approach the classical tradition with respect, but without deference. Picasso regarded the tradition as a stimulus, not as something which had to be imitated devoutly. He knew that the great masters of the past, like Raphael or Ingres, had approached the classical tradition in the same innovative spirit precisely because for them it was not dead, but the true and living source of their art.

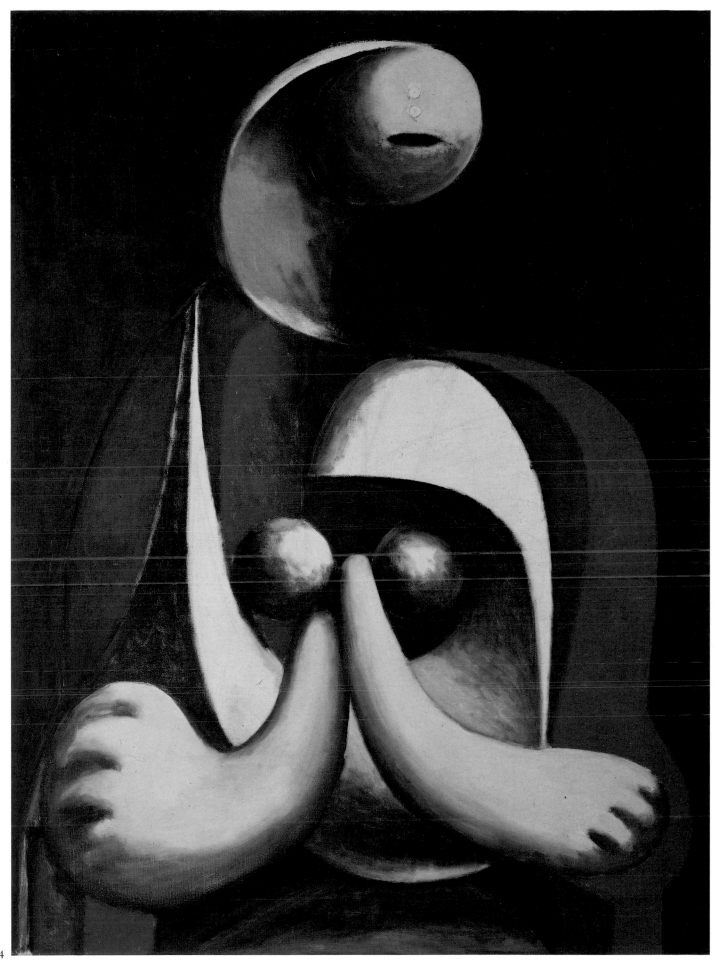

145 Head of a Woman 1932

Bronze, 128.5 × 54.5 × 62.5
Musée Picasso, Paris

In 1930 Picasso purchased the Château de
Boisgeloup, near Gisors, about forty miles
north-west of Paris. He converted some
stables into a large sculpture studio, and in
1931 began work on an extensive series of
modelled clay and plaster sculptures. The
present work, which is the largest piece he
made at the time, was chosen for display
outside the Spanish Republican pavilion in
1937 at the Exposition Internationale in
Paris.

Picasso's preferred subject in 1931–2 was
the female head, and in style the heads range
from the relatively naturalistic to the highly
abstracted. All are organic in form, and their
surfaces are gently pitted all over and tactile
to a high degree. They were inspired by
Marie-Thérèse Walter, who had been his
lover for several years, and many contem-
porary paintings and drawings revolve
around the theme of the sculptor's studio.
Given an antique setting, the theme was
further developed in a series of etchings
later incorporated into the Vollard Suite.
For Picasso the act of making sculpture had
become a symbol for creativity.

Marie-Thérèse was seventeen when her
liaison with Picasso began. She had a broad,
regular, oval face, with a prominent nose and
straight, blond hair cut in a bob. Her
face lent itself to idealisation for it had a
natural symmetry and clarity. He saw her in
terms of the Odalisques of Ingres, voluptu-
ous but serene, and these qualities charac-
terise 'Head of a Woman', in which all the
forms are rounded, taut and full. The effect
of the great head on its long column of a
neck is majestic, and the scale and grandeur
of the work suggest that Picasso wished to
emulate the giant sculptures of antiquity
dedicated to the cult of the Olympian gods.
But his conception of the head was also
influenced by a huge wooden African mask
he had hanging in the Château de Boisge-
loup, which came from the Baga tribe in
Guinea. In many of Picasso's paintings of
Marie-Thérèse she is associated with
sprouting seeds and plants, with water, sun
and flowers, and thus with archetypal
symbols of natural fertility. She becomes a
kind of nature goddess. The Baga mask was
used in fertility ceremonies, and was thus
the perfect model for him. In 'Head of a
Woman' the fullness and the bunching of
the forms, which seem to spring from a
central core, have a metaphoric resonance

suggesting fruitfulness. This is yet another
instance of Picasso's ability to see the
underlying similarities between classical and
primitive works of art, and to draw on both
traditions simultaneously when interpreting
his own experiences. The same alliance of
the classical and the primitive had occurred
in his work in 1906 – a major reason for the
remarkable continuity between his pre- and
post-Cubist classicism.

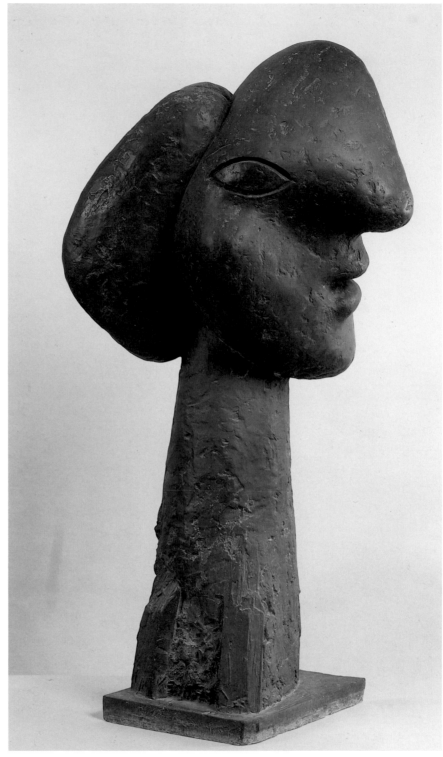

145

146 Minotaur and Nude 1933

Ink and wash on paper, 96.5 × 61
Private Collection

This is one of the most monumental and powerful of all Picasso's many representations of the Minotaur, the mythic half-man, half-bull, which became for him a kind of alter-ego. He had depicted the bullfight now and then ever since his childhood, and it once again became a dominant theme in 1933, the year he made this drawing. It was through his interest in the bullfight that he came to be interested in the myth of the Minotaur, for the modern sport was believed to have developed from traditional games involving bulls held in ancient Crete, where the Minotaur had reigned.

Picasso's first depiction of the Minotaur took the form of a huge collage made on New Year's Day 1928 (Musée National d'Art Moderne, Centre Georges Pompidou), but the theme became obsessive after he was commissioned to design the cover for the first issue of a new magazine entitled *Minotaure* (published in June 1933). The inexhaustible sexuality of the Minotaur particularly fascinated Picasso, and many of the drawings and etchings show the Minotaur making love to a woman with such violent urgency that it is indistinguishable from rape, just as her ecstasy is indistinguishable from pain. The contemporary bullfight paintings turn on exactly the same theme of the intimate relationship between love and death, passion and violence, and many of them are just as erotic in effect.

All these works, whatever the style Picasso employs – and they are stylistically extraordinarily varied – are united in their dependence on classical mythology. Moreover one senses a complete imaginative identification with the myths to which Picasso refers, for, rather than illustrate them with the pedantic accuracy of the academic, he adapts them freely to his own purposes. Thus the Minotaur is sometimes shown carousing with the sculptor in his studio, and the girl he makes love to closely resembles his mistress Marie-Thérèse Walter. Picasso shared this profound interest in classical mythology with the Surrealists, who, following Freud and Jung, saw myth as the sublimated expression of the deepest impulses of the human psyche, and regarded Surrealism itself, in André Breton's words, as 'a myth for our times'. But although the Surrealists encouraged Picasso's interest in ancient myth and ceremony, his tendency to mythologise reality dates back at least to the early Rose period when he painted the Saltimbanques and Harlequins; and in the immediate post-war period some of his 'minor' classicising works turned on mythological themes. The unbridled loves of the Minotaur, an archetype of the primitive and the savage, are equivalent to the loves of nymphs and satyrs, so that a work like 'Minotaur and Nude' relates closely at a thematic level to the 'Nessus and Dejanira' series of 1920 (cat.135). In style 'Minotaur and Nude' has a real, but covert, relationship to the classical tradition similar to 'Seated Woman in a Red Armchair' (cat.144). Specifically it seems to rely on the extraordinary erotic configurations of Ingres's 'Turkish Bath' (repr.p.22).

146

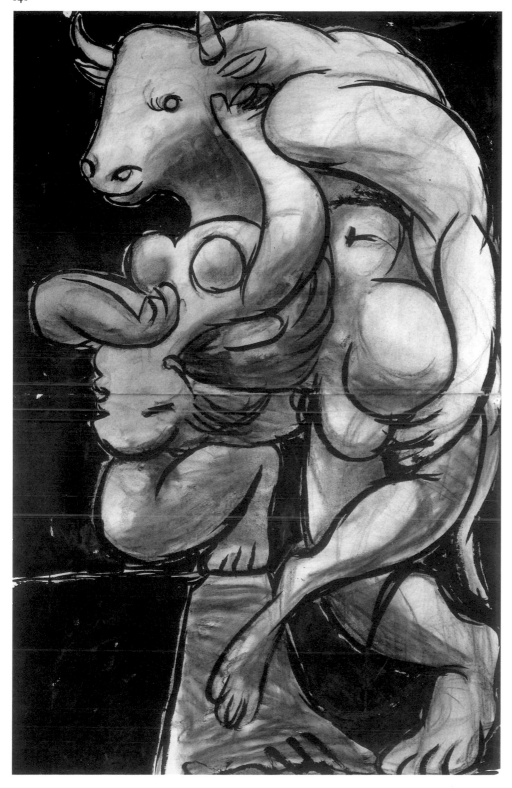

PIERRE AUGUSTE RENOIR 1841 LIMOGES – 1919 CAGNES

Although Renoir was a leading member of the rebel Impressionist group in the 1870s, his position vis-à-vis the classical tradition of Western art was in many ways analogous to that of Cézanne, and he was among the first of the original group to express deep dissatisfaction with what he came to feel were the serious limitations of Impressionist subject matter and methods. With Cézanne, Gauguin and Seurat, he was seen as the 'true foundation' for modern art by artists and critics who, before and after the First World War, advocated a return to more permanent values as the best way forward. His influence may be detected in a number of the French, Italian and Spanish works in this exhibition, for he was greatly admired in all three countries.

Renoir entered the studio of the Ecole des Beaux-Arts painter Charles Gleyre in 1861, and like all academically trained artists of the period he made frequent visits to the Louvre, and many drawings after the antique and the old masters. His intense admiration for the art of the eighteenth century, which dates from the beginning of his career, encouraged an identification not only with the Rococo, but with the French tradition as such – an identification which he often articulated in later life, and which became a leitmotif of much writing about his work in the 1920s. Renoir first exhibited in the Salon in 1864, and his earliest major paintings, despite their dependence on the radical styles of Delacroix and Courbet, indicate a thoroughly traditional conception of the primacy of large-scale figure subjects, the nude in particular. Prophetically, several take mythological or Orientalist themes, then the staple of popular academic painting. This preference for figure painting, and a tendency to favour lyrical, faintly anecdotal subjects, mostly revolving around the pleasures of love, distinguished him sharply from the other leading artists in the Impressionist group, and in 1879 Renoir returned to exhibiting in the Salon. That year he scored a critical success with his 'Portrait of Madame Charpentier and her Children' (Metropolitan Museum, New York), a painting which reveals his admiration for the informal but aristocratic portraits of Sir Joshua Reynolds and Sir Thomas Lawrence.

It was at this period that Renoir's deep ambivalence about Impressionist methods began to surface. He spoke of his sense of the style as a cul-de-sac and of his need to begin all over again. A trip to Algeria in the spring of 1881, in imitation of Delacroix's visit to North Africa half a century before, was followed that autumn by several months in Italy, where Renoir visited Venice, Rome, Naples and Palermo. His drawings and paintings executed thereafter frequently made open allusion to the masters he most admired, whether the Roman painters of Calabria, Raphael, Titian, Veronese or Rubens. For a time in the mid-1880s he abandoned the Impressionist broken touch in favour of a hard-edged, drier and more draughtsmanlike manner modelled loosely on Raphael and Ingres. Meanwhile his various visits to Cézanne in Provence in 1882–5 can only have encouraged this new classicist orientation, as did his reading of Cennino Cennini's *Il libro dell'arte*.

The south of France, where he eventually settled, became associated for Renoir with the ideal of an earthly paradise and with his nostalgia for the classical world. In the last twenty years of his life he left the south infrequently, his work reflecting a rhapsodic response to the Mediterranean: he eschewed contemporary references, introduced mythological themes, and explored obsessively the timeless subject of the female nude as a generalised symbol of the harmony and fertility of nature.

In the 1890s Renoir began to enjoy widespread success, and his work found bourgeois patrons at home and abroad. He was made a Chevalier of the Légion d'Honneur in 1900, Officier in 1911, and Commandeur in 1919. He had numerous one-man shows after 1900, and the first monographs on him appeared before the war. After his death there were several important memorial exhibitions, including a retrospective at the Galeries Durand-Ruel in Paris in 1920, a special showing of thirty-one paintings dating from 1915–19 at the Salon d'Automne in the same year, and a retrospective of his watercolours, pastels and drawings at Durand-Ruel's in 1921. It was at this period that Renoir's late work began to enjoy prestige, and that insistence on the instinctive and innately classical character of

The artist with his model Dédée, 1915

his vision became a critical commonplace, especially with those committed to the dogma of the 'French classical tradition'. Thus in 1920 Maurice Denis, while stressing their 'innocent animal quality', spoke of the 'classical serenity, free from perverseness' of Renoir's 'beautiful nudes', and compared his pantheism favourably with that of antiquity (*La Vie*, 1 February 1920). This interpretation found perhaps its most emphatic statement in Robert Rey's significantly titled *La Renaissance du sentiment classique* (Paris, 1931). In this text Renoir, we are told, 'thought continually of antiquity', and was 'a great representative of classical feeling at a time apparently so lacking a sense of order'. His work, Rey says, 'breathes serenity', and, after the trip to Italy, demonstrates a profound desire for 'discipline' and 'composition'. Sculpture was an inevitable development: 'He tackled it at the highest point where Degas had left off. And he added that sense of the divine with which he was more and more deeply imbued.'

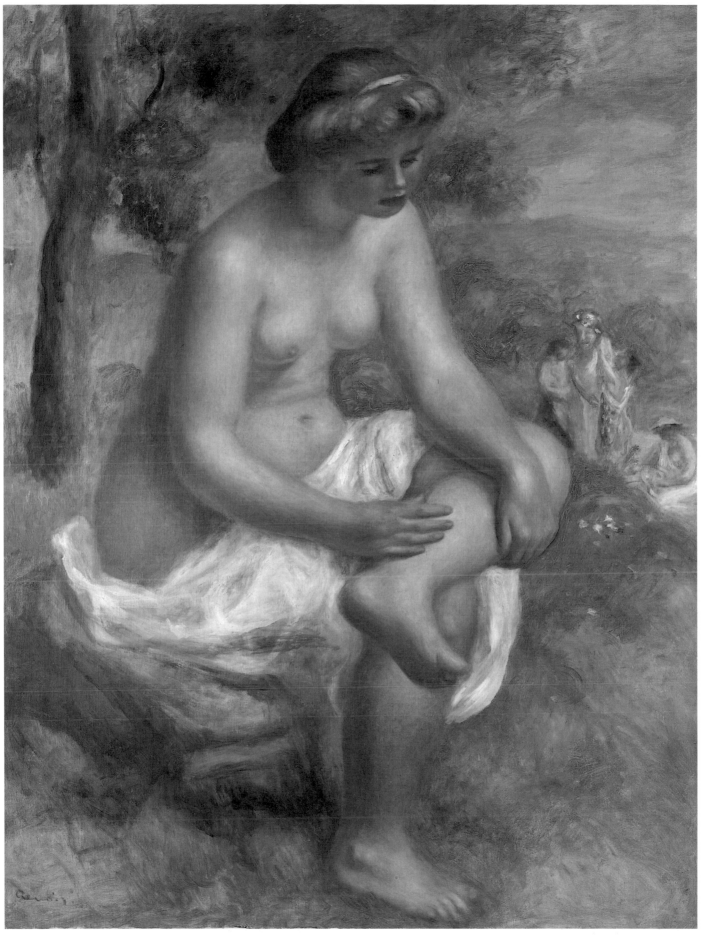

147

147 Seated Bather in a Landscape (Eurydice)

c.1895–1900
Oil on canvas, 116 × 89
Musée Picasso, Paris

This painting was exhibited at the Exposition Triennale in Paris in 1916 with the title 'Eurydice'. It is undated, but although it was ascribed to *c*.1882 by F. Daulte in his catalogue raisonné (Lausanne, 1971), recent writers are agreed that it belongs to the last twenty or so years of Renoir's life.

Although there seems to be no specific allusion to the mythic Eurydice, the painting makes several clear, if generalised, references to antiquity. The bather herself adopts a pose derived directly from the 'Spinario', and in the background three loosely draped companions decorate with garlands the figure of a herm. The richly coloured and fertile landscape, drenched in sunshine, alludes to the ideal of an unspoilt Mediterranean paradise which, for the aged Renoir, was the earthly equivalent of Arcadia. Renoir had explored the 'Spinario' pose as early as 1879 in the 'Small Blue Nude' (Albright-Knox Art Gallery, Buffalo), and in that same year had depicted bacchantes decorating a herm in 'The Feast of Pan' (whereabouts unknown). But direct references to mythology, allied with the virtual elimination of any allusion to the contemporary world, are characteristic only of his late work, when he was living, with few interruptions, in the south of France.

Paul Rosenberg, Picasso's dealer, bought the picture from Ambroise Vollard in 1919. Shortly afterwards Picasso obtained it from him by exchange. It was one of several Renoirs that Picasso owned, the largest of which is a splendid sanguine on canvas called 'The Coiffure'. All of them belong to Renoir's late period, an indication of Picasso's preference for his classical, rather than his Impressionist work, and it was the emaciated and crippled – but still creative – Renoir whom Picasso chose to depict in a portrait drawing he copied from a photograph. The portrait drawing dates from 1919, the year which marks the beginning of Picasso's closest study of Renoir – a study which led to a form of stylistic identification as Picasso sought to equal the almost oppressively sensual physicality that characterises Renoir's ideal of beauty. In that year Picasso made several figure drawings of peasant men and women which have the soft, heavy-limbed voluptuousness and the swelling three-dimensionality of Renoir's

late works, and during the next few years many of his paintings of women, clothed or nude, seem to allude directly to those of Renoir. 'Large Bather' (cat.141) could, for instance, be compared to 'Seated Bather in a Landscape'.

RENOIR and RICHARD GUINO (1890–1973)

148 Venus Victorious 1914

Bronze, 182 × 102 × 77
Tate Gallery

Renoir had been fascinated by sculpture since his youth; sculpture had inspired several of his most important paintings, and he had often regretted his lack of specialist skills. His extant sculptures all date from the last years of his life, and all of them, except a small relief and a bust of his youngest son, Coco, which he modelled in 1907, were executed under his supervision by assistants, because he was too crippled to work the clay himself. It was the dealer Ambroise Vollard who urged Renoir to turn sculptor, and who introduced his first collaborator, Richard Guino, to him in 1913. Guino was a Catalan, who had studied under Maillol at the Académie Ranson, and worked as Maillol's assistant since 1910. Maillol and Renoir had great admiration for each other, and it was Maillol who particularly recommended Guino as the ideal collaborator – dextrous, technically sound, suitably devoid of commitment to a style of his own, and himself, as Paul Haesaerts has it, 'a participant of the Greco-Latin and Mediterranean spirit' (*Renoir Sculptor*, New York, 1947). The association lasted until 1917, but it was only after a lawsuit, settled in 1973, that it was agreed that works Guino had executed should be credited to him as well as to Renoir.

'Venus Victorious' was the first large-scale sculpture Renoir made with Guino, and is the only one on which he himself worked closely, supervising the various stages at all times, and insisting on significant alterations to the hips, breasts and pelvis. The figure of Venus, who holds the apple as a sign of her victory, is based closely on her counterpart in a contemporary oil painting, 'The Judgement of Paris' (Hiroshima Museum of Art), but Renoir

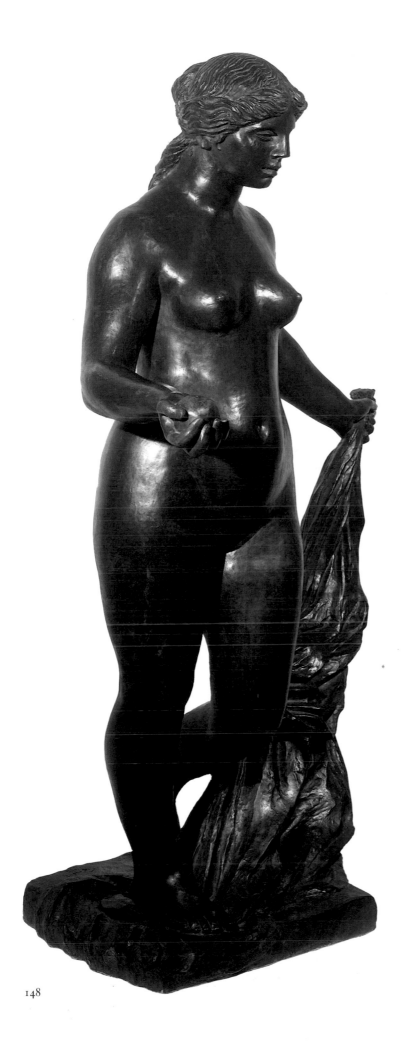

also supplied Guino with various drawings. Initially, in the summer of 1913, Guino created a small full-length figure of Venus, and some accounts suggest that Renoir himself took a hand in the modelling of that version. At any rate he was pleased enough with the result to wish to see it realised on a monumental scale, and Guino began work on this early the following year. That February Renoir wrote to his friend Albert André to ask him to take measurements of comparable Greek statues in the Louvre . because he was determined that his statue should possess a genuinely classical character. He stipulated, however, that André should not measure the 'Venus de Milo' – 'an old gendarme' – but the 'Venus of Arles' or the 'Medici Venus' instead. By the spring of 1914 the sculpture was well under way, but although the Tate cast is dated 1914, it may be that work continued over the next year or so. (The first time a cast was exhibited was in the spring of 1916 at the Paris Triennale.) The finished sculpture is relatively smoothly modelled, and the forms are clarified by simple contours and well-marked spaces. 'Venus Victorious' seems, indeed, to have been influenced not only by the Greek sculptures Renoir wished to emulate, but also by the work of his friend Maillol.

Originally Renoir's intention was to provide the statue with a plinth decorated with a relief of 'The Judgement of Paris'. Guino, basing the composition on Renoir's paintings of the subject, completed the relief, but in the event it was never used as a base, and was exhibited as a separate sculpture in the Triennale in 1916. Renoir had other grandiose schemes for 'Venus Victorious' at the end of his life, intending to make it the focus of a 'Temple of Love' in his garden at Cagnes, and to surround it with a hemicycle of columns. The project was never realised, but corresponds to a remark he made at the time: 'What admirable people the Greeks were. Their existence was so happy that they imagined that the gods came down to earth to find their paradise and to make love. Yes, earth was the paradise of the gods. That is what I want to paint.'

148

ALBERTO SAVINIO 1891 ATHENS – 1952 ROME

Andrea de Chirico adopted the pseudonym Alberto Savinio in 1914 to distinguish himself in the public's eye from his elder brother Giorgio de Chirico. He displayed a precocious musical talent, and at the age of fifteen composed his first opera. His family moved from Athens to Munich in 1905 for four years, so that he could pursue his musical studies. In 1910 he went to Paris in the hope of making a name for himself, and through his avant-garde compositions and articles in literary journals he quickly met leading writers and artists. The poet and critic Guillaume Apollinaire was particularly impressed by him, and praised his attempt to express in his piano works (which mixed folk tunes, popular dances and disharmonious sounds), 'the shock of the unexpected and the curious' (*Paris Journal*, May 1914). Their friendship was cut short by the war, but there is no doubt that Apollinaire was an important source of encouragement to both Savinio and de Chirico.

Savinio was very much an equal partner, even at this early date, in the development of those metaphysical themes that were to become famous through his brother's paintings. In his dramatic poem, 'Les Chants de la mi-mort', for example, published in Apollinaire's *Les Soirées de Paris* in August 1914, Savinio described 'semi-death' as a state of suspension between dream and reality where half-forgotten ideas came to the fore; and he used the imagery of mannequins, towers and piazzas, which featured in the work of his brother. Savinio and de Chirico (who were to be on close terms for many years) remained in Paris together until 1915, when they returned to Italy to enlist.

Savinio's interest in music gradually lessened, and it was as a writer and theorist of metaphysical painting that he became known in Italy. During the war he was in close contact with the Florentine writer Giovanni Papini, whose long-standing fascination with a metaphysical reality, inspired by his reading of Nietzsche and Schopenhauer, had a strong influence on both brothers. (Interestingly, the first recorded reference to the image of the Argonauts, so central to the private mythology of the de Chirico brothers, comes in a letter from Papini to Savinio in early 1916; perhaps in

recognition of his debt to Papini, Savinio dedicated his text 'La partenza dell'argonauta' to him in 1917.)

Immediately after the war Savinio wrote two poetic novels, *Hermaphrodito* and *La Tragedia dell'infanzia*, which feature many of the themes that were to recur in his later paintings. He also produced important articles for such reviews as *Valori Plastici* and *La Ronda*, elaborating some of the main ideas of metaphysical painting, such as the 'fantasmic' nature of the world and the hidden essence of things. Through these writings Savinio became recognised as a moving force in the intellectual and iconographic development of the new painting. He was also involved with a group of writers associated with the 'return to order' movement in literature; and it was through them, as he later recalled, that he met the ambitious editor of *Il Popolo d'Italia*, Benito Mussolini:

> Between 1918 and 1919 I was in Milan, and together with Giuseppe Ungaretti, Carlo Carrà and Massimo Bontempelli, I met Benito Mussolini on several occasions. He felt that we represented the future, and outlined a programme in which *we too* would have to participate in the cultural, as well as the political, renewal of Italy. Needless to say, having seized power, Mussolini no longer remembered us (and we, if the truth must be said, thought no more of him), and he turned for his 'cultural renewal' to writers of a rather different kind. (*Sorte dell'Europa*, Milan, 1945)

Savinio always insisted that he was not interested in painting *per se*, but in the ideas it expressed: 'The works of Dürer, Böcklin, Giorgio de Chirico, and me, are conceived primarily as thoughts. To convert them into a painted or written form, is an act of translation, a secondary process' (*Alberto Savinio*, Milan, 1949). Savinio may have dabbled in art before the war, but his earliest known pictures – collages and drawings with classical statuary in incongruous settings – date from late 1925 and early 1926. He sent them to his brother, who by then had returned to Paris, asking for his opinion. Ever supportive, de Chirico

The artist, 1925

praised them (though he warned Savinio to avoid the pitfalls of Surrealism), and assured him that an exhibition of the pictures in Paris would have great success.

Encouraged by this, Savinio came to Paris with very little money but plenty of hope for his career as an artist. He managed to sell an oil painting, based on a photograph of himself as a child, to the dealer Paul Guillaume, and followed this promising start with a successful one-man show at the Galerie Bernheim-Jeune in 1927. Savinio soon became part of the literary and artistic circuit in Paris, and included among his friends and supporters Jean Cocteau, Waldemar George and the dealer Léonce Rosenberg. Even the Surrealists, despite their disapproval of the 'retrograde' tendencies of his brother, liked Savinio and recognised his talents. In 1931 André Breton included his name in a list of 'approved' authors, and later wrote, 'All modern mythology, still in the process of formation, is based ultimately on the work, almost indivisible in spirit, of Alberto Savinio and his brother Giorgio de Chirico' (*Anthologie de l'humour noir*, Paris, 1947). Savinio, however, insisted that his art was different from that of the Surrealists in that he sought to

give form to the unconscious and not merely 'represent' it ('Della pittura surrealista', *Prospettive*, January 1940).

Savinio's paintings were clearly related to those of de Chirico, not least because the brothers had shared experiences and a common vision of art. In particular, they both alluded to the classical past and to the myths of the ancient world. However, Savinio's works displayed less intensity and drama, and were marked by irony and a sometimes disturbing humour (Léonce Rosenberg saw them as akin in spirit to the pictures of the former Dadaist Francis Picabia). The main themes in Savinio – memories of childhood, and ancient myths of creation, metamorphosis and travel – were first developed in his writings, and for this reason, perhaps, his paintings have a strong literary quality. They also, as the novelist Elio Vittorini observed, have an air of great sophistication: Savinio's work, he wrote, was, 'intensely humanistic, where by humanism we understand a refined and highly cultivated cultural position (a Hellenistic one)' (*L'Italia letteraria*, January 1933).

Following the onset of the Great Depression in 1929 and the collapse of the art market, Savinio was obliged to return home. He exhibited in Italy for the first time at the Venice Biennale of 1930, and his subsequent shows were generally well received by the critics. However, he relied increasingly on journalism to support himself, and in 1934 he began contributing to *La Stampa*. The following year he moved to Rome, where he became an established figure in intellectual circles. He continued to paint, but his main energies were channelled into writing, and later, into music and stage design.

Savinio died prematurely in 1952, and for a number of years his work was overlooked in accounts of inter-war art. However, his stature as a multi-talented artist, no less interesting for his writing and music than for his painting, has come to be recognised in recent years.

149 The Return 1929

Oil on canvas, 73.5 × 60.5
Private Collection, Milan

This painting combines classical references with a romantic sense of pathos and ambiguity in a manner typical of Savinio's work of the period. Nietzsche had challenged the traditional 'Apollonian' view of Greek culture, with its values of restraint, harmony and spirituality, and stressed instead the 'Dionysiac' elements of passion and the irrational. Savinio, like his brother, had been greatly influenced by Nietzsche (in 1914 he signed a ballet score, 'Albert Savinio, artisan dionysiaque'), and through paintings such as this he developed an unconventional modern vision of the classical world, emphasising instability, transience and pessimism.

'The Return' is one of a series of paintings featuring Herculean figures, either singly or in pairs, and can be seen as related to de Chirico's contemporary 'gladiator' scenes (see cat. 39). Records in Savinio's archives suggest that he based these figures on photographs of male nudes, clad in fig leaves and adopting 'heroic' poses inspired by classical statuary and famous paintings, of the sort used for reference by academic artists. Like de Chirico, Savinio was interested in the philosophical and emotional aspects of the connection between past and present, and thus often used as sources pastiche, academic and photographic representations of classical themes, already several stages removed from the original. While such imagery created in de Chirico's works a sense of enigma, in Savinio's paintings it tended to underline their humour and irony. Savinio was also more concerned than his brother to present his imaginings as real, and, unlike de Chirico, did not accept dreams as a valid source for art; hence, perhaps, his emphasis in this painting on three-dimensionality and exuberant energy.

The image of a dramatic embrace, in which the faceless beings cling together and yet simultaneously seem to struggle to pull apart, can be regarded as a symbol of primal creation, a theme central to Savinio's work. In fact, the colossal appearance of the figures has led certain commentators to see them as Titans, the first race of earth-dwellers in ancient myth. According to the story in Hesiod's 'Theogony' (which struck a particular chord with poets and dramatists of the Romantic era), the Titans were the monstrous sons of Heaven and Earth who staged a doomed rebellion against the gods.

It is quite possible that Savinio had such a theme in mind when he painted this work, as he was fascinated by origins, chiefly for what they revealed about human psychology. 'Our highest aspiration, our deepest desire', he once said, 'is to return to the conditions we experienced before our birth; and since it is not possible for us to re-enter our mother's womb, we content ourselves with a metaphor, and return to the womb of the earth' (*Narrate, uomini, la vostra storia*, Milan, 1942).

Savinio saw the distant reaches of time – whether in terms of personal memories or accounts of the origins of the world – as synonymous with the furthest frontiers of the imagination. In other works of the period, toy-like forms and prehistoric animals are clearly related to this theme, but in 'The Return' Savinio has used more veiled clues. The open window (a recurring motif in his paintings) symbolises the threshold of consciousness and access to the unknown. Beyond it lies the sea, with its invitation to travel to unknown places and its connotations of primordial creation. The strange black form hovering in the middle distance like a prehistoric bird is another symbol of voyage: as other paintings make clear, it is a cloth billowing in the wind, and represents the sail of Jason and the Argonauts, or perhaps that of another ancient traveller, Theseus (according to legend, Theseus' father committed suicide when he wrongly interpreted the black sail as a sign that his son was dead). The painting's title, 'The Return', refers at one level to travel, but it also suggests an allusion to the pre-Socratic doctrine of 'eternal return', according to which all things revert to their origins, and repeat themselves in cyclical fashion. The central figures in the work are locked in a seemingly perpetual embrace or struggle, with one apparently being born from the other; the hallucinatory zig-zag patterns blot out any possible indication of the time and location of the scene; and the whole image can be seen as representing the interior consciousness of the artist or viewer, in which past and present are subsumed in an eternal present.

The symbolism and philosophical allusions in Savinio's work are complex and cryptic, chiefly because they derive from the artist's own biography and his private iconography. As he later said, his paintings appear to be like worlds, complete unto themselves, and in a strange way, 'were already born before they were painted' (*Alberto Savinio*, Milan, 1949).

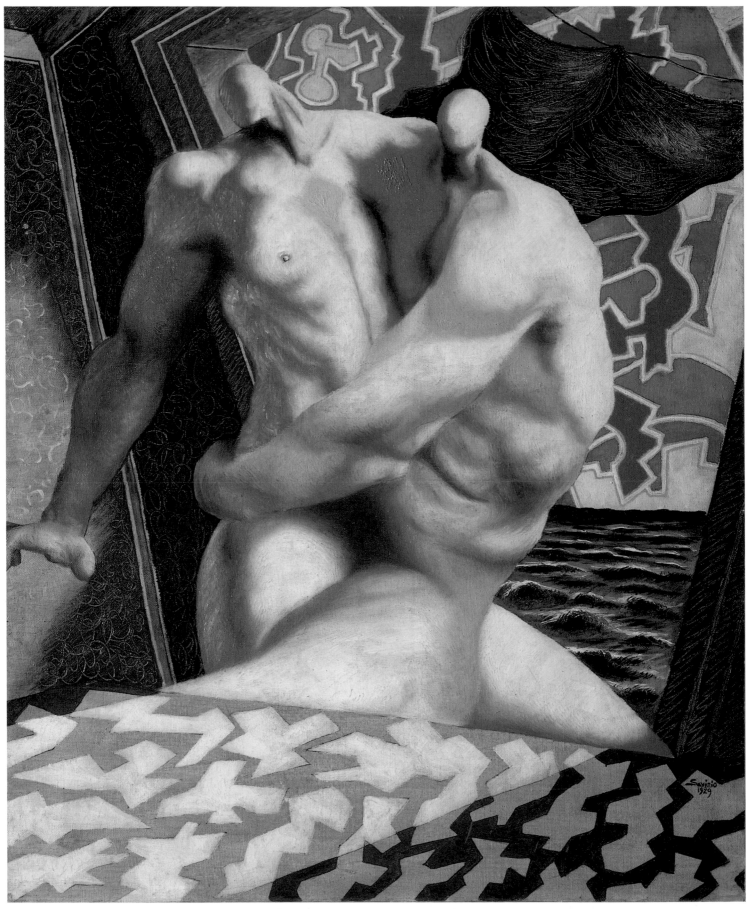

149

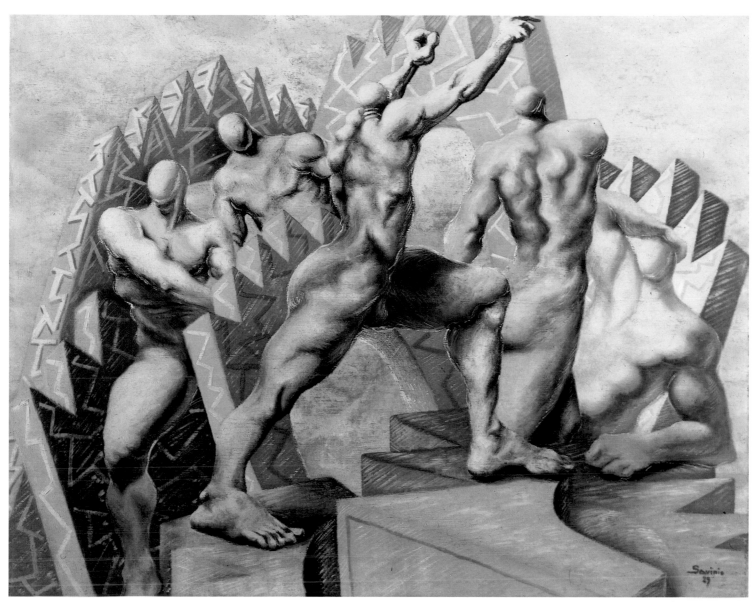

150

150 Builders of Paradise 1929

Oil on canvas, 73 × 91
Galleria dello Scudo, Verona

Savinio believed that the sense of a lost paradise, whether of infancy and childhood or a mythical primal state of being, was a driving force in human psychology. As early as 1921, he argued that art could tap this vein of fantasy and emotion, which was inevitably bound up with the theme of memory:

> Memory was born at the very moment that the exiled Adam crossed the threshold of the Earthly Paradise. It was then that this thought-related faculty was born, so that he and all his descendants would never forget, amid the trials,

tribulations, dangers and threats of death, that state of innocent and endless delight to which in the beginning he had been called, and to which we always hope to return. In short, Memory was born as an instrument whereby desire for the lost happiness might be passed on from man to man. . . . In art, and art alone, does the memory of primal happiness return with full vividness and focus, and become, once again, miraculously, a certainty. ('Primi saggi di filosofia delle Arti', *Valori Plastici*, no. 3, 1921)

In this painting Savinio has created a surreal image of paradise based on elements drawn from childhood and classical archetypes.

The 'builders' belong to the same race of muscular giants as in 'The Return' (cat.149), and their 'heroic' poses appear to imitate those of ancient and academic sculpture. As with photographs by Eadweard Muybridge, the figures seem to move in an endless circle, and this gives the work an appropriate sense of timelessness. The distorted perspective, with the figure in the foreground apparently holding up the wall at the rear, adds to the surreal atmosphere. The strange forms on which the builders walk, and the brightly painted elements of walling, bring to mind children's building blocks. In a discussion of the clear colours and air of suspended action in the paintings of Giotto, Savinio wrote about childhood toys and the suggestion of a lost paradise:

These pure, vivid colours are the same as those that used to shine on the dice, the balls and marbles of my childhood. And over there is my rocking-horse. Art always rekindles the lights of the lost paradise, while the grey hand of the unartistic returns every time to quench them. But Giotto rekindles, not so much the image of the lost paradise, but rather the games that we used to play to pass timeless time, in that light sweet to the touch, in that life lived as in a pearl. Here, as in the art of Ancient Greece, nothing exceeds the strength of man. (*Ascolto il tuo cuore, città*, Milan, 1944)

151 Roger and Angelica 1931–2

Oil on canvas, 90 × 73
Private Collection, Milan

Savinio was particularly fond of the story of Roger and Angelica as told by Ariosto in the famous sixteenth-century poem 'Orlando Furioso'. In 1927 he published a novel entitled *Angelica o la notte di maggio*; and he named his daughter, born in 1928, and his son, born in 1934, after the pair. He based the figure of Angelica in this painting on Correggio's 'Education of Love' (National Gallery, London), but drew his inspiration for the work as a whole from 'Roger Frees Angelica from the Clutches of the Dragon', *c.*1880 (formerly in the Staatsmuseum, Berlin) by Arnold Böcklin. Savinio, like de Chirico, had come to know the work of the Swiss artist while studying in Munich in the late 1900s, and remained a life-long admirer of Böcklin's romantic and mysterious vision of the classical world. In the Böcklin painting, Roger, dressed as a medieval knight, stands on the right of Angelica, and chivalrously attempts to wrap her in a cloak, while at her feet lies the coiled, beheaded dragon. Savinio described the painting as follows: 'The knight opens his cloak to cover Angelica, a German maiden, naked and contorted with shame, while the severed head of the dragon looks up from the ground with an expression full of irony at this spectacle of love, honour, and chivalrous illusions' (*Narrate, uomini, la vostra storia*, Milan, 1942). In Savinio's painting it is Angelica who is love-lorn, while Roger's head has been transformed into that of a cock, an idea

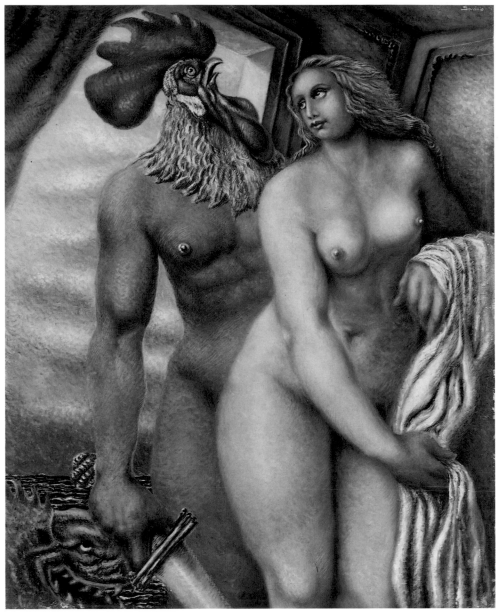

151

suggested perhaps by the plumes of the knight's helmet in Böcklin's picture, or by the Italian term 'gallismo' (literally 'cockerelness') used to indicate strutting male sexuality.

This is one of a series of works by Savinio from the early 1930s, in which figures are represented with animal heads. Perhaps the most extraordinary of these was 'The Wedding of the Cock', *c.*1931 (private collection), in which a bridal party is shown with animal heads and mid-sixteenth-century dress of the kind familiar from portraits by Holbein and Titian. Inevitably such anthropomorphism suggests links with the hybrid creatures of classical myth, or with ancient deities; but Savinio himself said he was fascinated by the idea of using animals to represent a person's character, and also suggested that these creatures, half-human, half-animal, might indicate in some way a desire for a state of perfection or a lost paradise ('Autopresentazione', *Bolletino della Galleria del Milione*, no. 66, 1940).

GINO SEVERINI 1883 CORTONA — 1966 PARIS

Severini was one of the 'Italiani di Parigi', and his life and work reflect the currents that brought together Italian and French art in the new classicism of the 1920s.

His early paintings were typical of turn-of-the-century naturalism, but, under the influence of Balla and Boccioni, whom he met in Rome, he quickly adopted a Divisionist technique inspired by French neo-Impressionism. He moved to Paris in 1906 where he befriended Amedeo Modigliani and the main avant-garde artists and poets of the day. His place in Parisian cultural life was cemented by his marriage in 1913 to Jeanne, daughter of the Symbolist poet and leading literary figure Paul Fort. By this time he had joined the Futurist movement, whose emphasis on the dynamic inter-penetration of form and space he regarded as a development of neo-Impressionism and a response to modern theories of physics and psychology. Combining a neo-Impressionist brushwork and a Futurist fracturing of forms, Severini painted highly coloured depictions of Parisian café life and street scenes which established his reputation as a leading avant-garde artist in the pre-war years.

The year 1916 was crucial for Severini, both emotionally and artistically. His second child Antonio was born, and he experimented briefly with a naturalistic style inspired by the art of the early Renaissance. In subject matter and style, the magnificent painting 'Maternity' (repr. p.12) anticipates the 'return to order' of the 1920s. However, Severini later emphasised that his main concern in this work was the underlying geometry of its composition; he described it and the 'Portrait of Jeanne' (cat.152) as experiments with which he felt no need to continue. It was also in 1916 that he moved away from Futurism and adopted a synthetic Cubist style which was to be the mainstay of his work until 1920.

After the war Severini exhibited with leading Cubist artists at the Galerie de l'Effort Moderne under contract to the dealer Léonce Rosenberg, and was very much involved in discussions about the future development of Cubism. In his auto-biography he recalled visiting Picasso in his studio in 1917 and seeing his Ingresque

portraits of his wife Olga; but Severini was not tempted to follow this stylistic path. He felt closer affinity with Juan Gris, with whom he had long theoretical discussions, and also with the poet Apollinaire, who called for a revival of classicism of spirit and substance rather than simply of style. Seeking a scientific basis for harmony and beauty in art, Severini plunged into a period of intensive study, researching theories of composition and proportion, and deriving from ancient treatises practical lessons on the craft of painting. The fruit of this research came with the publication in 1921 of *Du Cubisme au classicisme: Esthétique du compas et du nombre*. To his great disappointment, the book met with nearly universal condemnation. He might have expected support from the Purist artists Ozenfant and Jeanneret (Le Corbusier) and from fellow Italian artists who were fascinated by the traditional craft of painting; but Severini was criticised on all fronts for what was seen as his over-dependence on mathematics and theory.

By this time Severini had abandoned a Cubist structure of overlapping planes in his works and allowed his subjects, generally still lifes, to exist within a fully three-dimensional space. His squared-up preliminary drawings show that his compositions were far from naturalistic: they were, in fact, rigorously composed according to geometrical principles, and for this reason Severini saw them as a development of his Cubist work. However, contemporaries regarded his new style as an example of the new classicism in modern art, reflecting the conservative tastes of the period.

In 1921 Severini returned to Italy to execute a cycle of frescoes on the theme of the *commedia dell'arte* in the house of Sir George Sitwell at Montegufoni near Florence. This was a major commission which marked a turning point in his career, not least because it allowed Severini to put into practice many of his ideas, and confirmed him in his love of this characteristically Italian subject matter. It was perhaps no coincidence that while reaching for the artistic absolutes in the laws of mathematics and geometry, he turned towards Catholicism. He became friends with Jacques

The artist, 1920

Maritain, a leading Catholic intellectual, through whom he received important commissions in the mid-1920s to decorate churches in the canton of Fribourg, Switzerland. Severini was one of the first modern Italian artists to begin to experiment with the ancient techniques of fresco and mosaic in large-scale church decorations.

Severini always maintained contact with developments in Italy. He exhibited at the Rome Biennale in 1923 and 1925, and participated in both major *Novecento Italiano* exhibitions. In the late 1920s and early 1930s Severini, with de Chirico, Savinio, Campigli, de Pisis, Tozzi and Paresce, appeared in a number of exhibitions in France and Italy devoted to the 'Italiani di Parigi'. The French critic Waldemar George was closely involved in these exhibitions and wrote admiringly of a new

Mediterranean 'magic realism', based on a fruitful reworking of national traditions, in particular the Quattrocento. Although Severini was opposed to narrow nationalism, he like many other leading artists of the period was fascinated by the painting and architecture of Ancient Rome, which he interpreted in a modern allegorical and decorative idiom. During the 1930s he worked on further church commissions, and in 1933 participated in the prestigious mural decorations of the main room of the fifth Triennale in Milan, alongside Campigli, de Chirico, Funi and Sironi (his mosaic 'The Arts' is the only one of these works to survive). From 1936 to 1946 he lived in Italy, but after the Second World War he returned to Paris where he worked on a number of large-scale decorative projects, and revived his earlier Futurist and abstract styles.

152

152 Portrait of Jeanne 1916

Oil on canvas, 46 × 38
Private Collection

In his autobiography Severini wrote movingly about this difficult period in his life. He and his wife Jeanne were delighted with the birth of their second child Antonio, but were in desperate financial straits and uncertain health. Unable to keep Antonio in their cramped flat, they decided it would be best if the baby were sent to a wet-nurse on the outskirts of Paris. Before his departure Severini painted a portrait of Jeanne breast-feeding the baby. It was executed in what Severini called a simple manner, reminiscent of the Tuscan Primitives of the early Renaissance. The painting, entitled 'Maternity' (repr. p.12) is faithful to his model, but, according to Severini, it was not the work's naturalism so much as its underlying geometrical composition which interested him most as an artist. Without doubt it also had a very strong personal significance for him. He later wrote in his autobiography: 'I still have this painting and I never intend to be separated from it, it is part of my personal collection along with another, done in the same idiom and at the same time – the portrait of Jeanne aged eighteen' (*La vita di un pittore*, 1946). With its soft colours and heightened light, this portrait is reminiscent of Renaissance frescoes; but it is also a naturalistic portrait of the young Jeanne in a pensive, wistful mood. The child died shortly afterwards, partly because Severini

was unable to afford the specialist medical attention he needed. The funeral was attended by all their friends in Montparnasse; 'from Picasso to Kisling,' he wrote, 'no one abandoned us.'

Both the 'Portrait of Jeanne' and 'Maternity' were exhibited in a mixed show at the Galerie de Mme Bongard in 1916. Severini remembered how the Cubists, especially Metzinger, were extremely irritated by the new style of these works; but others saw the paintings as proof of his pictorial talent (indeed, he had painted them, he said, partly to display his skill). In their combination of naturalism with stylistic and thematic references to tradition, these works appear to anticipate the later 'return to order' (they are a full year earlier than Picasso's Ingresque portraits of his wife). Severini, however, saw them at the time as

one-off experiments, and continued with his exploration of synthetic Cubism for the next four years. In his memoirs Severini distinguished between these early neo-Renaissance works and his classical paintings of the 1920s:

I had already satisfied the need to turn . . . to forms still close to concrete reality (though transcended sometimes by style), and so, in a sense, had worked it out of my system with the 'Portrait [of Jeanne]' and 'Maternity'. . . . As Apollinaire said to me one day . . . these essentially representative forms belong to a language of the past, that cannot be entirely forgotten when one is constructing a new language, which in its own way is also representative of external reality and does not exclude its predecessor.

153

153 Still Life with Brown Jug
1920

Oil on canvas, 33 × 55
Rijksmuseum Kröller-Müller, Otterlo

In the period 1916–19 Severini focused almost entirely on still lifes, using the familiar Cubist repertoire of bottles, glasses and fruit. Over the course of 1919, however, he based his works increasingly on theories of geometry and proportion, as his careful preliminary drawings show. At the beginning of the following year all traces of Cubist planes and arbitrary fracturing of forms were eliminated from his works and replaced by a naturalist three-dimensionality. The new works had an overtly traditional air: often executed in tempera, their bright colours and heightened light echoed early Renaissance art, while their ordered composition recalled the tradition of Chardin. However, their modernity was still evident in their flatness of style and use of shifting viewpoints, a continuing point of contact with the works of Cézanne and the Cubists.

Severini painted this work and another, now lost, during a three-month period of convalescence at Langrune-sur-Mer on the Normandy coast. In his memoirs he wrote that even though 'they turned out well, [Léonce] Rosenberg did not like them initially, but he later changed his mind, as he often did, and said that they were among the best that I have given him'. Severini's works sold well in the 1920s, and this classicised rendering of a Cubist repertoire of still-life objects – with the addition of an earthenware jug, a recurrent feature of many Italian still lifes in the 1920s – was no exception. It was bought from Rosenberg by the Dutch collector Mrs Hélène Kröller-Müller probably as early as 1921.

154 Conjugated Projections of the Head *c.*1920

Indian ink on paper, 74 × 90
Gina Severini Franchina

Towards the end of the First World War
Severini set out to study the practical and
theoretical aspects of painting. Other artists,
such as Ozenfant and Gris, also tried at this
time to base their work on an understanding
(which Severini dismissed as being rather
vague) of the so-called universal laws of
harmony and proportion in art; but Severini
was perhaps unique in his determination to
seek out a genuinely rational and scientific
basis for these laws. He read many treatises
on proportion, from Vitruvius to Leon
Battista Alberti, from Viollet-le-Duc to
Choisy. He discussed the mathematical
basis of colour harmonies with Charles
Henry, the Sorbonne professor whose
theories had had a great impact on the neo-
Impressionists; and he studied mathematics
and geometry with Raoul Bricard at the
Conservatoire Nationale des Arts et
Métiers. It was Bricard who helped him to
understand the system of orthogonal projec-
tions first developed by Dürer. Severini's
mastery of that technique is displayed in
this drawing, which delighted Bricard.
Severini himself was equally pleased with
the almost magical effects of his new-found
ability to project an image seen from any
view. He wrote in his memoirs:

> The impression of life that emanates
> from certain forms is in fact extra-
> ordinary when they are conceived solely
> by the intellect, when they proceed from
> pure geometry to an albeit remote imita-
> tion of reality. They give rise to intense,
> vivid emotion. I then understood how
> certain great masters of the past, such as
> the Greeks, could have represented life
> by building according to number or
> geometry.

In *Du Cubisme au classicisme: Esthétique du
compas et du nombre*, published in 1921,
Severini used this and other similar draw-
ings to show how knowledge of such tech-
niques could allow artists to escape direct
dependence on nature. Severini began his
book by describing the modern anarchy in
art, caused, he claimed, by the abandon-
ment of an architectural understanding of
painting after the Renaissance, and an ill-
judged reliance on the individual and on
sensations. Later artists such as Ingres and
Signac, he wrote, had aspired to classicism,

154

but had no clear theory on which to base
their work. Cézanne had wanted to 'redo
Poussin after nature'; but he and even the
Cubists, Severini said, relied on subjective
sensation. For his part, Severini claimed
that 'art is the realisation of an ideal that lies
between the reality of knowledge or con-
ception, and the reality of vision'. The
importance of techniques, such as Dürer's
orthogonal projections, was that they pro-
vided a basis on which to construct images
independently of nature, and placed the
artist on the same footing as an architect or
engineer.

Severini's book was widely condemned
for what seemed its excessive faith in math-
ematics and geometry. The author felt that
these criticisms were more than a little
unfair, as he had intended his discussion of
techniques not as an end in itself, but as an
aid to expressing emotion. But, as the
hostile response to the book showed, his
failure to link an understanding of classi-
cism with the poetic and human aspects of
art had caused him to fall foul of the overtly
humanistic values that lay at the heart of the
'return to order' movements in both France
and Italy.

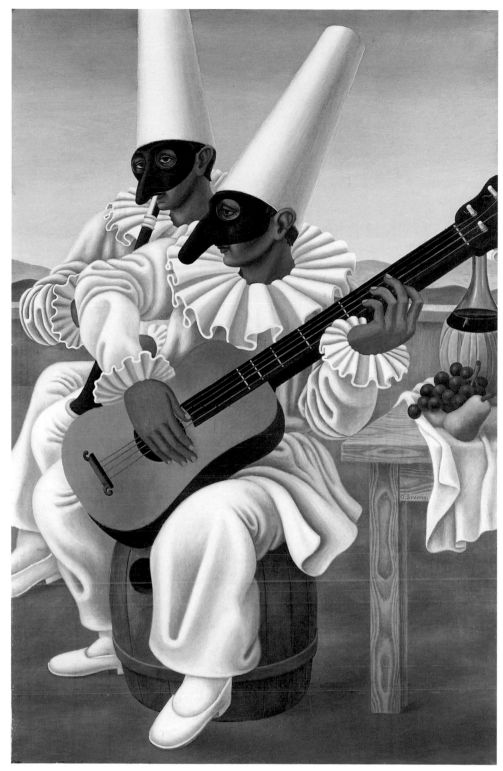

155

155 The Two Pulchinellas 1922

Oil on canvas, 92 × 61
Haags Gemeentemuseum, The Hague

Severini had first used the imagery of masked figures and harlequins (which were popular with many artists associated with the Galerie de l'Effort Moderne) in his Cubist works of 1918. The costumes' chequered patterns and the dehumanising effect of the masks lent themselves well to a Cubist treatment, while the harlequin figure signalled reference to the *commedia dell'arte* scenes of the French eighteenth-century artist Watteau and, more eliptically, to the idea of the modern Cubist painter as a play actor and jokester. Severini made the subject of the *commedia dell'arte* his own in the early 1920s, and went on using the imagery of masked and melancholic figures throughout his career. He never explained his fascination with this theme, saying simply that the characters from this form of popular theatre gave him pleasure; but it seems clear that he identified at some level with the stories of the loves and losses of Pulchinella, Harlequin and Columbine. He had begun to explore the subject before receiving in 1921 a commission to decorate a room in the home of Sir George Sitwell in Montegufoni, near Florence; but this commission, in which he used the traditional technique of fresco painting and applied classical concepts of order and proportion, proved a turning point in his career. The Montegufoni paintings of masked musicians, set against an illusionistic Italian landscape, with luscious still-life scenes of wine and fruit, provided Severini with many of the themes of his later works, and marked the beginning of his engagement with this obviously 'Italian' subject matter.

'The Two Pulchinellas' was painted immediately after his return to France, during the summer months of 1922 which he spent at Vallorcine in the Haute Savoie. He later wrote in his autobiography that this was one of his best works of this period. The painting has a disturbing and haunting quality: despite the traditional nature of its subject matter, the picture's heightened colours and crystalline clarity create a strangely dream-like atmosphere, reminiscent of de Chirico's earlier metaphysical works.

156 Portrait of Gina (Homage to Fouquet) 1927

Oil on wood, 31 × 22
Gina Severini Franchina

This portrait of his daughter Gina, together
with a pastel of his wife, marked Severini's
return to small-scale works after his fresco
decorations of the churches of Semsales in
Fribourg, Switzerland, in 1925–6. Painted
on panel, this work may from the start have
been intended to be, as its subtitle indicates,
a homage to the fifteenth-century French
artist Jehan Fouquet, whose portraits com-
bined Flemish-style realism with a Gothic
stylisation. The style and colour range of
this small, intimate portrait, as well as
Gina's simple costume and bobbed haircut,
suggest a vague late medieval influence.

Severini's interest in Fouquet and
French Renaissance painting as a whole can
be seen as a minor aspect of his engagement
with the art of the past. He had studied the
methods of Flemish painting, notably Van
Eyck, in the late 1910s; and in the prospec-
tus for the school of art he attempted to
establish in 1923 he had offered to teach the
'techniques of the pictorial arts of the Italian
and Flemish traditions'. Furthermore, in his
autobiography Severini cited particular
works by Fouquet in refutation of the claim
made by Alberto Savinio that French art
was inherently naturalistic and lacking in
philosophical depth. Unlike many other
Italian artists, Severini did not base his
contribution to the 'return to order' simply
on the model of Italian Renaissance art;
instead, he ranged widely and absorbed
many different traditions and themes in his
anti-naturalistic vision of classicism.

156

157

157 Still Life with Pumpkin and Mask *c.*1930

Oil on canvas, 60 × 49
Galleria d' Arte Moderna, Palazzo Pitti, Florence

This is one of a number of works by Severini which were inspired by Roman decorative paintings. Archaeological excavations, in particular those at the Villa dei Misteri at Pompeii, had had enormous impact on many leading Italian artists, including de Chirico, Savinio, Funi and Campigli. These painters were concerned to create a decidedly 'Italian' modern art incorporating allusions to Italy's past, a tendency paralleled by the government's attempt to reinforce its claims to authoritarianism by appeals to imperial Rome. Although critical of narrow nationalism, Severini was greatly attracted to the historical and mythical aspects of Ancient Rome, and in the late 1920s and early 1930s he sought to reinterpret Roman art in a modern vein, combining archaeological ruins, musical instruments, fruit and birds in a style that recalled both Pompeian and Byzantine art. The speckled brushwork in this work recalls the surfaces of the ancient mosaics he admired, while the collection of objects has a mysterious emblematic quality. The painting was exhibited in the Venice Biennale of 1932; and in the catalogue Severini wrote that he had relaxed his former insistence on rule and order in art, and now sought to draw out from objects what he called their spiritual reality. The dream-like quality of this and other still lifes of the early 1930s can be seen as secular, almost surreal, counterparts to the sacred iconography in his earlier religious paintings.

MARIO SIRONI 1885 SASSARI – 1961 MILAN

In the 1920s and 1930s Sironi was widely regarded in Italy as one of the most gifted artists of his generation. However, his sympathy for the Fascist movement led to a sharp decline in his reputation after the Second World War, and only in recent years has his work begun to be seriously reappraised.

He was born on the island of Sardinia but spent nearly all his childhood and youth in Rome. He studied engineering at the university of Rome, but severe depression forced him to abandon his studies after only a year, and in 1903 he decided to devote himself to painting. He attended the Scuola Libera del Nudo and worked in the studio of Balla through whom he became friendly with Boccioni and Severini, later key figures in the Futurist movement. What survives of his early work shows him to have been a gifted naturalist painter using a Divisionist technique inspired by Balla. This period of artistic apprenticeship coincided with crippling bouts of self-doubt and melancholy which were to recur throughout his life. In 1910 Boccioni wrote to Severini about the troubles of their mutual friend:

> Sironi is completely mad. He is totally closed in on himself and never goes out of the house. . . . he does not speak or study any more: it really is very sad. They were on the point of locking him up in a sanatorium. Imagine, he has the house full of plaster casts and copies a Greek head from all directions 20 or 25 times!! Naturally, he disapproves of us.

Encouraged by the example of his friends, Sironi began to work in a Futurist style in 1912, and was formally accepted into the group three years later. As a Futurist artist he was interested less in movement or 'lines of force' than in portraying the power of the modern industrial world. His paintings of this period were remarkable for their solidity of form and expressionistic qualities. The Futurists welcomed the outbreak of war, which they saw as Italy's chance to develop a more aggressive spirit; and Sironi, along with his friends, volunteered for military service in 1915, and served at the front. Following a small victory, the group issued a Futurist manifesto entitled 'Orgoglio Italiano', celebrating the 'creative genius' of the Italian people and its capacity to wage war. Towards the end of the war, Sironi became aware of the metaphysical works of de Chirico and Carrà, as his paintings of mannequins suggest; but, in stark contrast to the irony and sophisticated classicism of the works of these artists, those of Sironi were dominated by a sense of drama and an intense physicality.

Following his discharge from the army, Sironi did a series of works on the theme of the industrial suburbs, showing grim factory buildings with soulless streets, animated only by trams or horse-drawn carts. The emphasis in these paintings on simple geometrical shapes has been seen, at least in part, as a response to the 'return to order' movement in France, and in particular to the ideas expressed in the periodical *L'Esprit Nouveau*. Sironi was fully aware of the new trends sweeping Europe, and was one of those responsible for a manifesto entitled 'Contro tutti i ritorni in pittura' issued in 1920. In this it was noted that a number of French Cubist artists had begun to imitate Ingres, that certain German Expressionists were copying the sixteenth-century master Grünewald, and that in Italy former Futurists were looking to Giotto. These painters were seeking 'support and Dutch courage in a pure and simple return to the all too familiar manner and forms of the ancients', and they were urged instead to develop in their work a 'new structural synthesis'.

Sironi's urban landscapes were partly inspired by his search for a new way of painting which would combine the avant-garde qualities of Futurism with a stable and disciplined pictorial structure; but, as in all his works, there was also an element of the artist's own emotional response to his subject matter. Painted in sombre blacks and browns, the townscapes display at times a near apocalyptic quality. The post-war period was marked by social and political turmoil in Italy, with widespread industrial unrest that culminated in the occupation of northern factories in the early autumn of 1920. The urban proletariat and the industrial suburbs (where many of the factories were located, particularly in Milan) were thus at the forefront of the political agenda

The artist in his studio, c.1936 (Photo: Dott.ssa Claudia Gian Ferrari)

when Sironi painted his street scenes; but, as was so often the case with his paintings (though not, of course, his political illustrations), his works lacked an obvious political content and expressed instead a personal melancholy and pessimism.

Sironi's sympathy with the Fascist movement (founded in Milan in 1919) is well known. From an early date he contributed drawings and later on art reviews to Mussolini's newspaper *Il Popolo d'Italia*; he accepted major State commissions in the 1930s; and after 1943, he gave his support to the Republic of Salò, Italian Fascism's last and most radical incarnation. However, what is less clear is the extent to which Sironi's political views can be seen as influencing his art. Like many veterans of the First World War, he would have been

deeply hostile to the Socialist party, which had opposed intervention in the war. None the less, his drawings and paintings of ordinary workers always showed sympathy for their plight, and he may well have shared the socially progressive views of many of his Futurist friends who in 1918 had called for political and social reforms, including an eight-hour working day, the right to strike, unemployment benefit and equality for women.

The manifestos signed by Sironi in the inter-war years show him to have been a fervent nationalist who hoped that the Fascist movement would restore and promote the confidence of the Italian 'race'. He also shared the aspiration held by many to see a progressive modern Italian art associated with the new regime. Immediately after Mussolini formed his cabinet in 1922, for example, a number of writers and artists, including Sironi, Carrà and Funi, published a statement in *Il Principe*: 'We are confident that in Mussolini we have the Man who knows how to value correctly the strength of our world-dominating Art.' Margherita Sarfatti, the main organiser of the Novecento group of artists in Milan, and Mussolini's mistress, was particularly successful in developing links between the style and aims of Novecento art and the rhetoric of the new Italian state. Mussolini himself, however, although he inaugurated Novecento exhibitions in 1923 and 1926, never officially endorsed any particular group or style of art.

From the early 1920s Sironi started to deploy overtly classical themes in both his paintings and political cartoons. Although this may have been the result of his own tastes and interests (Boccioni had mentioned Sironi's copying classical statues in 1910), such imagery, with its echoes of the Roman imperial past, quickly became identified with the regime. Sironi, indeed, with his numerous political illustrations (979 in *Il Popolo d'Italia* and 784 in *La Rivista Illustrata del Popolo d'Italia*), was instrumental in elaborating the alliance between classical motifs and the values of the Fascist state, although he was severely criticised by right-wing extremists in the 1930s for the individualistic and artistic concerns of his work and its lack of ideological content.

Sironi exhibited in the first Novecento show organised by Margherita Sarfatti in Milan in 1922, and from then onwards he was one of the leading figures of the movement, helping to organise group exhibitions at home and abroad. Sarfatti had known Sironi since the earliest years of the war, and admired the formal qualities of his paintings, based, as she wrote in 1924, on ideals of 'concreteness and simplicity'. However, the geometry and stylisation of Sironi's works in the early and mid-1920s gave way towards the end of the decade to a looser, painterly style, inspired by a more primitivist and mythological vision of classicism. In 1931 he won second prize at the Carnegie Institute in Pittsburgh, and thereby achieved international recognition as one of Italy's leading artists.

Sironi's 'Manifesto della pittura murale' of 1933, which was signed also by Campigli, Carrà and Funi, claimed that in function, scale and technique mural painting was the embodiment of a truly popular art and expressed the ideals of the Fascist state. By this stage he had come to reject easel painting and the commercial market, and longed for a collective, community-based style of art. Consequently, Sironi devoted most of his energy in the 1930s to large-scale works in public places. Among his most important commissions in this period were a monumental stained-glass window, entitled 'Work', for the Palazzo dell'Industria in Rome in 1931–2, 'Italy between the Arts and Sciences' for the university of Rome in 1935, and the bas-reliefs 'The People of Italy' for the Palazzo del Giornali in Milan in 1939–41. Sironi returned to easel painting in 1943, and after the war he lived and worked in relative isolation in Milan, bitter that his work was not understood, and shunning publicity.

158 Composition – Urban Architecture *c*.1923
Oil on canvas, 58 × 80.3
Galleria dello Scudo, Verona

At the end of the First World War Sironi focused on the theme of the urban landscape. His scenes of tenement and factory buildings with deserted streets were stark and simple, and this austerity added to the pervading air of melancholy and desolation. In 1921–2, however, under the influence of contemporary calls for a new classicism in art, Sironi jettisoned the elements of social realism in his earlier works, and turned to overtly classical motifs. The factories gave way to cupolas, columns and arches, while the expressionistic raking perspectives and often crude handling of paint were replaced

by a new 'classical' frontality of composition and smoothly painted surfaces. In 'Composition – Urban Architecture' Sironi combines a Roman portico and Roman arches with unadorned, modern-looking buildings, overlooked by a late Renaissance or early baroque cupola. The improbability of this arrangement suggests (and the word 'Composition' in the title underlines the suggestion) that the imagery is partly a pretext for exploring the relationship of forms and volumes. As this and other works make clear, Sironi chose to work from memory and imagination, combining favourite elements at will. The imaginative quality of this painting and its air of romantic grandeur recall some of the neoclassical fantasies of late-eighteenth-century architects such as Boullée and Ledoux. Bathed in the gloom of dusk or dawn, the painting has an intensity in which light and dark, and the conflicting forces of order and emotion, seem to be only just held in balance.

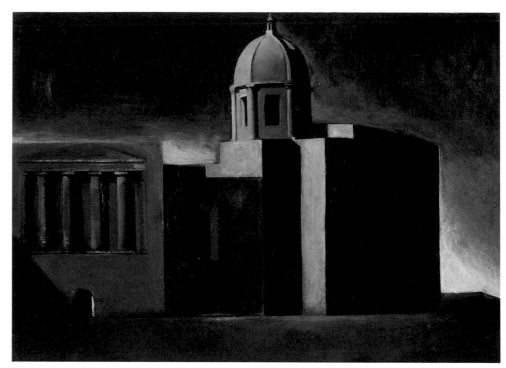

158

159 Self-portrait 1922–4
Pencil on paper, 32 × 24
Fondazione Antonio Mazzotta, Milan

As this drawing and a related painting entitled 'The Architect', 1922 (private collection), indicate, Sironi preferred to depict himself as an architect, rather than a painter. He had briefly studied engineering as a young man, and throughout his life retained a fascination with mathematics; but in showing himself here with a set of dividers, an instrument of measurement, he was consciously alluding to the tradition of the artist as 'pictor–artifex'. With its pursuit of rational structures based on laws of proportion and harmony, architecture was regarded in the classical and Renaissance periods as the highest form of art, allowing man to approach most nearly to divine creation. The theme of the 'craftsman' was much in vogue in post-war Italian art, and carried with it nationalist connotations of pride in the country's artistic traditions. Carrà, for example, proclaimed in 1919, 'we are a great race of contructors'; and the emerging Novecento movement attached much importance to the qualities of precision and control embodied by architecture.

159

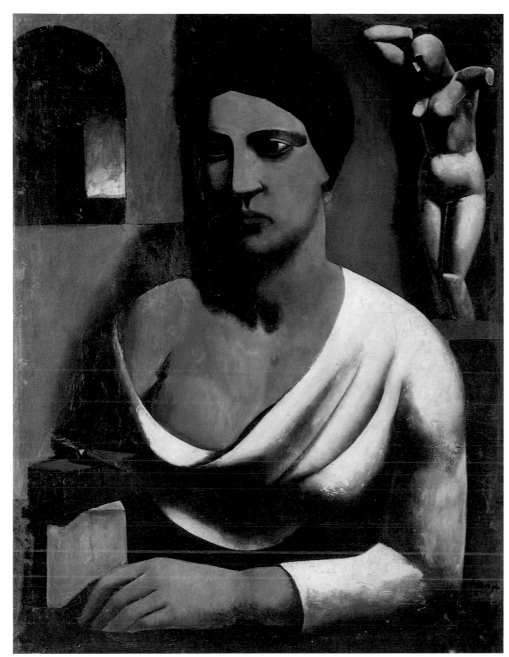

160

160 The Sculptor's Model *c.*1923–4

Oil on canvas, 71 × 53
Private Collection, Rome

Sironi made a number of works in this period showing solitary figures against a background of classical architectural features and symbols of studio practice. The combination of the woman and the statue recalls similar subjects in paintings by, for example, de Chirico, where past and present, animate and inanimate, are juxtaposed in a disturbing manner. Here, however, there is no contrast or ambiguity in the reality of the elements: they are all simplified into harmonious volumes and suggest a world of ideas or ideal forms rather than a naturalistic scene. The woman is particularly idealised: she is posed formally as in a Renaissance portrait, although her clothes suggest classical drapes, while her features are vaguely reminiscent of the women in Picasso's neoclassical paintings of this period.

In its combination of concern for plastic forms and archaic subject matter, this work can be seen as a response to the ideals of the Novecento movement, of which Sironi was a founding figure. The emphasis, so apparent here, on clearly defined and modelled shapes epitomised the value that Margherita Sarfatti, the group's guiding force, placed on solidity and simplicity, qualities judged to be both avant-garde and the quintessence of the Italian tradition.

161 Maternity 1923

Pencil on paper, 31 × 21
Aglae Sironi

162 Male Figure 1923

Pencil on paper, 27 × 19
Aglae Sironi

163 Female Figure 1926

Pencil on paper, 30 × 24
Aglae Sironi

Sironi was a gifted draughtsman and is known to have spent much time copying and reinterpreting the works of the old masters.

In both subject matter and composition 'Maternity' recalls works of the High Renaissance. The heavy *sfumatura* and incompleteness are reminiscent, in particular, of drawings by Michelangelo, while the head of the Madonna figure has a Raphael-like quality to it. The pose of the supplicant figure to the right is similar to that of the distraught Mary Magadalen in fourteenth- and fifteenth-century crucifixions. Yet, for all these references to the past, the dress of the woman and the architectural style of the buildings in the background can be interpreted as modern, making it possible to read the scene as one of a working-class mother and child against the backdrop of an industrial city.

In 'Male Figure', the man's pose seems to be directly inspired by Michelangelo, while the background of pillars and ghostly figures has a strange, North European, Gothic feel to it. Sironi made a number of drawings showing skeletal people hovering behind male figures, and it is possible that this theme reflected his innate pessimism which earned him the epithet of 'tragic artist' in Giovanni Scheiwiller's monograph of 1930.

The style and composition of 'Female Figure' recall works of the late Renaissance, in particular, perhaps, the paintings of Bronzino.

164 Solitude 1925

Oil on canvas, 103 × 85
Galleria Nazionale d'Arte Moderna, Rome

This painting was first shown in Milan in 1926 at the *Novecento Italiano*, an exhibition of the work of over a hundred contemporary Italian artists. Widely reproduced in the

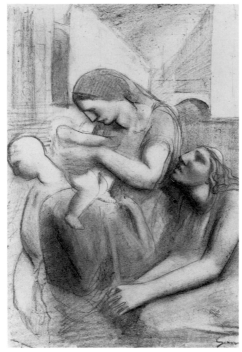

161

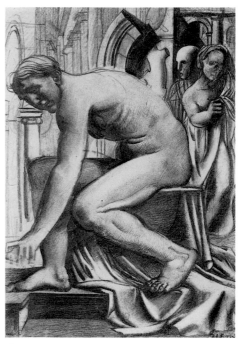

162

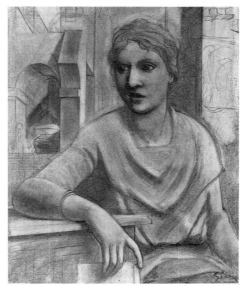

163

daily newspapers, it quickly became one of the best known works on display, and was bought in the same year by the Galleria Nazionale d'Arte Moderna in Rome. One critic wrote that Sironi's own 'desolation' found in this painting 'its truest and most sincere expression'.

Sironi was beginning at this time to move away from his preoccupation with pure forms and architectural composition towards a more personal vision of classicism. In his illustrations for Fascist periodicals such as *Gerarchia* and *Il Popolo d'Italia*

Sironi used images of classically draped figures and Roman architecture from as early as 1922 to express the ideals of the regime; but in paintings such as 'Solitude' he was evidently more concerned to express an essentially tragic view of human life. The monumentality of the figure is not only classical and modern but also strangely primitive; and from this point on, Sironi was to embrace a mythopoeic vision of classicism, increasingly removed from his former, almost Purist view of pictorial construction.

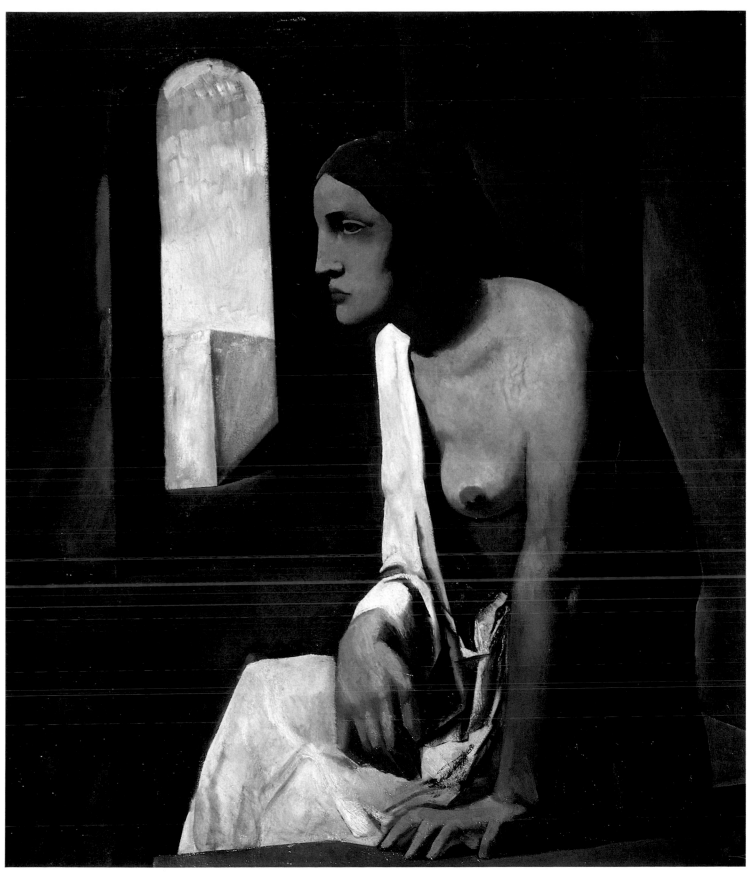

164

165 The Miner's Family 1929

Oil on canvas, 150 × 120
Private Collection

In the late 1920s and early 1930s Sironi
produced a number of pictures on the
themes of the family and of work, both
subjects central to the ideology of the
Fascist regime. Here Sironi presents a typi-
cally idealised vision of the family in which
the mother resembles a Renaissance
Madonna. Sironi's sympathy for the poor is
evident from many of his drawings in the
early 1920s, but towards the end of the
decade he began to remove all sense of class,
region or period from his images of workers,
focusing instead on more or less archetypal
shepherds and farmers. The drudgery of
their lives was no less than that of their
earlier urban counterparts, but was pre-
sented in these later works as inescapable
and natural. In attempting to suggest
grandeur and monumentality, Sironi's male
figures often appear overblown in scale.
However, the monstrous element that
creeps into the portrayal of the 'miner' in
this and other works may have an unex-
plained personal meaning.

This painting was first exhibited in *Nove-
cento Italiano* in Prague in 1929, but has
remained little known since then.

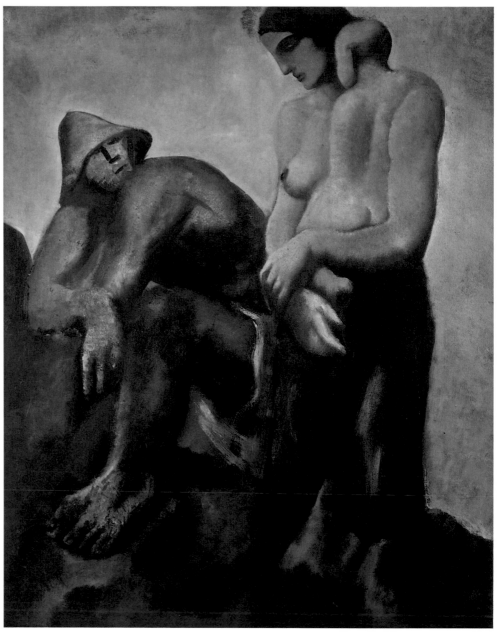

165

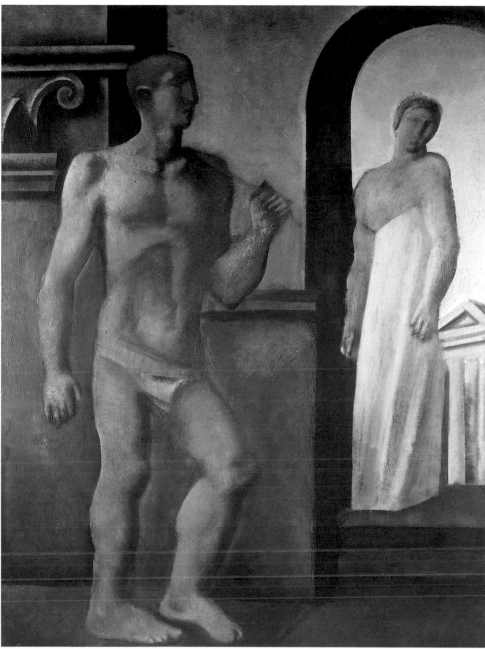

166

166 Architecture with Vestal Virgin and Athlete 1929–31

Oil on canvas, 121 × 92
Private Collection, Milan

The references to imperial Rome in this and other works by Sironi may be seen as reflecting attempts by the Fascist regime in the late 1920s to exploit the imagery of Ancient Rome for nationalistic purposes. The male figure, for example, recalls the monumental statues of Roman athletes that were used to decorate the Foro Mussolini in Rome in the late 1920s. Significantly, however, this is not a work of propaganda (indeed, Sironi was an outspoken critic of the vacuous and kitsch representations of classical themes found in the work of untalented apologists of German Fascism and Italian National Socialism). The misty, romantic atmosphere surrounding the figures, and their imprecise representation, impart a mythical quality to this painting which make it very different from the illustration-like style of propaganda works. Most of Sironi's pictures of this period deal with the themes of rural work and the family, and this overtly classical subject is therefore something of a departure for him. The painting was first reproduced in a monograph of 1944 and was not exhibited until 1985.

167 Untitled *c.*1933

Tempera and charcoal on paper,
232 × 211
Private Collection

This cartoon-sized drawing remained in Sironi's studio throughout his lifetime, and was only mounted on to canvas in recent years. It does not seem to relate to any known final work, but is typical of Sironi's mural style of the early 1930s.

In these years Sironi attempted to forge a style and imagery that expressed his vision of a popular national art. Uppermost in his mind (and in a sense the ideal to which he aspired) was the Renaissance, and in particular its frescoes and large-scale decorative pieces; and it is possible to see in the solid, sculptural quality of the figures in this drawing, and their immobile poses, echoes of works of early Renaissance masters such as Masaccio and Mantegna. At the same time, the emphasis here on monumentality and grandeur – as in other works of Sironi

from this period – echoed the concern of the regime to foster heroic and martial qualities in the Italian people.

In late 1933 Sironi and three other major contributors to the fifth Triennale in Milan, Campigli, Carrà and Funi, issued a manifesto in which they attempted to present mural painting as the most suitable form of Fascist art. The manifesto, which was written by Sironi, began, 'Fascism is a way of life: it is the very life of Italians.' It went on to say that true Fascist art should be social art, without any avant-garde cliques or coteries, or any of the individualism and experimentation of late nineteenth- and early twentieth-century painting. Mural painting, the text continued, provided artists with the chance to influence the popular imagination; and the rigours of its technique would constrain emotions and temper facile virtuosity. What was essential was not so much the subject matter of these murals but their ethos, which was to be consonant with that of the Fascist party. 'In order to keep in step with the spirit of the revolution, the style of Fascist painting must be simultaneously ancient and brand new.'

Sironi derived his mural style of the 1930s from a range of artistic traditions in Italy, among them Byzantine, Pompeian, Etruscan and Romanesque. He was particularly intrigued by exaggerated proportions, which in his eyes signified a vernacular or popular influence. At the same time, he defended the idea of art as a representation of daily reality. He thus opposed the backward-looking antique classicism favoured by sections of the government, and was outspoken in his criticism of propagandist and kitsch art. Although Sironi continued to receive official commissions throughout the 1930s, his work was the subject of bitter controversy. He was disliked by supporters of the modern movement for what was seen as his stale revival of ancient styles, but he was also condemned by right-wing Fascist commentators for being too avant-garde and individualistic. Roberto Farinacci, a former secretary of the Fascist party who led a campaign against Novecento art, accused Sironi of a 'Jewish' intellectualism that was fundamentally anti-Fascist and anti-Italian. This controversy cost Sironi his job as art critic for Mussolini's newspaper *Il Popolo d'Italia*, and led to his not being invited to

167

exhibit in the Venice Biennale of 1934. One of his very few supporters at this time was the critic of *La Stampa*, the artist Alberto Savinio, who wrote:

I must in fairness acknowledge that Mario Sironi is one of the very few Italian artists who in themselves are a credit to the new artistic civilisation of Italy. Many people extol this new civilisation in words but very few make a real contribution to it. Sironi has not only made a real contribution to Italian art today, but has largely shaped it with his own hands. . . . He is one of our very few artists of whom one could use the words style, spirit and thought. The profound seriousness of his art imposes respect. (2 June 1934)

CARLO SOCRATE 1889 MEZZANABIGLI – 1967 ROME

Socrate spent most of his youth in Argentina where his parents, who were actors, had moved when he was a child. He returned to Italy before the war and studied art in Florence. In 1915 he took a studio in the Villa Strohl-Fern, a centre for artists close to the Villa Borghese in Rome. He mixed in the literary and avant-garde circles associated with the 'terza saletta' of the Caffè Aragno, and was friends with such artists as Antonio Donghi and Virgilio Guidi. Socrate was initially much influenced by the late-Impressionist painter Armando Spadini, who was greatly respected by both traditional critics and younger artists. However, he became acquainted with the works of Cézanne through exhibitions of the Rome Secession group, and this encouraged him to seek a solid geometrical basis for his compositions.

Socrate had had experience of painting stage scenery for his parents, and in 1916 he worked on the sets for a production of *Las Meninas* by the Ballets Russes during its tour of Italy. This led to a meeting with Picasso, who arrived in Rome in February 1917 to work on the sets for the ballet *Parade*. While living in Argentina Socrate had learnt Spanish, and this provided an obvious basis for friendship between the two men. Socrate followed Picasso back to Paris to assist him with the scenery for *Parade*, and while there met many of the leading avant-garde artists of the day. He and Picasso travelled to Barcelona and Madrid, and visited the Prado where, Socrate later recalled, Picasso spoke with passion of the 'timeless blacks' of Velázquez, and Rubens's 'fiery genius'.

Inspired by Picasso's renewed interest in traditional art and the climate of the 'return to order' in Paris, Socrate began imitating the old masters on his return to Italy in July 1918. The resulting paintings, chiefly still lifes, were initially not well received; but in the early 1920s critics began to discuss his work in terms of a new classicism, and he quickly became seen as one of the major new talents of the period. Socrate's sense of quality in art, based on the standards of the museums, and his reworking of traditional subject matter, led him to exhibit with the *Valori Plastici* group in the Florence Prima-

verile in 1922. Paintings by him were also included in the first *Novecento Italiano* exhibition held in Milan in 1926, and in the smaller show of ten Novecento artists held in Rome in the following year.

The challenge of reconciling tradition with modernity in the new post-war climate of the 'return to order' inspired Socrate to some of his best work. He continued to paint in a traditional vein for the rest of his career, but his compositions no longer had the same sense of underlying order and discipline. However, as a statement in the catalogue of the Rome Quadriennale of 1931 shows, he remained faithful to the themes and concerns that had inspired him since his return from Paris in 1918:

> For me, form alone has quality and value, not technical facility, nor routine (which is the original sin of art), nor originality made by upsetting things. . . . My main concern is to arrive at quality. . . . My favourite masters are Caravaggio, Courbet and Cézanne. In imitating nature, my aim is to imitate its creative forces, and not its material and empirical aspects. Natural forms are a pretext, and serve simply to justify creation.

The artist in the studio at the Villa Strohl-Fern, c.1915

168 Girl Carrying Fruit 1924
Oil on panel, 50 × 49
Private Collection

The style and tonality of this work, which critics quickly recognised as one of his best, reflects Socrate's love of old master painting. The girl's pose echoes that of Salome holding the head of John the Baptist on a platter in a well-known work by Caravaggio, an artist whom Socrate much admired, while the soft light has a strongly Venetian quality. Like other Rome-based artists associated with the 'return to order', such as Guidi and de Chirico, Socrate studied paintings at the Museo Borghese, but he avoided direct quotation from the works of the past. Instead he tried to combine an obviously contemporary or timeless subject matter with a classical sense of order and harmony in the composition. In this paint-

ing, for example, there is a subtle interplay between the checked pattern of the dress of the impassive, statue-like girl and the squares on the surface of the pineapple, while the arcs of the bananas echo the curve of her arm.

This painting belonged to the critic Roberto Longhi, who wrote a monograph on Socrate in 1926 in which he emphasised the Caravaggio-like quality of his work. It was included in an exhibition of ten Novecento artists organised by Margherita Sarfatti in Rome in 1927, and was much praised. One critic thought Socrate among the best of the group, writing, 'He is an artist who has dropped modern conventions in good faith, and has started again with tradition, in order to continue and renew it, without neoclassical or archaic mutterings' (V. Golzio, 'La Mostra degli Amatori e Cultori delle Belle Arti', *Roma*, July 1927).

Socrate had evolved his very particular type of modern classicism independently of the Milanese Novecento group, but the 'Italian-ness' of his work allowed him to be included in the broad 'nationalistic' vision of the movement. In the catalogue of this exhibition in Rome, Sarfatti wrote of the artists:

> They are not bound by the ideology of any school. They are united in their diverse yet unanimous pursuit of one style of clarity and synthesis, which is at once classical and highly modern. To create in every great epoch a new ideal of beauty, beyond inconstant reality and eternally true, is the task of the Mediterranean; once it lay with the Egyptians and Greeks, now with the Italians. For this reason, the word 'Art' moves our love-stricken hearts, for it is the second name of our fatherland. For this reason we want the word 'Novecento' to resound, like 'Quattrocento', throughout the world to the glory of Italy.

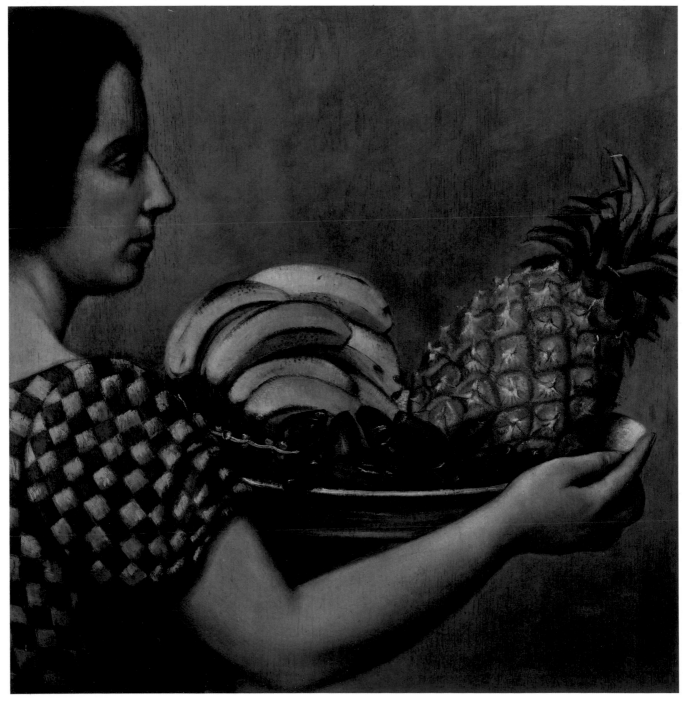

168

JOAQUIM SUNYER 1874 SITGES – 1956 SITGES

Sunyer was the leading Noucentista painter, his work perfectly embodying in both its iconography and style the central preoccupations of the movement. His abandonment of the 'decadent' urban themes fashionable in Barcelona at the turn of the century, in favour of pastoral imagery idealising the 'traditional' Mediterranean way of life, is a paradigm of the general shift within the Catalan avant-garde from about 1906 onwards. Seen as exemplary by contemporary Catalan critics, he exerted a considerable influence on younger artists, including Miró, and was, arguably, a catalyst behind Picasso's return to a classical, figurative style in 1917.

When Sunyer was fifteen his family moved to Barcelona, and shortly afterwards he began his studies at the La Llotja School of Fine Arts. He made friends with Joaquim Mir, and together they went on painting trips in the surrounding countryside. Henceforward landscape would be a principal subject for Sunyer, the focus for his lyrical sensibility and idealistic vision of the harmony of man in nature. Other fellow students at the La Llotja school, besides Mir, were Nonell, later one of the most prominent Modernista painters, and Torres-García, who was for several years around 1910 a committed exponent of neo-classicism and a significant force in the Noucentista movement. In 1896 Sunyer settled in Paris. He painted numerous working-class street scenes in a style reminiscent of the late work of Pissarro, while his graphic work – generally more sombre in mood and more pointed in its depiction of both the poverty and the seamy glamour of Parisian street and night life – betrays his familiarity with Symbolism, and his admiration for Daumier and Lautrec, and for Steinlen, who became a personal friend. By 1903 Sunyer was on close terms with Picasso, and there are distinct similarities between his work and Picasso's paintings of the same period.

A significant change in Sunyer's work is noticeable in a canvas painted in the summer of 1908 on a return trip to Sitges. 'Maternity' (Ajuntament de Sitges, Museu Municipal del Maricel) depicts a strongly built, firmly modelled peasant woman suck-ling her baby son. Behind her is the flat expanse of the Mediterranean, and three white-sailed fishing boats are ranged across the top of the canvas. In its subject and its simplified style it recalls the Tahitian paintings of Gauguin, which Sunyer would have seen in the huge retrospective held in Paris in 1906. But it also indicates his positive response to the doctrines of Eugeni d'Ors, the principal theorist of Noucentisme, who had come to prominence as a critic a few years before. From this time onwards, although he continued to live in Paris, Sunyer spent long periods in Catalonia, which now replaced Paris as the locus of his paintings.

In March 1909 Sunyer was well represented in the spring Salon in Liège, and in a favourable review published in *L'Œuvre* Tyge Moller specifically drew attention to the Mediterranean character of his work. Having emphasised Sunyer's contempt for academic art, and his identification with the land in which he was born and bred, Moller concludes: 'His last paintings of Sitges have a tone which is grave and serious, simple and idyllic. They remind one of Puvis de Chavannes and give promise of future large and splendid murals singing the freshness and the happiness of life on the shores of the Mediterranean.'

This notion of Sunyer as the 'poet' of an unspoilt, rustic way of life rooted in antiquity is quite common in the early writings about his work. The one-man exhibition Sunyer had at the Galerie Barbazanges the following year drew the praise of Apollinaire and André Salmon; Louis Vauxcelles, in his review published in *Gil Blas*, stressed the 'synthetic' and 'purified' character of his latest paintings, and the complete absence of any anecdotal content.

Sunyer's real breakthrough, however, came with his exhibition at the Faianç Català galleries in Barcelona in April 1911. Although in comparison to contemporary French painting Sunyer's pictures may seem relatively unadventurous, the show provoked a local scandal, incensing conservatives who saw the pictures as iconoclastic and revolutionary in their primitivist, anti-naturalistic style. To capitalise on the publicity, the critic Miguel Utrillo, who had

The artist in his studio in the Caller Mozart, Barcelona, 1918 (Photo: Jaume Sunyer)

provided a text for the catalogue, invited the celebrated Modernista poet Joan Maragall to give his 'impressions'. Maragall's commentary, published in the review *Museum*, focused on Sunyer's effort to reach the universal essence of his subjects, his expressive use of stylisation and distortion, the visionary conception of landscape and figures united by a common rhythm, and the sense of urgent and untamed life emanating from the canvases. Concluding with a rhapsodic account of the recently completed 'Pastoral' (cat.169), which he identified as Sunyer's masterpiece, Maragall wrote that the overriding characteristic of his work was its 'Catalan-ness' – that his very 'faults' were those of all true Catalans and of the very territory of Catalonia: 'Above all Sunyer is becoming a true Catalan artist. A great artist but a Catalan. Or, if you prefer, a Catalan but a great artist.'

In 1912 Sunyer spent several months in Céret, where he saw much of Manolo and painted a series of landscapes in a primitivist style which not only reveals his deep

admiration for Cézanne, but suggests an interest in the recent landscapes of Derain and the early Cubist landscapes of Picasso and Braque. However, these faint signs of a move towards the abstraction of Cubism had no sequel, whereas the debt to Cézanne – regarded as the greatest modern master by d'Ors – became more pronounced and was long-lasting, leaving its imprint on many of Sunyer's most ambitious and impressive canvases.

In 1913 Sunyer went to Italy, visiting Rome, Florence, Venice and many of the other major centres of Renaissance art. In Florence he copied one of Ghirlandaio's frescoes in Sta Maria Novella; in Orvieto he was deeply impressed by Signorelli. The Arcadian scenes that he painted on his return frankly reflect his ambition to emulate the monumentality of Renaissance art. The following year Sunyer painted in the countryside around Banyuls, where he was able to renew his long-standing friendship with Maillol, and in 1915–16 he worked alongside the sculptor Casanovas on the island of Mallorca.

By 1920 Sunyer's reputation in Spain was firmly established. 'Cala Forn' (1917), a large idealised landscape with a group of statuesque children strung out in a line across the foreground, was acquired for the Museu d'Art Modern in Barcelona in 1918 – a sign of his prestige – and in 1922 a special room was reserved for his work in the spring Salon in Barcelona. His importance in the national context was recognised in 1930 when he was accorded a retrospective exhibition at the museum of modern art in Madrid. His paintings during the 1920s represent a consolidation of his earlier achievement rather than a new direction, his favourite subjects, apart from portraits of members of his family, being nudes in landscapes, young girls, maternities and children. These subjects dominated his repertoire for the rest of his life.

169 Pastoral 1910–11

Oil on canvas, 106 × 152
Joan A. Maragall

'Pastoral' was the centrepiece of Sunyer's one-man exhibition at the Faianç Català galleries in Barcelona in April 1911. The great Modernista poet Joan Maragall devoted a long, lyrical passage to it at the end of his essay 'Impresión de la Exposición Sunyer':

> I found myself facing 'Pastoral', and there I seemed to see condensed, clarified, sublimated, the whole of the artist's work. I seemed to stand at an intersection in our mountains, those mountains that are so typical of Catalonia, at once rugged and undulating, as lean and harsh as our souls. . . . Consider the woman in Sunyer's 'Pastoral' – she is the embodiment of the landscape; she is the landscape which, in coming to life, has assumed flesh. That woman is not there by chance: she is destiny. She represents the whole history of creation: the creative force which produced the curves of the mountain went on inexorably to produce the curves of the human body. The woman and the landscape are stages of one and the same thing.' (*Museum*, no.7)

But the overriding impression the painting produced in him, he concluded, was a 'feeling of Catalan-ness'. 'I felt this work to be so much a part of me – so Catalan.'

In 1911 Eugeni d'Ors published the various pieces that were then incorporated into his 'novel' *La ben plantada* (1912). Here the enduring strength of the Mediterranean tradition and of the Catalan people is symbolised in the image of a woman; and in his association of the naked woman lying on the earth with the rolling, fertile Catalan landscape, Sunyer has provided the perfect visualisation of this concept. D'Ors had first mentioned Sunyer in 1909, but did not include him in his *Almanach dels noucentistes*, published in 1911. After the April exhibition, however, and with the backing of such respected figures as Maragall, Sunyer quickly assumed the position of the leading young Noucentista painter, and many of the canvases he painted after 'Pastoral' developed the same potent theme of the earthly Arcadia, expressed in terms of a mythology of rural life. Other Catalan artists take up exactly this theme – Manolo in his robustly earthy nudes (cat.101), and Gargallo in his (cat.57).

But the emphasis in 'Pastoral' on Catalo-nia as a mythic site did not preclude influence from recent French art, provided that that art had a 'Mediterranean' aspect. Sunyer's pictorial sources were, of course, primarily French, for he had been based in Paris since 1896. Matisse was, surely, an inspiration – particularly perhaps the expressive rhythms of 'Bonheur de vivre' (Barnes Foundation, Merion, Pennsylvania), the sensation of the 1906 Salon des Indépendants. Matisse's followers into this idyllic, pagan world, such as Othon Friesz, must also have impressed Sunyer when he abandoned his 'decadent' Parisian subject matter around 1908. (See 'Spring', cat.53.) There are, too, signs of Sunyer's growing appreciation for the structure and handling of the Provençal landscapes and the Bather paintings of Cézanne – although the classical pastoral imagery has no exact equivalent in Cézanne's work.

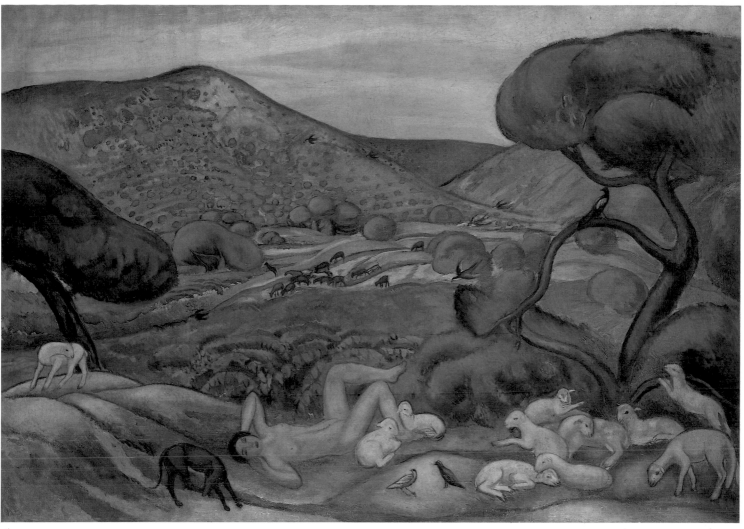

169

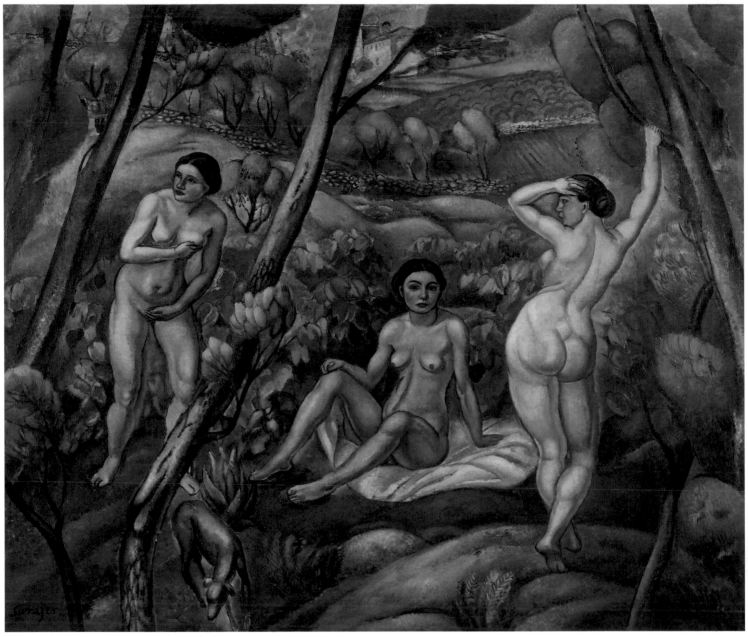

170

170 Landscape with Three Nudes 1913–15

Oil on canvas, 125 × 151
Museu d'Art Modern, Barcelona

This may have been painted soon after Sunyer's return from Italy, where he spent a few months in the autumn of 1913. It also relates closely to another canvas of the same size depicting four nudes in a landscape, which is dated 1915 (private collection). In any case, it is a clear instance of Sunyer's direct response to the great Renaissance paintings he saw in Italy, and particularly to Signorelli's fresco of 'Paradise' in the cathedral at Orvieto, which is known to have impressed him greatly. The painting was recognised as a major achievement at the time, and was reproduced in Alexandre Plana's illustrated monograph published in 1920.

In contrast to 'Pastoral' (cat.169), the nudes in this picture are less sensual, and more dominant in the composition. This tendency was confirmed in Sunyer's subsequent figure paintings, and corresponds to his desire to infuse his new work with a greater classic grandeur and seriousness. It was also at this period that his admiration for Cézanne – the hero of the Noucentistes – became more apparent, particularly in the synthetic, flattened treatment of landscape, the abstraction of the colour, and the patterned quality of the brushwork. 'Landscape with Three Nudes' intentionally realises the goal of an anti-academic, 'modern' classicism, in which the great art of the Renaissance is not imitated slavishly, but is reinterpreted in terms of avant-garde pictorial preoccupations with surface design and abstract formal harmony.

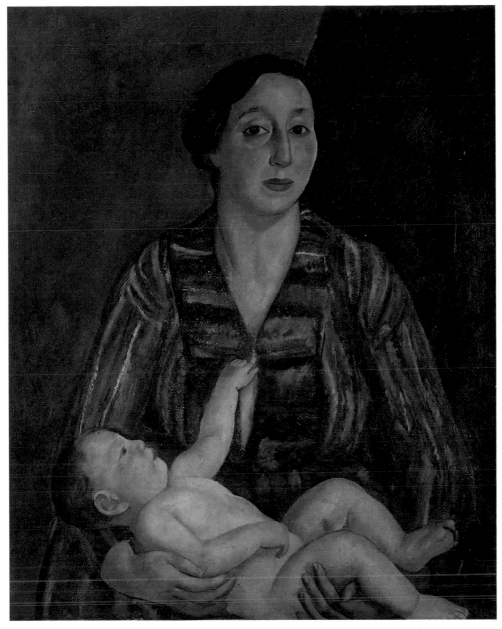

171

171 Maternity 1921

Oil on canvas, 92 × 73
Private Collection

This depicts Sunyer's wife Elvira, with their infant son Jaume. Sunyer had been fascinated by the subject of the secular Maternity ever since his 'conversion' to a timeless, classical manner around 1908. But with the birth of his own children, the subject assumed greater importance for him, although, unlike Picasso, he seems never to have wanted to mythologise and depersonalise it through the use of costume or stylistic pastiche.

This said, the present painting makes clear allusions to Renaissance paintings on the theme of the Madonna and Child, especially, perhaps, in its statuesque conception of form and in the impressive, almost iconic clarity of the composition, to the work of Raphael. The strength of the drawing, and the way the broad, full body of Elvira is thrust up against the picture plane, suggest a debt to Ingres's great female portraits. But the abstracted brushwork is Sunyer's homage to Cézanne. This trilogy – Raphael, Ingres, Cézanne – was entirely representative of the prevailing taste of the 'call to order' movement in the 1920s.

172 Teresa: the Girl in the Shawl 1923

Oil on canvas, 100 × 73
Museo de Bellas Artes, Bilbao

This painting, with two others, was purchased by the museum in Bilbao in February 1925. Very probably it had been exhibited that January in Sunyer's exhibition at the Salon de los Amigos del Arte in Madrid.

Like other Noucentista artists, Sunyer gave a classic, monumental interpretation of the country girls of Catalonia. In this painting the calm, expressionless face of the girl, the simplified modelling of the body, and the clarity of the contours, are comparable to the contemporary sculptures of Casanovas. Unlike Casanovas, however, Sunyer does not make explicit references to Greco-Roman traditions, but rather to the Italian Renaissance (Raphael, in particular), and to the modern classicism of Cézanne. The imaginative, expressive distortions of works painted a decade or so earlier, in which a strong sense of rhythmic movement united the compositions, have given way to a more sober, more tranquil mood. Joan Maragall, when writing about Sunyer's work at the time of his exhibition in Barcelona in April 1911, had described the element of 'violence' and the absence of complete 'harmony' (*Museum*, no. 7): serenity and harmony are the very qualities that Sunyer sought in the major paintings he executed after 1917.

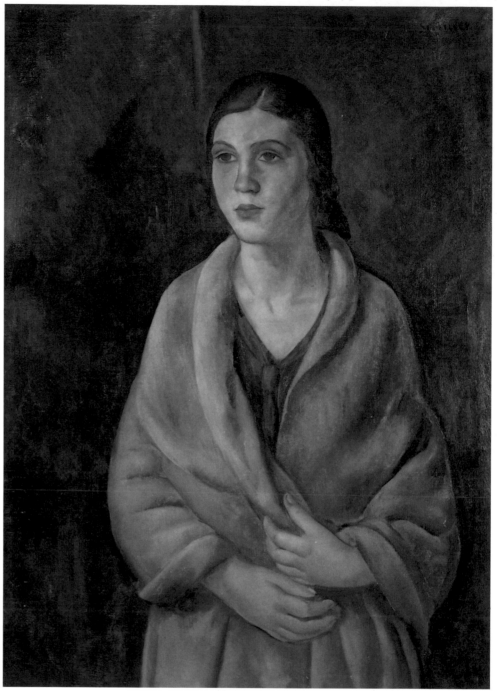

172

JOSEP DE TOGORES 1893 CERDANYOLA DEL VALLÈS – 1970 BARCELONA

Togores was trained at the La Llotja school of art in Barcelona, where his master was Fèlix Mestres. He distinguished himself very early as a draughtsman, at first specialising in the depiction of local types. When he was only 16 a drawing of his, 'The Madman of Cerdanyola', was bought in 1909 for the Belgian national collection from an exhibition of Catalan art held in Brussels. In 1913 Togores went to Madrid to study in the Prado, and then to Paris where he was deeply impressed by the work of Cézanne. In Paris, where he mixed with Picasso, Gris and Manolo, Togores concentrated on still lifes and nudes, and a group of these canvases was exhibited in Barcelona in 1917 on the premises of *La Publicidad*. In Barcelona, where he lived during the First World War, Togores worked as a portraitist and joined a studio specialising in the restoration of old master paintings. Meanwhile he was active in the Agrupació Courbet, a short-lived avant-garde group founded in 1918.

In 1919 Togores returned to Paris, where at first he continued to work as a restorer. However, through his friendship with Max Jacob he was introduced to the dealer Kahnweiler, who gave him a contract in 1921. His one-man show held in February 1922 was the inaugural exhibition of Kahnweiler's new Galerie Simon. Jacob provided the catalogue preface, and the show was, as Kahnweiler reported in a letter to Manolo, 'an enormous success in terms of sales'. Kahnweiler included Togores's work in an exhibition of his contract artists in May 1923, and in the same year published Henri Hertz's *Le Guignol horizontal*, with four original lithographs by Togores. Through

Kahnweiler's various arrangements with galleries abroad, particularly in Germany and Switzerland, Togores's work was exhibited widely in the 1920s, and in 1926 he had the first of many one-man shows at the Sala Parés in Barcelona.

Togores's wartime experience as a restorer had fostered a strong sense of the value of tradition, which was underlined by his contact with Noucentisme and by the prevailing 'return to order' in France. Initially he quite successfully maintained the delicate balance between modernism and tradition, but already by the late 1920s his paintings of nudes and children were showing unmistakable signs of a form of sentimentalised academicism redolent of a popular Salon style. In 1931 Kahnweiler terminated the contract with him, explaining in a letter to Max Jacob dated 21 November:

> I am very upset about the separation with Togores, whom I like personally. But for some years I have not liked what he is doing. I've been patient, always hoping for a change. The series of canvases he brought back from Italy obliged me to call a halt. I don't like them at all, and I don't feel capable of defending them. I took Togores on penniless and unknown eleven years ago. I leave him – but with money and fame.

That same year Togores returned to Barcelona for good. The conservative tendencies in his art were confirmed during the following years, and by the 1940s Togores was concentrating on mural painting and illustration, while his attitude to modernism became frankly hostile and intolerant.

The artist in his studio

173 Catalan Girls 1921

Oil on canvas, 130 × 81
Museu d'Art Modern, Barcelona

There is a Galerie Simon ticket on the back of this painting, which was very probably one of the twenty-seven canvases exhibited in Togores's one-man show held there in February 1922. It was painted in the year that Togores became contracted to Kahn-weiler, and in its balanced, 'mirror image' composition, as well as in the subject of sturdy, simply dressed Catalan peasant girls, it recalls the reliefs of Manolo, who had been under contract to Kahnweiler for over a decade and was a close personal friend. Other sources for this painting include Picasso's recent classical paintings. There is, for instance, a marked similarity between the execution and modelling of the hands, faces, clothing, and even the balustrade and abstracted background in this painting, and Picasso's 'Harlequin' (cat. 132), which was painted in Barcelona in 1917 and which Togores would surely have seen.

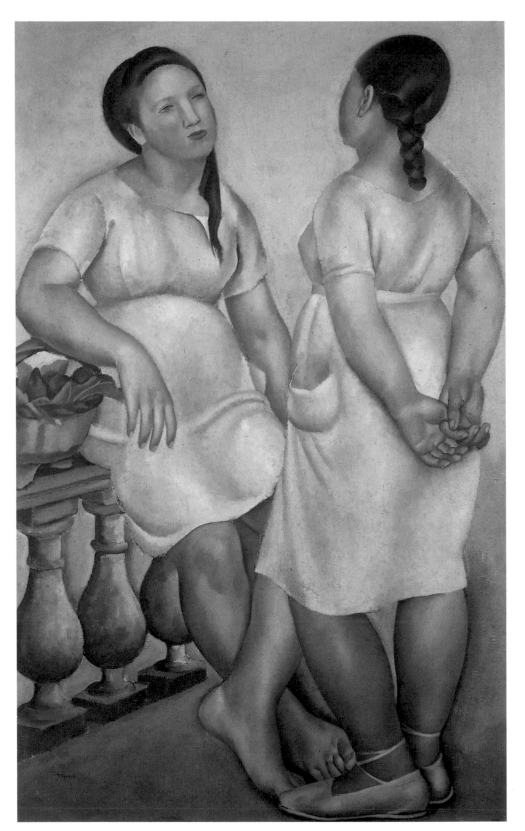

173

174

174 Landscape: Le Coteau

1921

Oil on canvas, 65 × 82

Private Collection

This painting also has a Galerie Simon label on the back, with the date 1921. Like 'Catalan Girls', it may therefore have been included in the exhibition organised by Kahnweiler in February 1922. Landscape was a genre much practised by Noucentista painters, for the idea of the Catalan countryside as a symbol of fertility and a repository of all that is eternal, strong, true and beautiful was an article of faith. Togores, here depicting a hillside in the Loire, responds to the French countryside in a way that is reminiscent of Sunyer's earlier paintings of the hills and farms of Catalonia and Mallorca. Like Sunyer, Togores was also

directly indebted to the formal structure of the Provençal, classical landscapes of Cézanne. In this picture he closes the sky out altogether in order to concentrate on the land, interpreting it in terms of harmonious, gently rhythmic undulations which peak towards the centre of the composition, and stressing the unity of the whole through a system of interlocking wedges, repeated clusters of trees arranged in directional sequences, and a simplified colour scheme based on the opposition of orange–red and grey–green. The result is a satisfying blend of the real and the ideal, for there is not a person in sight, and there is nothing to identify a particular moment. It may be compared with the much more detailed landscapes of Miró (cat.121), and the modernised but none the less classical 'animated landscapes' of Léger (cat.78).

LENDERS

Public Collections

Antwerp, Middelheim Open Air Museum for Sculpture 108

Baltimore Museum of Art, Maryland 28
Barcelona, Institut del Teatre 3
Barcelona, Museu d'Art Modern 21, 22, 41, 59, 60, 97, 104, 170, 173
Barcelona, Museo Clarà 42a–d
Barcelona, Museu Picasso 132
Basle, Kunstmuseum 82 (not exhibited)
Berlin, Nationalgalerie 83
Bilbao, Museo de Bellas Artes 172
Bordeaux, Musée des Beaux-Arts 51

Cologne, Museum Ludwig 18, 45, 124

Florence, Galleria d'Arte Moderna, Palazzo Pitti 157

The Hague, Haags Gemeentemuseum 155
Hawaii, Honolulu Academy of Arts 127 (not exhibited)

Leningrad, Hermitage Museum 14, 123
Liverpool, Walker Art Gallery 48
London, Tate Gallery 7, 30, 37, 76, 84, 94, 95, 148

Madrid, Centro de Arte Reina Sofia 44, 58, 61, 62
Madrid, Museo del Prado 64
Mannheim, Städtische Kunsthalle 98
Milan, Civico Museo d'Arte Contemporanea, Palazzo Reale 26, 69, 107
Milan, Fondazione Antonio Mazzotta 159
Minneapolis Institute of Arts 46
Moscow, Pushkin State Museum of Fine Arts 38

Nancy, Musée des Beaux-Arts 75
New York, Museum of Modern Art 31, 81, 128, 135, 143
New York, Solomon R. Guggenheim Museum 117
New York, Metropolitan Museum of Art 131

Otterlo, Rijksmuseum Kröller-Müller 79, 120, 153

Paris, Fondation Dina Vierny, Musée Maillol 88, 89, 90, 91, 92, 93
Paris, Fondation Le Corbusier 70, 71
Paris, Musée d'Art Moderne de la Ville de Paris 53
Paris, Musée de l'Orangerie 49, 50, 141

Paris, Musée du Petit Palais 86, 87
Paris, Musée National d'Art Moderne, Centre Georges Pompidou 10, 11, 12, 47, 66, 74
Paris, Musée Picasso 130, 134, 136, 137, 142, 144, 145, 147
Philadelphia Museum of Art 129

Rome, Galleria Nazionale d'Arte Moderna 17, 105, 164

Saint Louis Art Museum 116
Saint-Paul, Fondation Maeght 6, 65
Saint-Rémy-lès-Chevreuse, Fondation de Coubertin 4
Santa Barbara Museum of Art 133
São Paulo, Museu de Arte 118
Stockholm, Moderna Museet 121, 139
Stuttgart, Staatsgalerie 115

Tossa de Mar, Museo Municipal 23
Trento and Rovereto, Museo d'Arte Moderna e Contemporanea 112
Trieste, Galleria d'Arte Moderna 19
Turin, Museo Civico di Torino 13

Valls, Museu de Valls 24

Winterthur, Kunstmuseum 35

Private Collections

Beyeler Collection, Basle 138
Bourdelle Collection 8, 9

Anna Derossi Caretta and Cristina Caretta 110

Galleria Arco Farnese, Rome 111
Gian Ferrari, Milan 15
Antonio and Marina Forchino, Turin 54

Godia Collection, Milan 101

M. and Mme. Claude Laurens 77
Galerie Louise Leiris, Paris 68, 72, 73, 80, 114

Joan A. Maragall 169
Marlborough International Fine Art, A.G. 85
Galerie Marwan Hoss, Paris 56

Bernard Picasso Collection, Paris 140
Private Collections 1, 2, 5, 16 (not exhibited), 20, 25, 27, 29, 32, 33, 34, 39, 40, 43, 52, 55, 57, 63, 67, 78, 103, 106, 109, 113, 119, 122, 125, 126, 146, 149, 151, 152, 160, 165, 166, 167, 168, 171, 174

Salvador Riera Collection, Barcelona 96, 99, 100, 102

Galleria dello Scudo, Verona 150, 158
Gina Severini Franchina 154, 156
Aglae Sironi 161, 162, 163
Galleria Spazio Immagine, Milan 36

INDEX OF ARTISTS AND THEIR WORKS

ANDREU, Mariano
1 Women with a Bird
2 The Game of Cards
3 Figures from the Commedia dell'Arte

BERNARD, Joseph
4 Modern Sphinx
5 Serenity

BONNARD, Pierre
6 Summer
7 The Bowl of Milk

BOURDELLE, Emile Antoine
8 Penelope
9 France

BRAQUE, Georges
10 Basket Bearer
11 Basket Bearer
12 Woman with a Mandolin. Free Study after Corot

CAMPIGLI, Massimo
13 Woman with Folded Arms
14 The Seamstresses
15 Two Sisters

CARRÀ, Carlo
16 The Drunken Gentleman (not exhibited)
17 The Oval of Apparitions
18 The Daughters of Lot
19 Woman by the Sea
20 Study for 'Justinian Liberates the Slave'

CASANOVAS, Enric
21 Persuasion
22 Youth and Love
23 Mallorcan Peasant Woman
24 Youth

CASORATI, Felice
25 Silvana Cenni
26 Still Life with Mannequins
27 Portrait of Casella

CÉZANNE, Paul
28 Bathers
29 Young Italian Woman Leaning on her Elbow

CHIRICO, Giorgio de
30 The Uncertainty of the Poet
31 Song of Love
32 La Muta, after Raphael
33 Roman Piazza (Mercury and the Metaphysicians)

34 Roman Villa
35 Self-portrait
36 The Philosopher
37 The Painter's Family
38 Roman Women
39 Gladiators
40 Melon with Grapes and Apples

CLARÁ, José
41 Rhythm
42a Isadora Duncan Dancing to Schubert's Marche Militaire
42b Isadora Duncan Dancing to Schubert's Marche Militaire
42c Isadora Duncan Dancing to Tchaikovsky's Marche Slave
42d Isadora Duncan – A Tragic Destiny

DALÍ, Salvador
43 Portrait of the Artist's Father and Sister
44 Seated Girl Seen from the Back

DERAIN, André
45 View of St Paul-de-Vence
46 The Bagpiper
47 Portrait of Madame Kahnweiler
48 The Italian Model
49 The Lovely Model
50 Still Life with a Melon

DESPIAU, Charles
51 Girl from the Landes

DONGHI, Antonio
52 Washerwomen

FRIESZ, Emile-Othon
53 Spring

FUNI, Achille
54 Maternity
55 Earth

GARGALLO, Pablo
56 Torso of a Young Gipsy
57 Small Torso of a Woman

GONZÁLEZ, Julio
58 Head of a Woman
59 Woman Washing
60 Woman Sleeping on the Beach
61 Reclining Nude
62 Kneeling Nude

GRIS, Juan
63 Bathers, after Cézanne
64 Portrait of Josette Gris

65 Portrait of Pierre Reverdy
66 Portrait of Madame Berthe Lipchitz
67 The Bay
68 The Pierrot

GUIDI, Virgilio
69 The Visit

JEANNERET, Charles-Edouard, known as Le Corbusier
70 Still Life with Bowl
71 Pale Still Life with a Lantern

LAURENS, Henri
72 Woman with a Basket of Grapes
73 Two Women
74 Reclining Woman with Drapery
75 Large Woman with a Mirror
76 Bather (Fragment)
77 Small Maternity

LÉGER, Fernand
78 Man with a Dog
79 Animated Landscape
80 Study for a Landscape
81 Three Women (Le Grand Déjeuner)
82 Nudes against a Red Background (not exhibited)
83 The Two Sisters

LIPCHITZ, Jacques
84 Pregnant Woman
85 Portrait of Raymond Radiguet

MAILLOL, Aristide
86 Two Seated Women
87 Study for 'The Mediterranean'
88 The Mediterranean
89 Flora
90 Woman with a Thorn
91 Holding Both Feet
92 Holding One Foot
93 Torso of the Ile de France
94 Venus with a Necklace
95 The Three Nymphs

MANOLO (Manuel Hugué)
96 Totote
97 Girl from Roussillon
98 Young Catalan Woman
99 Ox and Ox-cart
100 Old Peasant Woman
101 Seated Girl
102 Woman with a Mirror
103 Bacchante
104 Bacchante

MARINI, Marino
105 Fragment (Female Nude)

MARTINI, Arturo
106 The Stars
107 Head of a Boy
108 La Nena
109 Torso
110 Leda and the Swan
111 Reclining Woman
112 Woman in the Sun

MASSON, André
113 Women
114 The Abandoned City

MATISSE, Henri
115 The Coiffure
116 Bathers with a Turtle
117 The Italian Woman (Lorette)
118 Plaster Torso, Bouquet of Flowers
119 The Three O'Clock Session

METZINGER, Jean
120 Woman with a Pheasant

MIRÓ, Joan
121 Vegetable Garden with Donkey
122 Montroig, the Church and the Village

MORANDI, Giorgio
123 Still Life
124 Still Life

OPPI, Ubaldo
125 Portrait of the Artist with his Wife (The Double Portrait)
126 The Friends

OZENFANT, Amédée
127 Fugue (not exhibited)

PICASSO, Pablo
128 Two Nudes
129 Seated Nude and Standing Nude
130 The Painter and his Model
131 Portrait of Ambroise Vollard
132 Harlequin
133 Italian Peasants, after a Photograph
134 Still Life with Pitcher and Apples
135 Nessus and Dejanira
136 Seated Woman
137 Studies
138 Head of a Woman
139 The Source
140 Maternity
141 Large Bather
142 Two Women Running on the Beach (The Race)
143 Studio with Plaster Head
144 Seated Woman in a Red Armchair
145 Head of a Woman
146 Minotaur and Nude

RENOIR, Pierre Auguste
147 Seated Bather in a Landscape (Eurydice)
148 Venus Victorious

SAVINIO, Alberto
149 The Return
150 Builders of Paradise
151 Roger and Angelica

SEVERINI, Gino
152 Portrait of Jeanne
153 Still Life with Brown Jug
154 Conjugated Projections of the Head
155 The Two Pulchinellas
156 Portrait of Gina (Homage to Fouquet)
157 Still Life with Pumpkin and Mask

SIRONI, Mario
158 Composition – Urban Architecture
159 Self-portrait
160 The Sculptor's Model
161 Maternity
162 Male Figure
163 Female Figure
164 Solitude
165 The Miner's Family
166 Architecture with Vestal Virgin and Athlete
167 Untitled

SOCRATE, Carlo
168 Girl Carrying Fruit

SUNYER, Joaquim
169 Pastoral
170 Landscape with Three Nudes
171 Maternity
172 Teresa: the Girl in the Shawl

TOGORES, Josep de
173 Catalan Girls
174 Landscape: Le Coteau